Objects for Use

Objects for Use | Handmade by Design

Paul J. Smith, General Editor

Essays by
Paul J. Smith
and
Akiko Busch

Harry N. Abrams, Inc., Publishers,
in association with the American Craft Museum

Editor: Elisa Urbanelli
Designer: Joseph Cho / Stefanie Lew, Binocular, New York

Library of Congress Cataloging-in-Publication Data
Smith, Paul J.
 Objects for use : handmade by design / essays by Paul J. Smith
and Akiko Busch.
 p. cm.
 ISBN 0–8109–0611–2 (hardcover)
 ISBN 1–890385–07–7 (paperback)
 1. Decorative arts—United States—Exhibitions. 2. Handicraft—
United States—Exhibitions. I. Busch, Akiko. II. Title.
 NK808.S635 2001
 745'.0973'0747471—dc21
 2001001343

Published in 2001 by Harry N. Abrams, Incorporated, New York
All rights reserved. No part of the contents of this book may be
reproduced without the written permission of the publisher.
Printed and bound in Hong Kong
10 9 8 7 6 5 4 3 2 1

Harry N. Abrams, Inc.
100 Fifth Avenue
New York, N.Y. 10011
www.abramsbooks.com

Front cover: Lisa Schwartz and Kurt Swanson, Pinkwater Glass Studio.
Dinnerware set. Glass. Blown. Photograph Eva Heyd

Back cover: (top row, left to right) Karen L. Pierce. Double-walled bowl.
Copper, 24k gold, electroplate, lapis lazuli, garnet. Spun, fabricated,
patinated. Photograph Dan Morse; Thomas Davin, Davin & Kesler.
Chopsticks with holders. Exotic and domestic wood. Formed. Photo-
graph Eva Heyd; Thomas Davin, Davin & Kesler. Bookends. Maple.
Shaped, laminated, glued. Photograph Eva Heyd; (middle row, left to
right): Charles Crowley. "Star" cocoa pot. Sterling, aluminum, gold-
plated bronze. Fabricated. Photograph Lynn Swigart; Pamela Hill.
"Architectural Squares" quilt. Dupioni silk. Hand cut, pieced, machine
quilted. Photograph James Woodson; Doug Hendrickson. Herb chopper.
Iron, forged, sharpened. Photograph Eva Heyd; (bottom row, left to
right): Mary A. Jackson. Covered box with handle. Sweetgrass, pine
needles, palmetto. Coiled. Photograph Eva Heyd; Peter Danko. "Gotham"
rocker. Maple veneer, recycled automotive seat belts. Mortise-and-
tenon joinery, parts formed and bonded in a hot mold. Photograph Tim
Rice; William R. Cumpiano. Requinto guitar with cutaway. Compressed
molded carbon fiber soundboard, purpleheart, Ceylon ebony, mother of
pearl, polished lacquer finish. Collection Roberto Irizarry. Photograph
José Ramon Garcia

Contents

Foreword

In 2000, the American Craft Museum presented the first in a series of exhibitions under the general title "Defining Craft" to reflect the museum's mission to explore the evolving and expanding definitions of craft and craftsmanship in contemporary, post-industrial society. The exhibitions in the series examine the increasingly important points of creative intersection between craft and related fields, such as art, design, architecture, interior design, fashion, and the performing arts. "Defining Craft I: Collecting for the New Millennium" presented four of the many aspects of craft that inform our understanding of the word today, such as virtuosity in the handling of materials by accomplished practitioners, the ways in which the craft media are used by artists to produce independent, self-referential works of art, and the ways in which craft and craftsmanship come into play in the design process. The fourth section, devoted to function, linked the work of many craftspeople today to the rich heritage of craft history. It is the functional aspect of craft being made today by skilled professionals in a wide variety of media and with an impressive diversity of aesthetic visions that is so eloquently revealed in "Objects for Use," the second exhibition in the "Defining Craft" series.

From the earliest days of human culture, craft and craftsmanship have served as a bridge between practical and cultural needs. Tools, implements, clothing, furnishings, and ornaments have reflected profound human aspirations on both functional and aesthetic levels. Functional objects that serve basic requirements of daily life can also be vehicles for expressing deeply felt artistic and spiritual values. The connections between use and beauty that have engaged craftspeople, curators, and critics over the centuries have not diminished in significance today. Art, craft, and design can be seen as a continuum of human creative thought and action, an attitude that has shaped the progress of this institution from its founding to the present.

In 1953, three years before the founding of the Museum of Contemporary Craft, later to become the American Craft Museum, the distinguished industrial designer Don

Wallance (1909–1990) contributed an article to *Craft Horizons* entitled "Craftsmanship and Design" that illuminated the designer's respect for the functional craft traditions. Wallance wrote of the ways in which craft linked historical traditions to contemporary needs and innovations by "using forms that had been perfected through continuous adaptation by successive generations of skilled craftsmen. These forms evolved in response to real needs and were a commonplace of daily living. . . . The artist-craftsman of today, while maintaining contact with the soundest traditions of his craft, must relate his work to the conditions of a highly industrialized society, and must explore new forms that are appropriate to modern life and technology. . . . Design and crafts- manship are inseparable aspects of all well done things."

The present exhibition underscores this Museum's commitment to plurality and diversity in the definition of craft, as well as the institution's longstanding role as an advocate for those who choose to make objects that are both functional and beautiful. It is particularly appropriate that the exhibition has been curated by Paul J. Smith, direc- tor emeritus of the American Craft Museum. Throughout his tenure as director, Paul recognized that craft was a profoundly important link between the worlds of art and industrial design. Organized at a moment in our history when digital technologies, cyberspace, and virtual reality are features of our daily lives, this exhibition reveals that our need to surround ourselves with objects that are tangible and sensual, intimate and personal, practical and beautiful, has not diminished. We are still engaged, delighted, and gratified to see, touch, and enjoy using objects made with skill, pride, and talent. These objects designed and made for use—dishes and vessels for food and drink, furniture and furnishings for our homes, and surfboards, fishing rods, and musical instruments—suggest that art, craft, and design are ultimately about relationships established between the makers of things and the individuals who become the possessors, consumers, and users of those things. Through these objects we are invited into the artistic, emotional, and spiritual worlds of the creator; by selecting and using these objects, we complete a creative process begun by the maker. Objects designed and made for use underline humanistic values honored and shared by makers and consumers, values that give meaning and purpose to our lives at many levels.

Holly Hotchner
Director
American Craft Museum

Perspectives on Craft and Design Akiko Busch

At a moment in history when the allures of the immaterial realm
seem to hold us captive, it is no surprise that handmade objects have renewed appeal.
As the digital revolution reforms the modern landscape with its elusive and often invisi-
ble channels and connections, we prize all the more what we can have in hand, to touch
and hold. The allures of the intangible have fostered an undeniable appetite for the
tangible, and the craft objects that demonstrate this point with the greatest clarity and
grace are distinguished not simply by their physical beauty, but also by their apprecia-
tion for the ideals of contemporary design.

The integration of craft and design, though diminished in recent years, is hardly a
new idea. More than a century ago, the Arts and Crafts movement was a fusion of
design and craft. Confronting the social ills caused by the Industrial Revolution, Arts and
Crafts practitioners advocated the restorative value of the simple life, arguing for a
return to individual expression through handcrafts, the use of natural and native
materials, and the practice of regional art and design traditions.

Yet much of the work that evolved from this period ultimately gave a measured
consent to the innovations of the Machine Age. Consider the elegant limited edition
silver flatware of Charles Rennie Mackintosh or the furniture of Ambrose Heal that
epitomized both the craft ideal and factory production. Even C. R. Ashbee, founder of the
Guild of Handicraft in London's East End slums and one of the most tenacious defend-
ers of the Arts and Crafts movement, ultimately designed a line of cast-iron fireplaces
intended for mass production. Ashbee acknowledged the paradox that the cost of
handwork made elaborately crafted objects unavailable to the ordinary people who
concerned him most and, with disparaging eloquence, concluded: "We have taken a
great social movement and turned it into a tiresome little aristocracy working with
high skill for the very rich."*

Simplicity and function continued to distinguish craft of the modern period. Indeed,
handcrafted objects were not costly, ornate, and overworked pieces made for the few,

* Wendy Kaplan, "Leading 'The Simple Life': The Arts and Crafts Movement in Britain, 1880–1910," catalogue
essay for an exhibition of the same title, *The Wolfsonian*, Miami Beach, Fla., October 6, 1999–August 2000.

but rather, frequent allies of industrial design—practical, straightforward objects that reflected the concerns and values of the Machine Age. Often, too, it was assumed that the craft practitioner could set standards for industrial designers working for mass production. The Jazz Bowl of Victor Schreckengost, the symmetrical lathe-turned bowls of James Prestini, the ceramic vessels by Maija Grotell, the glass work of Maurice Heaton—all of these reflected a sophisticated urbanism and an elegant machine aesthetic, determining finally that the sensibilities of handcraft and modern design were not nearly so antithetical as often presumed.

Today, that coalition of craft and design shows promise of renewal. After several decades of emphasis on crafts as art and "super object," the value of which lay chiefly in its conceptual or expressive content (and often for the benefit of a consumer group not unlike Ashbee's "aristocracy"), we are confronted with a renewed appreciation for objects meant simply for use. Certainly as less distinction is made between limited production work and one-of-a-kind, the former is regaining a sense of prestige.

Such pieces have clearly benefited from the vitality in all contemporary design disciplines, ranging from graphic design, furniture, and fashion to sports design and architecture. All of these are fertile areas where new forms, materials, and technologies have flourished in the last twenty years and where there has been a fluid exchange among disciplines. But the vitality in contemporary design goes well beyond emerging technologies. Because their work by nature recognizes a market, designers are attuned to the themes of their time, whether it be the social impact of information technology, the changing form of the American family, or the excesses of a consumer culture, to name only a few.

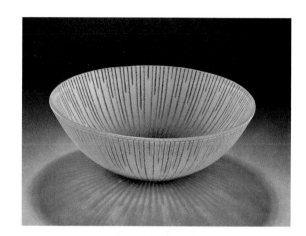

Fortunately, the creative circuitry that seems to run among the different design disciplines has extended to the craft realm as well, where it becomes evident that craft and design are not simply compatible; they are sensibilities that inform and augment one another. Often, it is the one-of-a-kind nature of craft work that allows its practitioners to contemplate and develop the inventive application of new materials and technologies that have been developed for altogether different reasons and purposes, and to respond to the social and cultural currents of their era. Such cross-fertilization of disciplines is further fueled by the fact that contemporary craftspeople are not always traditionally trained in craft; rather, they may come to their work through physics, engineering, sports, or myriad other trades and disciplines.

What all of this work demonstrates clearly is that crafts need not be remote or marginalized by the historical precedents in which they may be rooted. Rather, they can be responsive to and reflective of their time—objects that have some relevance to contemporary concerns. Just as the Arts and Crafts movement a century ago was a measured response to industrialization, so too can crafts today recognize and express the issues

left: Maija Grotell. **Flared cylinder vase**. 1941. Stoneware. Thrown, glazed. 15" x 11 ½" diam. Collection American Craft Museum, donated by the American Craft Council, 1990
right: Maurice Heaton. **Bowl**. 1964. Glass. Sagged, fused enamel. 2 ½ x 7 ¼" diam. Collection American Craft Museum, gift of Mr. and Mrs. Darell K. Slane, donated by the American Craft Council, 1990

raised by the age of technology. And it is this responsiveness that makes these pieces innovative and contemporary, rooted in this moment rather than in the past.

Such attentiveness can be expressed in a variety of ways. Work constructed from recycled materials may reflect a sensitivity to environmental concerns. Digital imagery appears as well, and along with computer-aided design and computer-driven tools and machinery, reflects a willing acceptance of emerging electronic technologies. In addition, there is a growing interest in applying new synthetic materials to time-honored craft processes in pieces that seem to integrate different moments of history; that such objects can flourish so pleasurably in a time warp is an idea that is purely modern. Finally, the graphics, imagery, and form of objects that beg, borrow, and steal from one another across national, ethnic, and cultural boundaries surely reflect a recognition of the global village.

At a time when design so thrives, it nevertheless remains a somewhat vague and abstract term. Very generally, it implies a broader set of concerns than pure expression; it implies production work, an awareness of manufacturing prerequisites, the recognition of a market and all its attendant cultural attitudes and values. But what design may be about most of all is finding a sense of fit—how artifacts of the physical world can be shaped to fit human need and use—whether it is how a spoon fits the hand, a chair fits the body, or a building fits the landscape. And when one considers how such things fit, it becomes clear that there is no place for extravagance; by nature, such a sense of fit brings with it an economy and elegance, an appreciation for what is essential.

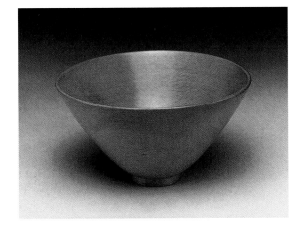

Above all, then, what most assures the craftsman's credentials as designer is the unique ability to locate this sense of fit—physical, psychological, cultural. Because craft objects, by definition, are shaped by hand, that sense of fit tends to be implicit, whether it is in a spoon, a sled, or a saddle. And it is the fit that comes from handwork that instills a sense of humanity in all such pieces. A century ago, Arts and Crafts practitioners were concerned above all with how human creativity might remain a presence in the artifacts of the Machine Age. Today, as the digital revolution sweeps the country, it is no surprise that we see a renewed appreciation for handmade things. But it is essential to note that these objects do not reject or defy the emerging technologies; rather, they give a measured consent, again bringing the human touch to a landscape redefined by technology. Which is to say, the sense of fit extends beyond the human body. These objects have been designed to fit their time as well.

left: James Prestini. **Bowl**. c. 1933–42. Beech. Turned. 5 ⅞ x 10 ¼" diam. Collection American Craft Museum, gift of Grace and Pauline Stafford in memory of Cora E. Stafford, donated by the American Craft Council, 1990
right: John Prip. **Teapot**. 1957–59. Silver, ebony, coral. Raised, fabricated, carved handles. 8 ¾ x 7 ⅝ x 5 ⅞".
Collection American Craft Museum, gift of the artist, 1994

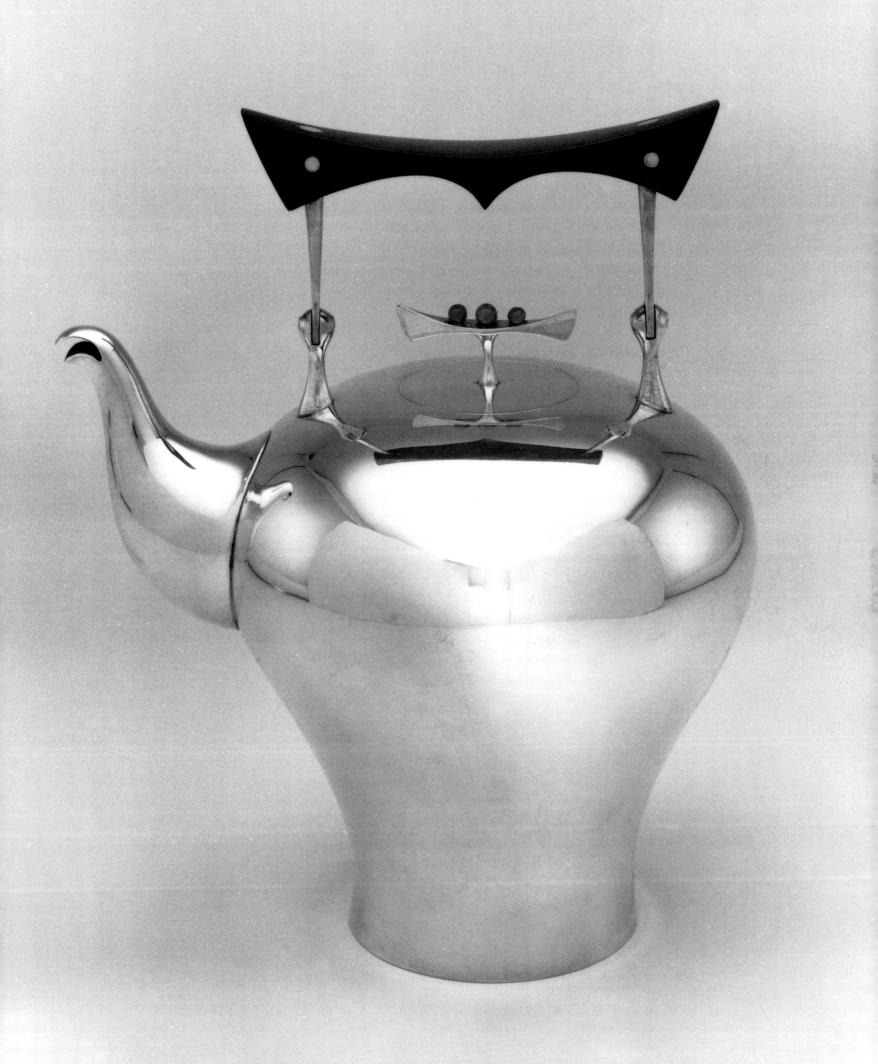

Handmade by Design Paul J. Smith

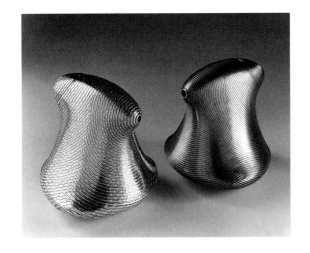

Amid today's technological advances, the handmade object fulfills our basic desire for things that are personal and appealing to us. *Objects for Use: Handmade by Design* pays tribute to handmade functional objects and their makers. This collection illustrates a wide range of innovative work currently being created by craftsmen residing in the United States. Their careers and lifestyle choices reflect the all-encompassing nature of their work, their challenges and rewards, and the integrity and clarity of purpose that inspires and sustains them.

A focus on design was a central criterion in the selection of objects featured. *Design* is a term that is not frequently used in the context of contemporary craft, as it is usually associated with manufactured products and the industrial and interior design professions. There is a basic difference between the craftsman and the designer in conceptualizing an object for a specific function. The craftsman makes a product by interacting with materials and employing complex craft skills. The industrial designer explores design ideas for a product and then conceives how to fabricate it. Although there is some overlap in these contrasting approaches, there is also a basic difference in their objective. A product designer is usually concerned with mass production, as compared to the studio approach, which allows each work to be individual and personal, and geared to a select market. As handmade objects increasingly compete in the marketplace with well-designed manufactured products, more emphasis on creating new, innovative forms with both a craft aesthetic and an attention to design will establish more rationale for the personal, handmade functional object.

Within the broad spectrum of the craft field presented here, twenty-five studios are profiled, giving insight into a variety of approaches to creating objects for a specific function and market. Illustrated works are organized into three categories: Objects for Food and Dining; Objects for Interior Space; and Objects for Sports, Music, and Play. In selecting work to be represented, emphasis was placed on successful designs that were well conceived for their designated use, fine craftsmanship, and clarity of intent.

Chunghi Choo. **Decanters**. 1980. Copper, copper plate, silver, silver plate. Electroformed. Largest 5 ¼ x 5 x 5 ¼".
Collection American Craft Museum, gift of Jack Lenor Larsen, donated by the American Craft Council, 1990

Freedom to experiment and to explore ideas, inherent in the hand process, accounts for the stylistic range in each section—some are unique works, some are produced as editions. Many works relate to the rich history of the handmade object, and others are associated with contemporary art and design trends. Musical instruments, canoes, and kayaks, having specific design requirements, are strongly influenced by their tradition, although most contain some aspect of innovation. The more avant-garde objects emphasize artistic exploration. Overall, each featured work reflects the craftsman's accomplished skill, sensitivity to his or her chosen craft, and flexibility to explore an idea. Whether utilizing clay, glass, wood, metal, fiber, leather, or paper, the hand process in each medium allows for endless possibilities of application and form, making each handmade object unique and personal.

The featured makers come from throughout the country and represent the broad cultural spectrum that is America today. Their backgrounds and approaches vary widely. There are those who have been working for several decades, as well as members of a new generation just embarking on their careers. Some have had formal art training. Others are self-taught, or have learned through apprenticeship. Some practice traditions handed down from their parents and grandparents.

Their production facilities range from solo studios to larger operations employing a number of assistants. Almost all are full-time makers who earn their living from their craft and are driven to some extent by market demands and influences. Some share their expertise by giving workshops and seminars, or hold part- or full-time teaching positions in universities or art schools.

Handmade in the 21st Century — Conflict or Contribution?

The earliest object makers were motivated by necessity, using instinct and ingenuity to produce items to assist in daily living. Throughout time, new inventions have brought about major changes in the way we live, work, and connect with the world. From the first automobile to the airplane to space exploration, from the light bulb to the telephone to the World Wide Web, our innovations have molded the way we function and communicate with our fellow habitants. Each decade brings new technologies that extend our minds and bodies into realms unknown before. Today automated machinery and computer-generated programs perform many production activities, challenging the role of hand skills.

Making objects by hand could be considered an obsolete activity in our time, given our seemingly endless supply of quality manufactured merchandise. Today there exists every conceivable product to aid us in every aspect of life, at affordable prices. Mail-

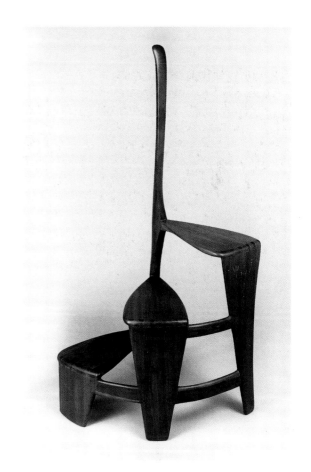

Wharton Esherick. **Library ladder**. 1966. Cherry. Constructed. 48 x 17 x 27". Collection American Craft Museum, donated by the American Craft Council, 1990

order catalogs have expanded to home-shopping TV networks, and the relatively new Internet resource enables us to buy anything from underwear to a Picasso painting with the click of a button. Why, then, does the urge persist to make, and to own, something crafted by hand?

Obviously, the vast array of mass merchandise available to us motivates our desire to possess something personal and unique. We look for personal identity in what we wear, the furniture we choose for our living environment, the colors we paint our walls. Finding an heirloom from the past in an antique store or flea market is one way to personalize our surroundings; acquiring a one-of-a-kind chair from a furniture maker or a casserole from a potter is another.

What attracts us to these objects is their essential humanity. A handmade object has a soul, reflecting the spirit and personal pride that went into its creation. When it becomes someone's treasured possession, this intrinsic living quality is transferred from maker to owner; the spirit of the object becomes an unspoken exchange of energy that is shared with subsequent owners, endowing the object with immortality.

Choosing a Career as a Maker

It is difficult to generalize why one chooses to be a potter, furniture maker, or boat builder, but it is very much a lifestyle choice that allows one the freedom to create in a self-styled living and working environment, outside of a structured nine-to-five workday. A primary motivation is the opportunity for personal expression of one's imagination and ideas. Many craftsmen are simply motivated to earn a living doing what they love to do, to enjoy the independence to live where they please, and to pursue a personal business. In theory, this is an ideal world: a full and rewarding life, no hectic office commute, and a flexible work schedule. In reality, it requires much stamina, focus, and energy.

One must first learn his or her chosen craft. With cultivated knowledge, creating work is only the beginning. Establishing a studio requires startup capital to acquire a workspace; equipment can be a substantial investment; and setting up a cost-effective means of production is very time-intensive. To be a good glassblower, musical instrument maker, potter, weaver, or metalsmith demands training, perseverance, and openness to exploring ideas. Essential to creating an object is respect for the material and deep understanding of the hand manipulation that can shape a form. Developing a saleable product is also a central challenge. Making beautiful objects that express one's imagination is personally rewarding, but it also takes ingenuity to produce a unique

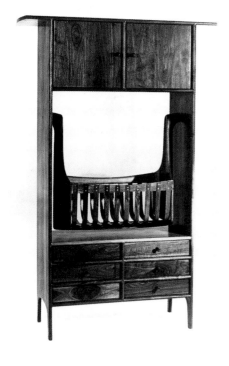

Sam Maloof. **Cradle-cabinet**. 1968. Walnut, brass screws. Constructed. 68 ½ x 47 ¾ x 18". Collection American Craft Museum, gift of the Johnson Wax Company, from OBJECTS: USA 1977, donated by the American Craft Council, 1990

product that is both functional and appealing. To be well crafted is not enough; a work must have a special charisma.

Learning the Craft

Throughout history, craft skills were passed on from one generation to the next, usually via a family or guild structure. In the United States, with the notable exception of the rich Native American culture, most traditions were imported from foreign lands. For early immigrants, these skills offered a way to survive in the New World. Blacksmiths, furniture makers, and potters produced their wares to meet the demands of the time, and in the process established a new craft tradition in America.

Today, mastering a complex craft skill involves a commitment to go to school or to study through independent sources. An extensive array of how-to books, videos, and other resources are available to acquaint the novice with basic techniques. Serving as an apprentice in a professional studio offers one of the most direct ways to learn a skill, as well as to observe a real, functioning operation. Learning technique is, of course, only part of becoming a craftsman. Even with natural talent and instinct, finding one's own unique and original vision can be the greatest challenge.

Hands-on experience in a working studio is invaluable, but there is a great advantage to having some formal training in an established art, design, or craft school. Since the emergence in the early twentieth century of a number of notable art schools and vocational training programs, professional education has been central to the development of the sophisticated craft skills currently practiced in this country. Even more significant has been the American impulse to share knowledge. The openness among craftsmen and their students or apprentices, the willingness to allow others to benefit from one's own experience, accounts in part for the rapid advancement here, not only in terms of technical skill, but in every aspect of being a craftsman. Camaraderie among colleagues has developed a craft community that is today international in scope.

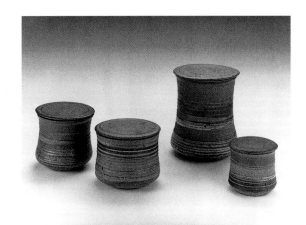

The Studio Movement: Roots

To comprehend the blend of educational forces that have helped shape the American craft scene over the past century, it is essential to note the contributions of craftsmen from Europe, who brought with them a teaching philosophy and knowledge reflecting their own backgrounds and traditions. Immigrant faculty exerted an important impact at prominent educational centers such as Alfred University, Black Mountain College,

Karen Karnes. **Cannister set**. 1962. Thrown, reduction fired. Largest 6 ½ x 5 ⅜" diam. Collection American Craft Museum, gift of Lenore Tawney, donated by the American Craft Council, 1990

Cranbrook Academy of Art, and the School for American Craftsmen at Rochester Institute of Technology. The Scandinavian Modern movement was a significant international influence in the 1950s and '60s, and the rich craft traditions of Asia have been and continue to be an inspirational resource. These important influences established a base for developing new concepts of object-making.

The period following World War II was a pivotal time of change for the studio craft movement. A key factor was the GI Bill of Rights, which gave returning soldiers the opportunity to receive a formal education. Government sponsorship also provided great incentive and support for colleges and universities to expand art departments and develop new craft programs. To meet the increased demand for professional training in the crafts, the number of teaching positions increased, and craft instruction became a profession unto itself. The school emerged as an arena for experimentation and exploration in the arts.

The 1960s brought a dramatic shift in the social climate of the country, an explosion of new ideas. Anything, it seemed, was possible. While some rebelled against the past, other explored traditional roots. Beyond baking bread and tie-dying fabric, the "back to the earth" movement had a profound effect, nurturing a new generation with new values. Many traveled the world seeking direct contact with traditional cultures, and returned inspired from their experiences. The Peace Corps, established during the Kennedy Administration, made it possible for young Americans to live and work in remote areas, where often they developed craft cooperatives. Such exposure was most valuable in cultivating a global craft network. World travel also nurtured international connections and exchange among schools, craft organizations, and museums.

As the craft movement thus gained momentum in the postwar decades, educational institutions played a key role not only in the training of many craftsmen but in the long-term evolution of their work. Professional programs set new standards and encouraged research and exploration of new ideas. A teaching job in an art school or a university art department became an attractive situation for a maker, since it offered a steady subsidy with benefits and, most important, a place to work. To establish tenure, one had to be not only a good teacher but an accomplished artist as well. Exhibiting work or having it illustrated in a publication became a means of gaining credibility. As graduating students went directly to teaching posts with little or no experience in the "real" world, academia became a protected and isolated environment. Within this cloistered universe, craftsmen were able to mature through graduate programs and to develop their art under the patronage of a school, resulting in the creation of a wealth of vital, personal work.

Outside of academia, the studio movement flourished as well. By the early 1960s many production potters, jewelers, weavers, and furniture makers, along with a few glass

John May. **Salt and pepper shakers**. 1957. Rosewood. Turned. Tallest 6 ½ x 1 ¾" diam. Collection American Craft Museum, donated by the American Craft Council, 1990

makers, had chosen to maintain their own businesses. Most lived in rural areas, where the cost of operating a studio was minimal. Their market was limited to selling from their studios, in the few shops that carried handmade work at that time, and within the emerging craft fair structure. Only a handful of serious collectors existed, most acquiring objects not as a financial investment, but for the real love of the work. They often knew the maker personally and would commission special pieces on occasion.

The late 1960s and early '70s saw a wave of major change in the craft field. The increasing sophistication of the work, together with a vast new network of promotional vehicles—exhibitions, magazines, conferences—brought the craft artist into focus as part of the larger art scene in America. The art-versus-craft debate became a central contention (and it still is today, to a lesser degree). New galleries devoted solely to craft proliferated and began to foster serious collecting. Most of these dealers took the position of presenting the work as fine art by showing innovative artists creating unique sculptural or two-dimensional pieces. Functional objects were sometimes shown, but the emphasis was on collectible "craft art." The motivation was partly economic, as selling a glass sculpture for several thousand dollars was more profitable than selling a set of goblets for a few hundred. There was also a certain stigma to be avoided, that of being a gift shop rather than a gallery. This rarefied approach to selling handmade objects was of great benefit to artists working in that vein, but not to production-oriented craftsmen. For them, a separate marketing system evolved.

The Studio Movement and the Emerging Market

Early in the twentieth century, a few pioneering organizations led the way in promoting and marketing the work of the hand. One of the first was the Society of Arts and Crafts, in Boston, which established a sales room in the old Twentieth Century Club building in 1900. Sales there the first year totaled $4,000, a significant sum in those days.* In the 1920s and '30s, the Southern Highland Handicraft Guild, based in Asheville, North Carolina, and the New Hampshire League of Arts and Crafts established marketing programs that today encompass annual fairs and retail shops.

A true visionary in the cultivation of a market for craft was the socially prominent Aileen Osborn Webb, whose lifelong efforts, both personal and financial, to advance the craft movement nurtured a great many programs, to profound effect. With a group of her friends, in 1929 she organized a small marketing program in Garrison, New York, to sell works produced in Putnam County. By 1936 this evolved into Putnam County Products, which operated a shop in Carmel, New York. In 1940, Mrs. Webb opened

* Data taken from *Handcrafts of New England* by Allen H. Eaton (New York: Harper and Row, 1949).

America House, a retail outlet in New York City, as a showcase for American crafts. Two years later she was instrumental in the formation of the American Craftsmen's Cooperative Council (now the American Craft Council). Determined to improve the quality of contemporary handwork, she launched various influential and enduring programs under the ACC banner: in 1942, *Craft Horizons* magazine (now *American Craft*); in 1944, the School for American Craftsmen (now School for American Crafts); and in 1956, the Museum of Contemporary Crafts (now the American Craft Museum). National in scope, these initiatives were critical in setting standards of quality and craftsmanship and in educating the public about the value of handwork.

In 1966, the Northeast regional chapter of the ACC presented a conference and fair at Stowe, Vermont. It was the first fair under ACC auspices and the progenitor of the current ACC craft shows held across the country. The growth of these shows over three decades—there are now ten annually—and of the craft market itself has been phenomenal. At the 1999 ACC Baltimore winter show, which is both a wholesale and retail event, gross revenue was projected in excess of thirty million dollars in five days. This prominent show included twelve hundred exhibitors and attracted more than six thousand buyers to the wholesale segment.

Many other craft fairs take place each year. And increasingly, gift and trade shows feature sections devoted to handwork. While overall statistics on the size of the market for craft objects in the United States are unavailable, attendance records and sales reported at various fairs suggest that the numbers are significant and growing.

Today we find a wide range of established selling venues for craft: art galleries that include select craft artists in their stables, specialized galleries dedicated to jewelry, furniture, or other media, and various shops and stores featuring handmade objects. Also, limited editions by production craftsmen can be found in department and specialty stores everywhere.

Marketing Today: From Studio to Website

The real challenge for a craftsman begins in finding the best way to market work. The successful maker today must be highly motivated in order to manage the complexities of creating and selling in an increasingly competitive marketplace.

Central to developing a business is the need to generate revenue. Selling has traditionally been a personal process for studio craftsmen, as they cultivate contacts with people who might buy their work. Those creating highly specialized items, such as fishing gear or musical instruments, must seek out customers who have specific interest

John Prip. **Letter opener**. 1948–52. Sterling silver. Forged. 9/16 x 9 1/2 x 13/16". Collection American Craft Museum, gift of the artist, 1994

in their products. Such craftsmen usually connect with a network of enthusiasts, often a subculture with its own magazines, gatherings, and standards.

For those making objects related to the home, craft fairs offer a great opportunity to meet buyers and collectors. As an alternative approach, some craftsmen establish retail shops as part of their studio complexes or have sales a few times a year. For the customer, there is a special pleasure to be had in visiting studios: one gets to talk to the makers, see how they live and work, and appreciate more fully the breadth of their work. The sales arena is not for every craftsman, since dealing with the buying public requires a great deal of energy and patience, but the rewards can be significant sales, stimulating feedback, and the chance to develop lasting relationships with new clientele.

In recent years a strong economy and a plenitude of craft marketing opportunities have made it relatively easy to sell good work if it is unique and of high quality. The major perennial fairs exert a powerful influence, as they help both emerging and established artists connect with an ever-increasing audience of buyers. Most quality craft shows have stringent application processes that require the artist to organize a good slide portfolio for submission up to a year in advance—an effort that can end in rejection, given the competitive nature of shows today. Once a craftsman is accepted, a lot of work is involved in making a collection to display, presenting it in a professional manner, and spending the time and money to staff a booth for several days. A show can generate enough business for several months to a year—or little public response at all.

Looking back on the growth of the craft market over the past four decades, one sees a marked evolution propelled by various trends. In the early days, a piece of felt or burlap over a table was an adequate display at a typical craft fair. By now, participants have honed sophisticated marketing skills and mastered the art of the appealing presentation. Their booths are frequently state-of-the-art exhibits, with dramatic lighting and innovative structures. The showmanship usually extends to beautiful brochures and other literature for the interested customer to take and keep as a reference. This professionalism has emerged out of market competition and often developed from artists observing and inspiring each other. A slick display is not enough if the work is mediocre, however. A fine teapot must be more than just that; it must have some special quality that allows it to stand out.

The latest approach to marketing is focused on the Internet. Many artists have their own websites and e-mail connections, and consider them a valuable means of promotion as well as a great, timesaving source of shared information. Galleries often have sites, too, and some large-scale craft marketing organizations have been developed specifically for the Web. While the outcome of all this online activity is hard to evaluate in terms of sales, early indications are promising, as people become accustomed to using the computer as a resource for craft artists.

George Nakashima. **New chair**. 1958. Walnut, ash. Constructed. 36 x 18 x 20". Collection American Craft Museum, donated by the American Craft Council, 1990

Age of Specialization: Handmade Today

At the dawn of the twenty-first century we see specialization as a defining characteristic of every field, particularly as all aspects of society become more complex. Now the arts encompass more disciplines than ever before.

Craftmaking has always been a specialized activity because of the intense study and dedication it entails. Today each craft medium has nurtured its own community, complete with specialized organizations, publications, and events. The National Council on Education for the Ceramic Arts, the Society of North American Goldsmiths, the Glass Art Society, the Furniture Society, the Handweavers Guild of America, the Artist-Blacksmith Association of North America, and the Surface Design Association are among the media organizations that have large national memberships. There are such esoteric groups as the Violin Society of America, the American Cuemaker's Association, and the American Kitefliers Association, to name just a few. A wonderful aspect of the Internet Age is the ease with which we can become familiar with these groups and their activities through their websites.

As we enter a new millennium, it is reassuring that craft skills practiced since the beginning of civilization continue to flourish. Though the future is unknown, chances are technology will not destroy the human urge to create objects for use, but rather will nurture it. The handmade teapot will always have a place in society, and the craft studio will endure as the hub of a respected profession for those who choose to take it on with passion and pride.

Wendell Castle. **Music rack**. 1964. Oak, Brazilian rosewood. 55 ½ x 25 x 20". Collection American Craft Museum, donated by the American Craft Council, 1990

To be human is to have the ability to make objects for use. It is to have the capacity for limitless creative imagination. The flexibly adaptable structures of the human organism, in contrast with the exact functions of many animal characteristics, require people to design objects for the specific uses they desire. Objects arise from the bedrock of the societies and cultures to which their makers belong, no matter how high they soar beyond them. Their uses are embedded in their landscapes of livelihood, themselves forged in their mother lodes of social traditions and contemporary structures of power, of cultural heritages and current meanings. The artifacts that people make are inevitably manifestations of their culture and social structure.

The objects are texts and albums of these activities and experiences. They are embodiments and images, palimpsests and portfolios, of their engagement with subsistence and existence, with ideology and conflict, with multiplicity and migrations. They are the tools of work and the things that are used routinely in the habits of everyday life. They include the instruments of invocation in symbol and ceremony. Just as much as being items of material necessity in ritual, they can be imaginative integrations of spiritual ideas. Disguised in humble or exalted uses, they may also be the icons of the dearest individual meanings, memories, and dreams.

In the early twenty-first century, many objects for use are designed by computer and made by mass production. Yet there is a remarkable efflorescence in appreciation and acquisition of objects made by hand. A meditative awareness may arise during the multitudes of hours required to make them; there are makers who describe these states of inner peace as when they are most fully alive. That presence permeates the most imaginative and effective objects. It may be no paradox that virtual electronics and the scarcity of time in the technological world have engendered a critical discernment and delight in recognizing the accomplishments of excellent design and the powerful presence of contemporary functional objects made by hand.

Cariadne Margaret Mackenzie, anthropologist

Studio Profiles

"From the very first sharpened stick to today's state-of-the-art steel tools, the knife has always accompanied mankind. Throughout the ages the style, materials, and purpose of cutlery have reflected many different eras and cultural histories. Yet whether we are discussing the legendary sword of Excalibur or the basic utility knife, the criteria of quality remain the same: strength, sharpness, and balance, all combined into a graceful art form. My endeavor is to perpetuate this tradition of uncompromising quality."

Joseph DiGangi knife maker Santa Cruz, New Mexico

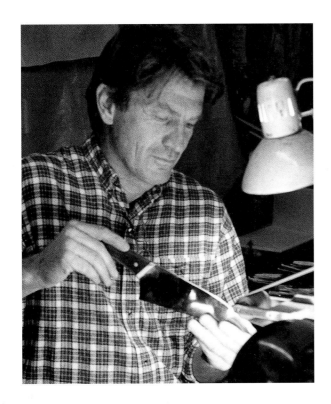

For more than fifteen years Joseph DiGangi has been producing custom handmade knives that combine beauty, sophisticated design, and function. He enjoyed various careers—flight instructor, dairy farmer, and real-estate agent—before a visit to the ACC Rhinebeck (New York) craft fair in 1983 inspired him to become a craftsman. A book entitled *How to Make Knives* by David Boye provided him with the technical guidance he needed to explore knifemaking. Within a year DiGangi had developed enough work to submit to the 1984 ACC West Springfield fair and was accepted, establishing him in his current career as master knifemaker. Today, in his New Mexico studio, he produces about five hundred cutting implements a year. Each knife entails a 140-step process that transforms plates of high-carbon stainless steel, bars of brass, and blocks of handle material. The blade is formed from a single piece of 440-C surgical-grade steel, ground to precision, then heat-treated to Rockwell 57, assuring great strength and edge-holding capability. Handles are hand cut and fitted, then carefully shaped to maximize comfort and security of grip. Specializing in kitchen cutlery, carving sets, and steak knives, DiGangi has received much national attention for his work, including twenty-seven awards.

"Kitchen system II" cutlery set (detail). Steel, black Micarta, brass. Hand ground, shaped, polished

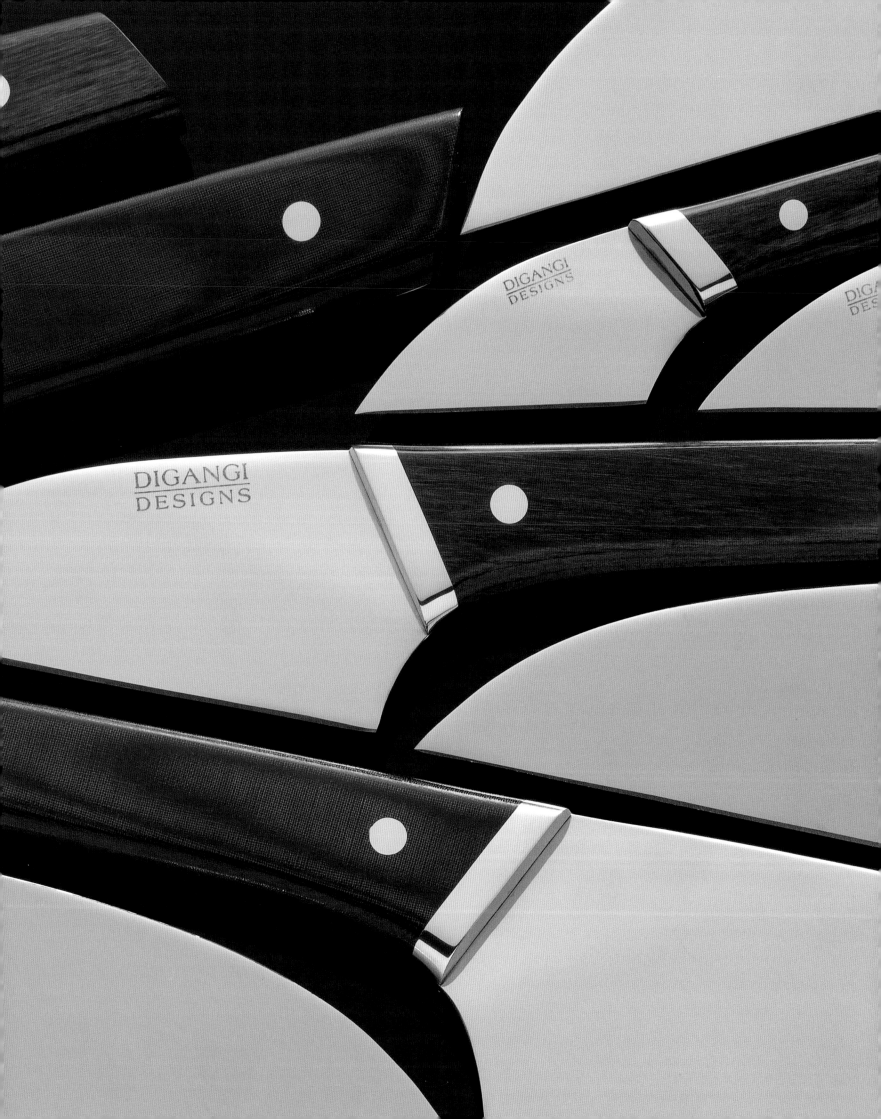

"I make things of wood that I'd like to have myself—functional pieces that are quiet, peaceful, and a pleasure to touch and look at. My approach emphasizes select materials, structural integrity, and utility. I like to let the wood do the work—to find art in nature."

Edward S. Wohl wood craftsman/designer Ridgeway, Wisconsin

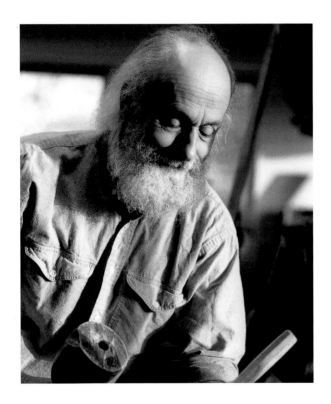

The beauty and intrinsic qualities of natural wood inspire and motivate Edward Wohl, who, after graduating from Washington University in 1967 with a degree in architecture, searched for an independent career through which he could combine his creative instincts with a skill he enjoyed. He began to design and make furniture in 1969. Today he works with several assistants to produce custom furniture and limited-edition pieces. His signature work is a line of bird's-eye maple cutting boards that he developed early in his woodworking career. The elegant and distinctive design of the boards combines function and aesthetics; when not in use, the forms can be displayed for their sculptural beauty. His board collection is now marketed internationally to high-end speciality shops, creating a continuing demand that helps maintain his small studio operation. All of Wohl's work is meticulously constructed or formed, and honors the special qualities inherent in the material. His home and studio, which he shares with his family, is located within the pastoral hills and valleys of southwestern Wisconsin. This ideal living working environment serves as inspiration for his work and creates a perfect setting for his rewarding lifestyle.

Cutting board. Bird's-eye maple. Glued, shaped, finished. ¾ x 12 ½ x 22 ½"
Cutting board. Bird's-eye maple. Glued, shaped, finished. ¾ x 10 x 23"

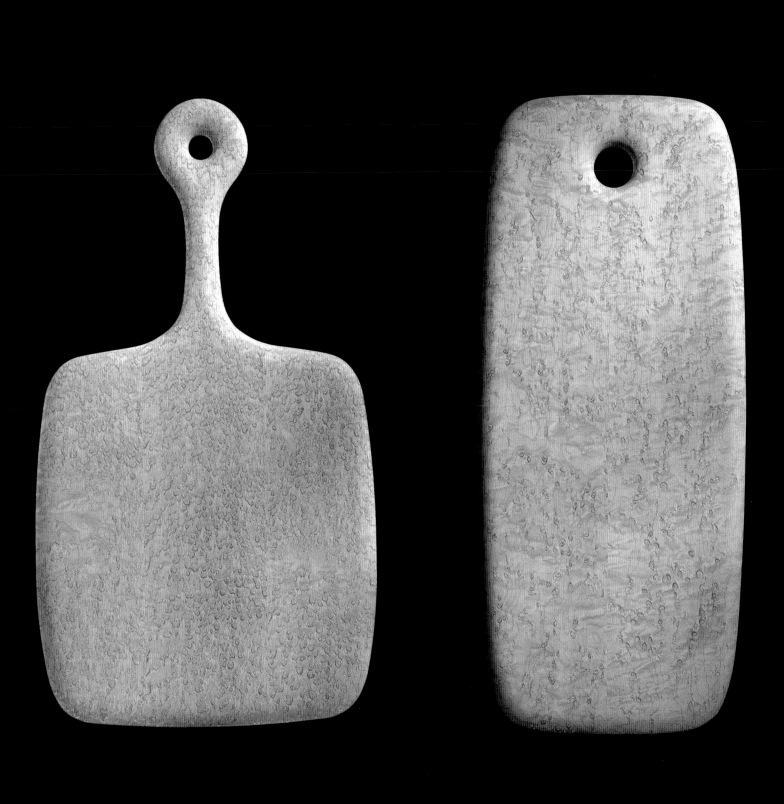

"It was always so amazing to me to see my mother make incredibly beautiful baskets from materials gathered from the wild. Strong feelings and deep emotions are involved in making baskets, so it is always exciting to make a new idea reality. Particular attention to form and function is of utmost importance, because my tradition has always emphasized that a beautiful basket is to be used for everyday living. It is my commitment to my ancestors to work within this context."

Mary A. Jackson basket maker Charleston, South Carolina

Mary Jackson's coiled baskets are rooted in an old and rich heritage derived from African and African-American cultures. Using local natural materials—sweetgrass, bulrush, and fiber strips from palmetto trees—she makes classic, functional vessels with a commitment to preserving the basket-making tradition that has existed in the South Carolina low country since the eighteenth century. She also takes pride in creating new and unique shapes. The process may take from a day for a simple container to several months for a more complex form. A fourth-generation basket weaver, Jackson learned the craft from her mother, and as a teenager was disciplined to practice it during the summer months, which she resented. As an adult, however, she gained new enthusiasm for the expressive potential of basketry and became inspired to pursue her personal vision. Today her work is represented in many museums and private collections. Determined to keep the tradition alive, she has taught her daughter the basic skills and devotes time to giving workshops and sharing her knowledge with others. Although urban development along the South Carolina shore has caused native sweetgrass to become nearly extinct, a communal ten-acre grass farm has been established in the wetlands with government funding, guaranteeing Jackson and other basket makers an ongoing source of material.

Covered box with handle. Sweetgrass, pine needles, palmetto. Coiled. 16 x 17" diam. Collection American Craft Museum, gift of Marcia and Alan Docter

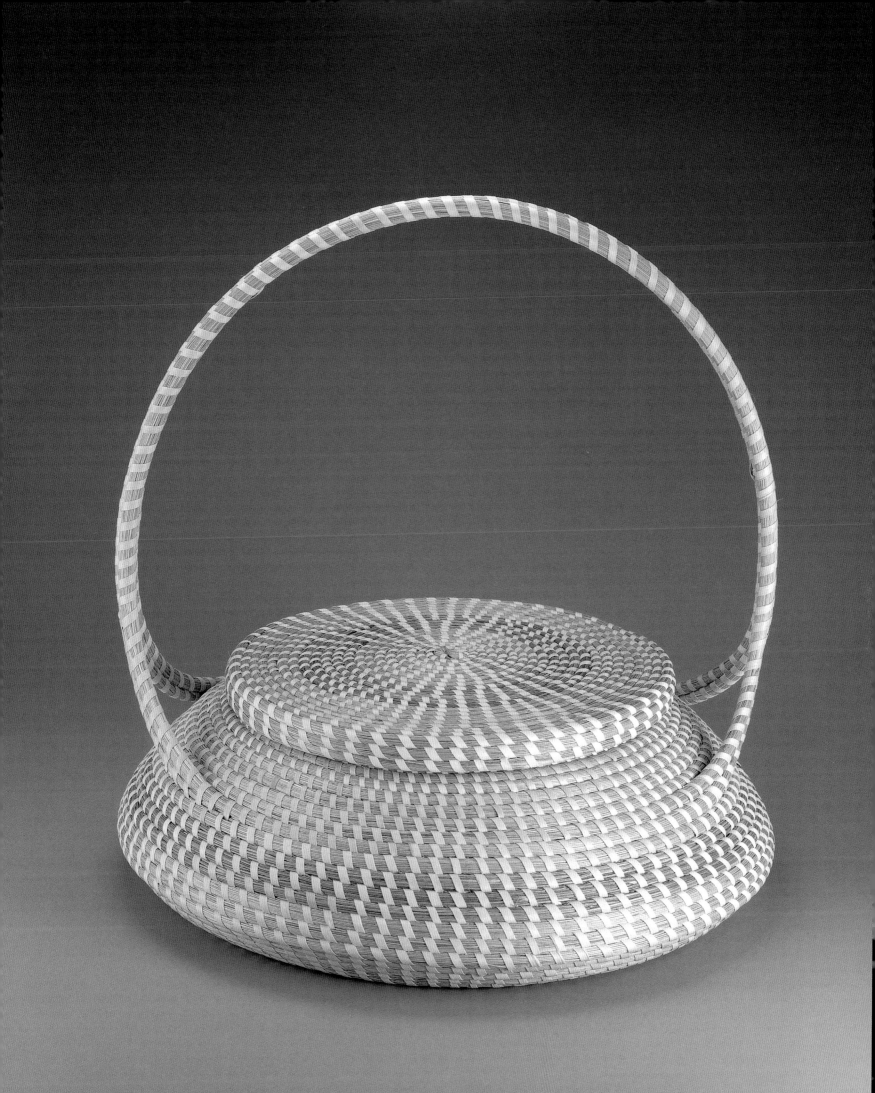

"Sweetgrass is also called Holy Grass. It is used in healing ceremonies and in the sweat lodge. When I make a basket with it—feeling it, smelling it—I repeat a craft of centuries ago when women collected and prepared materials and then used them to make a basket. The maker becomes infused with the materials, and then the materials make the basket."

Dawn Walden basket maker Omak, Washington

Dawn Walden was raised among the Ojibway people of northern Michigan, where she was surrounded by basket makers, wood carvers, and storytellers. After an extensive apprenticeship with traditional master basket makers, she now creates her own baskets that are a symbol of her own Native-American heritage and traditions. Currently, Walden works out of her studio in Washington state, where she moved in 1997 from Michigan. Half of her studio is for her fiber art, the other half for creating wood and stone sculpture. Her basketry is focused in traditional Native-American styles, predominantly Ojibway. Walden finds that collecting materials—willow, ash, porcupine quill, birchbark, sweet-grass—and then preparing and weaving them allows her close contact with nature and her heritage. Keeping the ancient technology of traditional basket-making alive through teaching and showing her work is of primary importance to her. As a member of the Native American Basketry Association and the Society of Primitive Technology she supports the education and preservation of ancient technologies.

Birch-bark container. Birch bark, spruce root, redbud, sweetgrass. Folded, stitched, woven, incised design. 9 x 12 x 6"

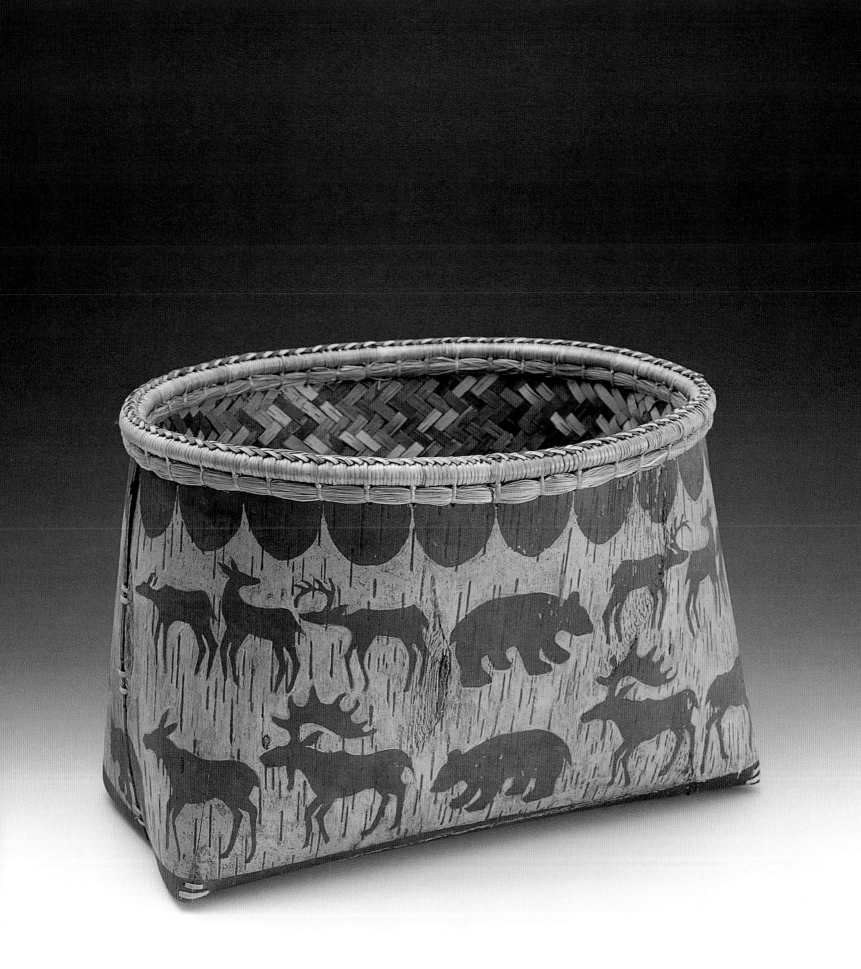

"Romulus Craft is about relationships—between two distinct individuals from two distinct cultures, between nature and time, between control and spontaneous reaction. The approach we take to our collaboration is that we listen to each other and then do as we will. The value of collaboration is that it gives each of us an opportunity to go beyond our own boundaries. Making simple objects used in daily life is our fulfillment and maintaining the goal to continue remains our objective."

Ikuzi Teraki & Jeanne Bisson ceramists Romulus Craft Washington, Vermont

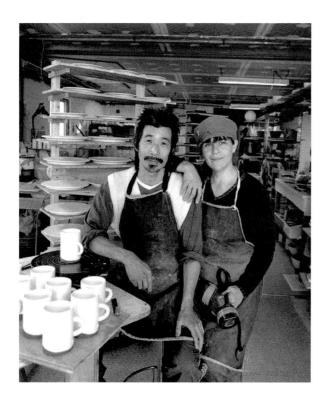

Ikuzi Teraki and Jeanne Bisson collaborate in designing and producing unique ceramic forms for the table. In 1979, seeking a meaningful way of life and believing in possibilities, they established their first studio in a defunct paint factory in Oakland, California. In 1986 their pioneering spirit and search for the right living and working environment took them to the scenic rural area of Washington, Vermont, where they transformed a large wood-working shop into their present home and studio. The name of their studio, Romulus, comes from the Roman myth in which twin infants, Romulus and Remus, who are left for dead in the wilderness, survive thanks to the nurturing of a she-wolf and meet the destiny ordained for them by the gods. For Teraki and Bisson, the concept that great goals are achieved one step at a time expresses the spirit of their enterprise. Teraki, a native of Kyoto, Japan, throws, trims, and carves forms; Bisson, a Vermonter, hand builds pinch and slab pieces. Together they share the other aspects of maintaining their successful business. Simplicity of form and minimal surface treatment is the emphasis of their limited-edition porcelain dinnerware, which they sell at craft shows, through established craft marketing outlets, and occasionally on commission.

"Setting the Table with Romulus: Black with Spray of Coppertone" dishes. Porcelain. Thrown, altered, black, terra-cotta, and applied coppertone slip oxides, glazed. Charger 1 x 12" diam.; salad plate 1 x 8" diam.; sauce dish 1 x 4" diam.; nut bowl 2 x 6" diam.

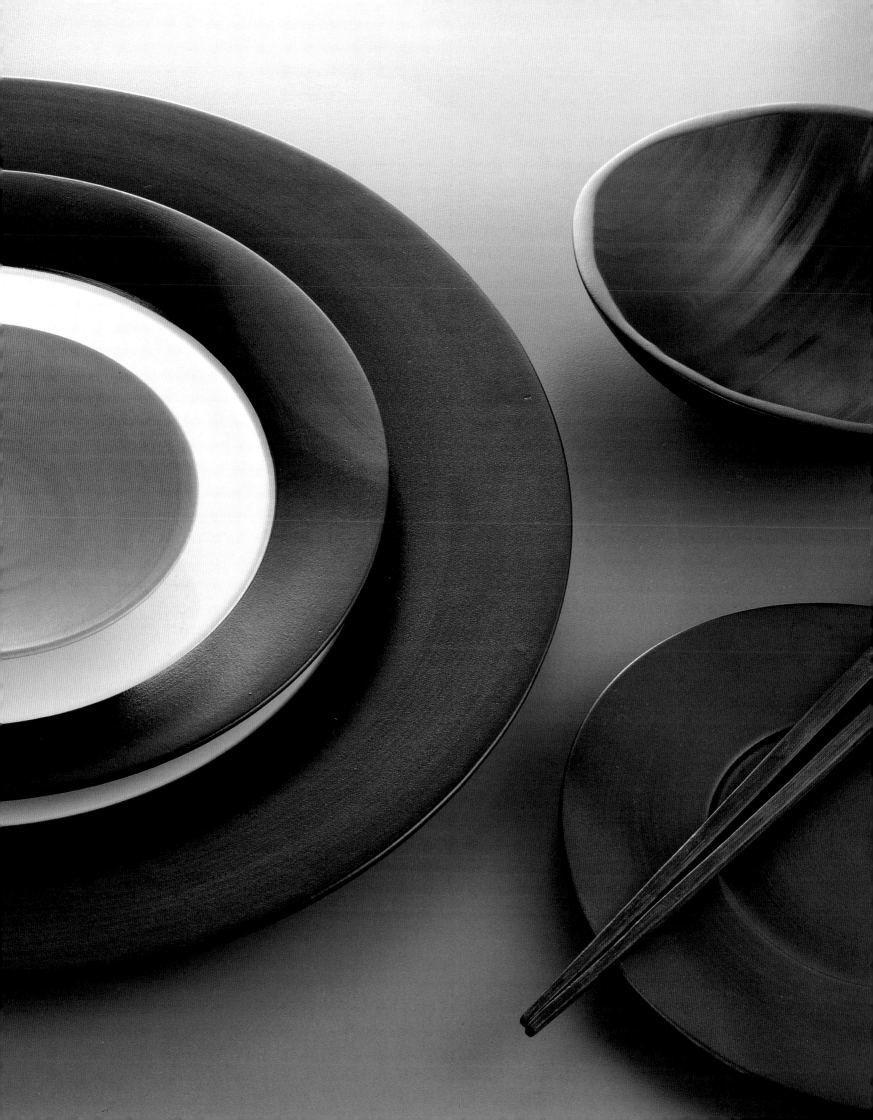

"Throughout my years as a ceramist there has always been a coexistence between my art and my design. As one direction cohabits with the other, there remains a wide overlap in the middle. It is within this intersection that the most interesting and creative aspects of art and design occur. I have developed a limited-edition series and short lines of productions in order to escape from the market momentum of one-of-a kind objects, providing original ceramic design for a larger group of customers."

Marek Cecula ceramic designer New York, New York

Marek Cecula combines creating unique work with his special interest in designing proto-types for industry. Born in Poland, Marek moved to Israel in 1960. After living and making ceramics in a kibbutz, he opened a pottery studio in Tel Aviv in 1972. Five years later he moved to Brazil to work at the Schmidt Porcelain factory, where he designed and produced his own line. In 1977, eager to be in New York, he and his wife, Elaine, settled in SoHo and established Contemporary Porcelain, a gallery and studio for innovative designs. It was later relocated to a large facility in Brooklyn, where Cecula produced functional ceramic objects for specialty shops and department stores. After closing the Brooklyn operation in 1992, he returned to SoHo to a smaller studio, where today he makes limited-edition tableware, as well as prototypes for ceramic factories in Europe. Committed to sharing his years of experience with students, he teaches at the Parsons School of Design, where he has headed the ceramic design department since 1984. While he continues to explore new concepts for functional work, he also creates sculpture, which he considers an important balance to his production designs.

"Liquid" forms. Porcelain. Slip cast. Tall 5 ½ x 2 ½ x 3"; short 3 x 2 x 5"
"Oval" forms. Porcelain, underglaze. Slip cast. 1 ½ x 3 x 14"

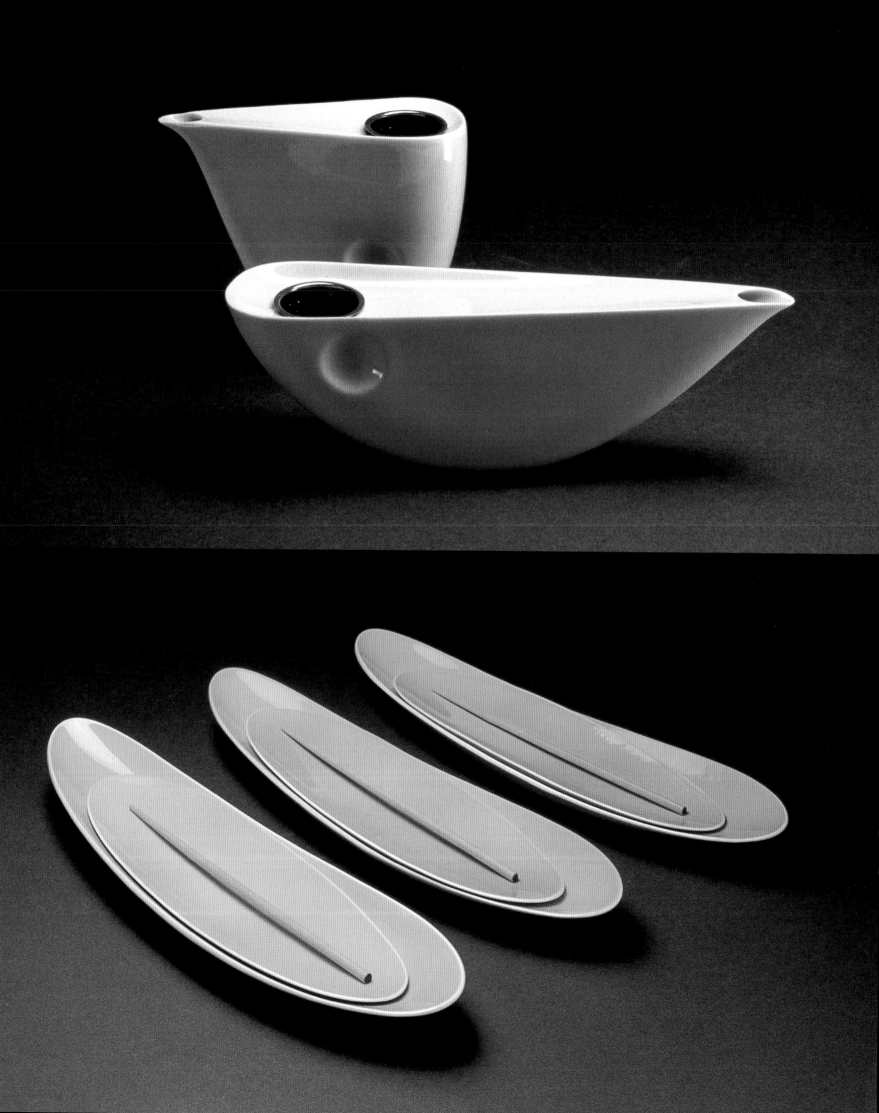

"The idea of orchestration ties my life together. From home and garden, to my studio and the school where I teach, there is a thread that holds it all together. That thread is my desire to make things."

Jacquelyn Rice ceramic and textile artist Providence, Rhode Island

Jacquelyn Rice has mastered the art of unique tableware by creating landscapes of texture and color that reflect her fertile imagination. Early in her working life she was involved as a fashion coordinator for window display in a San Francisco department store. This pivotal experience led to a love for visual presentation. For more than thirty years she has explored many directions in working with clay but has always maintained a special interest in function. Recently she expanded her focus to include computer-printed textile designs, producing table coverings that integrate with her ceramics. With technical assistance from her husband, Uosis Juodvalkis, a photographer and computer specialist, Rice develops patterns and images on the computer that are directly printed on fabric, allowing endless possibilities for decorative surfaces. The resulting composites showcase her special talent for combining texture, pattern, and color. With this same technique she has also produced a limited-edition collection of garments, scarves, and accessories. Since graduating from the University of Washington, Seattle, in 1970, Jacquelyn has had a dual career as teacher and artist. In her small studio in Providence, surrounded by a beautiful flower garden, she continues to explore new concepts for table art while maintaining her commitment to teaching at the Rhode Island School of Design, where she has been a faculty member since 1977.

Tablescape. Earthenware, glass, linen. Low-fire glazed earthenware with decals, slumped and enameled glass, digitally printed linen. 12 x 60 x 60" overall

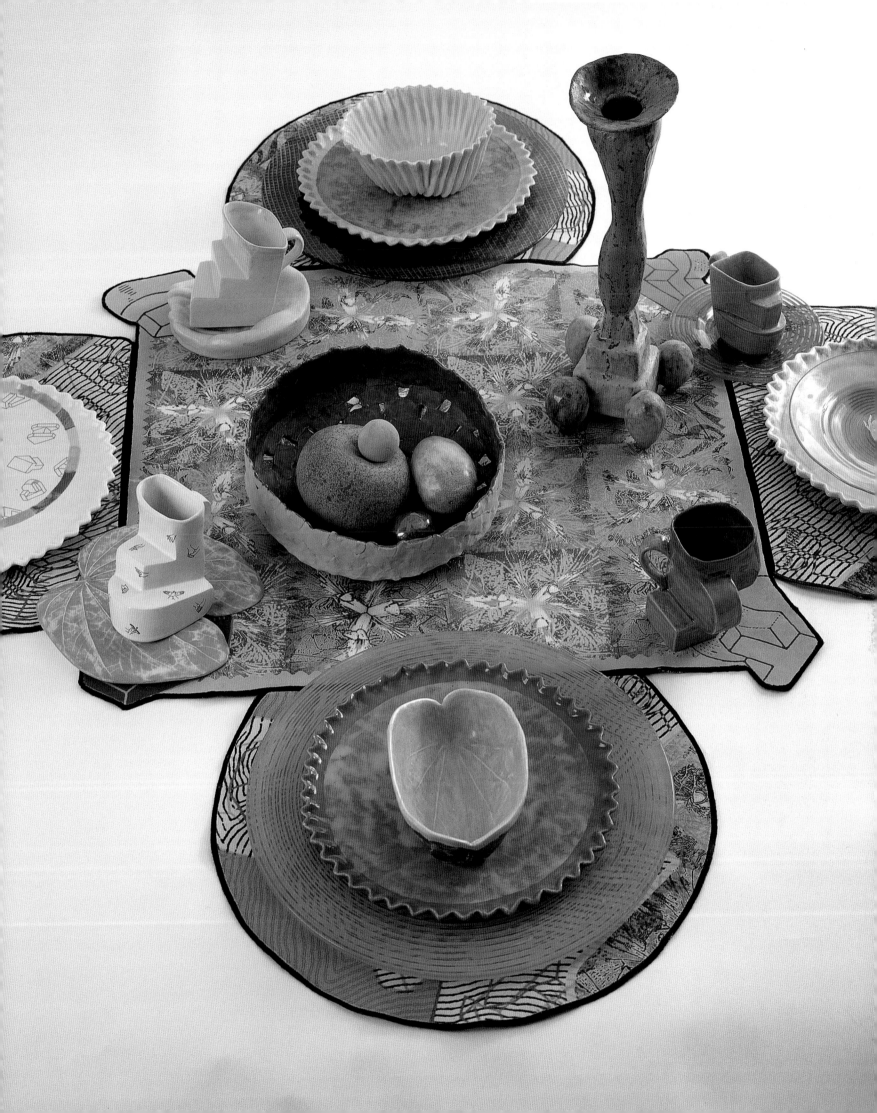

"Like most small-business owners, I am required to wear a lot of hats. Marketing, design, and sales management all put demands on my time and make it difficult for me to do what I love most, which is working with glass."

R. Guy Corrie glassblower/designer Union Street Glass Richmond, California

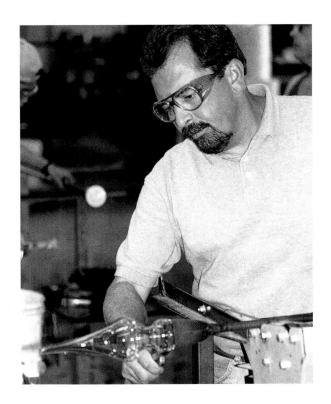

Combining his love of working with glass with his business intuition, Guy Corrie developed a small studio into the present Union Street Glass, which produces more than fifty thousand handblown items a year. Corrie first became involved with glass as a teenager at his stepfather's lamp-working studio and store in Reno, and later attended the California College of Arts and Crafts in Oakland. Upon completing the glass program there, he moved to Rhode Island to open a working glass facility, but his lack of both funds and experience forced him to close it after two years. In 1980 he and his wife, Leanne, opened a small studio in the San Francisco Bay Area, producing unique glass items that they first sold at the ACC Pacific States craft fair. As their business grew, they moved to larger quarters in 1983, and in 1986 Corrie began to design a series of functional glass objects to be produced in editions. In 1997 the studio expanded to its present location, which comprises fifteen thousand square feet of industrial space for twenty employees. Today Corrie remains central to the handmaking of stemware and functional objects, now sold internationally. He creates each new design by handblowing prototypes, and at times has hands-on involvement in the production, in addition to managing the business and marketing.

"Elroy" glass, decanter, and bowl set. Glass. Blown. Tallest 13 x 4 ½" diam.

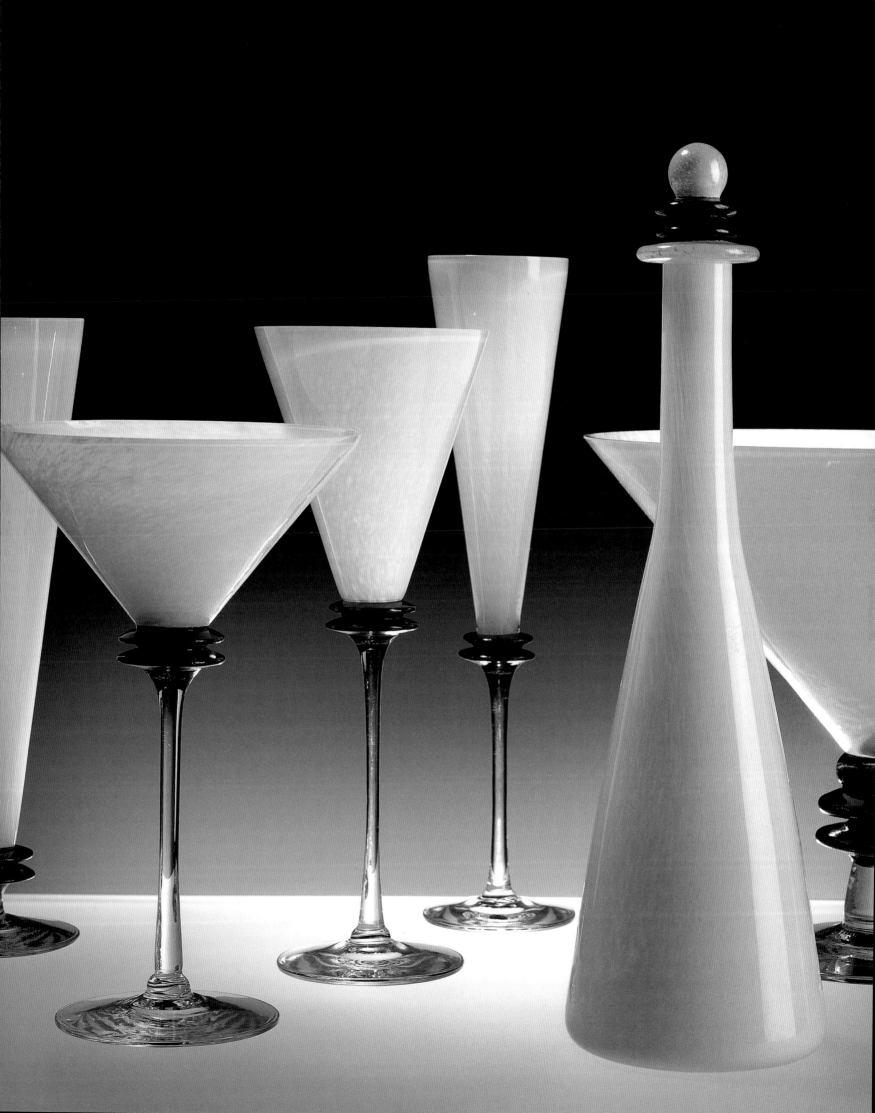

"One of the things we find most exciting about the medium of glass is it allows us almost instant gratification in design. We can take a drawing into the studio one day and have the vase or goblet of our dreams in our hands the next. We like glass that is beautifully designed, exquisitely made, and amusing to use, and that's what we are always striving to accomplish in the Pinkwater studio. Being collectors of beautifully designed things, we strive to design and produce functional glass that is worth collecting. It has always been our goal to create objects that we want to own, use, and display in our home."

Lisa Schwartz & Kurt Swanson glass artists Pinkwater Glass Studio Carmel, New York

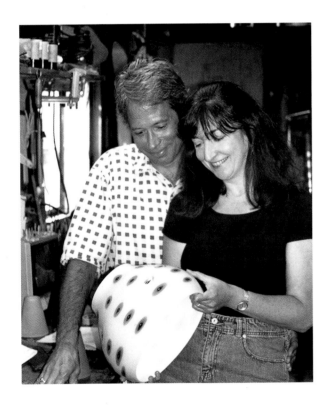

Lisa Schwartz and Kurt Swanson met in 1981 while studying at the Massachusetts College of Art, and they have designed and created glass together ever since. After receiving their masters' degrees, they founded Pinkwater Glass Studio as a means of developing an independent career and lifestyle that fulfilled their dream. Within a year they had developed a line of high-quality, distinctive designs that established them as leaders in their field. Their sophisticated, whimsical, and colorful creations range from dinnerware, goblets, candelabras, and vases to one-of-a-kind sculpture, furniture, and lighting, all signed and dated. Because of the complexity of the work, only a limited number of pieces can be produced each day. Over the years Pinkwater Glass has garnered numerous awards, received accolades from the press, and been exhibited internationally; it is represented in more than a dozen museum collections. Innovation has always been at the root of Pinkwater's success. Today, in their Hudson Valley studio, Schwartz and Swanson continue to produce some of their established popular forms while developing new designs for functional work each year. They market their work through craft fairs, as well as shops and galleries. They also take on commissions for select clients and corporate collectors.

Candlesticks. Glass. Blown. 14 x 4" diam.

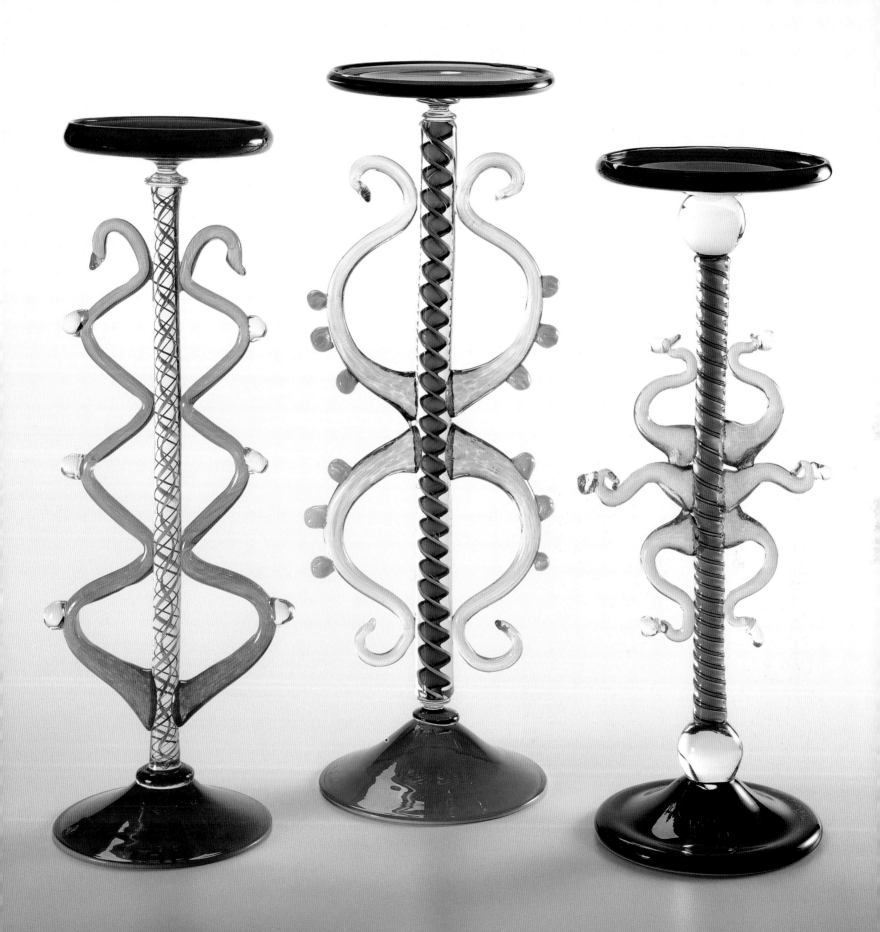

"I enjoy the use of many materials—precious, common, dull, and strange. I want to break down preconceived boundaries and rise to technical challenges to produce pieces with integrity and rich content. My favorite way to work and grow is by confining my designs in 'series' with calculated incremental changes. I try to look at things around me in a different context, often adding a pinch of humor or a dash of confusion. I hope to continue exploring and learning as much as possible about form and materials, while supporting my metals addiction through my business and occasional teaching. I enjoy the natural rhythm of hand-working metal."

Boris Bally metalsmith/designer Providence, Rhode Island

Employing his vast resource of hand skills with design imagination, Boris Bally transforms metal into flatware, vessel forms, furniture, and other functional objects. The influence of his father, an industrial designer, and his mother, a fiber artist, spurred him to make things at an early age. In his teens he was given a basement workshop, where he made martial-arts weapons related to his interest in karate, along with skateboards for play, and jewelry from found objects. At fourteen he participated in his first craft show and made three hundred dollars, which at the time he considered a "gold mine." This success encouraged him to seek formal training. A one-year goldsmithing apprenticeship in Switzerland, two years at Tyler School of Art, and another two at Carnegie Mellon University, where he received a B.F.A. in 1984, provided the base for a career designing and making metal objects. Bally operated his first working studio in a bedroom of his Boston apartment while maintaining a full-time job as a model maker for an industrial design firm. His desire to be independent led him to establish three subsequent studios before he opened his current twenty-five-hundred-square-foot, fully equipped space in Providence in 1998. With one full-time assistant, he produces a range of metal items that reflect his respect for the environment and commitment to making things for specific use. From refined works in precious metals to sophisticated objects from recycled materials, all demonstrate his fertile imagination, impeccable skills, and sensitivity to design.

"Trussware" place setting with serving spoon. Silver. Fabricated, pressed, riveted. Spoon 8 1/2 x 5/8 x 2". Collection Brooklyn Museum

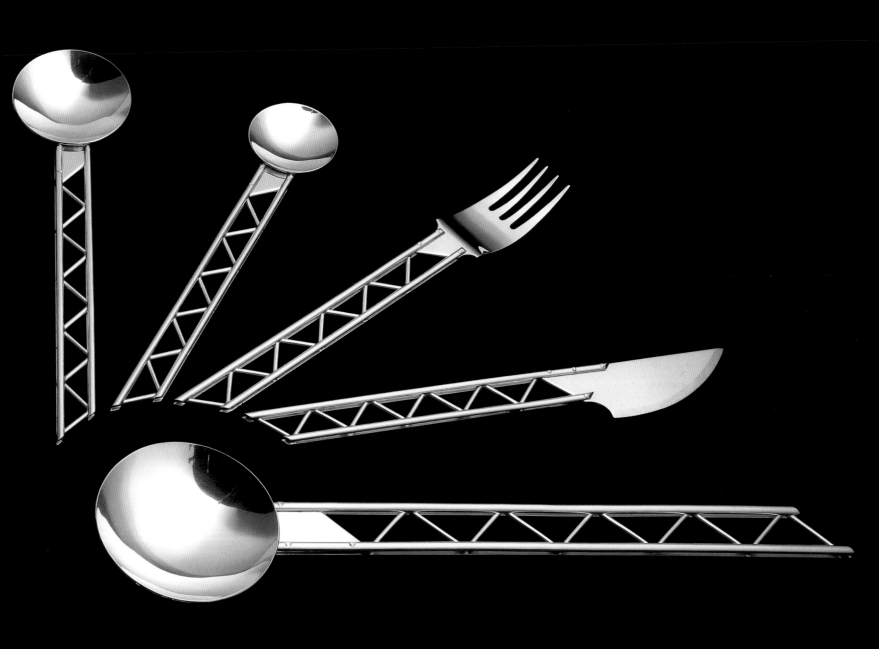

"Much of my design work carries with it some form of historical reference that may not be apparent at first glance, but offers additional depth with which to read meaning into a piece. These designs result from a need to satisfy functional requirements in a seamless way, so that aesthetic concerns are quietly addressed within the same functional detail and are not merely embellishments on the usefulness of the piece."

Tom Joyce blacksmith Santa Fe, New Mexico

In El Rito, New Mexico, at age fourteen, Tom Joyce began to work with Peter Wells, a local letterpress printer and blacksmith. After three summers of learning to forge, he knew this would be his life's work and left school to take over the blacksmith shop to make and repair implements for local farmers. Today, as a master blacksmith, Joyce specializes in custom architectural work as well as unique vessel forms, hardware, lighting fixtures, furniture, and sculpture. Most of his hand-forged work is designed to be site specific, with the objective of addressing the individual needs of his clients. Although he uses traditional skills, his designs have an affinity with the past while maintaining a fresh, contemporary aesthetic. He employs two assistants and, depending on the projects, occasionally engages students for a hands-on learning experience. In his carefully planned schedule, experimental time is set aside to explore new ideas, make prototypes, and create special pieces for exhibition. Joyce's work has been published in many books and periodicals, exhibited internationally, and represented in numerous public collections. After moving to Santa Fe in 1977, he established his present home and studio on the outskirts of town. Adjoining his well-equipped blacksmithing shop is the residence he and his wife, Julie, designed and built. The living environment they have created includes many examples of Joyce's own handwork and that of others. There, with the natural beauty of the Southwest as a backdrop, he remains dedicated to preserving the rich tradition of blacksmithing and contributing new forms that relate to the modern world.

Room divider. Mild steel. Forged, folded, fabricated. 60 x 16 x 220"

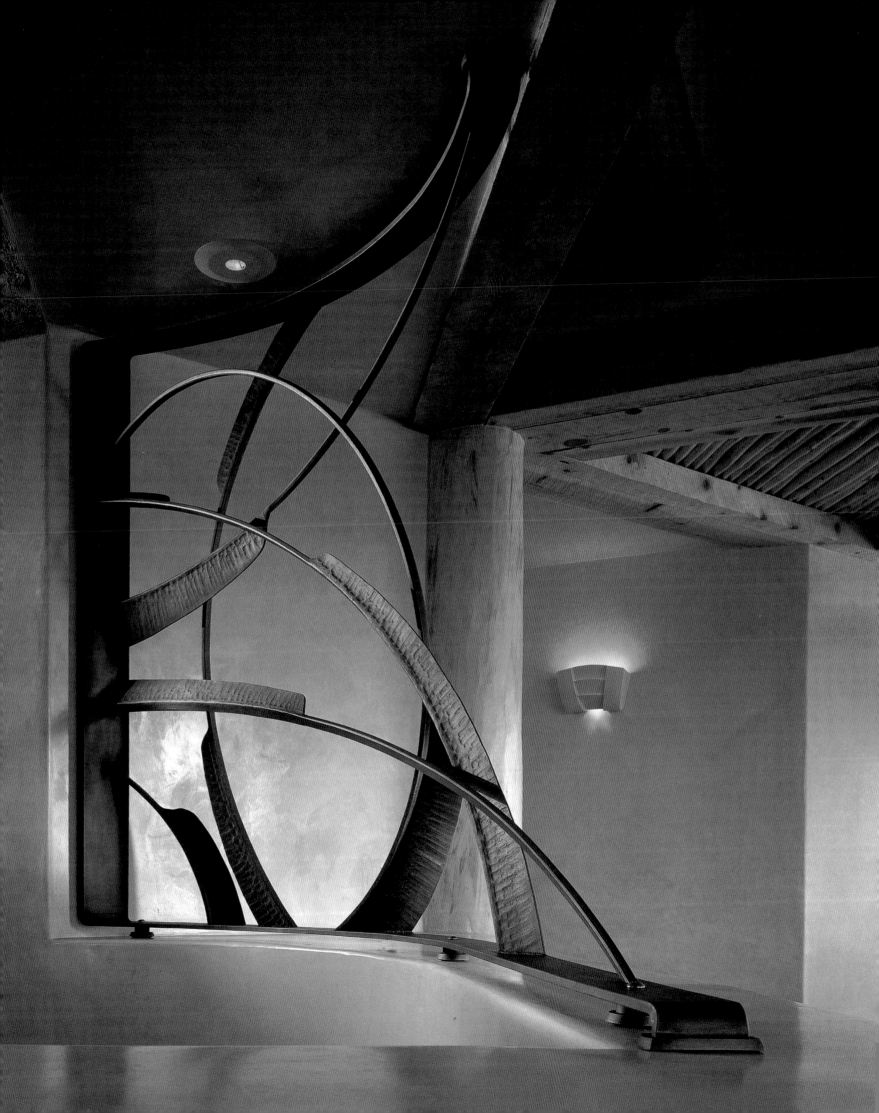

"The true challenge for me is to make something that is as comfortable to use as it is pleasing or interesting to look at. The function of the pattern or imagery in my work is to bring the forms to life and thus animate the furniture."

Judy Kensley McKie sculptor/furniture maker Cambridge, Massachusetts

Judy McKie creates very personal, imaginative furniture out of wood, stone, metal, and marble. Each handbuilt work reflects her vision of concept and aim: to combine function and beauty. After graduating from the Rhode Island School of Design in 1966 with a B.F.A. in painting, she sought a way to support her artistic motivation. Out of necessity, she first made basic functional objects for her home, which eventually led to making simple furniture for friends and associates who admired her work. In 1975 she decided to explore more innovative forms. Drawing upon her formal art training and inspiration from nature, animals, and primitive sculpture, she began to construct sculptural furniture that she decorated, carved, and painted. This departure launched her career and established her as one of the outstanding furniture makers in the United States. Self-taught, McKie has great respect for the materials she works with. In the late 1980s, when the opportunity arose to have her forms cast in metal, she developed new designs that honored the timeless beauty and richness of bronze. In recent years, a few of her cast-metal and carved-stone pieces have been produced in limited editions. Today, in her Boston area studio, with occasional part-time help, she develops a personal collection of new work each year. In the context of contemporary handmade furniture, Judy McKie's creations stand out as truly unique and contribute to the rich heritage of the master furniture maker's art.

"Shell" chest. Obeche. Constructed, carved. 64 x 42 x 16". Private collection

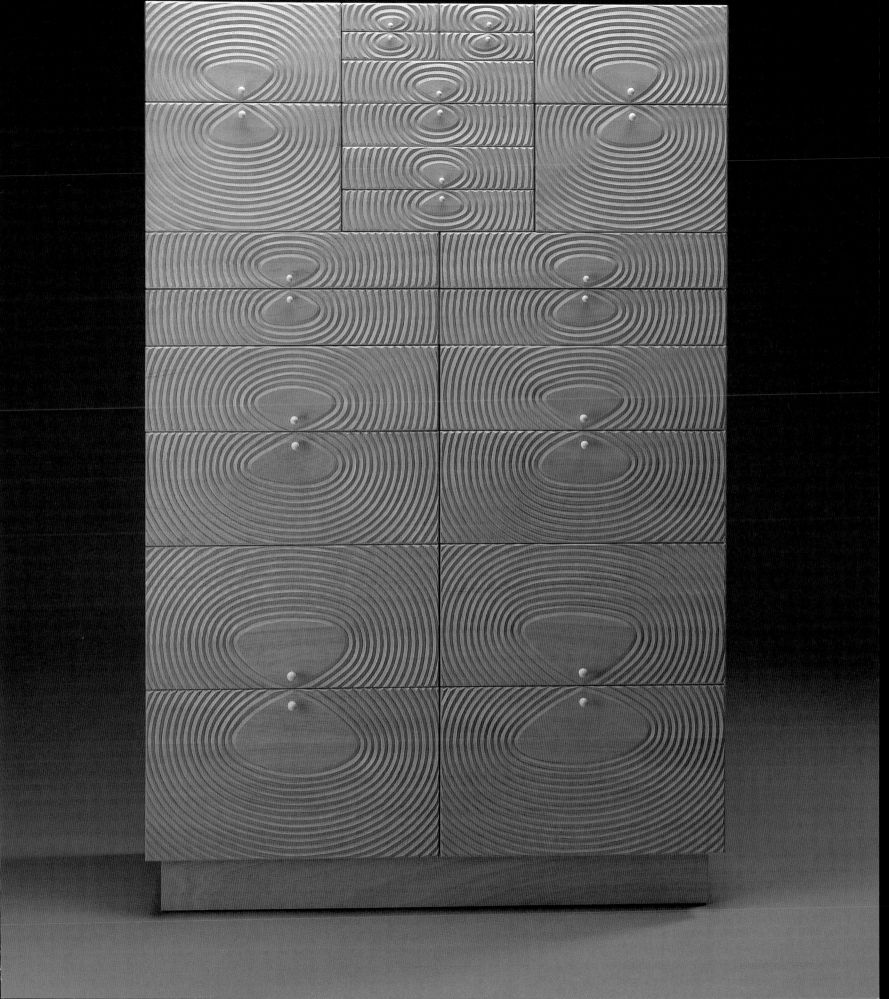

"The creative process is very important to me. Creativity in any form enhances the life of everyone it touches and marks the progress of civilization. My approach to furniture design is probably academic. My priorities focus on the rational. I find it intensely satisfying to push the limits of materials, find unique resolutions to furniture and structure, and balance aesthetics and comfort. I have always admired the work of Michael Thonet, Alvar Aalto, Charles Eames, and Harry Bertoia. All were craftsmen and had a hands-on understanding of materials. Each developed truly unique resolutions to furniture as structure and, in doing so, created their own personal styles. Their designs are unpretentious and their intent was to make designs accessible, so the average person could own it. They transformed our concept of what furniture can be and gave us a greater understanding of beauty. This is what I aim to achieve. I believe that craftsmanship, the actual experience of working with a material, is directly related to innovation in design. Craftsmanship is not only the means to an end but also the means to a beginning. It helps unlock the process of creativity."

Peter Danko furniture maker/designer York, Pennsylvania

Peter Danko's career illustrates the connection between being a studio craftsman and designing for production. After graduating from the University of Maryland in 1971, he was exploring various means of survival when he came upon a wood shop in Georgetown that produced custom fixtures for stores. Immediately intrigued, he took a job there, which provided him with hands-on training in woodworking. After a few years, with learned skills and the desire to be on his own, Danko began to make one-of-a-kind laminated furniture for clients in Washington, D.C. In 1976, curious about production on a larger scale, he visited the Thonet plant in Statesville, North Carolina, which inspired him to design his first one-piece molded plywood chair. The following year he established a retail showroom and studio in Alexandria, Virginia. After seven years he decided to change direction, and began a limited production of chairs that he marketed to the architecture and design communities. He soon had a successful operation, with twenty-five employees. The economic slowdown of the early 1990s affected his business, however, forcing him to sell his assets to Persing Enterprises. Fortunately, Danko is now able to follow his muse more freely than ever under the banner of the Danko Division of Persing Enterprises. His love of designing and building furniture that embodies new techniques and materials continues unabated, and he still carries a vision of making his ideas accessible, so that the average person can own and appreciate his work.

"Bodyform" chairs. Maple veneer layered, formed, and bonded in a hot mold. 33 x 20 ¾ x 22"

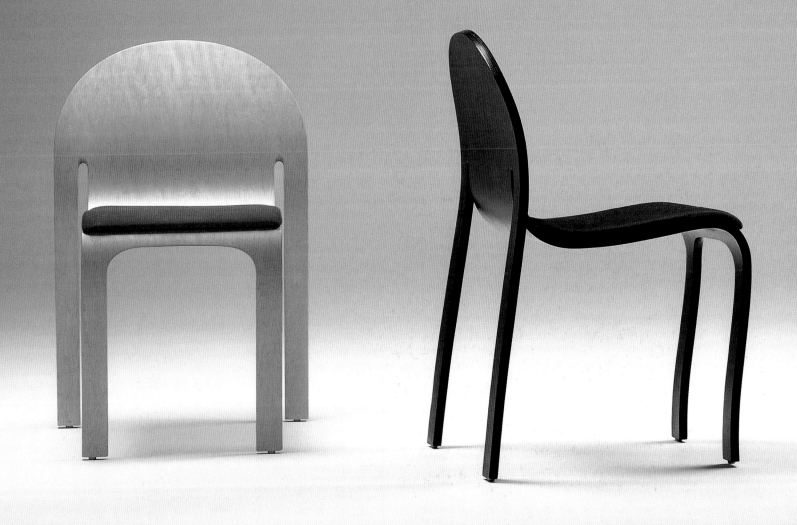

"My life as a craftsman suits me very well. I believe that for most craftspeople there is little distinction between life and work. My goal is to lead a simple life of self-reliance, close to nature and my work."

Anthony Beverly furniture maker Stephentown, New York

Anthony Beverly receives great satisfaction from creating furniture that is both beautiful and useful. In the mid-1970s, after practicing as an architect in Washington, D.C., Beverly made a career choice to become a furniture maker. It was motivated by his desire to use his training and design skills in a venue that allowed for more independence and creativity. After two years in a small studio in Washington, he decided to move to a rural area in up-state New York, where he currently works. Beverly's main focus is custom furniture made for site-specific requests. Over the years he has developed long-term, personal relation-ships with many of his clients, who respect his talent for making furniture that fits their needs and enriches their living environments. He also creates a small line of limited-production pieces that he sells mainly through the few craft shows he attends each year. Beverly has always maintained a two-man shop, working closely with an apprentice who becomes involved with all aspects of his work. Involvement with his craft over the years has allowed him to work toward mastering techniques while developing an evolving design vocabulary.

Coffee table. African rosewood, mahogany, granite. Traditional joinery with bolted joints. 17 x 28 x 60"

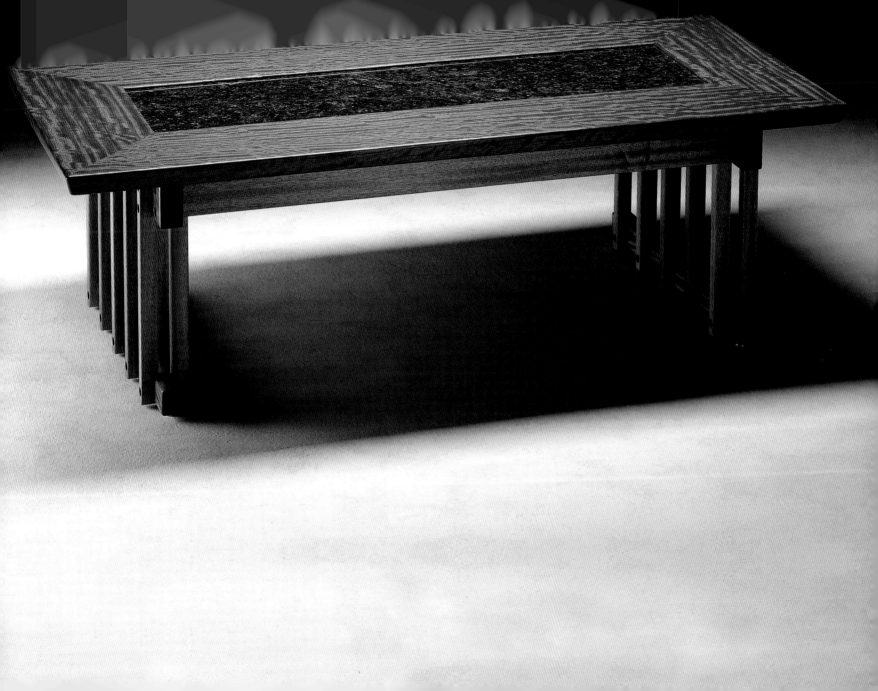

"I see my work as making use of old-fashioned tools and traditions and reinventing them using color. I love the effect of weaving with fabric to achieve geometric shapes, which feels modern and energizes me. My work is always about color. I design my garden just the way I design my carpets: always with color in mind. In fact, when I dream, I dream in color. The rest of the time I am possessed by it. My work reflects that obsession."

Sara Hotchkiss handweaver Portland, Maine

Sara Hotchkiss finds great reward in creating rugs and hangings that embody her respect for traditional skills and give her the opportunity to express herself and her fantasies with color and pattern. Taught to paint, sew, and knit by her mother and grandmother, she received professional training in art and weaving at Skidmore College. After graduating in 1974, she established a studio in Saratoga Springs, New York, and relocated in 1982 to her current base in Portland, Maine. Using a simple hand loom, she designs and makes carpets and wall hangings inspired by traditional rag rugs and tapestries. Her work reflects her love of basic weaving techniques used throughout history. To make functional carpets and decorative hangings, Hotchkiss draws inspiration from the beauty of the natural world—the coloration and markings of a bird's feather, the shading of a rosebud, the juxtaposition of flowers in a garden—using nature as a resource for pattern, design, and color. She is also influenced by Navajo rugs and Amish quilts. Her love of color has led her to explore new combinations of it, resulting in bold graphic statements. With two or three assistants, Hotchkiss produces a collection of one-of-a-kind works each year, which she sells at craft fairs; she also does custom designs for architects and interior designers throughout the country.

"Glory Morning." Cotton fabric, cable cotton warp. Woven. 72 x 48"

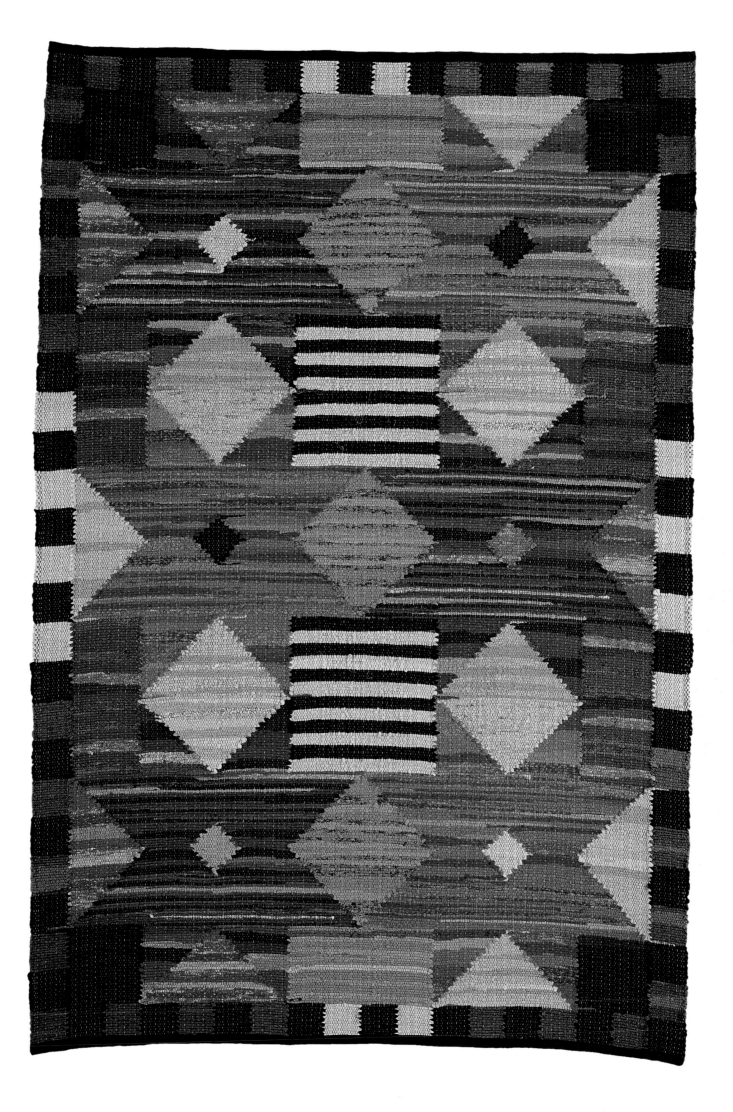

"I am crazy about my customers! Generally the fact that they love my work enough to make out a check predisposes me to like them, but it goes deeper than that. That so many become my friends provides one of the greatest satisfactions of my life. Each time I make a quilt, I am being invited into my customers' lives. Often they want to mark a milestone or special occasion for themselves or their families—whatever the event, my work becomes an intimate part of their daily awareness."

Ellen Kochansky quilt maker/fiber artist EKO Pickens, South Carolina

Ellen Kochansky designs and makes quilts with passion, and is proud that her creative endeavors can be shared with the individuals who admire and acquire them. By the age of seven she had developed an interest in sewing and began to make apparel and doll hats that she sold to her neighbors, reflecting an early instinct to market her creations. Her fascination with fabric continued into her teens when she won a regional Vogue Patterns sewing competition. This award encouraged her to attend Syracuse University to get a formal education. First specializing in fashion design, she later switched to theater costume, which gave her background in the history of fashion and greater freedom to experiment. Upon graduation, Kochansky worked in Manhattan on *The Vogue Sewing Book* and later traveled to Europe to see firsthand the rich textile traditions and museum collections. Returning to the United States in the early 1970s, she established her first studio in Pickens, South Carolina, and began to experiment with fabric collage to create wall hangings. A 1978 grant from the South Carolina Arts Commission freed her to further refine her ideas, which resulted in a collection of wearable art, tote bags, and other useful fabrications, including quilts. In 1979, her success at the Piedmont Craft Fair in Winston-Salem, North Carolina, motivated her to continue selling through craft fairs. Soon she began to focus on the development of original limited-edition quilts. Today Kochansky produces five new designs a year, as well as several new color variations on existing designs. Each season's collection represents some thirty varieties of bed coverings. She also does unique commissioned work for architects and public spaces.

"Padlock/Sand" quilt. Mixed fabric. Machine pieced, quilted. 100 x 86"

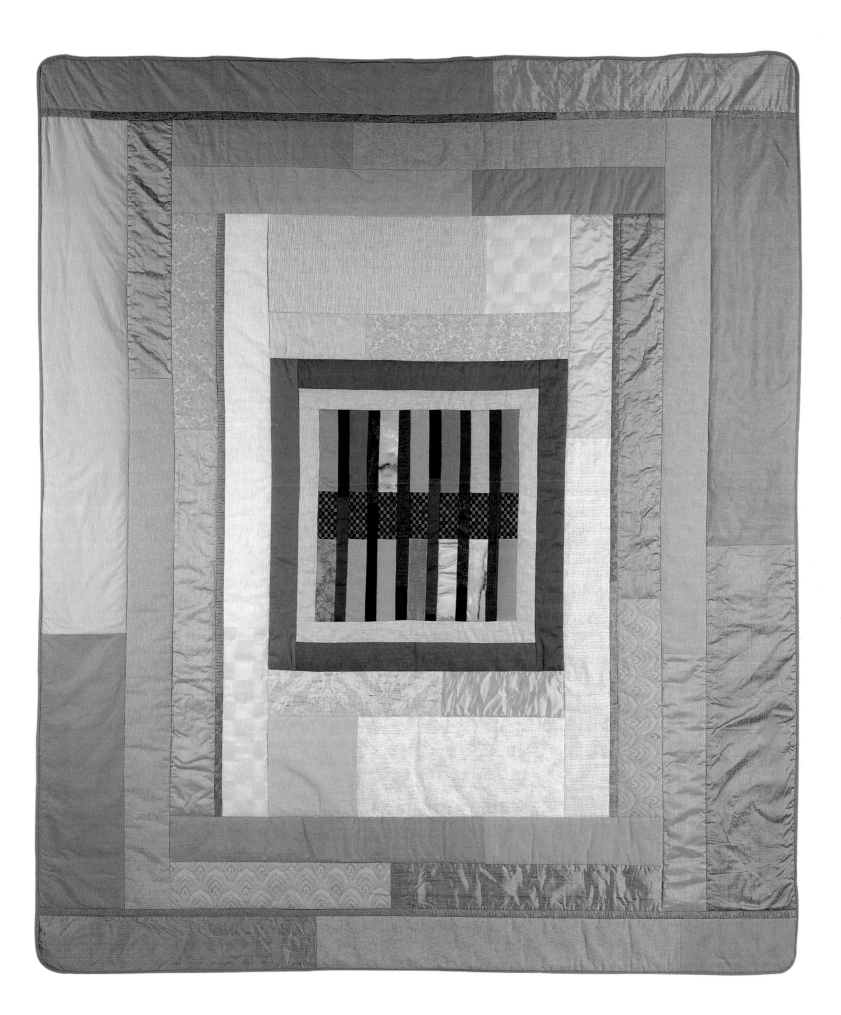

"The brush is an ordinary tool used to facilitate one aspect of everyday life. Natural materials incorporated into my work are an integral part of the design. The weaving and plaiting of fiber are labor-intensive techniques I use, striving to surpass tradition and reach the level of artistic beauty. My lifestyle mixes concentrated work with activities of living to produce an atmosphere of creativity from morning to night. Working without employees and living in a remote part of west Texas, I can work undisturbed and push the limits of artistic expression."

Bobbe McClure brush maker Van Horn, Texas

Making elegant and beautiful brushes is the aim of Bobbe McClure. After obtaining her undergraduate degree at the University of Kentucky, she began making brooms and brushes in a traditional style, gradually developing innovations and new techniques. Upon finding sources of softer and more subtle fiber, her work became more complex and refined. The desert environment around her Texas studio, rich with fiber-producing plant life, is her main source for materials. Lechuguilla, palma, and palmyra are incorporated with porcupine quill and other natural elements such as horse hair, camel hair, boar bristle, javelina hair, and various seeds and feathers. She creates each work individually—as they are time intensive, she produces a limited number each year. Humble in concept but sophisticated in design, her work combines function with aesthetic beauty. She sells through craft and art fairs in the United States and through galleries in the United States, Europe, and Japan.

"Himekami." Lechuguilla fiber. Woven, plaited. 30 x 16 x 2"

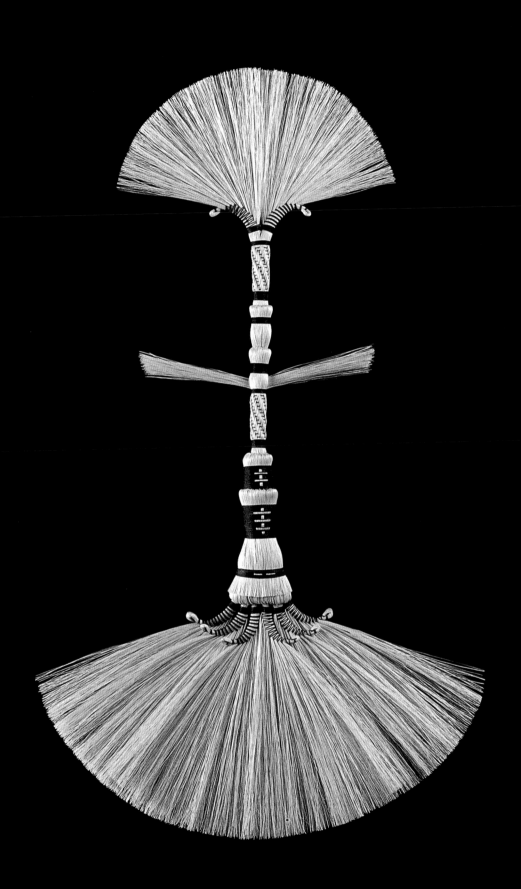

"For thirty years I have pursued a time-intensive, slim-profit profession. I felt all along that I am privileged that the world has let me make my guitars, surround myself with glorious music, and busy myself with reflective, contemplative work."

William R. Cumpiano musical instrument maker Northampton, Massachusetts

William Cumpiano's objective is to make fine instruments that reflect his love of music and respect for professional musicians. Upon his graduation from high school in Puerto Rico, his mother encouraged him to become an engineer rather than pursue his interest in art, which she considered a less stable career. One year in engineering school confirmed his lack of interest, and Cumpiano transferred to the industrial design department at Pratt Institute in Brooklyn, New York. After earning his degree in 1969, he joined the prestigious design division of Knoll International. He still felt that something was missing in his life, however, and he developed an interest in the Spanish guitar, which he taught himself to play. Wanting to learn how to make an instrument, he took an evening course with Michael Gurian, then one of the few professional guitar makers working in New York. When Gurian subsequently opened a guitar factory in New Hampshire, Cumpiano quickly accepted an offer to work there, although it meant leaving a lucrative design career for a minimum-wage job. Under the influence of Michael Millard, a shop foreman, Cumpiano cultivated the enthusiasm and skills to become a fine instrument maker. In 1974 he opened his own guitar-making and repair studio. Since then he has made more than two hundred instruments for musicians in the United States and the Caribbean; Arlo Guthrie and Michael Lorimer are among his customers. In 1993 Cumpiano received a patent for a compression-molded, carbon-fiber composite soundboard, and now produces a limited edition employing his invention. In the early 1990s he developed the Puerto Rican Cuatro Project to research and document the history of native instruments of his birthplace. The collected data now serves as an international resource, which he considers a gift to the Puerto Rican people.

Venezuelan cuatro. Flamed broadleaf maple, Brazilian rosewood, polished lacquer finish. 26 x 7 x 3". Private collection

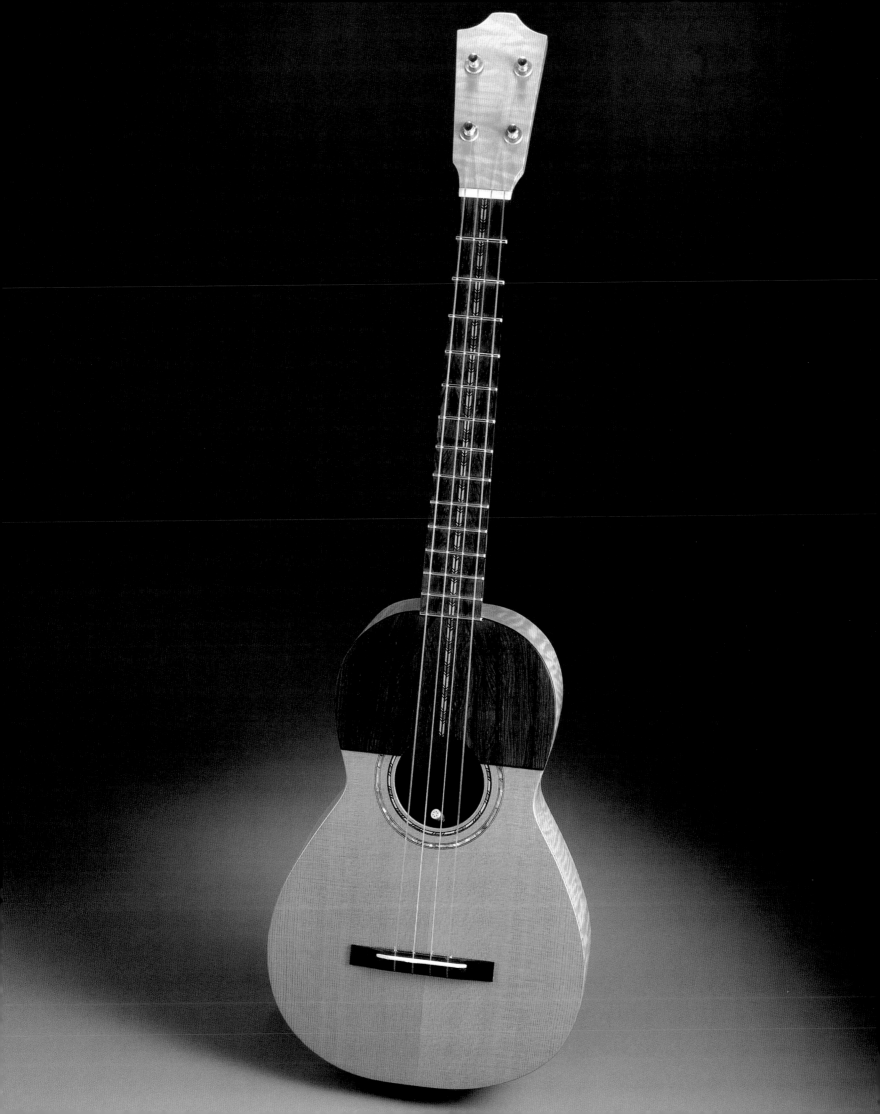

"The greatest trumpet maker in the world is Dave Monette.... Watching Dave's development as a trumpet maker has made me strive for another level of development as a trumpet player. I want to live up to playing his horns." —Wynton Marsalis

"My aim is to allow more intimacy in musical performance by building metal forms that amplify a musician's voice in the most efficient and resonant way possible."

David Monette trumpet maker Portland, Oregon

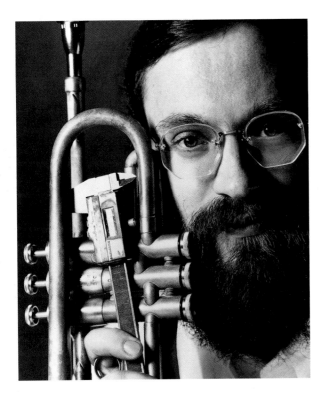

David Monette is committed to engineering and making the best trumpet possible. His reward is having a master musician honor his efforts with a brilliant performance. He began his career as a band instrument repairman in Salem, Oregon, in 1978. Taking advantage of his abilities as both a trumpet player and an instrument technician, he completed the first Monette trumpet in May 1983 in Bloomington, Indiana, where he was working with his mentor, Charles Gorham. His first few instruments were immediately purchased by top players from the Chicago, Boston, and Los Angeles symphony orchestras. With his move to downtown Chicago in 1984, Monette started working with jazz musicians as well. Players such as Wynton Marsalis and Art Farmer sought him out to design and build new instruments for them. His "constant pitch center" designs allow improved projection, greater ease of response, and better consistency in sound and response when played from soft to loud and from high to low. His success in this achievement can be credited to his understanding of the relationship between the resonance (body use) of the performer and the resonance of the horns and mouthpieces he designs. In his current studio in Portland, Monette and his eight coworkers produce about seventy trumpets per year, with his top-of-the-line, decorated "presentation" pieces often taking more than one year to complete.

"The Ajna II B-flat" trumpet, series no. 1322. Brass, 24k brushed gold. Fabricated. 21 x 6 x 7"

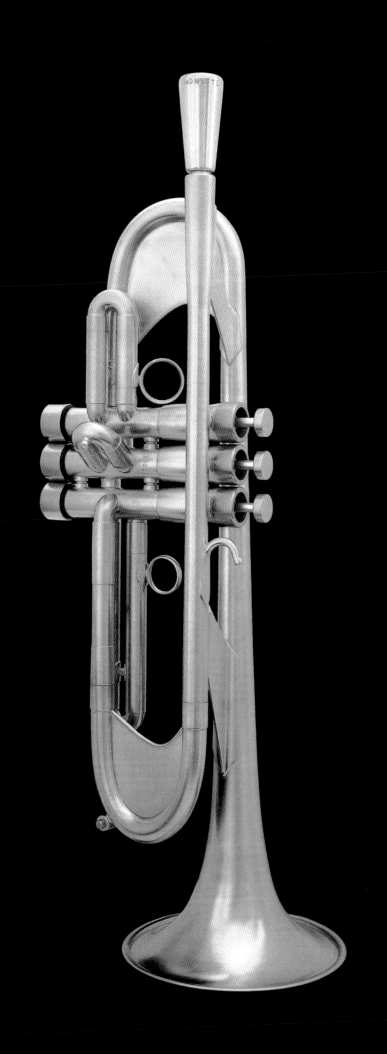

"Making bamboo rods is a religious experience. Every one I make has an individual personality. I experience a certain amount of regret as each of my creations passes from my hands. This may be the natural downside from the passion felt as the rod first takes shape and you feel this may be the best you have ever made. Rod-making is also a concrete expression of my artistic sense that allows me to indulge my passion for fishing."

Marc Aroner split-cane fishing-rod maker Conway, Massachusetts

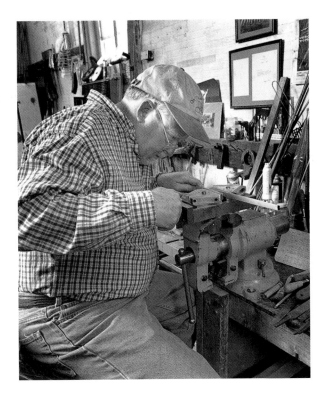

Marc Aroner takes great pride in making split-cane fishing rods. Introduced to fishing early on by his father, as a teenager he became fascinated by the skill of fly fishing, which nurtured his love of the sport. He attended the University of Massachusetts in Amherst, graduating in 1971 with a degree in art education and the intention of pursuing a career as a teacher. Unable to find a teaching position, Aroner worked for two years in a local machine shop, where he developed technical skills. One day he happened to discover Thomas and Thomas in Greenfield, Massachusetts, cane-rod makers with a lengthy pedigree. Intrigued, he expressed interest in learning the trade, and was hired as an apprentice, agreeing to work for five years to achieve the required training. Later, Aroner transferred to the prestigious rod making firm of H.L. Leonard Co. in Central Valley, New York. Uninspired by the mass-production atmosphere there, he established his own studio in Greenfield in 1983. Today he creates about twenty rods per year, some unique custom models, others in small editions. Each requires a great many painstakingly intricate steps to transform raw bamboo culm into a superbly balanced instrument for the discriminating sportsman. These rods are truly a form of functional art, representing the finest craftsmanship combined with the best materials available. A cane rod by Marc Aroner is a cherished possession for any sportsman privileged enough to own one.

"The Tournament" bamboo fishing rod. Split bamboo, German silver ferrules. Six-strip construction. 84 x 1 ½" diam.

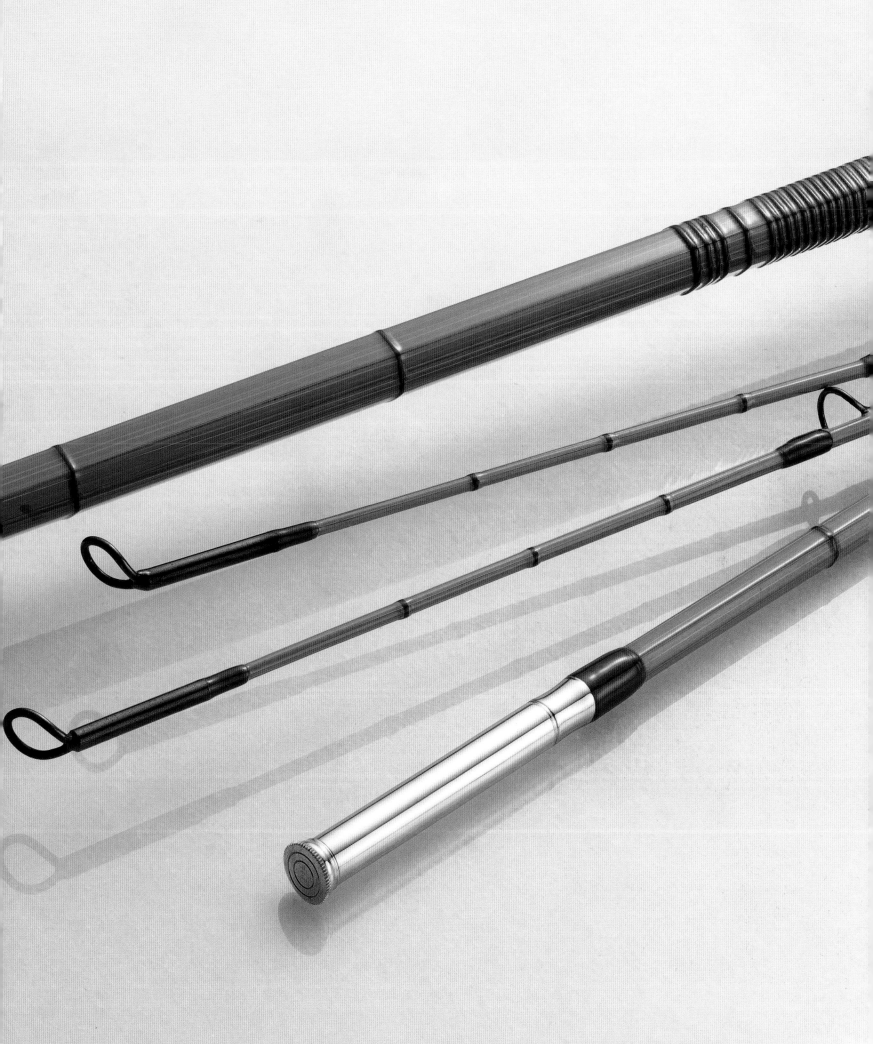

"The out-of-doors was a very important part of my upbringing. At first it was just plain playing outside; later it became golf, tennis, swimming, sailing, hunting, and fishing. That beginning has influenced everything I've ever done and is the heart of why I work with what I love."

John Betts fly tyer and fishing tackle maker Denver, Colorado

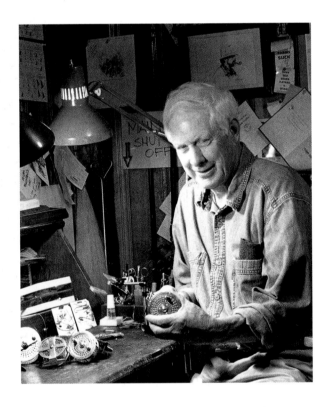

John Betts's love of the outdoors and sports as a young boy inspired him to make his first artificial fly using molted feathers from a pet quail that was spending the winter in his living room. After earning a degree in forestry from the University of Vermont in 1971, he began his career as a landscape architect and soon started tying flies professionally for an Orvis store in Clinton, New Jersey. He is considered one of the pioneers in manmade fly-tying materials, and for the last ten years has been committed to learning the history of the sport and techniques early anglers used to solve problems in reel, line, hook, and fly design. He felt that in order to understand the history, he needed to make fishing gear using time-honored techniques. While most fly makers today use commercial hooks, Betts fabricates each one individually of steel wire. He also produces more than one hundred varieties of fly forms, some based on tradition, others reflecting his own imagination. In 1995 he began to explore the making of fishing line—historically done in horsehair or braided, oiled silk—and invented a new method by manipulating modern braids and monofilaments to produce a tapered, waterproof, knotless line that meets the highest standards of performance. He also fabricates custom brass reels. Betts has written more than eighty articles for trade publications, and has published two books and two field guides. Currently he supplies a select fishing trade with high-quality equipment and fly-tying material, and shares his experience through talks and demonstrations.

Fly-fishing reels. Brass. Hand formed and constructed. 1 1/4 x 3" diam. **Fly-fishing line**. Mongolian horse hair. Hand twisted from 40 hairs to 6 hairs. 180"
Artificial flies for trout, bass, Atlantic salmon. Assorted fur and plumage, steel. Steel hooks, mostly handmade. Most flies tied by hand without vise

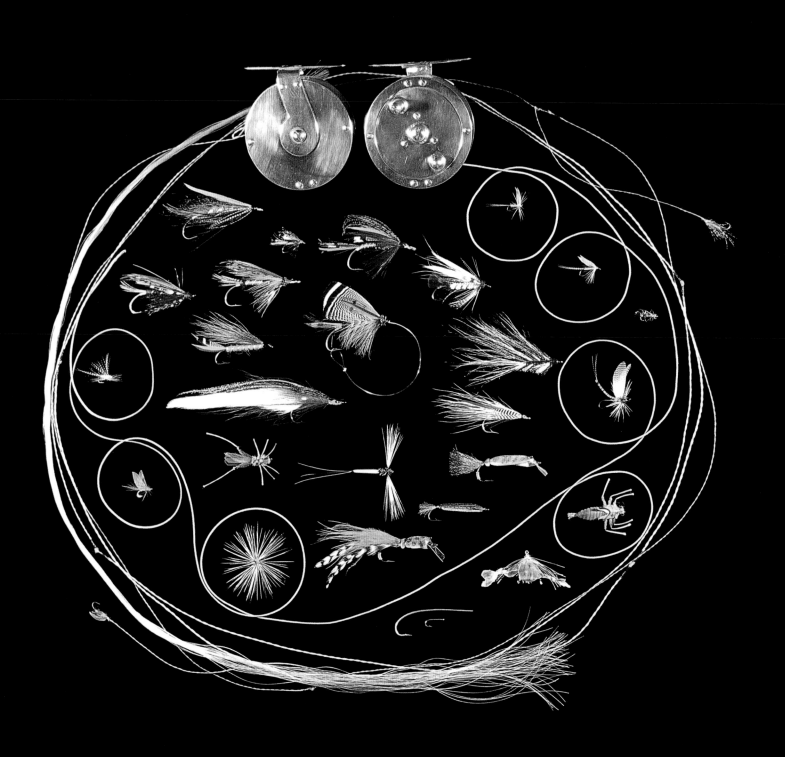

"The sport of surfing is really more of a lifestyle with me than a sport. I've spent most of my life on the ocean one way or another. Either surfing, diving, or fishing. Combining my love for the ocean with exotic woods to re-create some of the beautiful designs and shapes that surfboards represent as sculpture has become my second great passion in life."

Greg Noll surfboard maker Crescent City, California

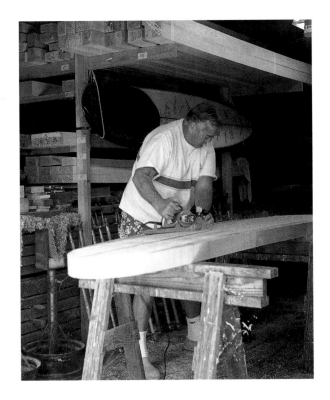

Greg Noll's love of surfing is part of each surfboard he creates. His career as a "beach rat, surfer, filmmaker, board builder, and surf-culture impresario," as the *Surfer's Journal* once described him, has spanned more than fifty years. His international fame as a surfer is identified with his challenge of the big waves in Makaha, Hawaii, where in 1969 he surfed a forty-foot storm wave. Greg's interest in the ocean began at age six, when his family moved to Manhattan Beach, California. He soon started surfing and hanging out at the workshop of Dale Velzey, a pioneer maker of balsa boards. It was there, at ten, that Noll had hands-on experience shaping a board; he later began to make them at home, while indulging his real passion, surfing. Eventually he developed a small business that rapidly grew, requiring him to expand his operation to a twenty-thousand-square-foot space in Hermosa Beach. There he developed a system of hand production of both wooden and foam boards, ultimately employing more than sixty workers and turning out 150 to 175 boards a week. As the demand for long boards diminished, he closed shop in 1971 and became a commercial fisherman. In the 1980s Noll once again became interested in making boards, and went to the Bishop Museum in Hawaii to study its collection of beautiful forms associated with more than two thousand years of Polynesian surfing history. Upon his return, he began to craft individual wooden boards inspired by his research. Today, each of his creations is unique and designed to function. However, their high quality and cost make them collectors' items for the growing community of serious surfboard collectors.

"Alia" surfboard. Koa, polyester resin, fiberglass cloth. Shaped, fiberglassed, hand polished. 100 x 17 1/4 x 2 1/4"
"1960s Beach Break"-style surfboard. Balsa wood, curly redwood, polyester resin, fiberglass cloth. Laminated, cut, shaped, fiberglassed, hand polished. 111 x 21 1/2 x 3 1/8"

"For most of my woodworking career I was searching for an art form that was useful and completely unique. Discovering the Aleut *baidarka* gave me that art form along with a mission to pass on to others what I believe is one of the best examples of form and function created by human beings."

R. Bruce Lemon kayak builder Lake Placid, New York

R. Bruce Lemon finds deep satisfaction in creating kayaks based on the *baidarka*, an old Russian word for the Aleutian skin kayak. After attending art school at the State University of New York at Buffalo he got involved in woodworking, which led to an interest in boatbuilding. With technical information and inspiration from George Dyson, a kayak expert, Lemon was directed to sources that gave him insight into the history and engineering of traditional "skin on frame" kayaks. Seeing a historical example of a *baidarka* at the Robert H. Lowie Museum of Anthropology in Berkeley, California, inspired him to create a kayak based on a blueprint he was able to acquire from the museum. After making one, he began to experiment with personal refinements; he then became interested in producing kayak kits and creating custom kayaks. Intended for the sports enthusiast who wishes to own a beautifully made, high-performance craft, a Bruce Lemon kayak comprises some seventy-five different parts of quality Douglas fir, white spruce, and white oak, with over thirty rib joints, hand lashed together. To waterproof the structure, which traditionally was covered with oiled sealskin, Lemon uses a nylon fabric hand stitched and coated with durable marine urethane. As each kayak is created individually, he often designs for the specific intended use and physique of the buyer, producing in the range of forty each year. Eager to share his skills and knowledge with others, Lemon often conducts workshops at boatbuilding schools, special boat events, and his own facility.

Kayak. Douglas fir, spruce, yellow pine, white oak, nylon. Constructed, stitched, coated with marine urethane. 11 x 23 x 192"

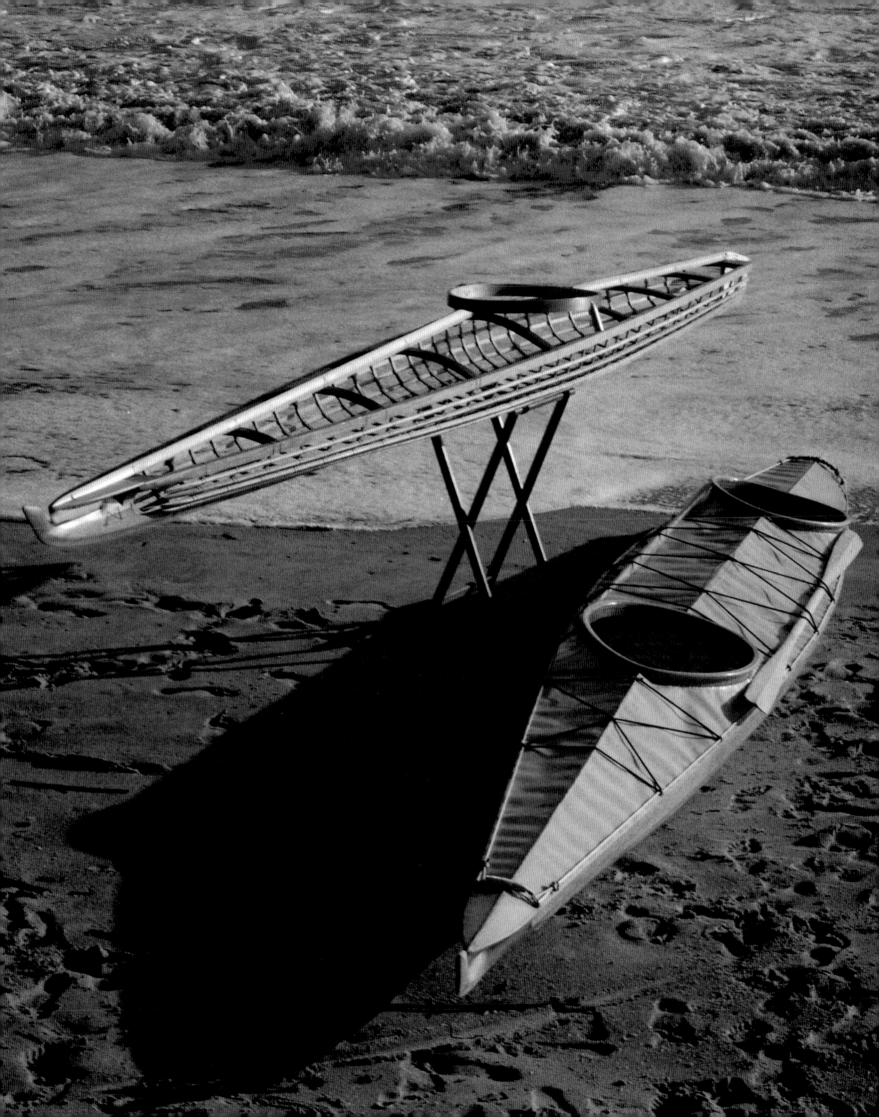

"Dogsleds in the past were used for back-country transportation of furs, supplies, even medicine. Traditional sleds were often very crude and heavy. Today sleds are used for recreation and racing. The sleds I create are sleek, lightweight, and easy to pull, allowing the driver to corner at top speed."

Paul Bergren dogsled and snowshoe maker Minot, North Dakota

At an early age Paul Bergren had an interest in outdoor sports and chose a career as a farrier, shoeing horses. His children's use of dogsleds for trapping expeditions led him to make snowshoes and build his first dogsled in 1978. When a 1982 car accident made him physically unable to continue his trade, he began to explore making sleds in earnest. Eventually he developed his own designs using the latest snow-ski technology to form runners for the sleds, which are made from laminated white ash in a herringbone pattern. Without nuts or bolts, all elements are lashed together with rawhide. He attended professional races in the northern United States and Canada, and when his son became an award-winning sprint racer, he began to perfect his designs to meet the highest standards of professional use. Today, Bergren is respected as a master dog-sled builder, creating sleds for serious racers in Japan, Europe, Canada, and the United States. As he is in direct contact with those who participate in the sport, he is constantly exploring new ways to make his sleds perform to maximum capacity for his customers. He also produces in the range of twenty pairs of snowshoes per year, each custom made and fitted to allow maximum flotation.

"Centennial" freight sled. Ash, nylon, fiberglass, varnish. Steam bent, laminated, lashed. 36 x 20 x 108"

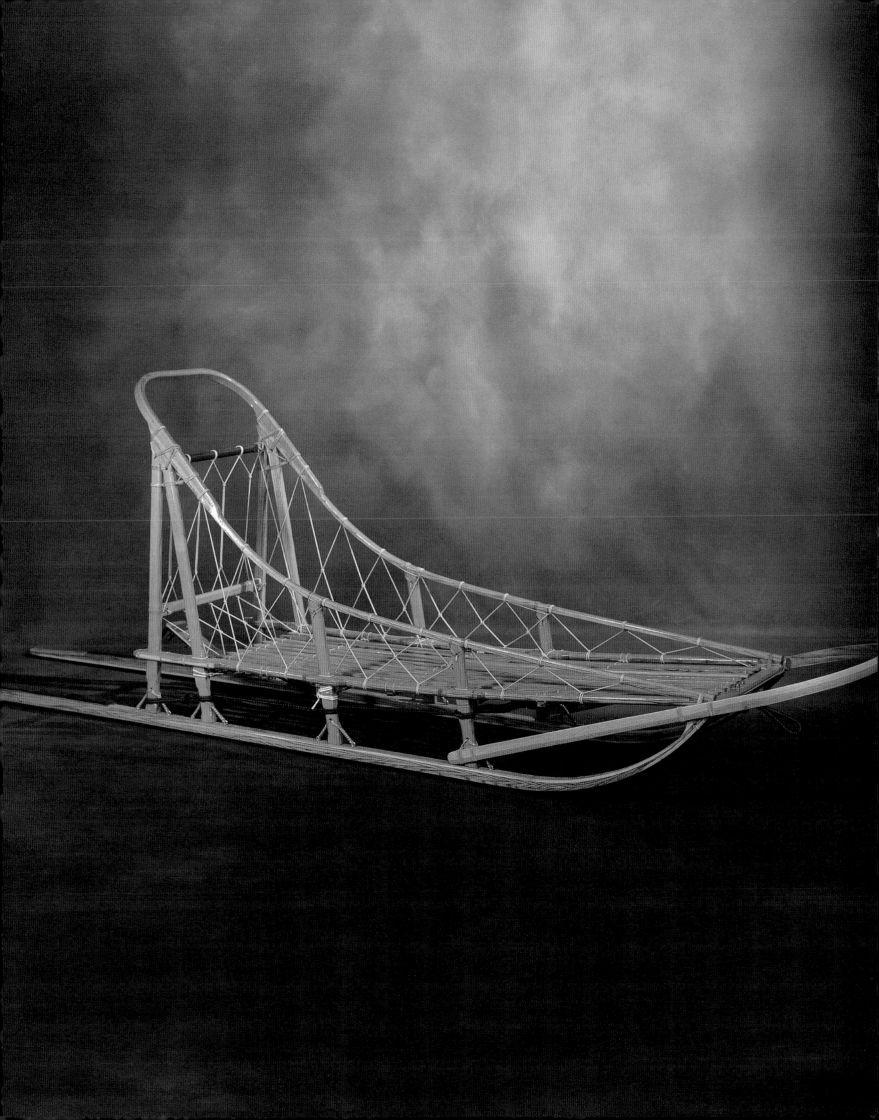

"I like designing kites because there is a challenge in making them function. All of my kites incorporate a technology where there is an airfoil shape that helps to gain lift once it is moving, like wings of a plane. As for flying, there is an engineering aspect that is crucial while still maintaining the artistic value of the kite. What I love about flying kites is the opportunity to meditate and get away from things—just me, the kite, and the sky."

Marc Ricketts kite maker / inventor Guildworks Braddock Heights, Maryland

For Marc Ricketts, play is central to designing, making, and flying kites. A kite enthusiast since childhood, Marc began to experiment with making them in his teens, and from 1988 to 1994 attended Pratt Institute in New York, where he specialized in design science. A part-time job at a kite store introduced him to the network of the kite world. After graduation, inspired by possibilities of form in flight and an awareness of the potential kite market, Marc spent six months developing a unique kite-design technology, acquiring a patent for the tension-suspended airfoil, a new concept that allows flight with minimum air movement. He presented a prototype collection at a Kite Trade Association international show in Las Vegas, received a tremendous response, and sold all the works he had made. His new career soon flourished, along with the challenges of developing a small business. Marc's kites incorporate space-age materials of ultra-lightweight ripstop sailcloth, composite spars, and polymer tension lines. Because of their innovative design, his forms can be flown inside without wind, the flier's motion producing lift. In addition to making limited editions sold throughout the world, he is currently involved with collaborative performances in which his kites become an integral part of dance and movement.

"Blooming Flight," performance/collaboration with Heather Henson. Wave Hill Dance Festival, Riverdale, New York, June 7–11, 1999

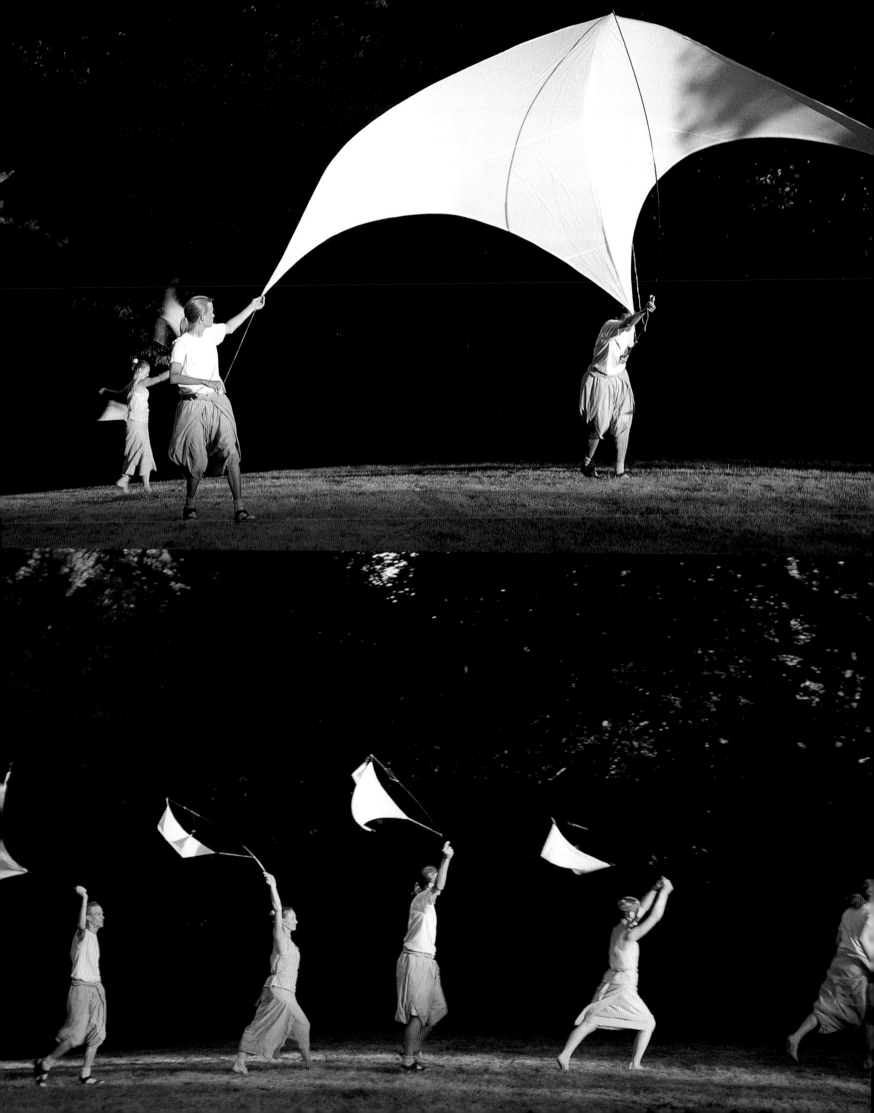

Teresa W. Chang. **"Enso" place setting**. Porcelain. Hand thrown, glazed. Dinner plate 1 x 10 ½ " diam.; salad plate 1 x 8 " diam.; cup 1 ⅞ x 3 ⅝" diam.

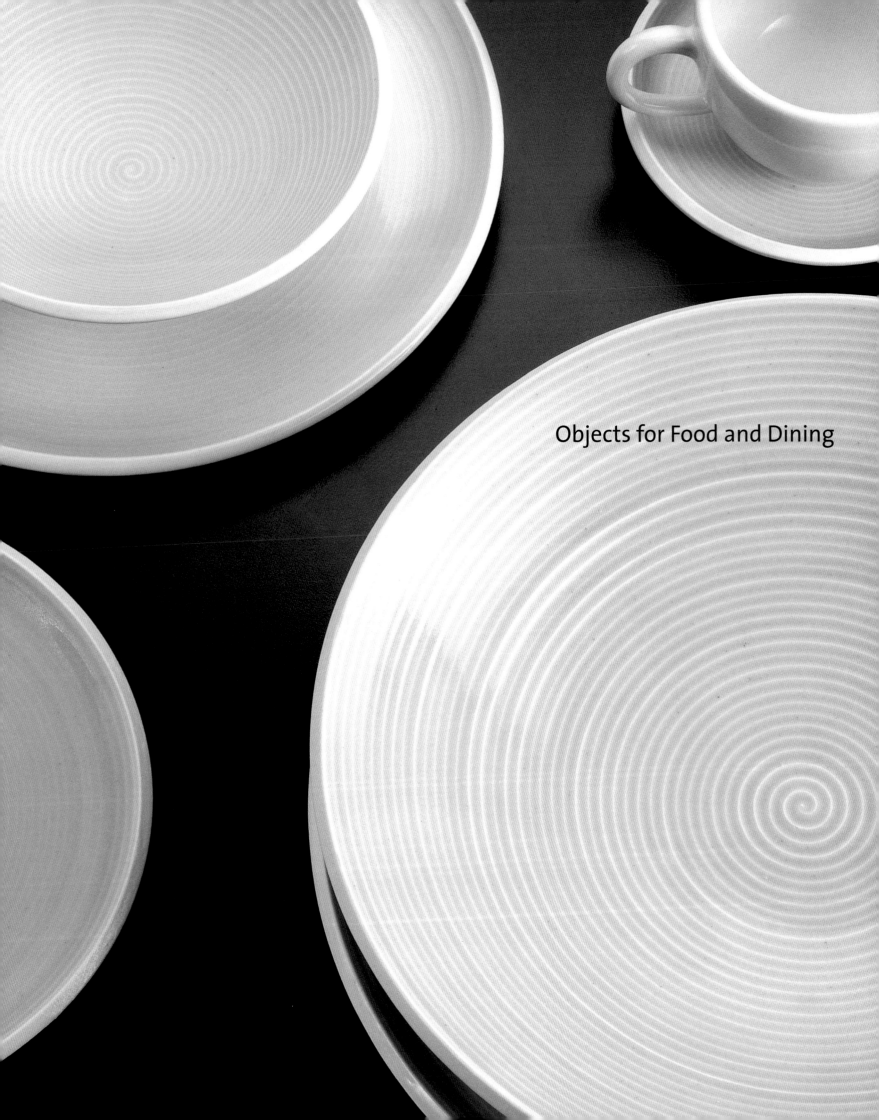

Objects for Food and Dining

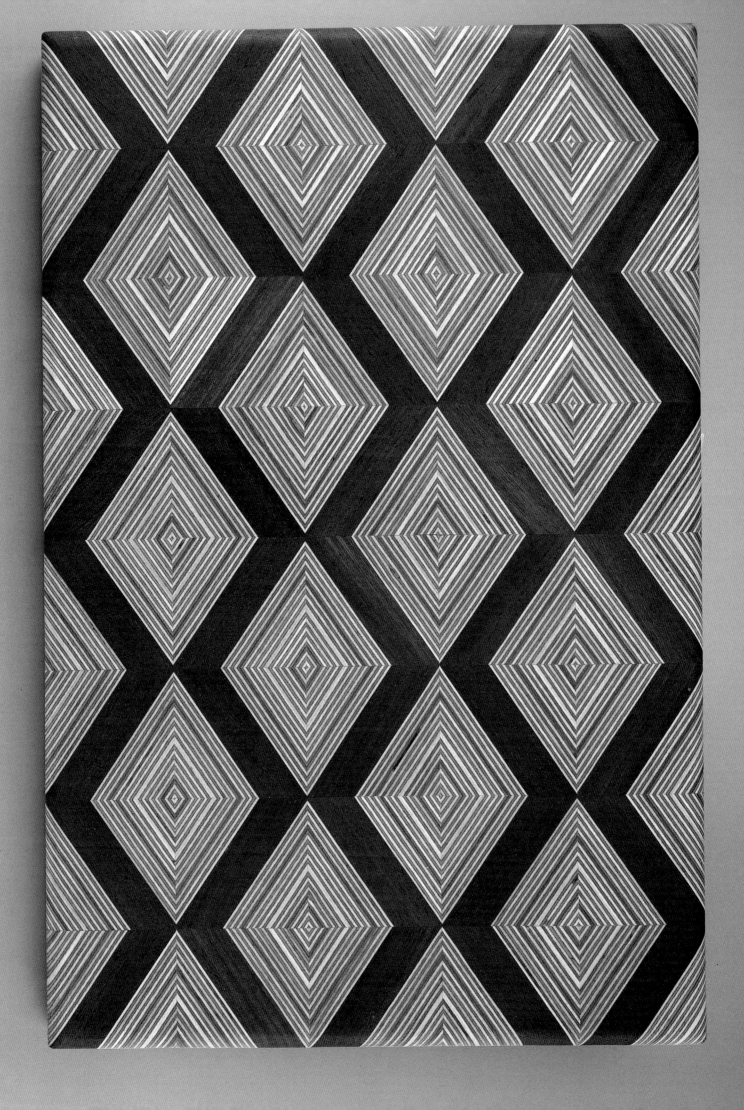

"My approach to the craft of fine woodworking is simple: I make each item as if it were my own. Durability, practicality, and artistic beauty are the foundations of my work." — David Levy

David Levy, Hardwood Creations
"Diamond Pattern" cutting board. Padauk, Finnish birch plywood. Laminated, oil finish. 1 x 14 x 20"
Rolling pin. Exotic and domestic hardwood. Laminated, lathe turned. 19 x 2 ¾" diam.

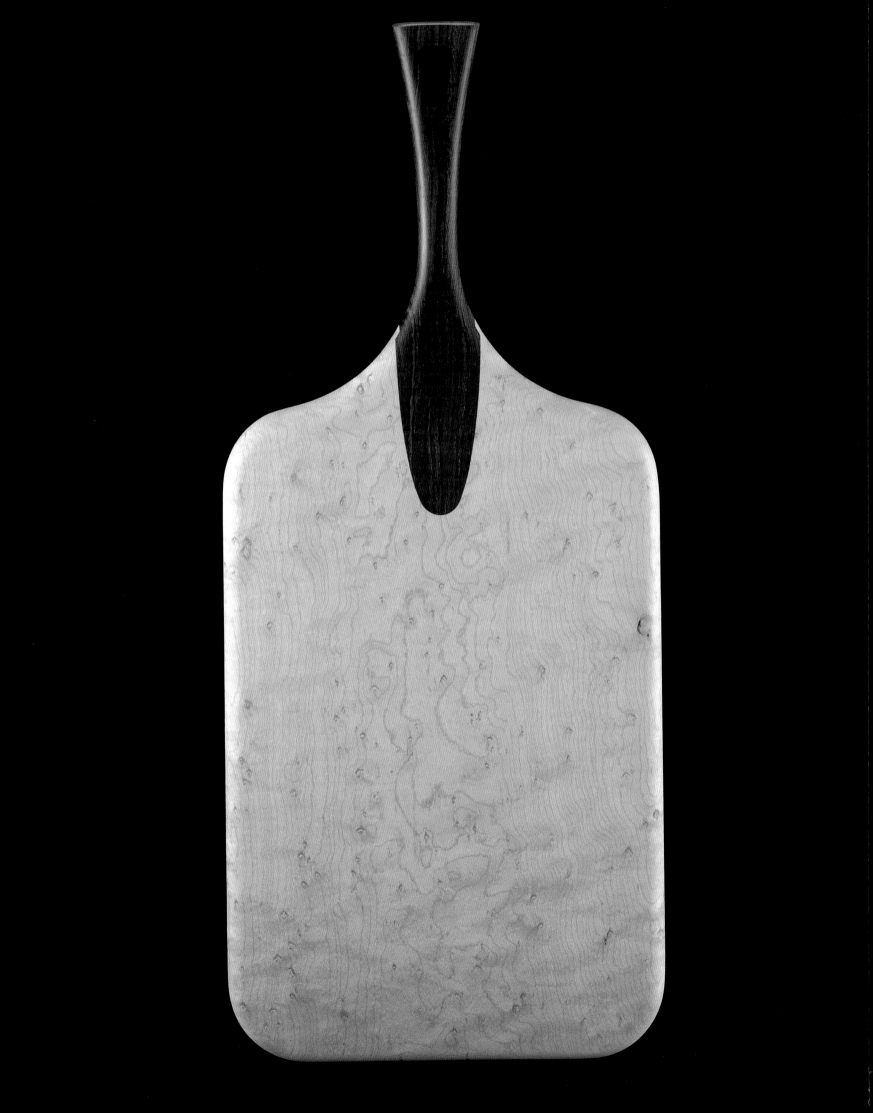

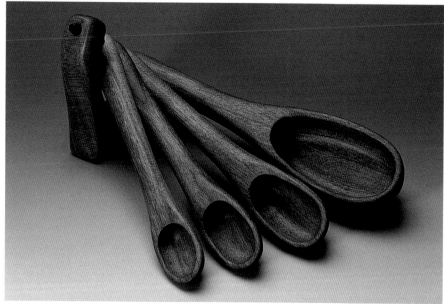

Thomas Davin, Davin & Kesler. **Cutting board**. Bird's-eye maple, cocobolo. Joined, shaped. ½ x 8 ½ x 20"
Mike and Roz Duflo. **Pot drainer**. Bird's-eye maple. Carved, shaped, drilled. 1 x 4 ¼ x 14 ¼"
Mike and Roz Duflo. **Measuring spoon set**. Cherry. Carved, shaped. 1 x 5 x 4"

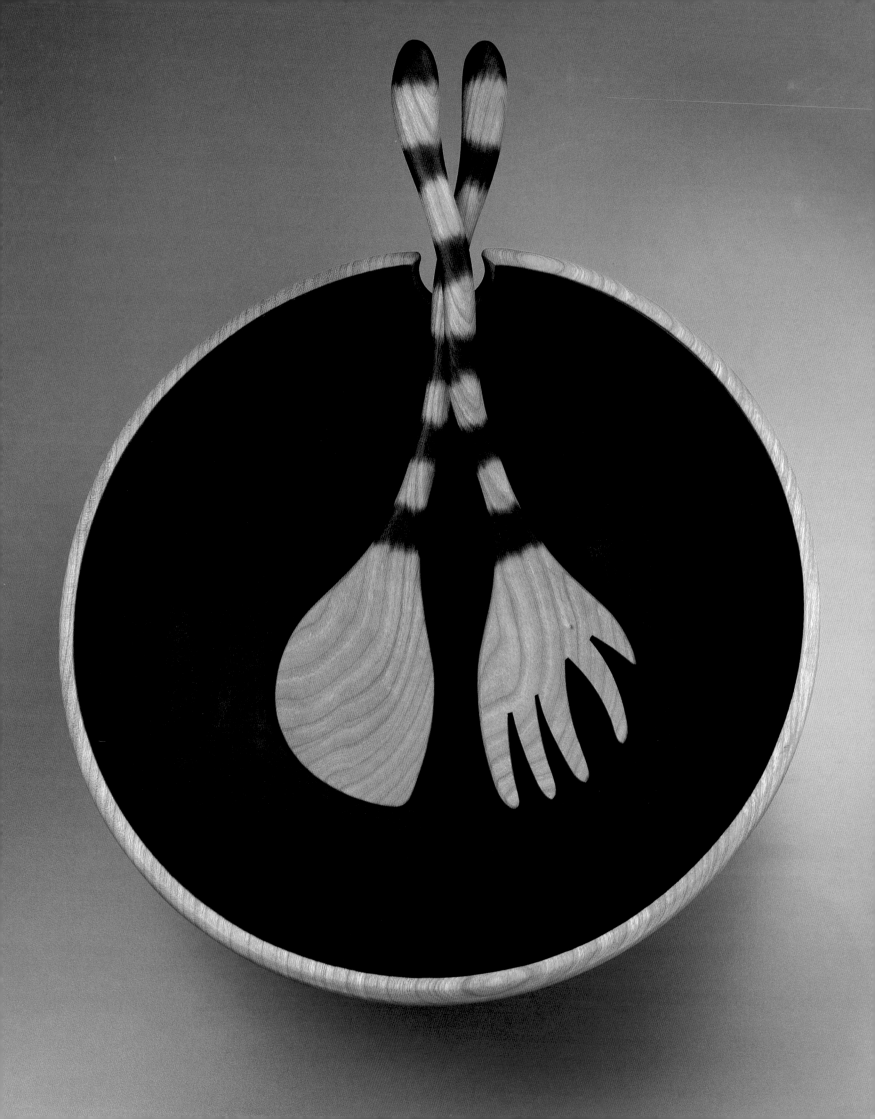

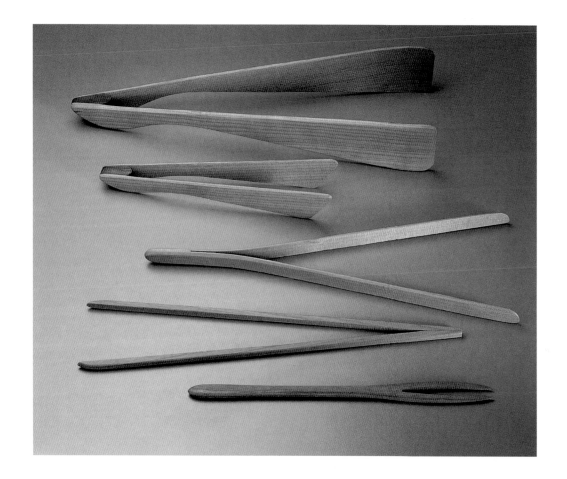

"I love making wooden spoons. They are the simplest tools of the
home, and yet remain profound: there are unlimited designs
and uses to explore." — Jonathan S. Simons

Jonathan S. Simons

Salad servers and bowl. Cherry. Servers: carved, shaped, scorched, finished light mineral oil; bowl: turned, scorched, finished light mineral oil. Servers 1 x 3 x 13" each; bowl 6 x 15" diam.
Tongs. Cherry. Formed, joined. 1 x 10–12"

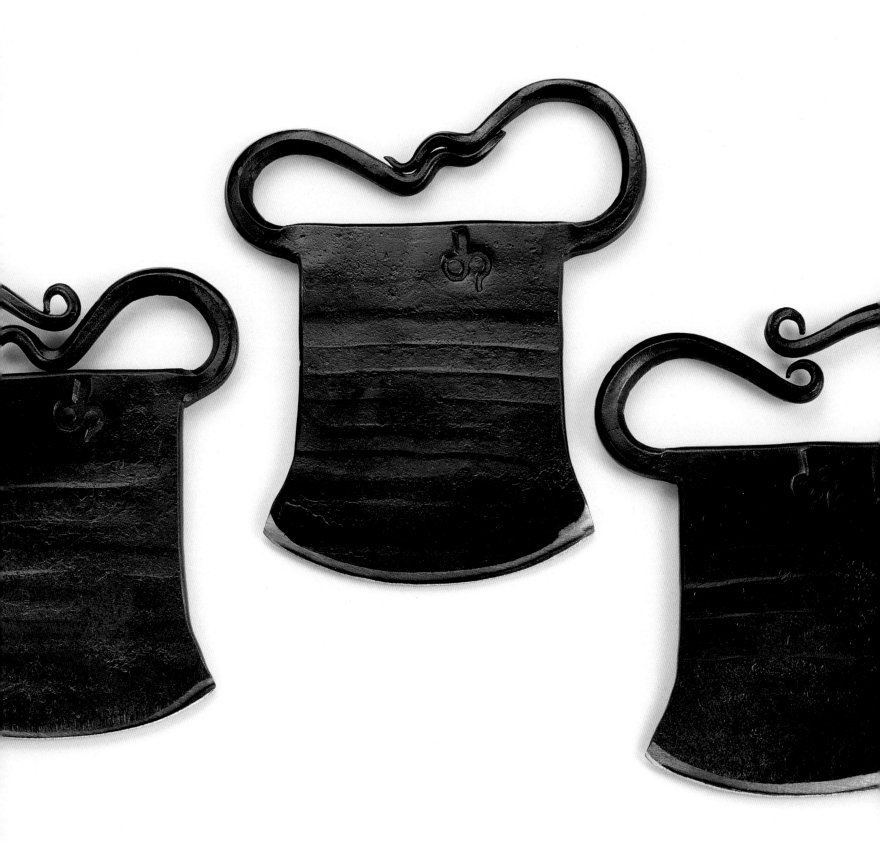

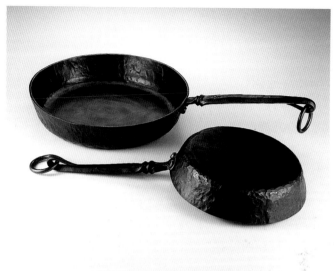

Doug Hendrickson
Vegetable choppers. Iron. Forged, sharpened. 4 x 3 ¾"

clockwise from top left:
Cheese cutter. Iron, stainless-steel wire. Forged, 4 ½ x 5"
Skillets. Iron. Forged. Small 1 ½ x 8 ½ x 14"; large 2 x 10 ½ x 16"
Pizza cutter. Iron. Forged, sharpened. 3 x 15"
Herb chopper. Iron. Forged, sharpened. 4 ¼ x 3 ½"

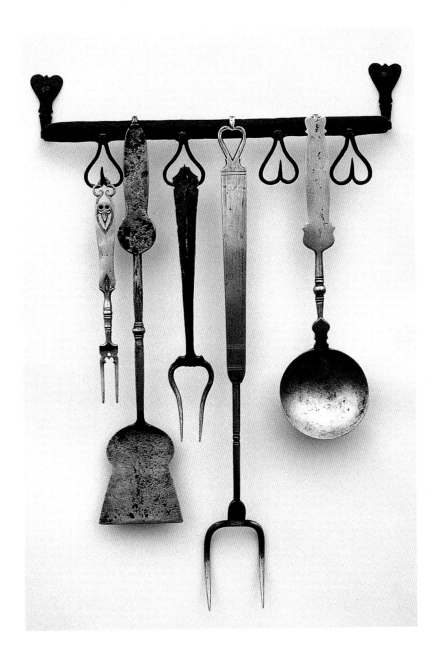

"I have always been inspired by the artistic embellishments on early hand-forged ironwork. The spirit invested in such a piece by the maker gives pleasure when the article is used. Craftspeople competing in an age of mass production cannot easily afford to embellish their work with decorative entertainment, but some of us do so out of delight in the work and the love of the art." — Thomas Latané

Thomas Latané. **Kitchen utensils with rack**. Mild steel. Forged, filed. 20 x 14"
Brian Cummings. **Skewers**. Mild steel. Forged. Each 7 x 7"

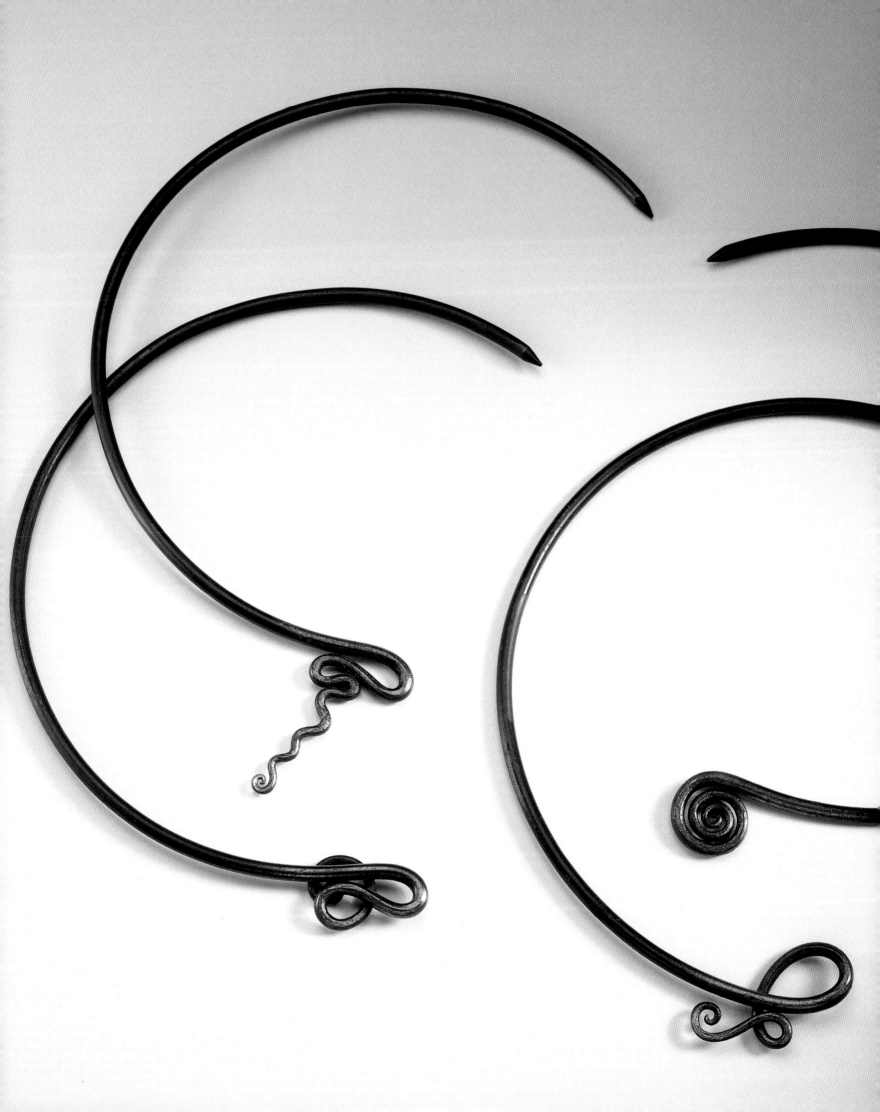

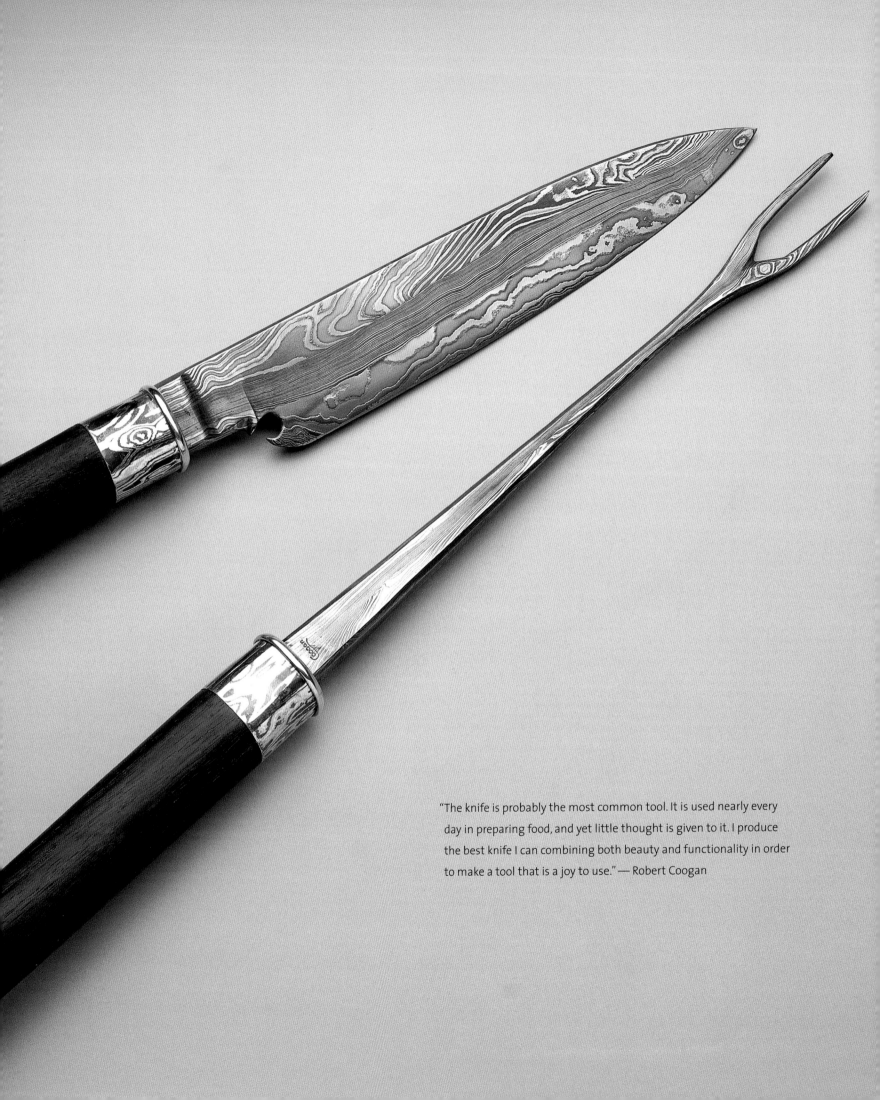

"The knife is probably the most common tool. It is used nearly every day in preparing food, and yet little thought is given to it. I produce the best knife I can combining both beauty and functionality in order to make a tool that is a joy to use." — Robert Coogan

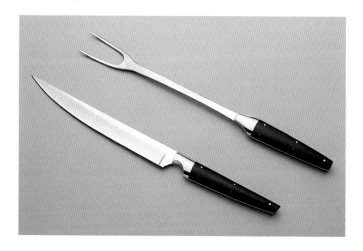
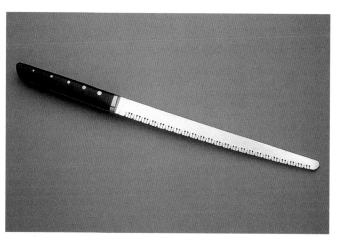
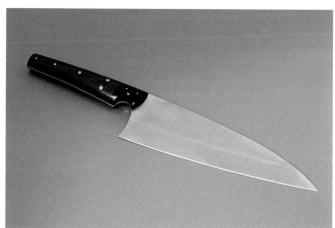
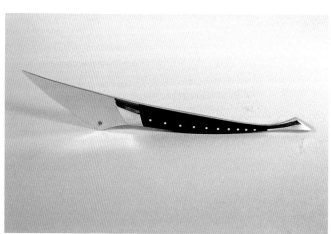

Robert Coogan. **Carving set**. Damascus steel, Mokume-Gane, rosewood. Forged, ground, fabricated. ³/₄ x 2 x 14"

clockwise from top left:
Peter Jagoda. **Carving set**. 440-C steel, black linen Micarta, brass. Ground, fabricated. 1 ¼ x ¾ x 16"
Michael Croft. **"Tanto" bread knife**. O1 steel, red linen Micarta, brass. Fabricated. ³/₄ x ⁵/₈ x 14"
Michael Croft. **Scrap knife**. O1 steel, dark green Micarta, brass. Fabricated. ³/₄ x 1 ½ x 8"
Peter Jagoda. **8-inch chef's knife**. 440-C steel, Micarta, brass. Ground, fabricated. 1 ¼ x 2 x 13"

"Our mission is to make a line of kitchenware that enhances the experience of food preparation with functional objects that are playful and ornamental. Our goal in making kitchenware is to create things we feel proud of, and that people are happy to own and use." — Sandra Bonazoli, Beehive Kitchenware Co.

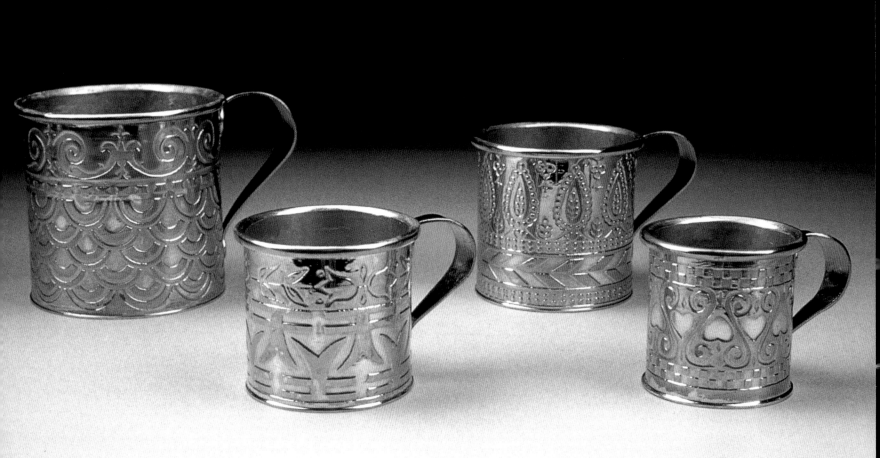

Sandra Bonazoli, Beehive Kitchenware Co. **Pancake spatula**. Stainless steel, copper, plastic. Stamped, milled, cast. 2 ¼ x 5 x 13"
Sandra Bonazoli, Beehive Kitchenware Co. **Measuring cup set**. Copper, tin. Fabricated, etched. Largest 2 ¾ x 2 ¾" diam.

clockwise from top left:
Cynthia Bringle. **Lemon and orange reamers**. Clay. Thrown and carved. 2 x 7" diam.
Sandra Bonazoli, Beehive Kitchenware Co. **3-quart colander**. Copper, tin. Spun, cast, fabricated, tinned. 5 ¼ x 10" diam.
Londa Weisman. **Disappearing jars**. Stoneware, slip, glaze. Thrown, altered. Largest 10 ½ x 7 ¾" diam.
Londa Weisman. **Disappearing nesting bowls**. Stoneware, slip, glaze. Thrown. Largest 7 x 15" diam.

Tommy Simpson. **Cookie cutters**. Tin-plated steel. Fabricated. 3 x 6" range
Thomas Latané. **Nutcracker**. Mild steel. Forged, chased, filed; box joint pivot. 1 ¾ x 1 ½ x 10"

"For me, pottery is always a surprise. Often I will begin a pot antici-
pating a certain result, but invariably I end up with something
entirely different than what I expected. Pottery is a mix of happy
accidents and nice surprises that renew me. I approach the wheel
with a sense of exhilaration and discovery." — Katheleen Nez

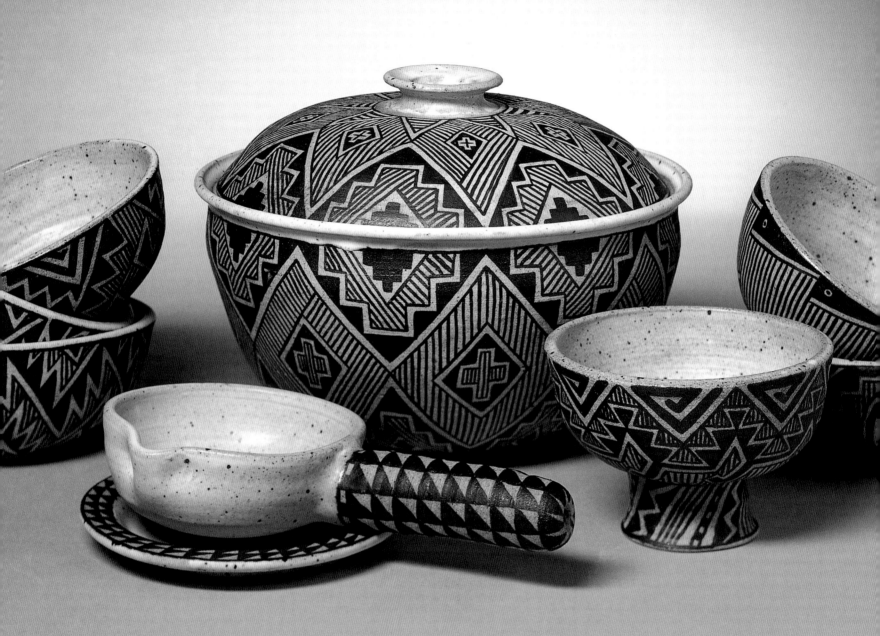

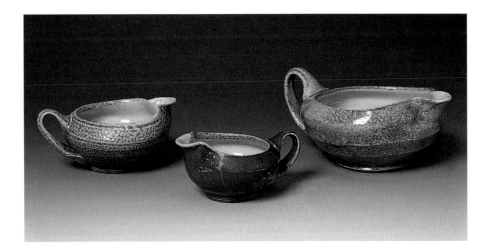

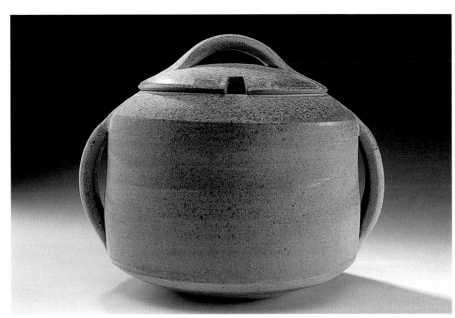

Katheleen Nez. **"Anasazi" serving set with casserole**. Stoneware, mineral paint. Thrown, painted, glazed. Casserole 7 ½ x 10 ½" diam.
Mark Shapiro. **Batter bowls**. Stoneware, salt glaze. Thrown, wood fired. Small 2 ½ x 4 ¾ x 5 ¾"; medium 3 x 5 ½ x 6 ⅜"; large 3 ½ x 6 ¾ x 8 ½"
Karen Karnes. **Soup tureen**. Stoneware. Thrown, wood fired. 8 x 12" diam.

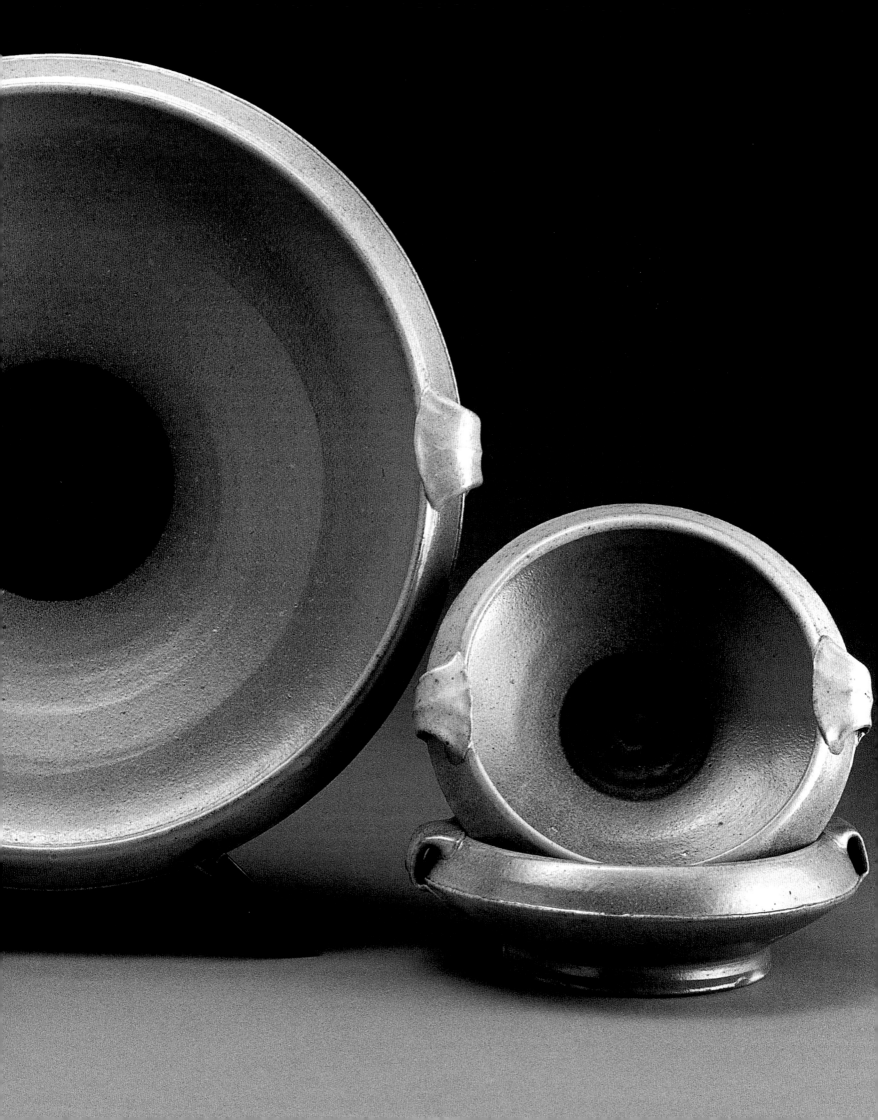

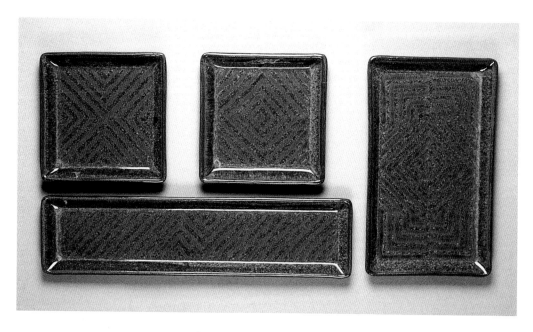

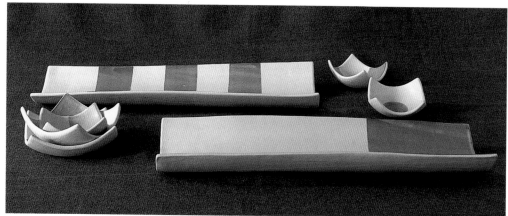

Linda McFarling. **Serving bowl set**. Stoneware. Thrown, salt glazed. Small 2 x 7" diam.; large 3 ½ x 15" diam.
Michael Cohen. **Trays**. Stoneware. Slab built, sponge-printed, glazed. Square 1 x 7 ½ x 7 ½"; rectangular 1 x 7 ½ x 12 ½"; bread tray 1 x 4 x 18 ½"
Klara Borbas. **Serving tray set**. Stoneware. Hand formed, painted underglaze, glazed. Largest 2 x 5 x 20"

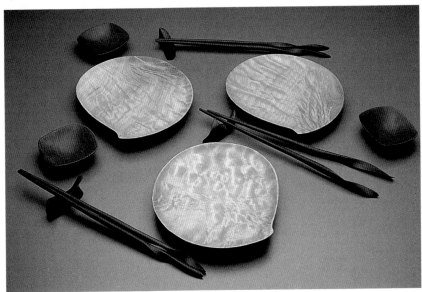

Thomas Davin, Davin & Kesler. **Sushi board with chopsticks**. Bird's-eye maple, cocobolo. Constructed. Board 1 ½ x 8 ½ x 14"
Holly Tornheim. **Sushi set**. Quilted maple, manzanita. Carved, formed. 1 x 3" diam.–1 ½ x 8" diam.
Thomas Davin, Davin & Kesler. **Chopsticks with holders**. Exotic and domestic wood. Formed. Chopsticks ¼ x 10"

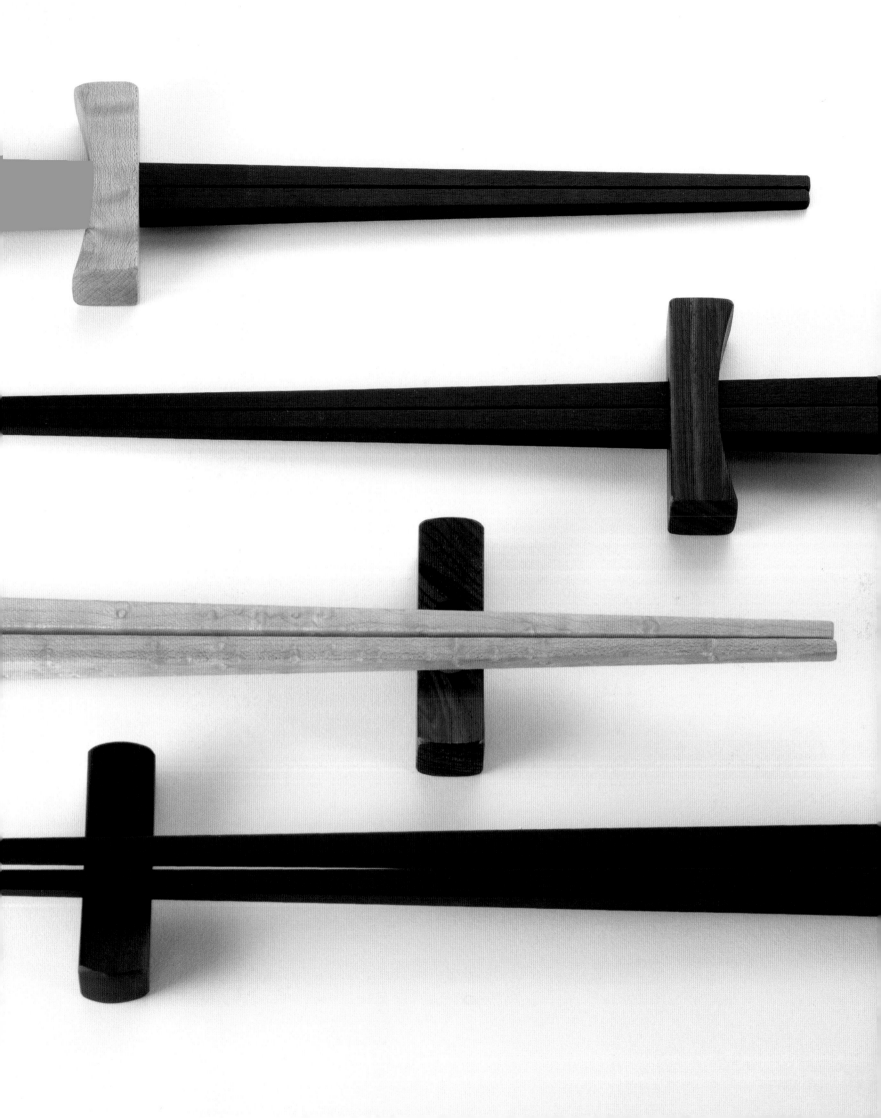

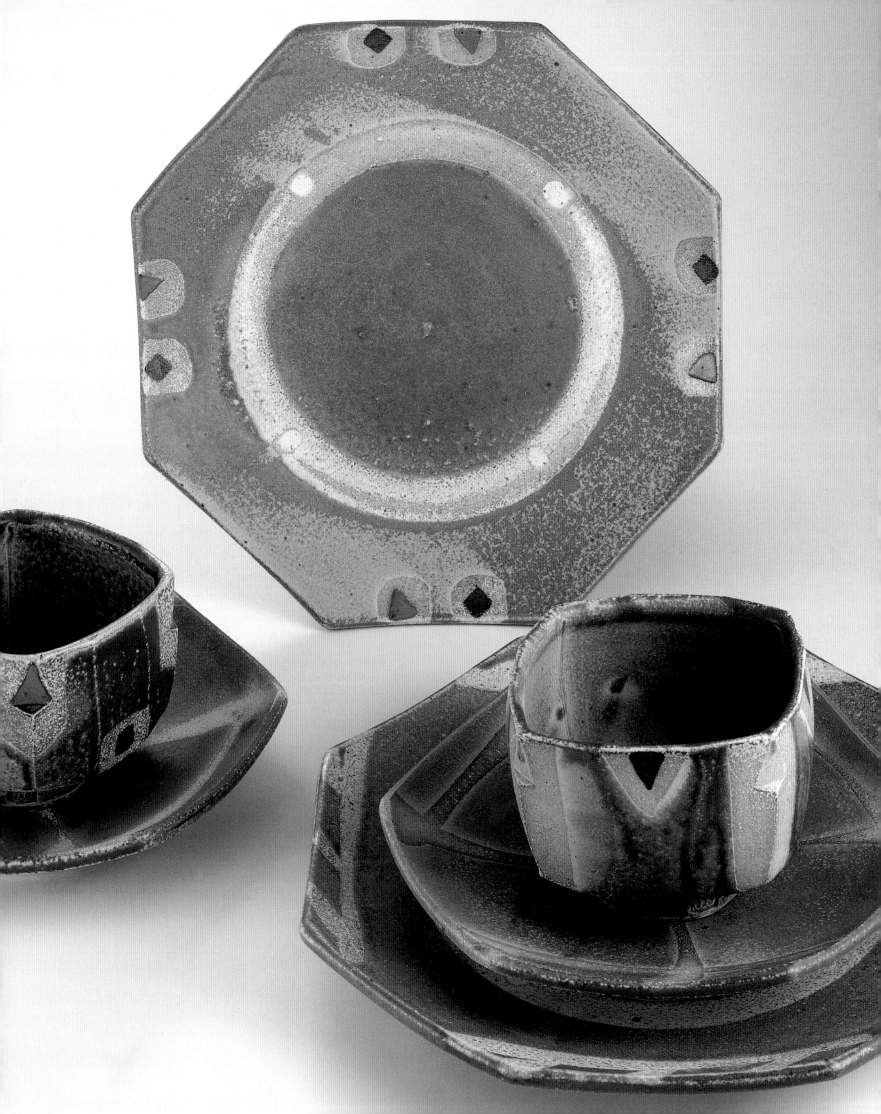

Jeff Oestreich. **Dinnerware**. Stoneware, salt glaze. Thrown, salt fired. Dinner plate 1 x 10" diam.; side plate 1 x 7" diam.; bowl 4 x 5" diam.
Jacquelyn Rice. **Table setting**. Linen, earthenware, glass, lexan. Formed and glazed clay, enameled and slumped glass, digitally printed lexan. 5 x 26 x 36"

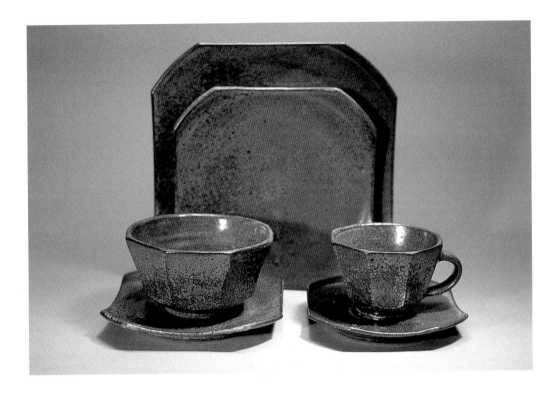

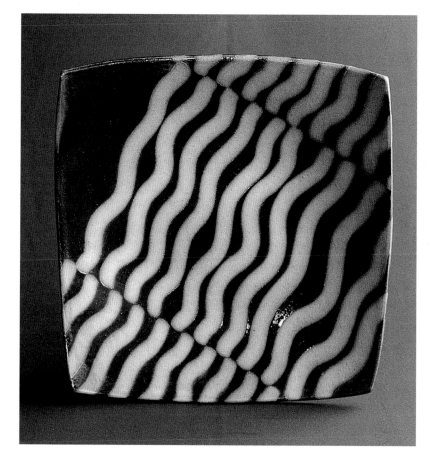

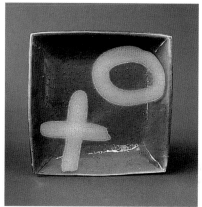

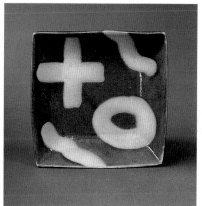

Will Swanson (opposite)
Dinnerware. Stoneware, shino-type glaze. Thrown, altered, fired in oxygen-reduced atmosphere. Large plate 1 ½ x 11" diam.; small plate 1 ½ x 8" diam.; cup and saucer 3 x 5" diam.
Dinner plates. Stoneware, carbon-trap glaze. Thrown, fired in oxygen-reduced atmosphere. 1 ½ x 11" diam.

Glenn Burris (above)
Platter. Porcelain, shino and wax-resist copper green glaze. Slab built, glazed, reduction fired cone 10. 3 ½ x 19 ¾ x 19 ¼"
Plate set with X's and O's. Porcelain, shino and wax-resist copper green glaze. Slab built, glazed, reduction fired cone 10. 1 ¼ x 10 ¼ x 10 ¼"

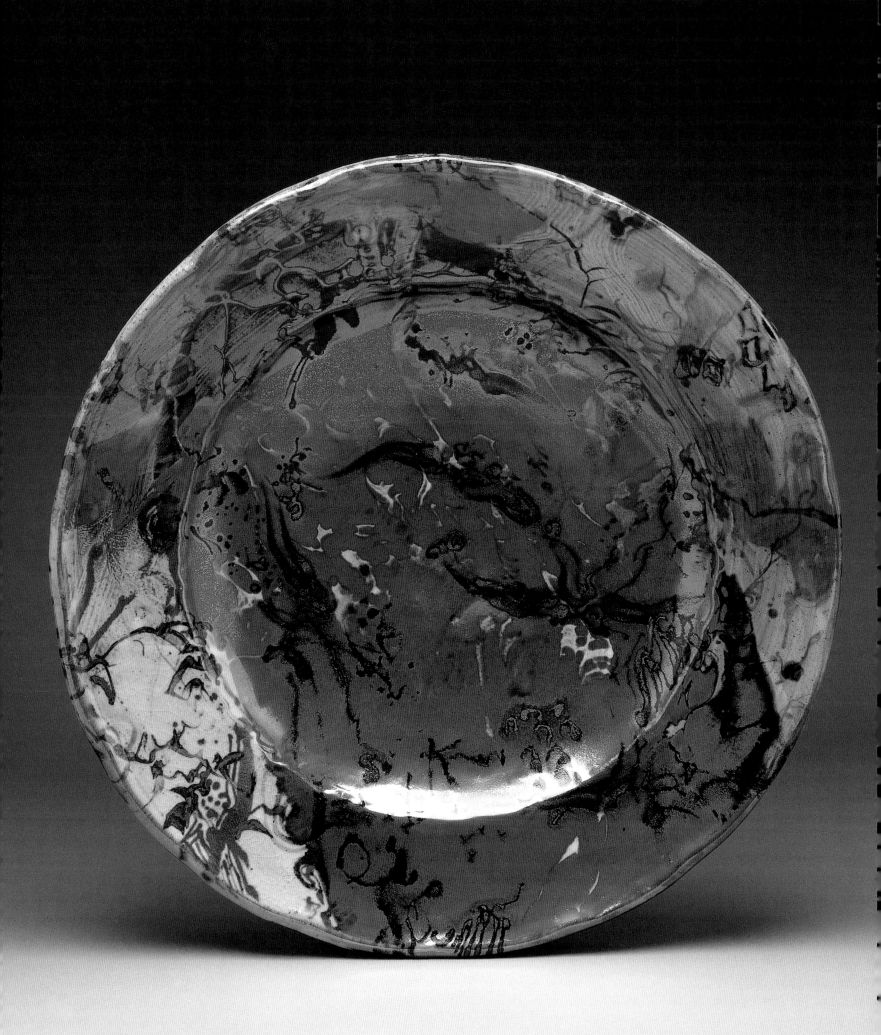

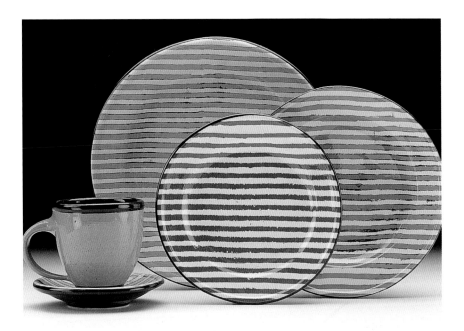

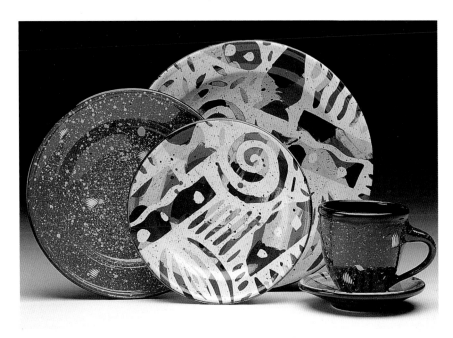

John Parker Glick, Plum Tree Pottery. **Platter**. Stoneware, glaze. Thrown, reduction fired cone 10. 2 x 23" diam.

Claudia Reese, Cera-Mix. **"Ragged Stripes" place setting**. Earthenware, slip, clear glaze. Applied slip decoration. Press molded. Dinner plate 1 x 12" diam.

Claudia Reese, Cera-Mix. **"Couva" place setting**. Earthenware, slip, clear glaze. Applied slip decoration. Press molded. Dinner plate 1 x 12" diam.

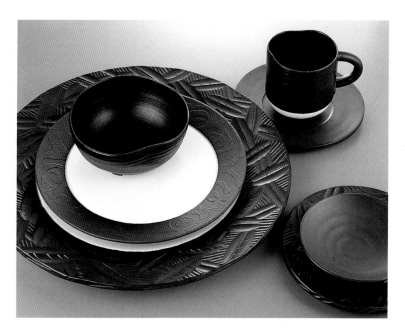

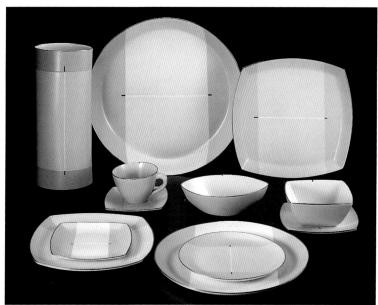

Ikuzi Teraki and Jeanne Bisson. **"Setting the Table with Romulus: Leaf Cut and Copper Brocade" dishes**. Porcelain. Thrown, altered, carved, black and applied coppertone slip oxides, glazed. Charger 1 x 12" diam.; salad bowl 1 x 8" diam.; berry bowl 2 ½ x 5" diam.; cup and saucer 3 x 5" diam.

Daniel Levy. **"Mojave" place setting**. Porcelain. Slip cast, sprayed and painted engobe pattern, glazed. Vase 13 x 4" diam.; platter 2 x 17" diam.; place setting 2 ½ x 6–12" diam.

Teresa W. Chang. **"Swirl" place setting**. Porcelain. Hand thrown. Dinner plate 1 x 10 ½" diam.; salad plate 1 x 8" diam.; cup 1 ⅞ x 3 ⅝" diam.

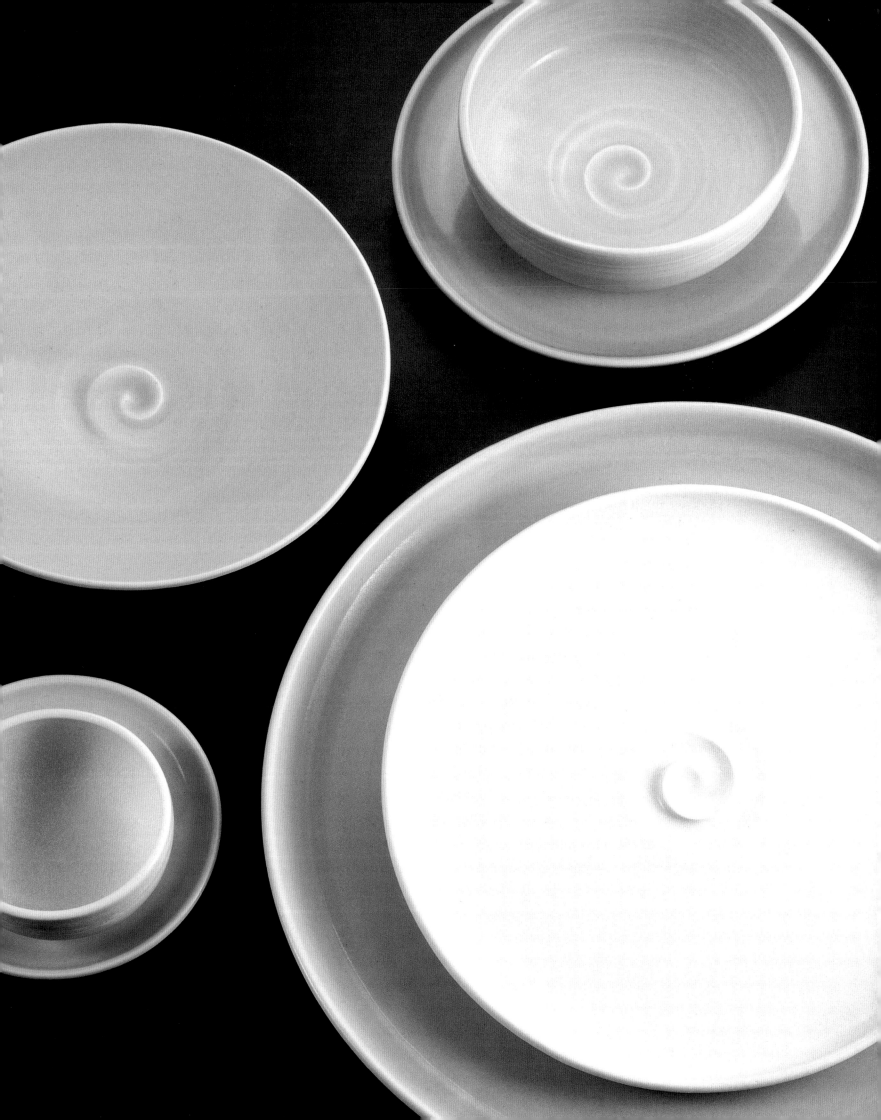

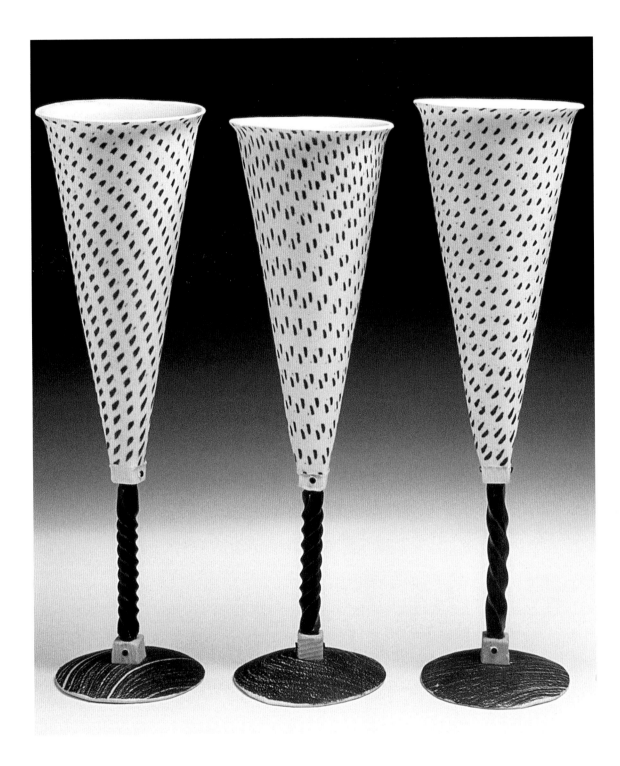

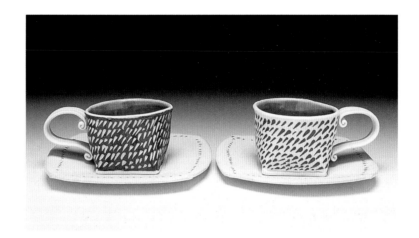

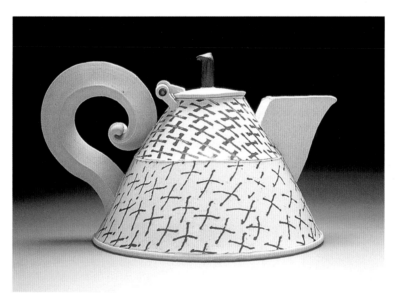

D. Hayne Bayless
Champagne flutes. Porcelain, black slip, steel. Hand built, stretched slab. 11 x 3" diam.
Demitasse set. Porcelain, black slip. Hand built. 2 x 4 x 4"
Teapot with hinged lid. White stoneware, black slip. Hand built, stretched slab, extruded parts. 7 x 8 x 11"

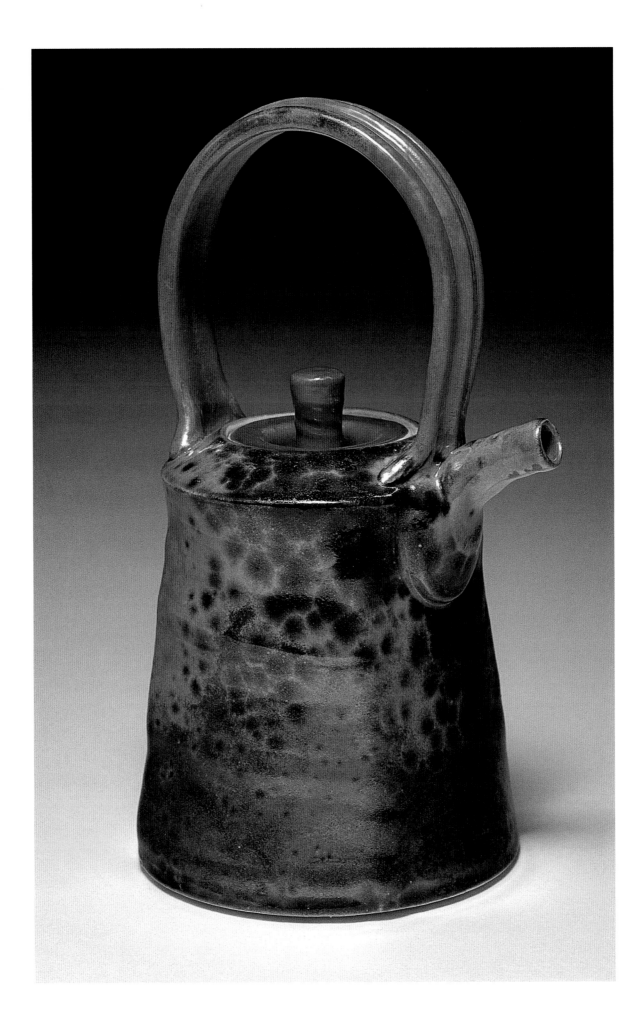

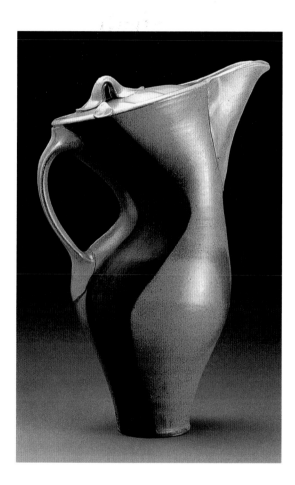

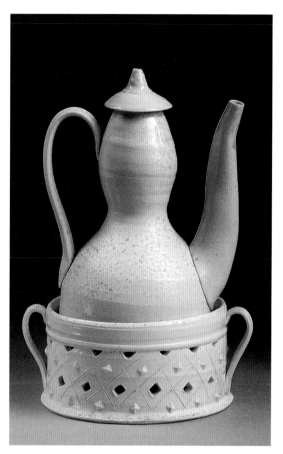

"My goal is to make fresh, spirited, graceful pots for daily use. My search is for fluidity and clarity of form within the context of function, striving for elegance rather than drama. My desire is to bring to life pots that are friendly and intimate, growing ever more personal with daily use." — Malcolm Davis

Malcolm Davis. **Shino teapot**. Porcelain, red shino-type carbon-trap glaze. Thrown. 10 x 6 x 7"
Linda McFarling. **Pitcher**. Stoneware. Thrown, altered, salt glazed. 15 x 4 ½ x 9"
Linda Sikora. **Ewer on stand**. Porcelain. Thrown, assembled, salt fired. 8 x 5 ½ x 6"

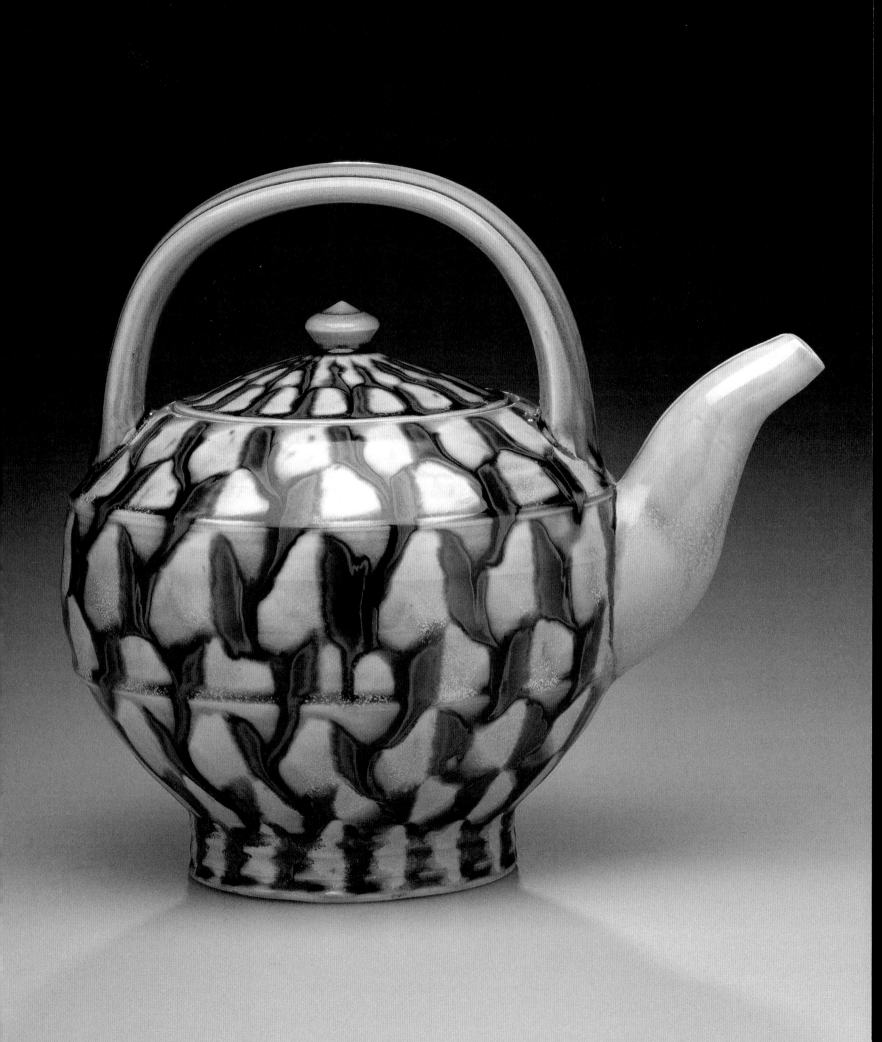

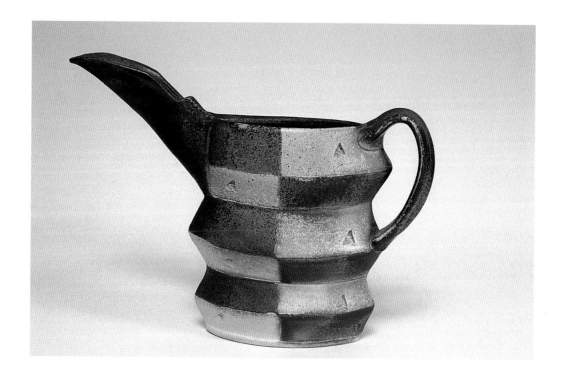

"I work under the umbrella of utilitarian pottery, exploring and rearranging the boundaries I have set up for what I believe constitutes function. My current work is thrown and altered, either by faceting, stretching, or cutting and rejoining. Being fond of glaze and not willing to give up this surface altogether, I play with the ration of glaze to clay surface." — Jeff Oestreich

Linda Sikora. **Teapot**. Porcelain. Thrown, assembled, wood-oil fired, resist salt glazed. 8 x 6 x 8"
Jeff Oestreich. **Beaked pitcher**. Stoneware. Thrown, altered, salt glazed. 10 x 10 x 4"

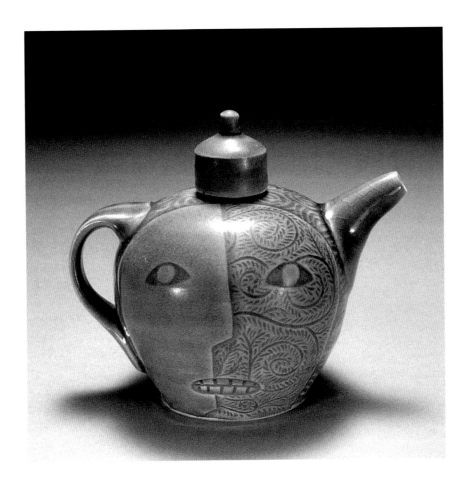

Matthew Metz. **Ewer**. Porcelain. Thrown, wood-oil fired, salt glazed. 4 ½ x 4 x 5"
Mary A. Roehm. **Cup set**. Porcelain. Thrown, glazed. 2 ½ x 2" diam.
Matthew Metz. **Cup set**. Porcelain. Thrown, wood-oil fired, salt glazed. 4 ½ x 3 ½" diam.

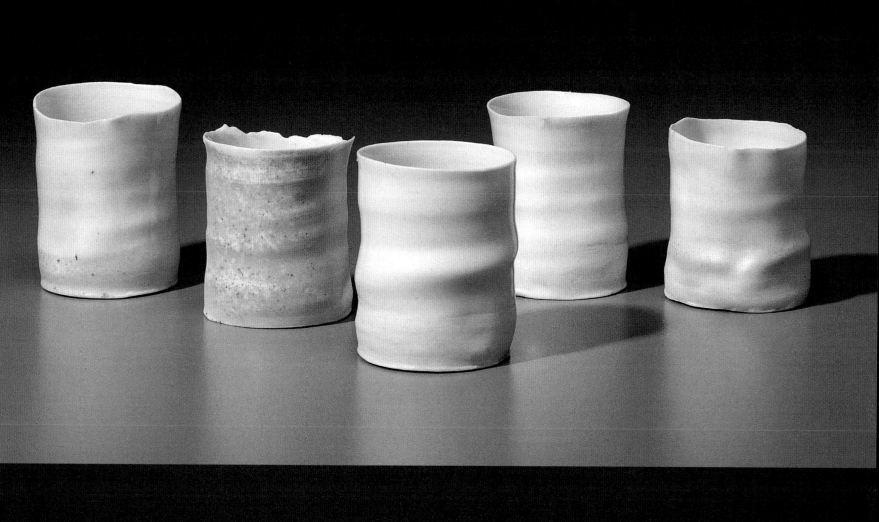

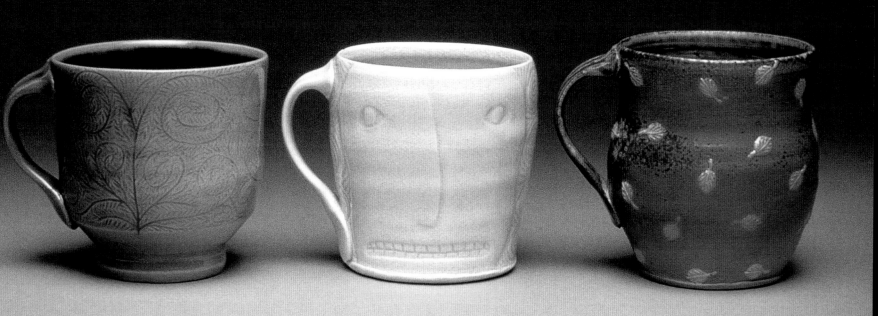

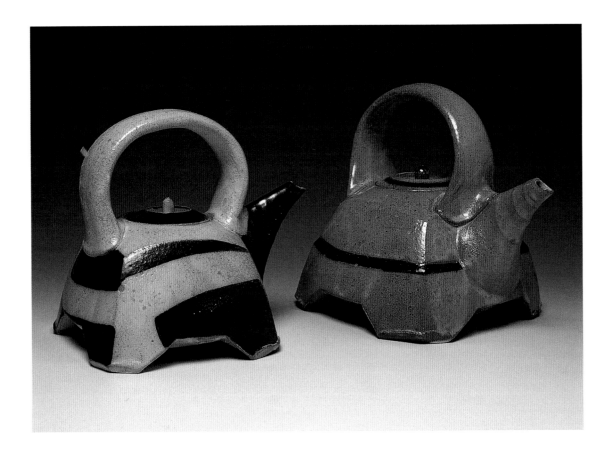

"As a potter, I have been able to control most aspects of creative production—the concept, making, finishing, marketing, and selling of the work—in a process and within a scale that preserves and enhances the humanity of the creative experience." — Mark Shapiro

Mark Shapiro, Stonepool Pottery
Teapots. Stoneware. Thrown, paddled and cut, wood fired, salt glazed. 6 ½ x 6 x 8"
Chalice set. Stoneware. Thrown and faceted, painted with slip, wood fired, salt glazed. 5 ½ x 3 ¼" diam.

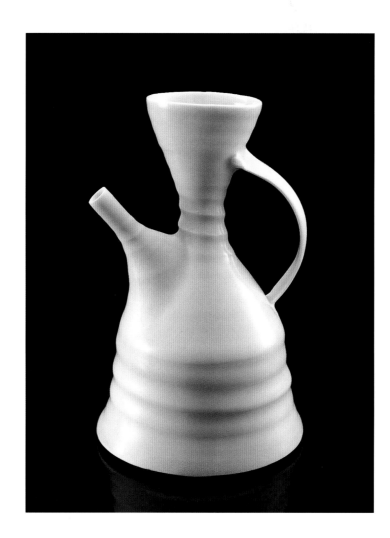

James Makins
Sake server. Porcelain. Thrown, glazed. 8 x 4 ½" diam.
Tea service with tray. Porcelain. Thrown, glazed. Tray 2 x 18" diam.

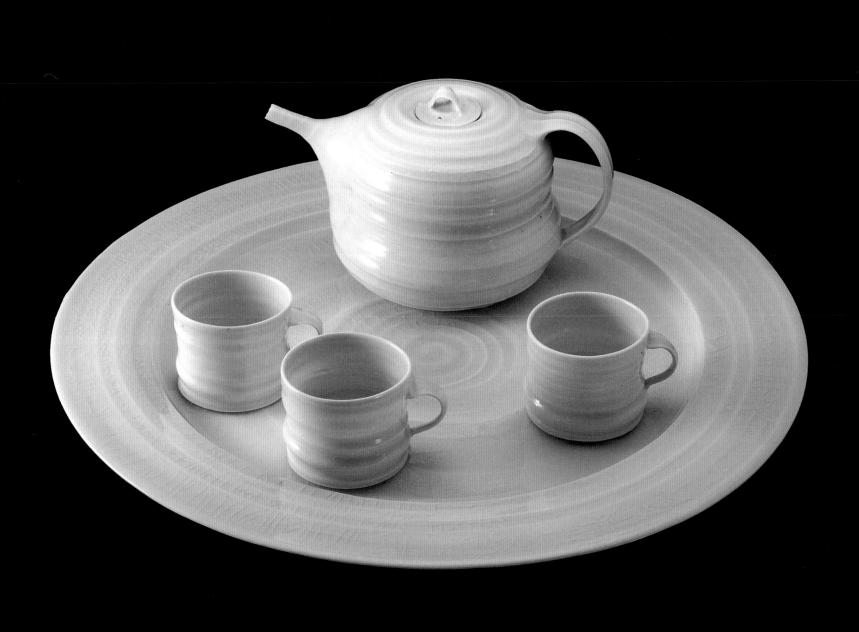

"I want my work to always feel fresh, to reflect the fact that
I love making each piece." — Teresa W. Chang

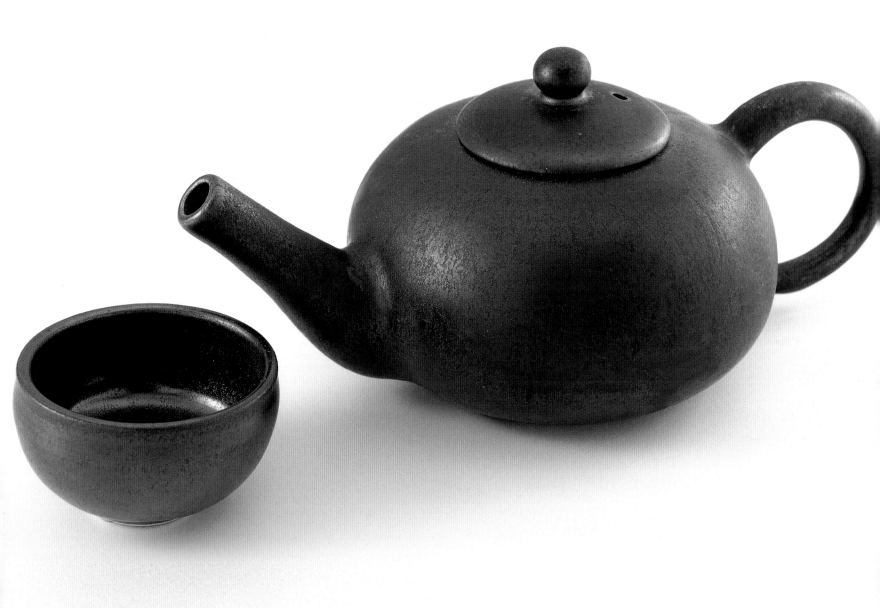

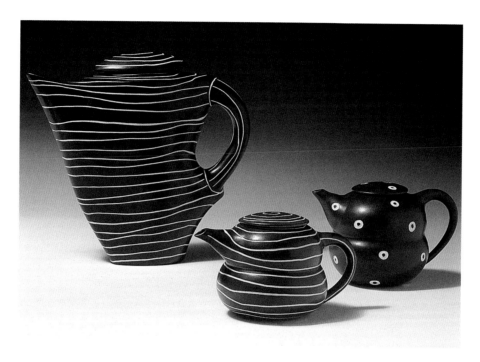

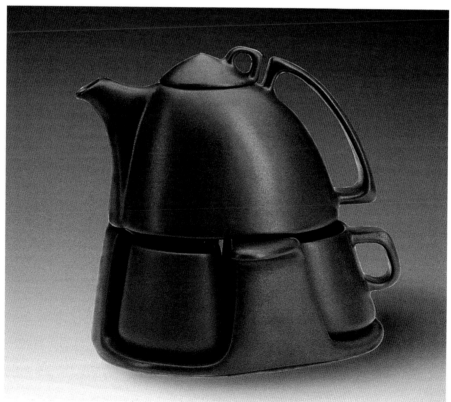

Teresa W. Chang. **Teaware**. Porcelain, metallic-oxide glaze. Hand thrown, glazed. Teapot 4 ½ x 6 x 10"
Kathy Erteman. **"Modern" teapots**. Whiteware, engobe. Slip cast, carved, glazed. Largest 11 x 3 ½ x 12"
Peter and Peg Saenger. **Service for One**. Porcelain. Cast, glazed. 8 x 7 x 8"

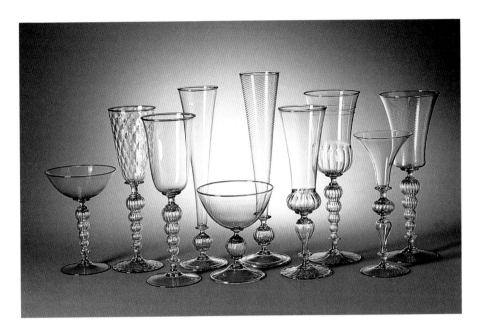

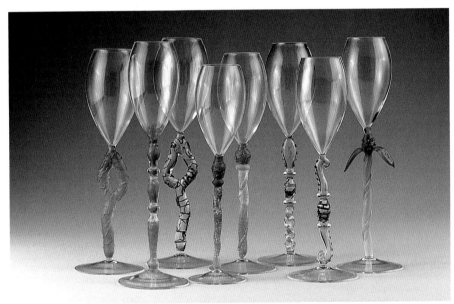

"The desire to master my craft, to make a living doing what I love to do, and to leave something of myself in the work is what compels me to return again and again to the studio." — John Chiles

Alan Goldfarb. **"Venetian Style" goblet set**. Glass. Blown. Tallest 9 x 2 ½" diam.
Robert A. Mickelsen. **Wine goblet set**. Borosilicate glass. Lamp worked, sandblasted, painted. Tallest 13 x 2 ½" diam.
John Chiles. **Goblet set**. Glass. Blown and formed. Tallest 10 ½ x 1 ½" diam.

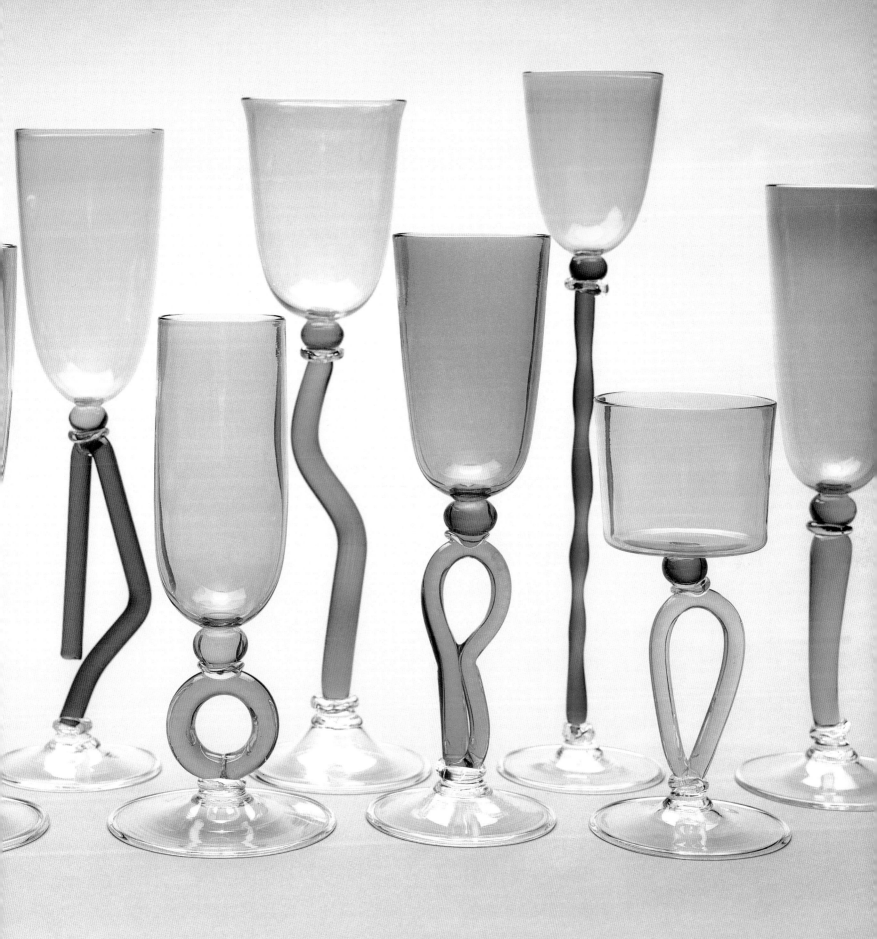

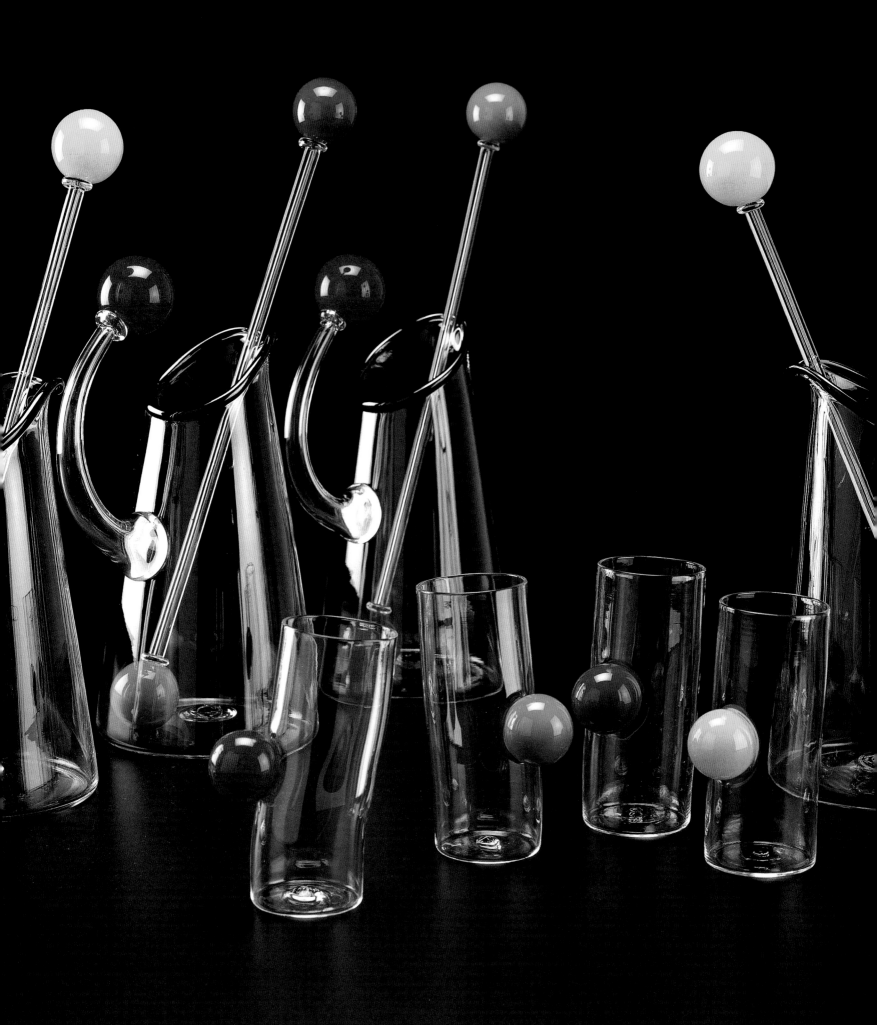

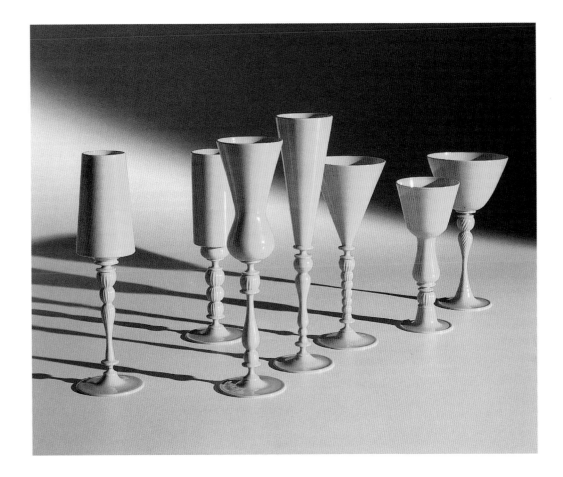

Janusz Pozniak. **"Clown Nose" pitcher and cup set**. Glass. Blown. Pitcher 15 x 6" diam.; cup 6 x 2 ½" diam.
James Mongrain. **Opaque yellow goblet set**. Glass. Blown. Tallest 11 x 2 ½" diam.

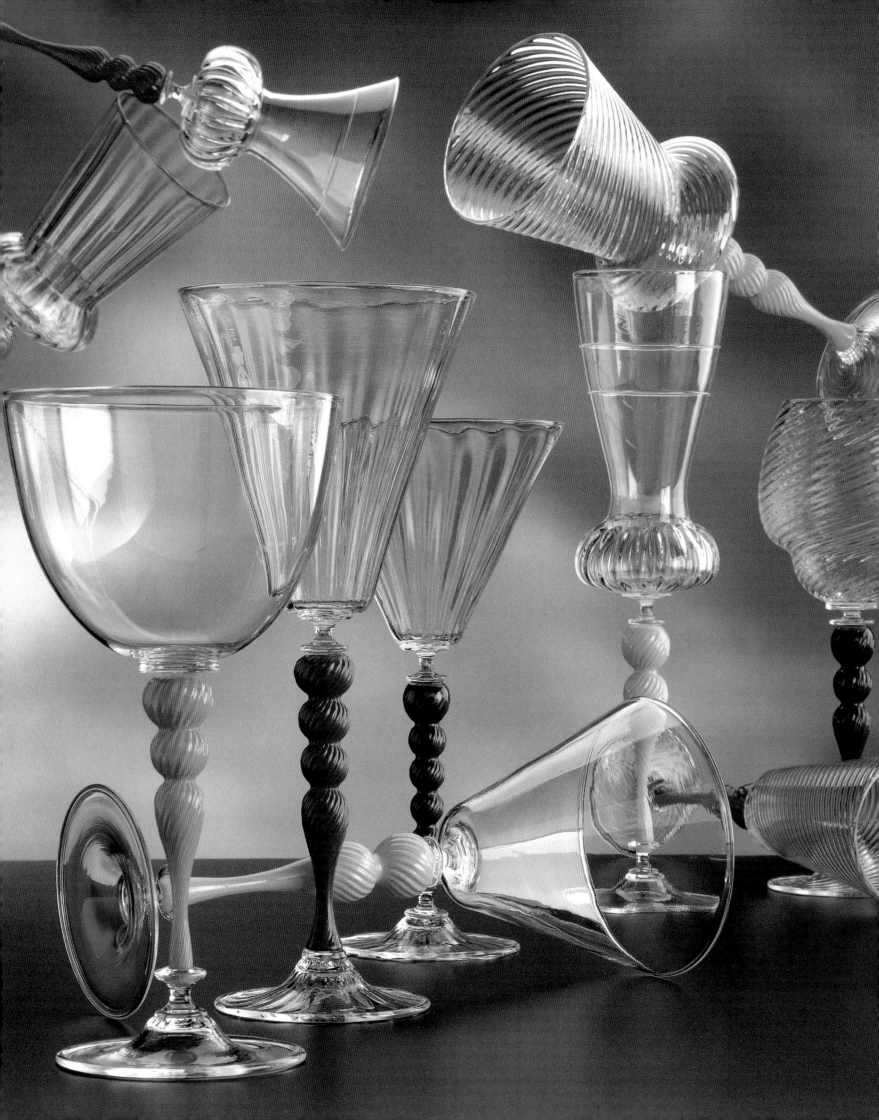

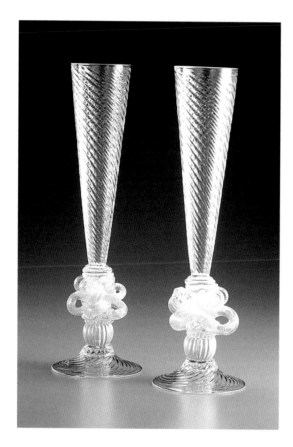 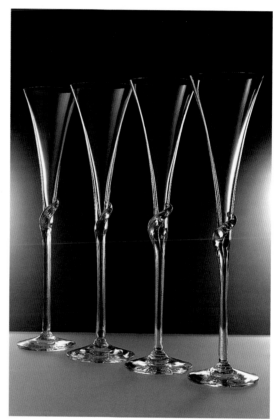

James Mongrain. **Clear cups with colored stems**. Glass. Blown. 7 x 4 ½" diam.
William Gudenrath. **"Gold-knot" champagne flutes**. Glass, gold leaf. Blown and manipulated, hot-applied leaf. 9 x 2 ½" diam.
R. Guy Corrie. **"Giselle" champagne glass set**. Glass, gold leaf. Blown, hot-applied leaf. 11 x 3" diam.

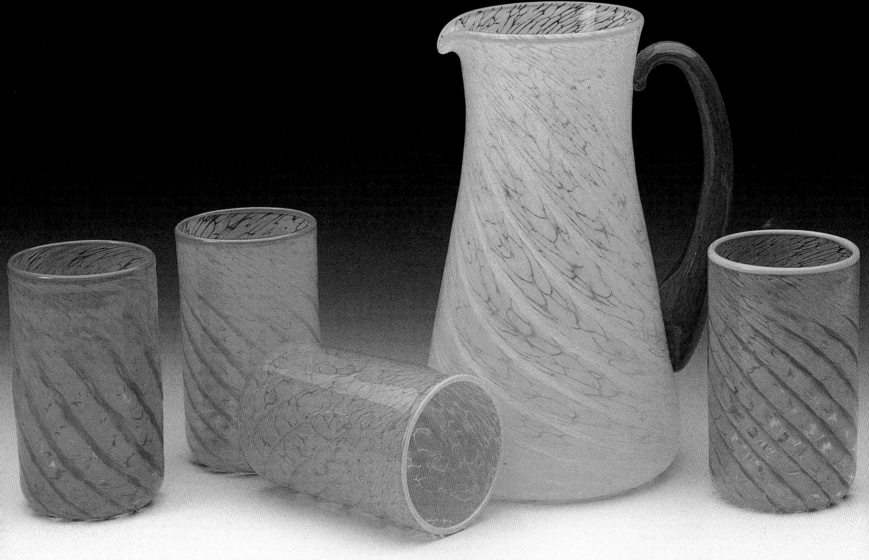

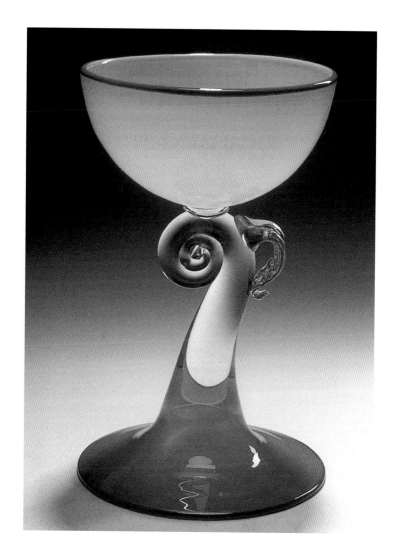

"I am intrigued by glass with its versatility in both our everyday lives
and as a design medium. My work has a futuristic aesthetic using
form and color to enhance its visual and emotional impact while still
paying tribute to past traditions of glass making." — Kevin Rogers

Jean and Kevin Rogers, Rogers' Glass Works. **"Sunray" sugar and creamer set**. Glass. Blown. Creamer 3 x 5 x 4 ½"
Jean and Kevin Rogers, Rogers' Glass Works. **"Sunray" pitcher and tumbler set**. Glass. Blown. Pitcher 9 x 6 x 5 ½"; tumbler 5 x 3" diam.
Alex Brand. **"Daffodil" goblet**. Glass. Blown elements, hot assembled. 9 x 4 ½" diam.

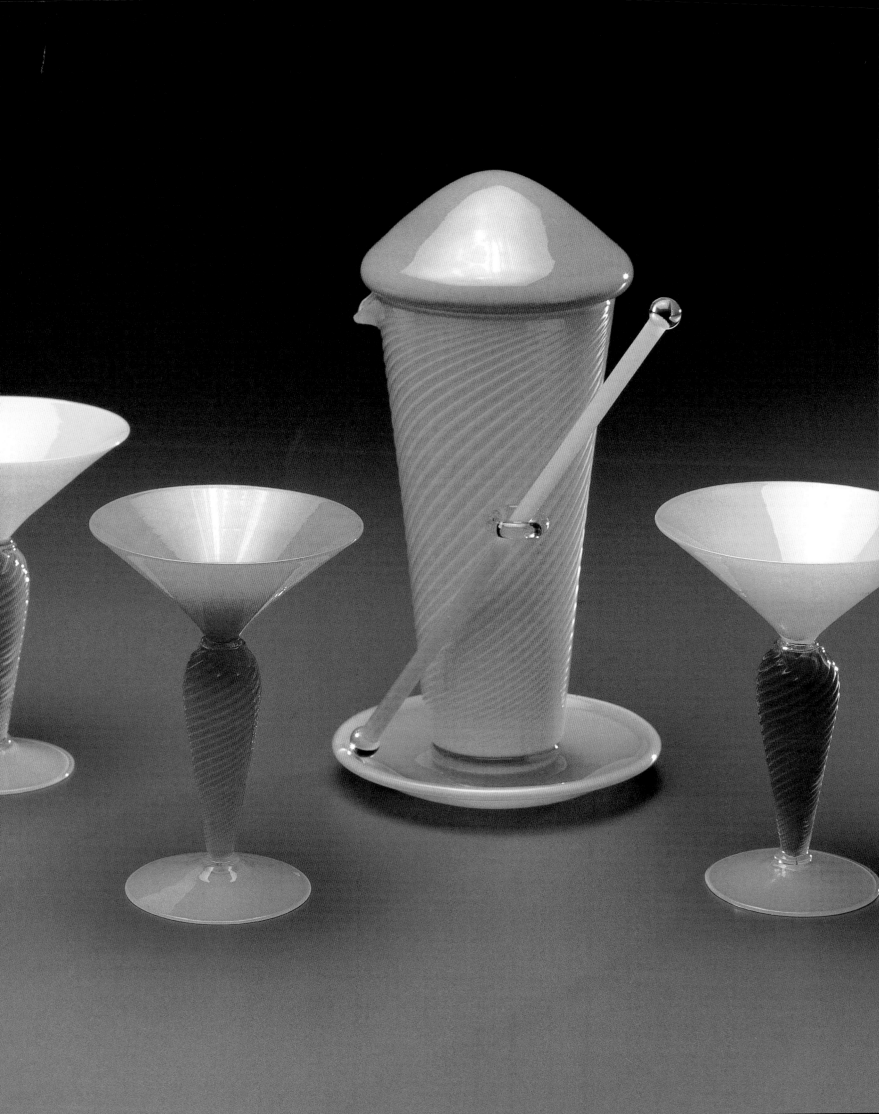

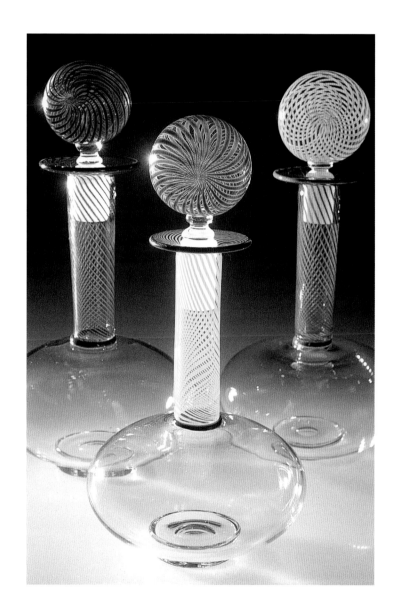

Boyd Ryo Sugiki. **Martini mixer and glass set**. Glass. Blown. Mixer 10 ½ x 5" diam.; glass 6 x 5" diam.
James H. Nadal, Nadal Glass. **Decanter set**. Glass. Blown, cane incalmo. 14 x 8" diam.

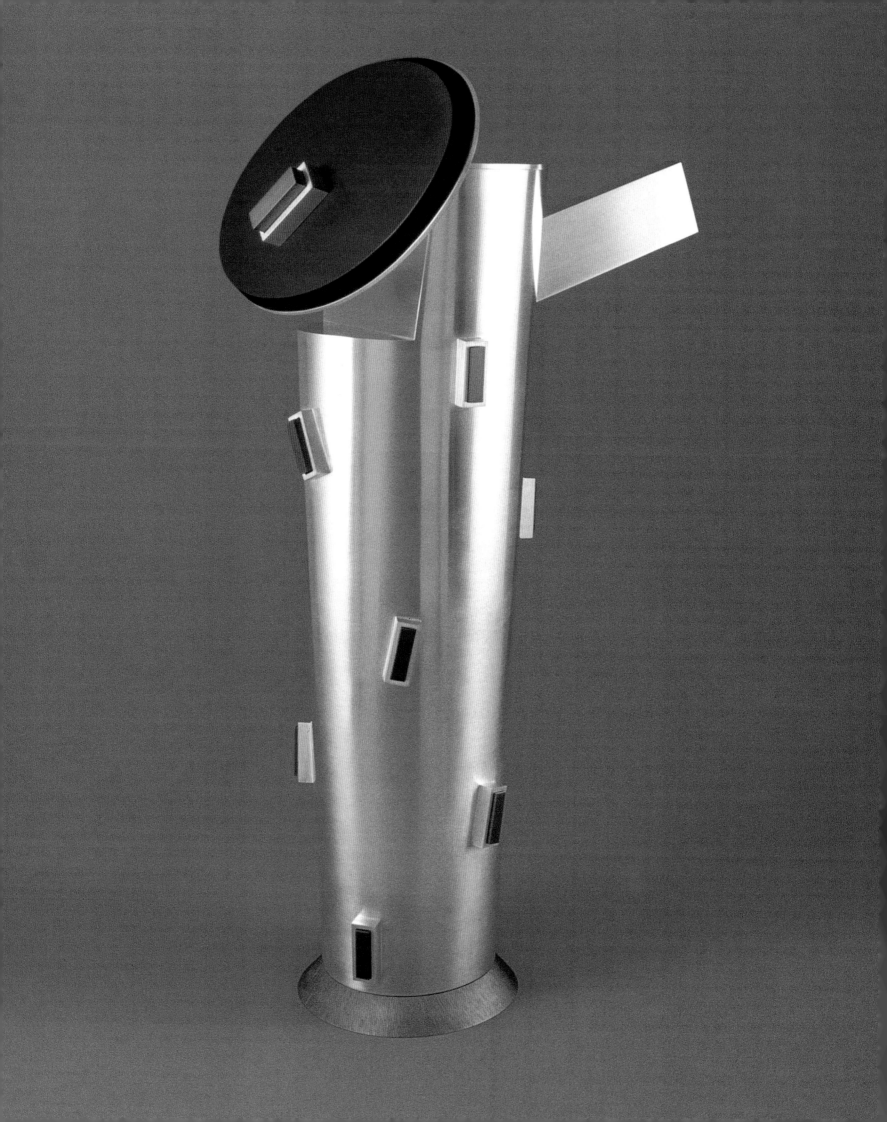

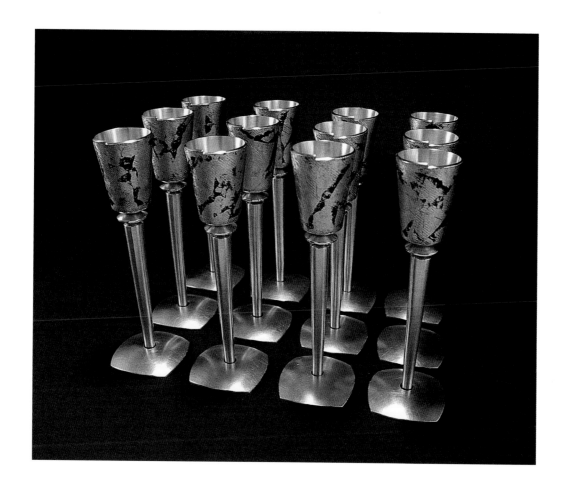

"I have made a career choice that may never make me wealthy, but that I believe will allow me to maintain the integrity of my work. Primary among these choices has been my decision to maintain a one-person studio, and to be sure that if a piece has my name on it, it was made by my own hands and not those of an employee. I hope to look back on my career someday and know that every object I've created has been made with care, pride, and devotion." — Robert Joseph Farrell

Billie Jean Theide. **"Confetti" beverage server**. Sterling silver, aluminum. Formed, fabricated, seamed, anodized. 12 x 6 x 4"
Robert Joseph Farrell. **Cordial set**. Sterling silver, 23k gold leaf. Hollow fabrication. Each 6 ½ x 1 ¼" diam.

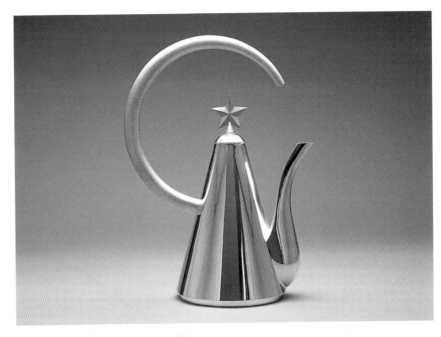

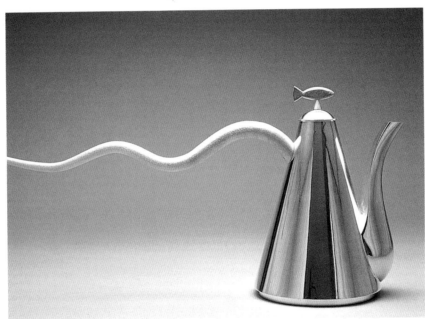

Charles Crowley. **"Star" cocoa pot**. Sterling, aluminum, gold-plated bronze. Fabricated. 13 x 7" diam.
Charles Crowley. **"Fish" cocoa pot**. Sterling, aluminum, gold-plated bronze. Fabricated. 10 x 7 x 18"
Michael and Maureen Banner. **"Unicorn" teapot**. Sterling silver. Hollow formed. 13 x 6" diam.

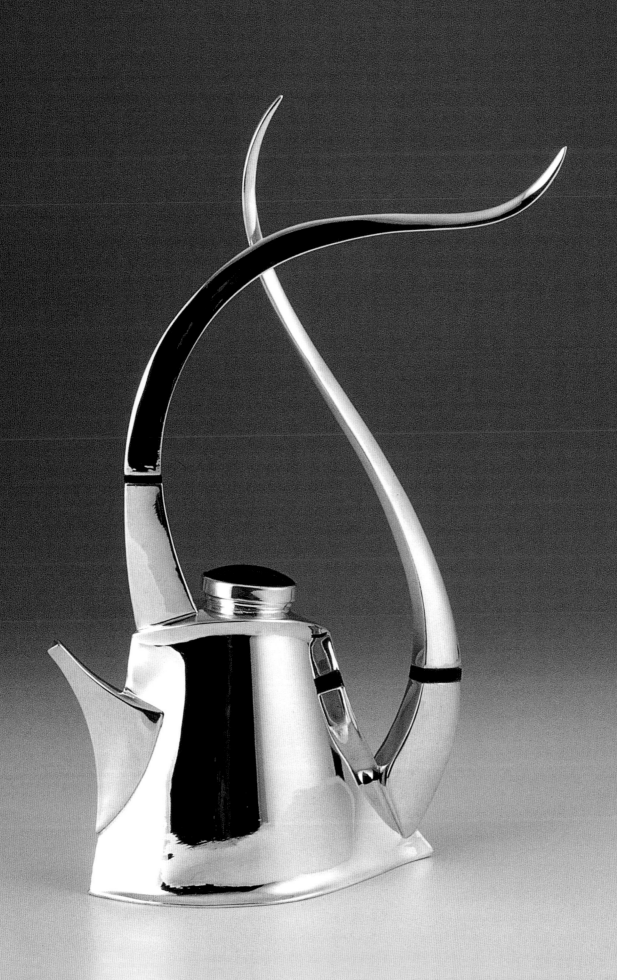

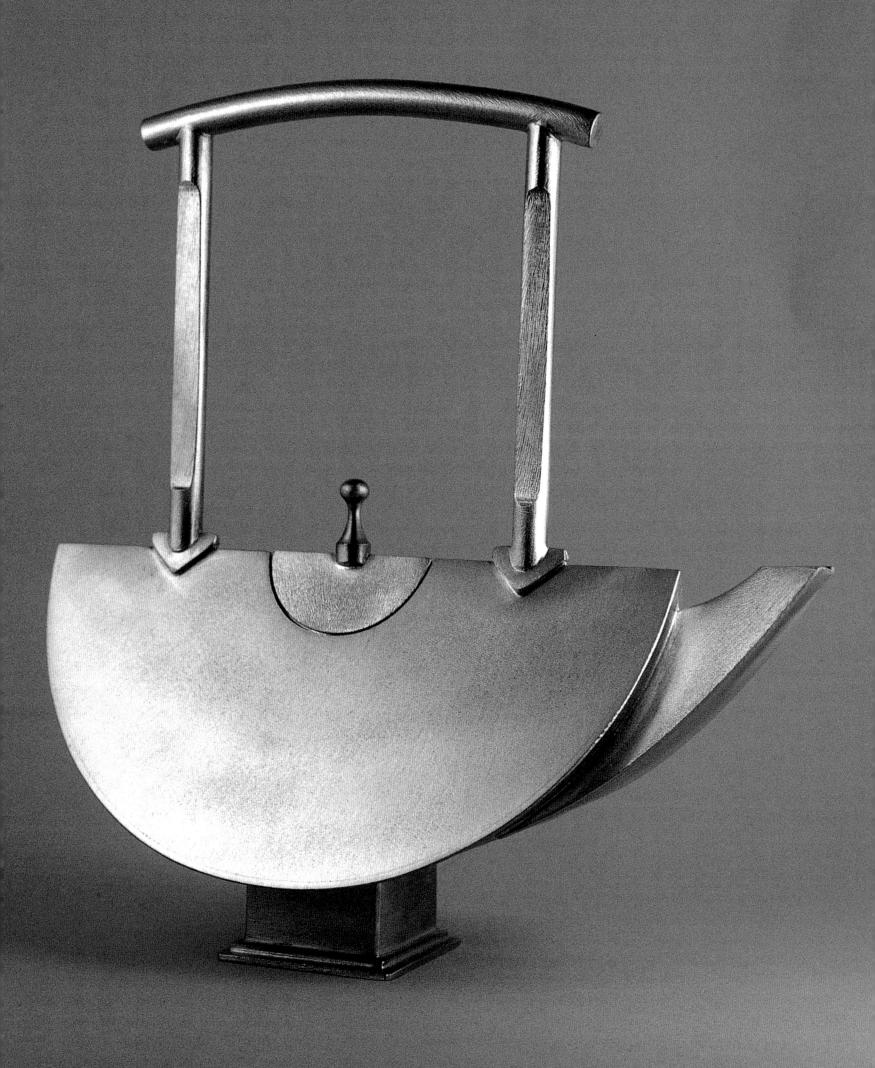

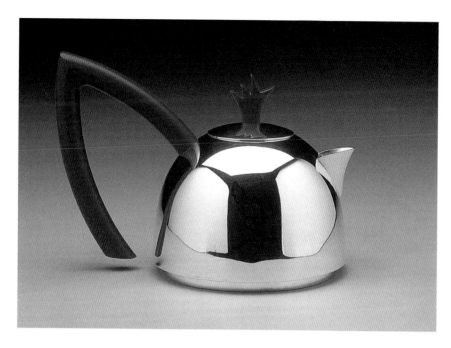

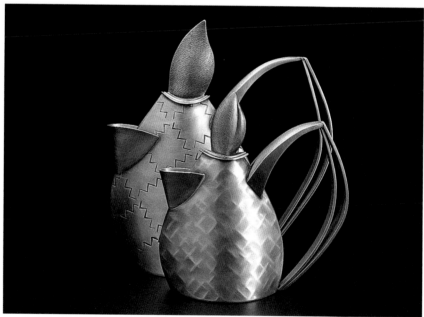

Fred Fenster. **Teapot**. Pewter. Fabricated. 9 ½ x 9" diam.

Charles Crowley. **Red handle teapot**. Sterling, painted aluminum. Spun, fabricated. 8 x 10" diam.

Jon Michael Route. **"Bud" teapots**. Pewter, brass. Fabricated. Tallest 11 x 9 x 4"

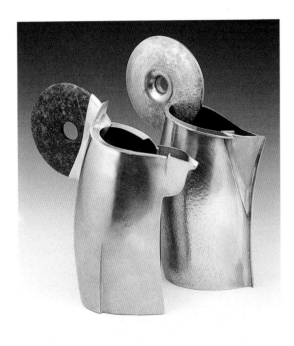

Michael Jerry. **Pewter vessels**. Pewter. Fabricated. 8 x 2 ¾ x 6"; 6 ⅛ x 5 ¾ x 2"

Billie Jean Theide. **"Swimming Swan" teapot tea infuser**. Sterling silver, aluminum. Formed, fabricated, anodized. 5 ¾ x 5 x 1 ½"

Louis Mueller. **Teapot**. Silver. Fabricated. 8 x 7 x 5"

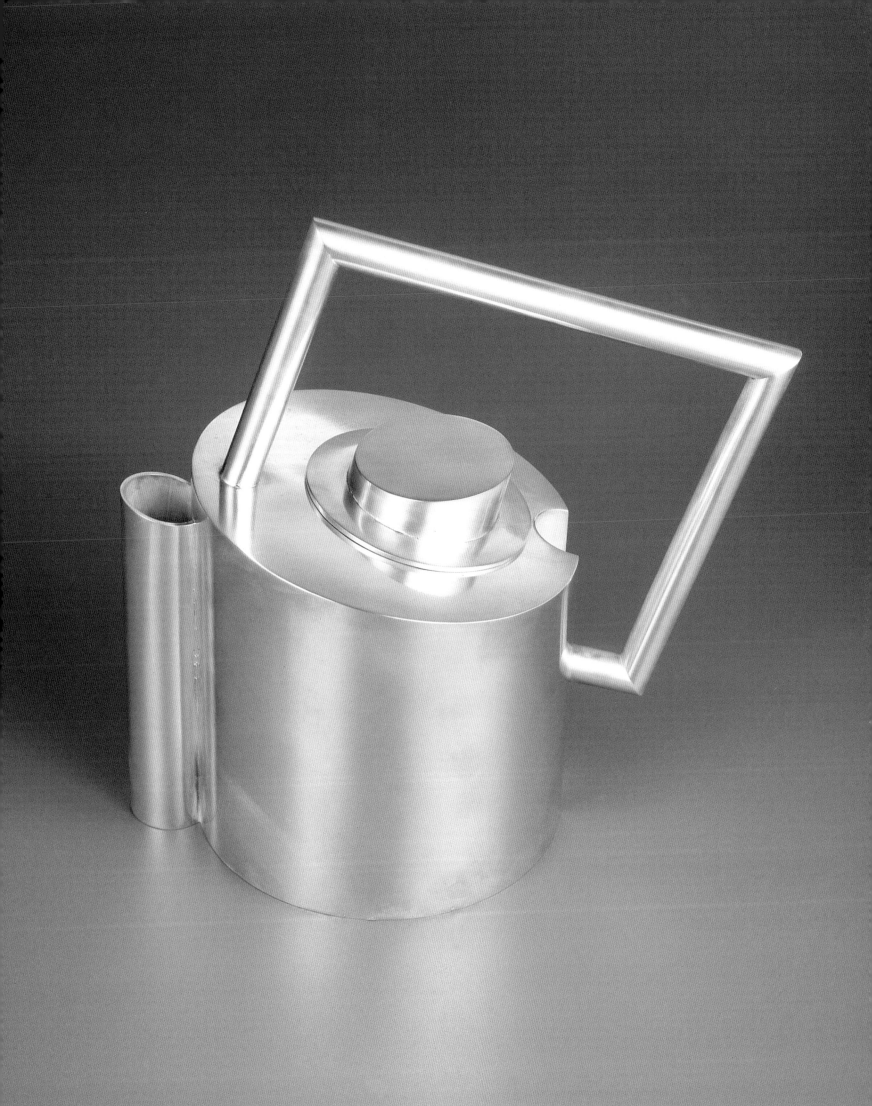

Boris Bally. **"Streamlined" bottlecork, "Dark Pagoda" bottlecork, "Warhead" cage bottlecork**. Silver, gold, aluminum, gold-plated brass, maple, ebony, cocobolo. Fabricated, pressed, lathe turned, cold joined. Tallest 11 x 3" diam.
Jack Brubaker. **Triple vertical wine rack**. Iron. Forged. 30 x 6 x 10"

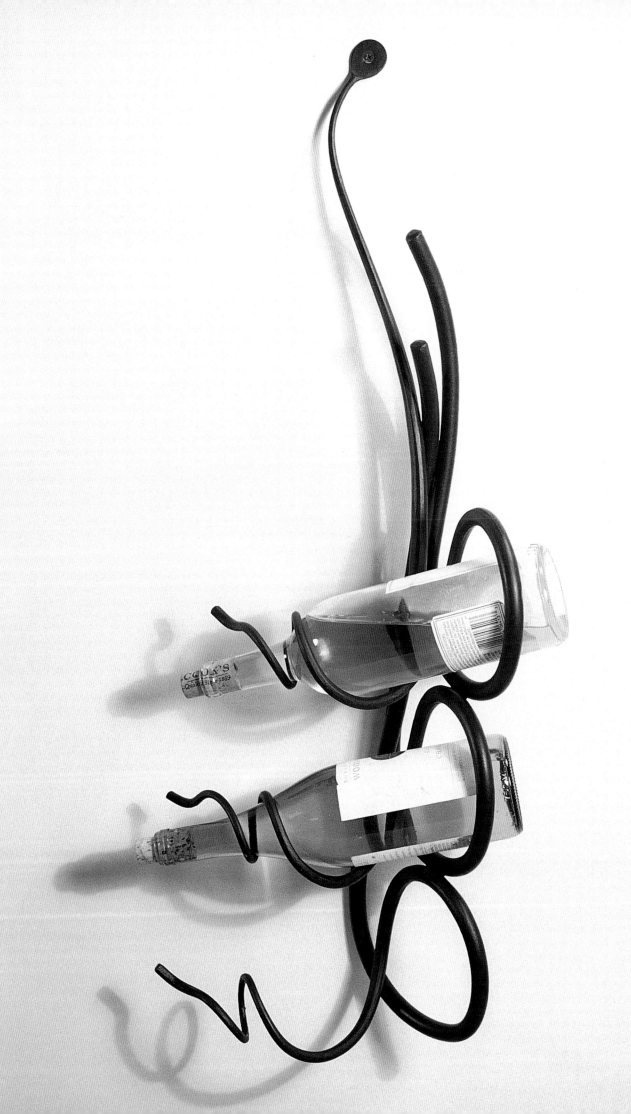

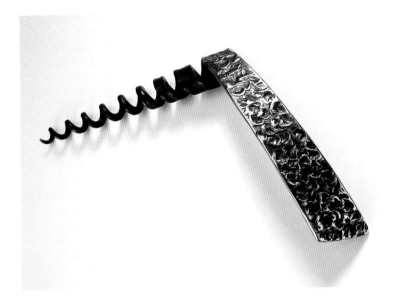

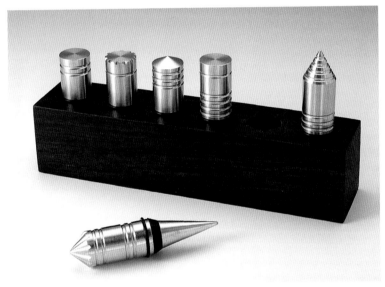

"An overly efficient world capable of producing objects and tools for daily living has, by its very nature, left out one important thing—soul. I'm not critical of industrial efficiency, I just feel that there are certain rituals in our life that need special tools. I hope my forged-iron tools for daily living can enrich and add meaning to the rituals of life." — Doug Hendrickson

Brian Cummings. **"Morpho" corkscrew**. Mild steel. Forged. 5 x 5 x 1"
Edith Axer. **Bottle stops**. Stainless steel, rubber, rosewood. Turned, formed. Block 2 x 2 x 8 ½"; stoppers 3–4 x ¾" tall
Doug Hendrickson. **Corkscrews**. Iron, steel. Forged, fabricated. Largest 6 x 4"

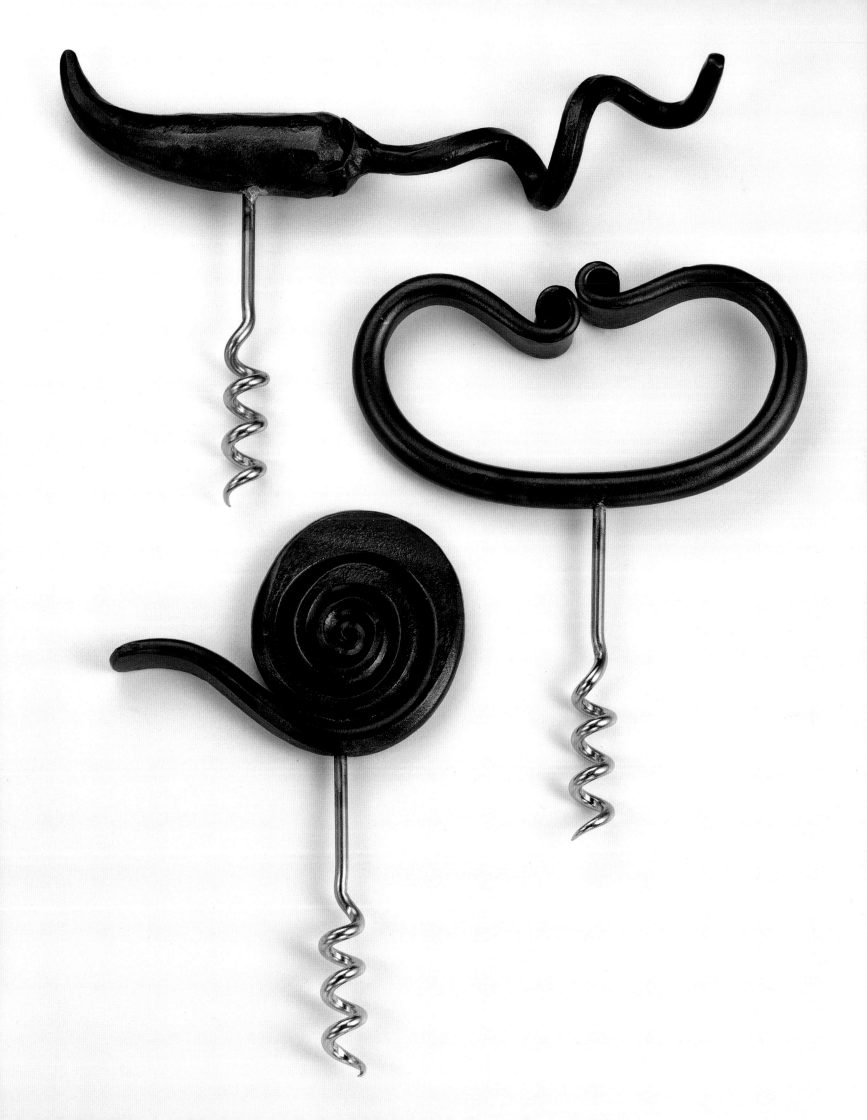

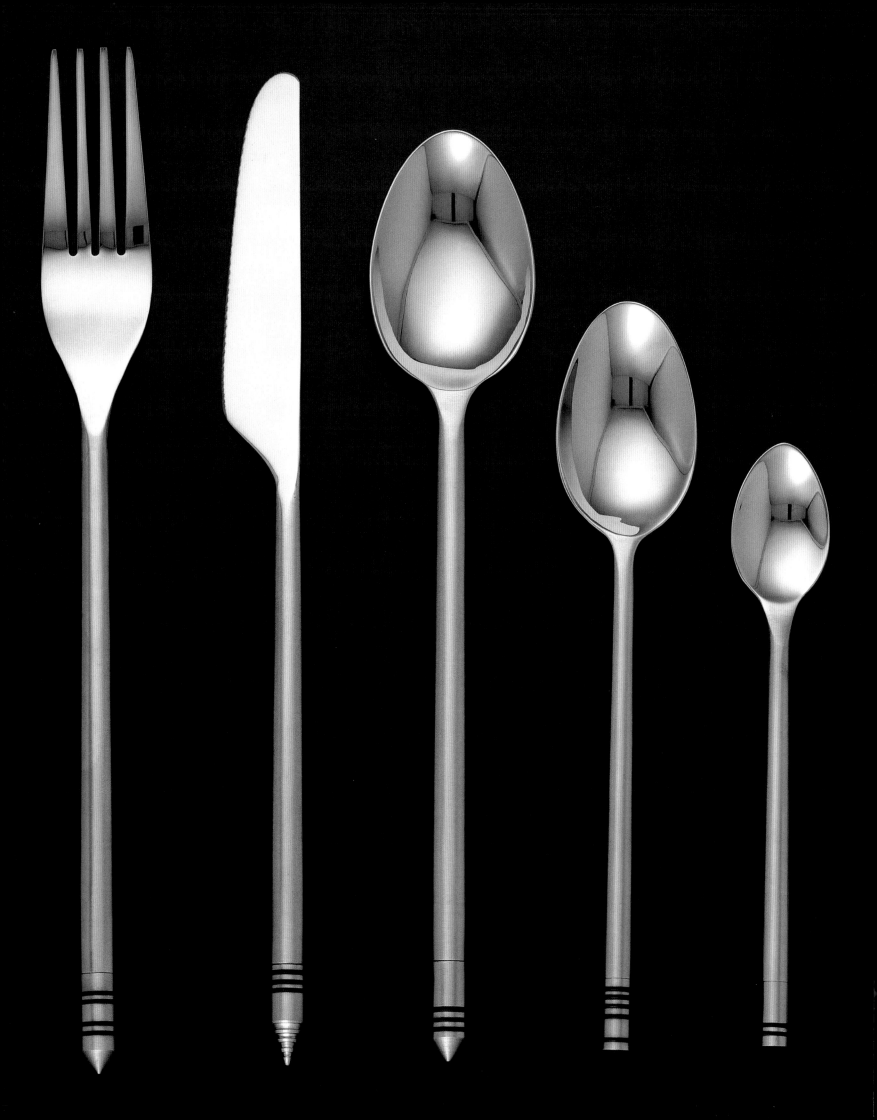

"I have always been intrigued by the process of how an individual can take a piece of material and invest it with ideas, values, or qualities, and transfer it to another individual who also brings their own set of ideas, values, and qualities to it, giving the piece a history of its own, as a marker of time, place, and memory." — Cheyenne Harris

Edith Axer. **"Chess" flatware set**. Stainless steel. Forged, handles and steel heads turned, welded. 5 ½–9 ¼" long
Olle Johanson. **Spoon group**. Sterling silver. Hand forged. 8" long
Cheyenne Harris. **Flatware set no. 1**. Sterling silver, 14k white and yellow gold. Forged, fabricated. 8 ½ –10" long. Collection Heard Museum

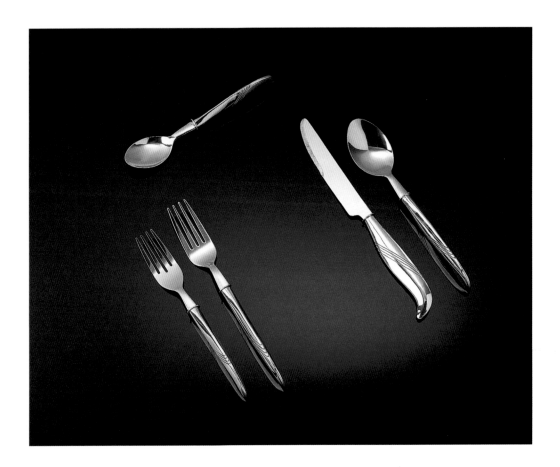

Edison Cummings. **Flatware set**. Sterling silver. Fabricated, stamped, soldered. 5 ½–9 ½" long. Collection Heard Museum
Boris Bally. **"X-panded" flatware set**. Silver, gold plated. Hand pierced and hydraulically stretched. Largest 1 x 8 ⅞" long

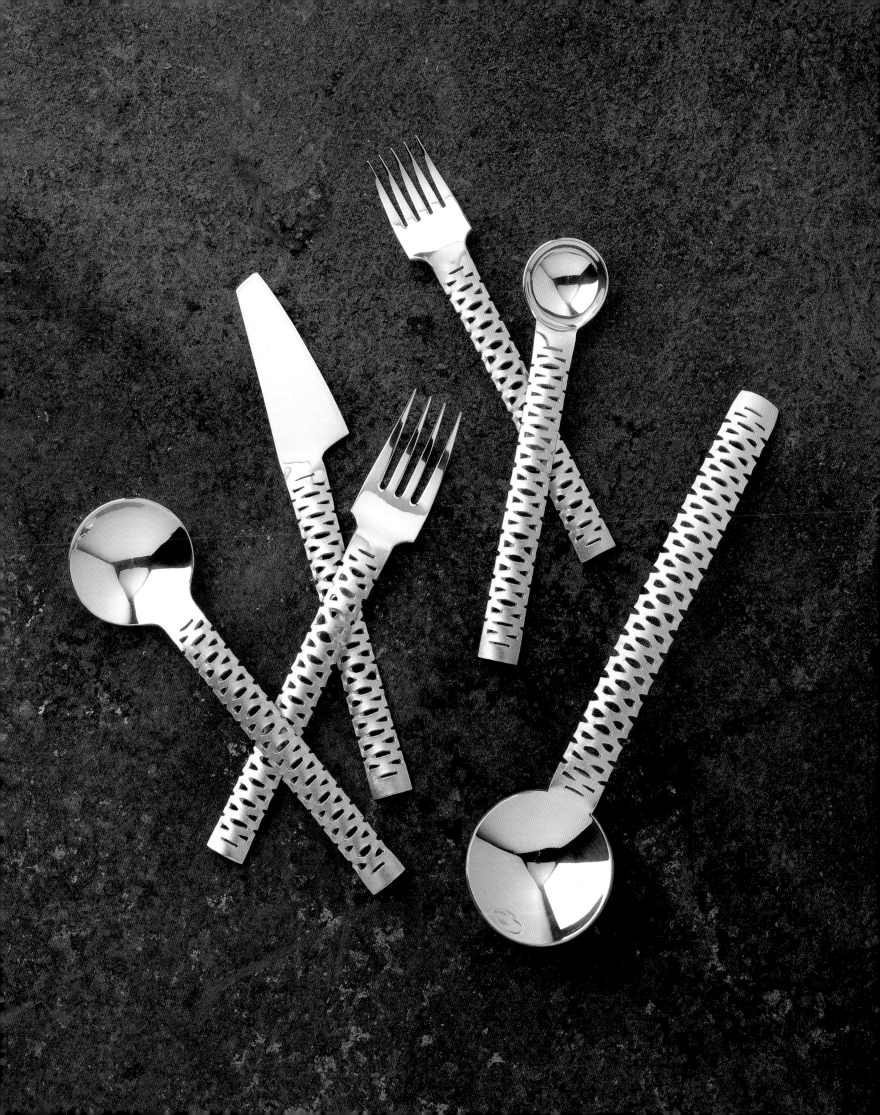

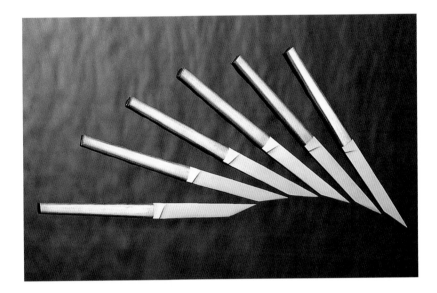

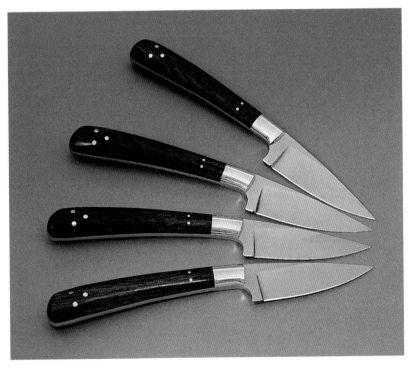

Phillip Baldwin. **Steak knife set V**. Steel, sterling silver, laminated metals. Fabricated. ½ x 1 ½ x 8"
Peter Jagoda. **Steak knife set**. 440-C steel, cocobolo, sterling silver. Ground, fabricated. ½ x 1 ½ x 7"
Chunghi Choo. **Cake server**. Stainless steel. Cut and folded. 1 ¾ x 3 ⅛ x 14 ½"

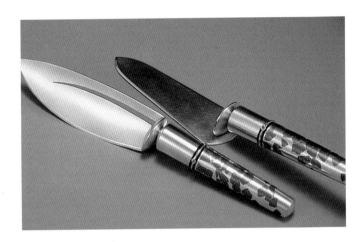

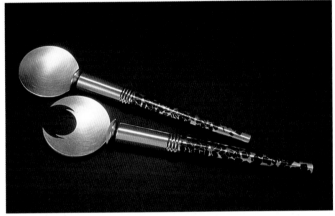

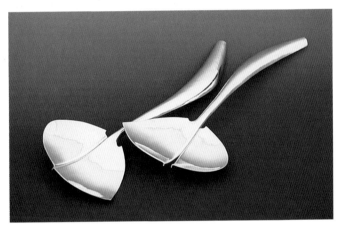

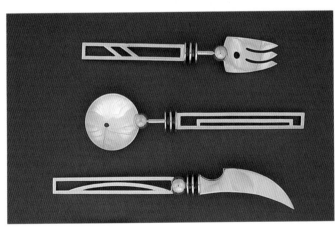

clockwise from top left:

Robert Joseph Farrell. **"Marble" fish and pie server**. Sterling silver, shibuichi, 18k gold. Hollow fabrication, hammered inlay. 2 x 11"

Robert Joseph Farrell. **"Marble" salad serving set**. Sterling silver, shakudo, 18k gold. Hollow fabrication, hammered inlay. 3 ½ x 12"

Mardi-jo Cohen. **Place setting**. Sterling silver. Fabricated. ½ x 2 x 6 ½"

Michael Jerry. **Salad servers**. Sterling. Forged. 4 ½ x 12"

right:

Mardi-jo Cohen. **Dessert forks and spoons**. Sterling silver, Formica, hematite, acrylic. Fabricated. ¼ x 1 ¼ x 6"

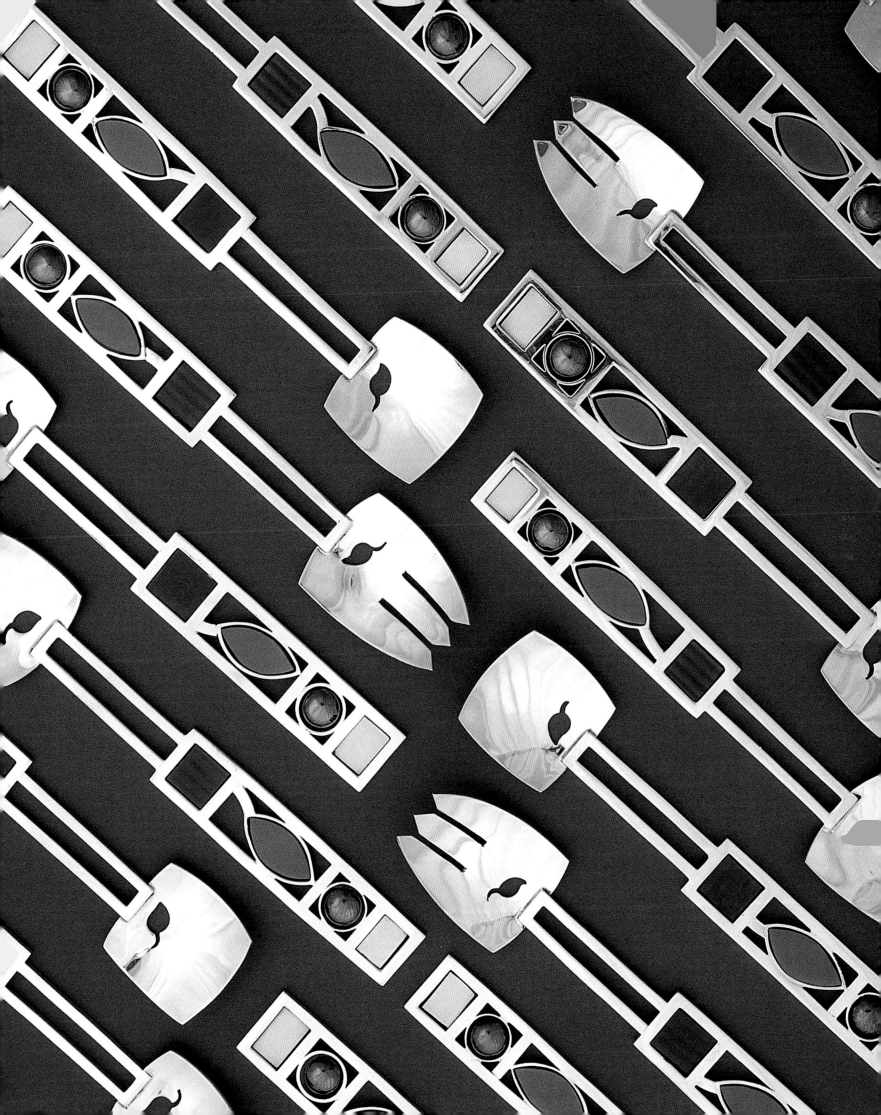

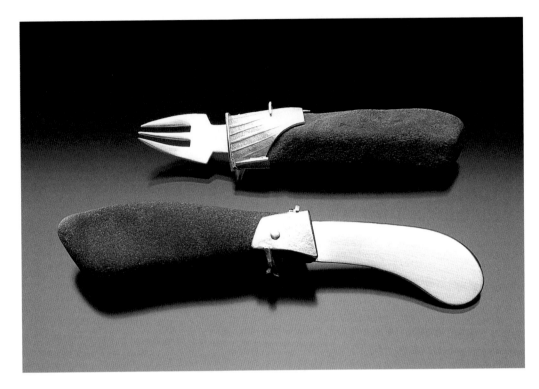

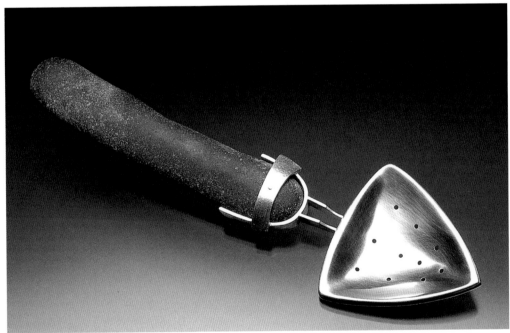

Ann Thompson. **Pickle fork and paté knife**. Sterling silver, natural stone. Fabricated, roll printed, riveted. 1 ¼ x 1 ¼ x 4"
Ann Thompson. **Berry server**. Sterling silver, natural stone. Fabricated, roll printed, riveted. ½ x 2 ½ x 7"

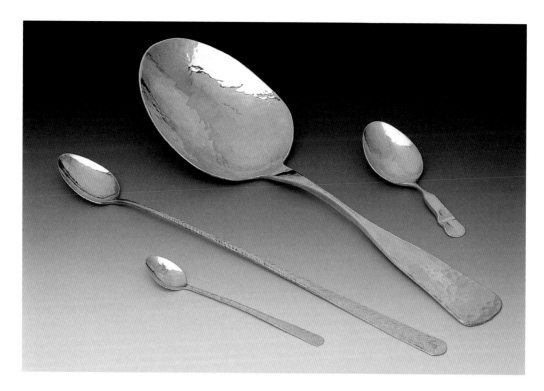

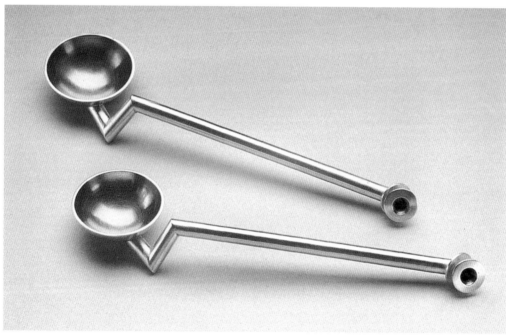

Gary Lee Noffke. **Spoon group**. 969 silver alloy. Forged. Largest 1 ½ x 5 x 16"
Lin Stanionis. **Teaspoons**. Silver, parcel gilt. Fabricated. ½ x 1 ¼ x 5"

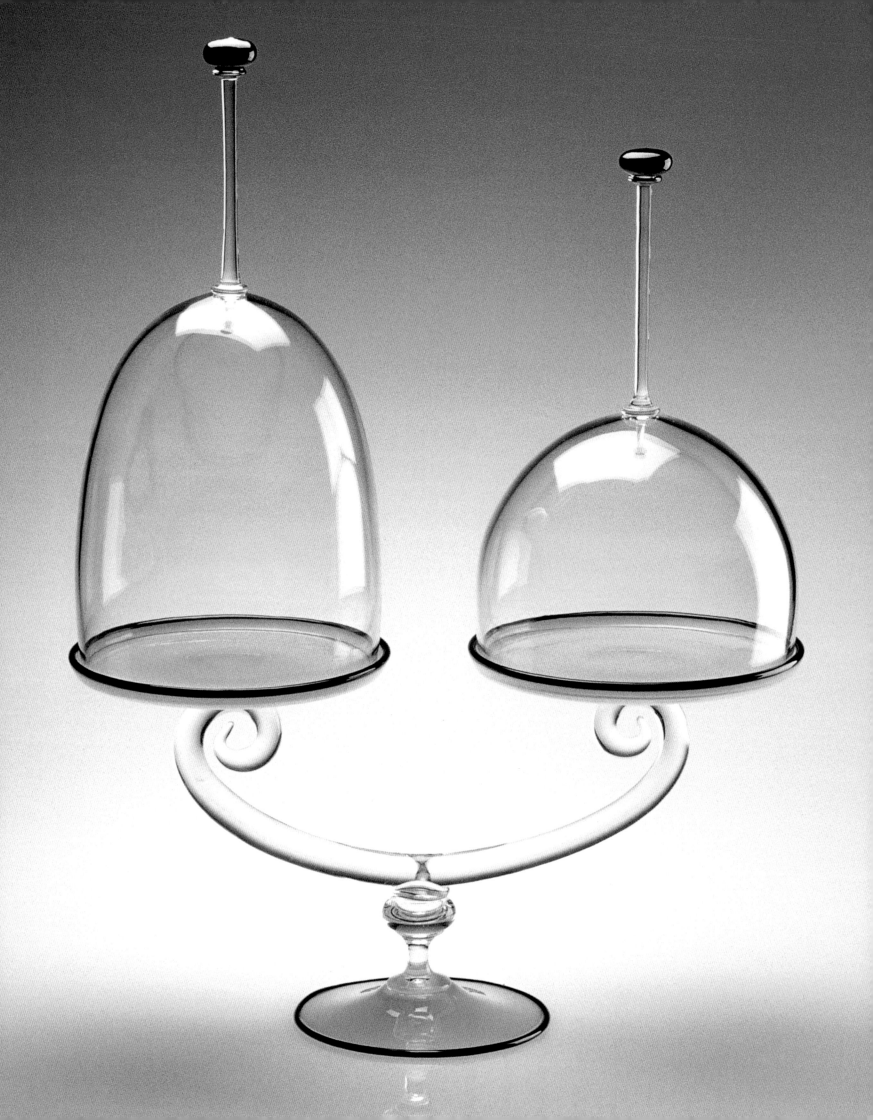

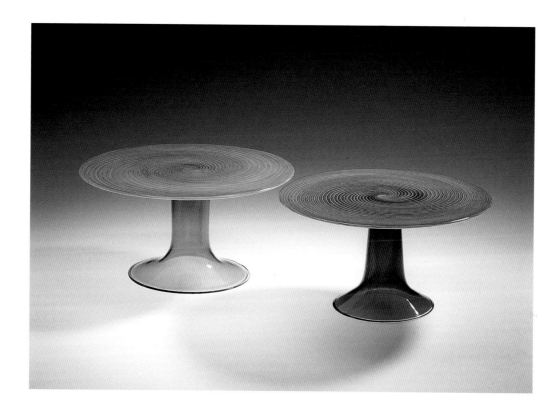

Katherine Gray. **Conjoined cake plate III**. Glass. Blown. 23 x 8 x 17"
Bud Shriner, Church & Maple Glass Studio. **"Ferris Wheel" cake plates**. Soda-lime glass. Blown, glue-attached base. 7 x 14" diam.

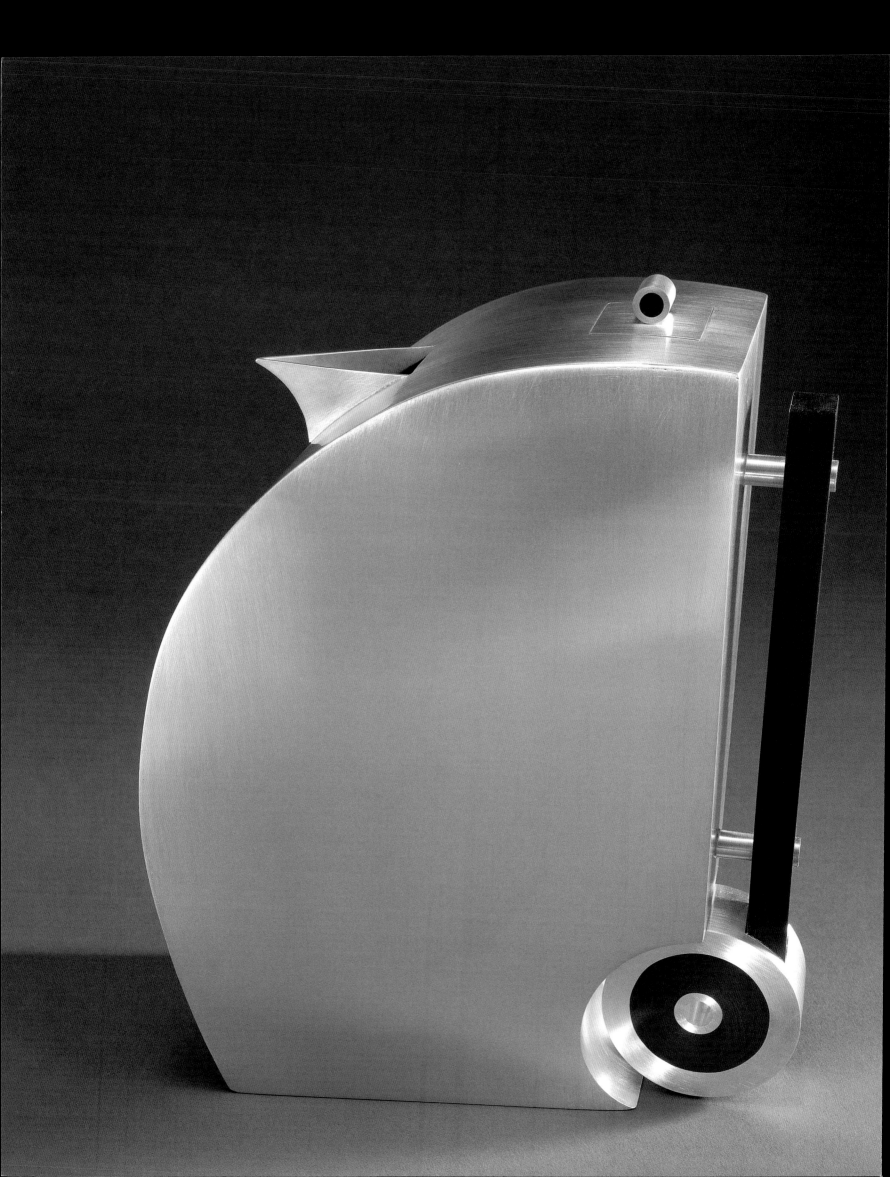

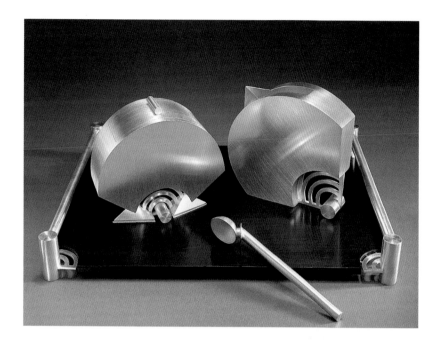

Lin Stanionis. **Teapot**. Sterling silver, resin. Fabricated, molded. 9 x 4 x 7"

Lin Stanionis. **Sugar, creamer, spoon with tray**. Sterling silver, acrylic. Fabricated. Tray 2 x 8 x 12"; creamer 5 x 4 x 2 ½"

Gary S. Griffin. **Charger**. Steel, pewter. Forged, hydraulic pressed. 12" square

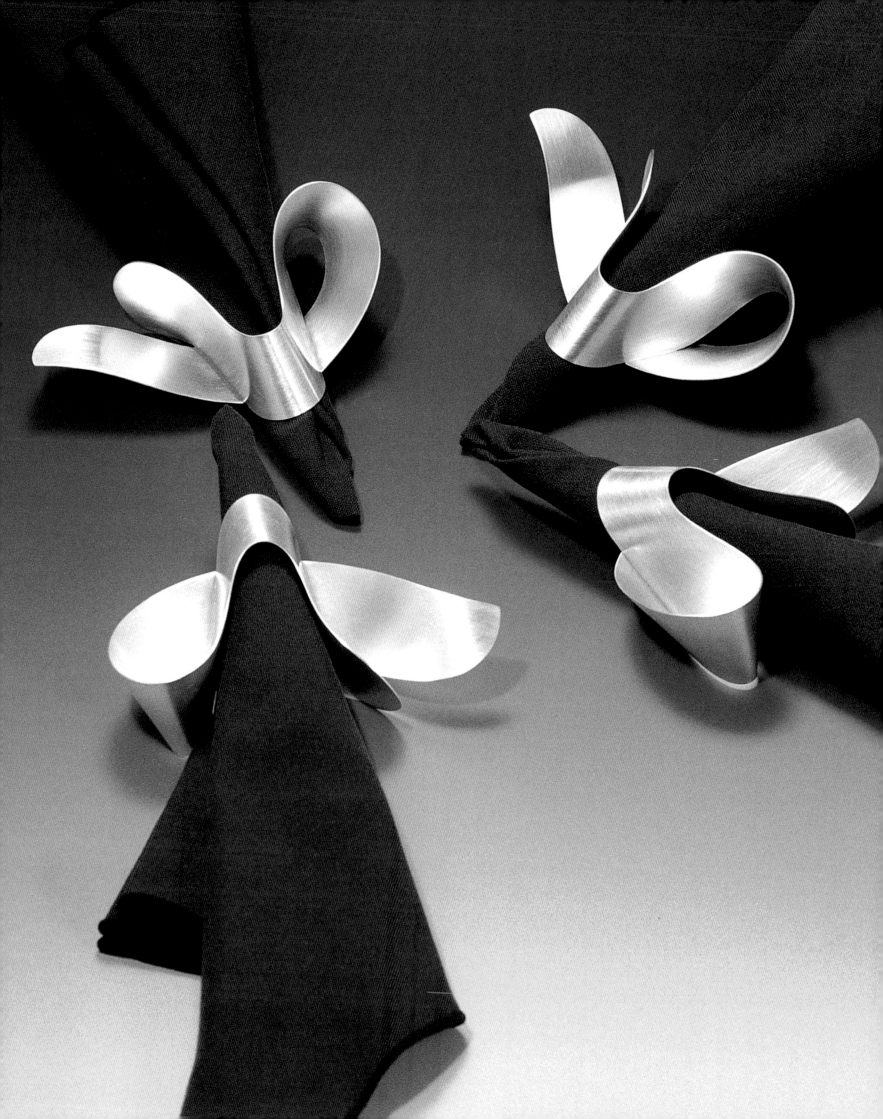

"I'm not trying to say anything obvious or direct about the issues of the day with my work, and in so doing I think I'm really making a statement: I prefer not to burden my forms with narrative or social concerns but rather just enjoy making things that are pleasing to the eye, and fun to hold and use. This seems to be a difficult position to hold in today's climate of 'craft has to be art' or to even be considered an eligible player. So be it. It will truly be enough for me, until I can no longer participate, to deal with line, form, texture, composition, and craftsmanship." — Jon Michael Route

Chunghi Choo. **Napkin rings**. Silver. Fabricated. 2 x 5 x 3 ¼"
Jon Michael Route. **"Half Round #9100" salt and pepper shakers**. Pewter. Fabricated. Tallest 3 ½ x 2 x 1 ½"

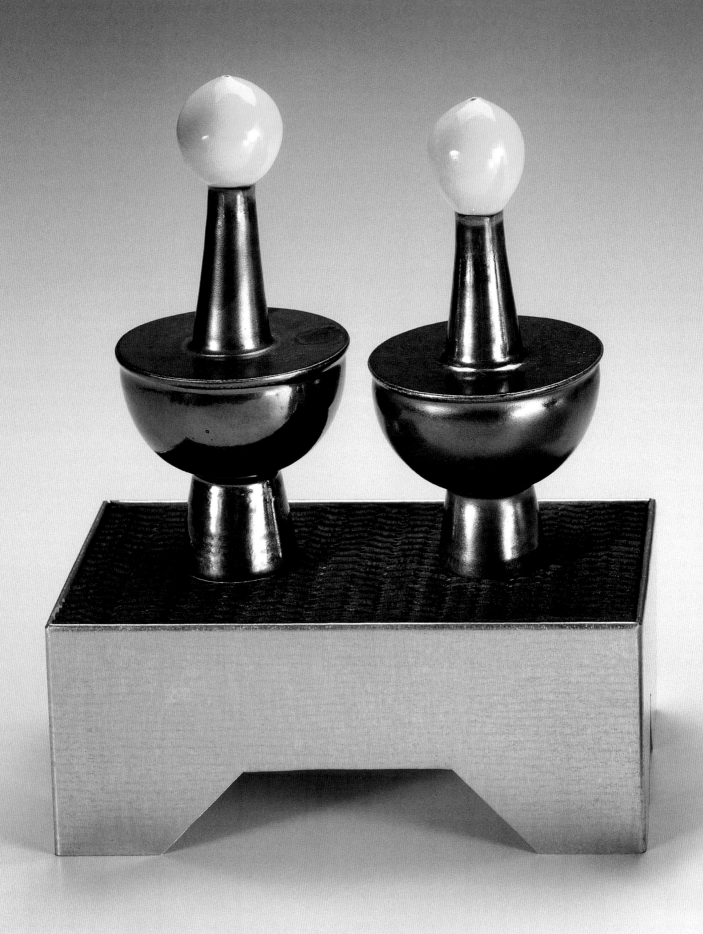

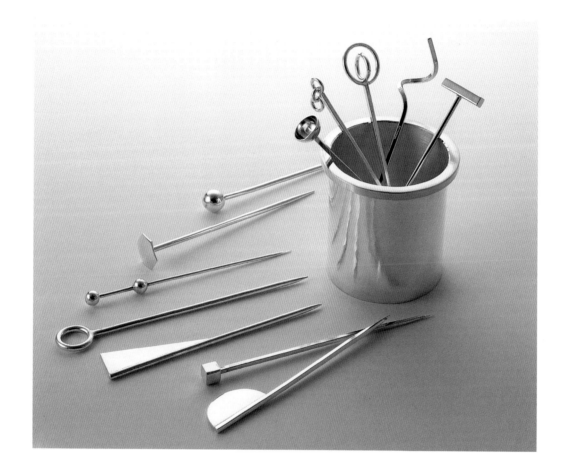

Barbara Diduk. **Salt and pepper sets with stands.** White earthenware, sheet metal, fabric, rubber. Formed, assembled, glazed. 9 x 4 x 9"
Olle Johanson. **Set of picks with holder.** Sterling silver. Fabricated. Holder 4 x 2" diam.

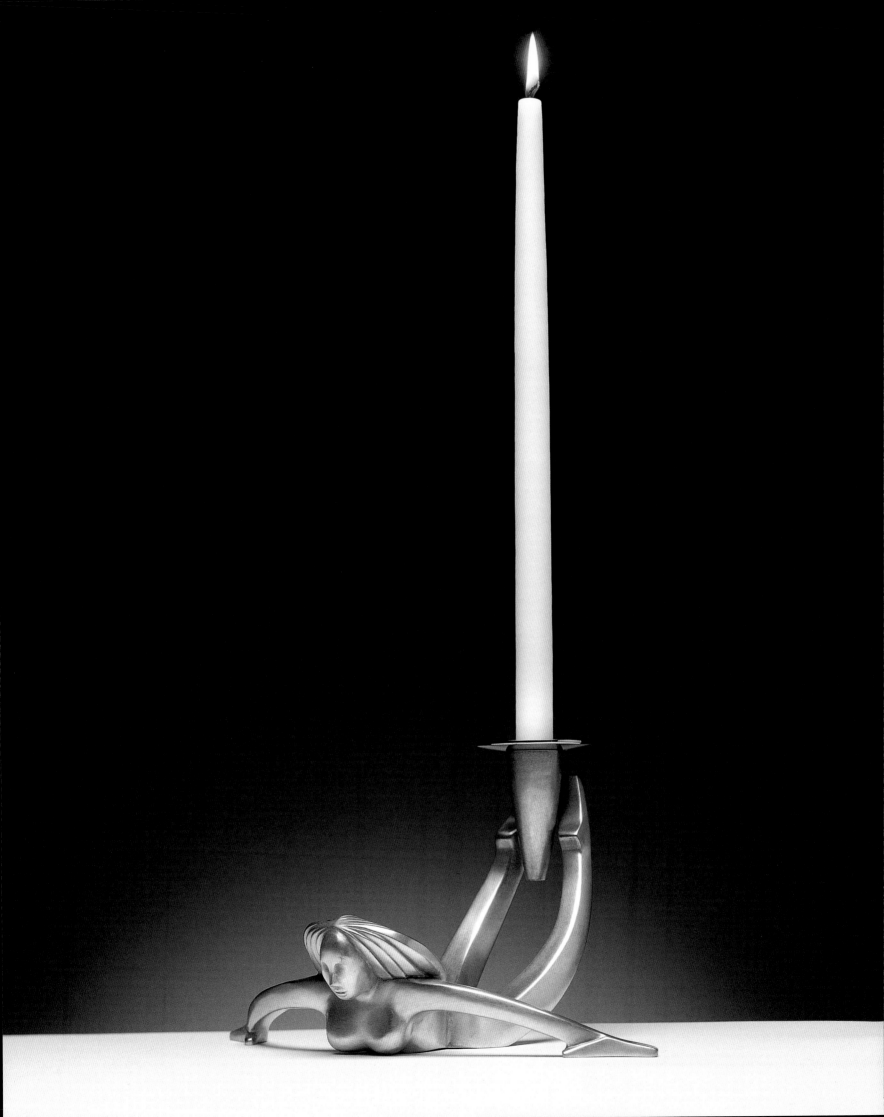

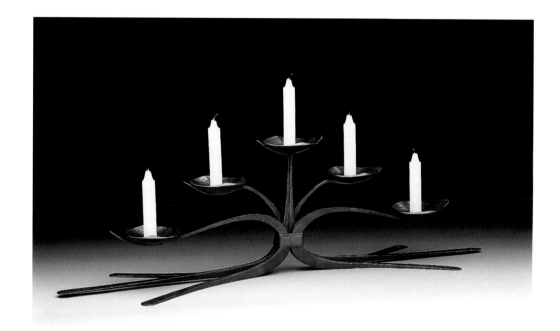

Dan Dailey. **"Balancing Female Figure" candleholder**. Bronze, nickel, gold plate. Cast bronze, plated. 7 x 11 x 7"
Daniel Miller. **"Sabbath Light" candelabra**. Mild steel. Forged, welded. 13 x 28 x 9"

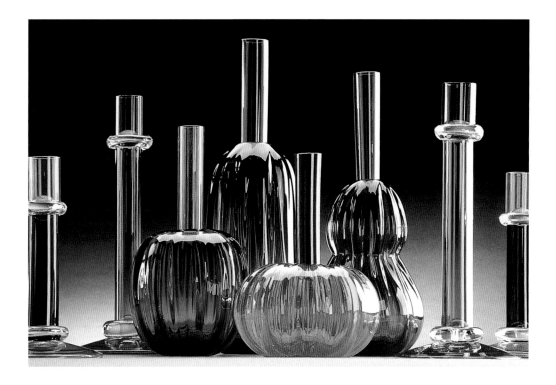

Jim Holmes, Chatham Glass Company. **"Jewel" candlesticks and vases.** Glass. Blown. 7–9" high
Janusz Pozniak. **"Squiggle Sticks" candelabra**. Glass. Blown. Individual elements 11" high

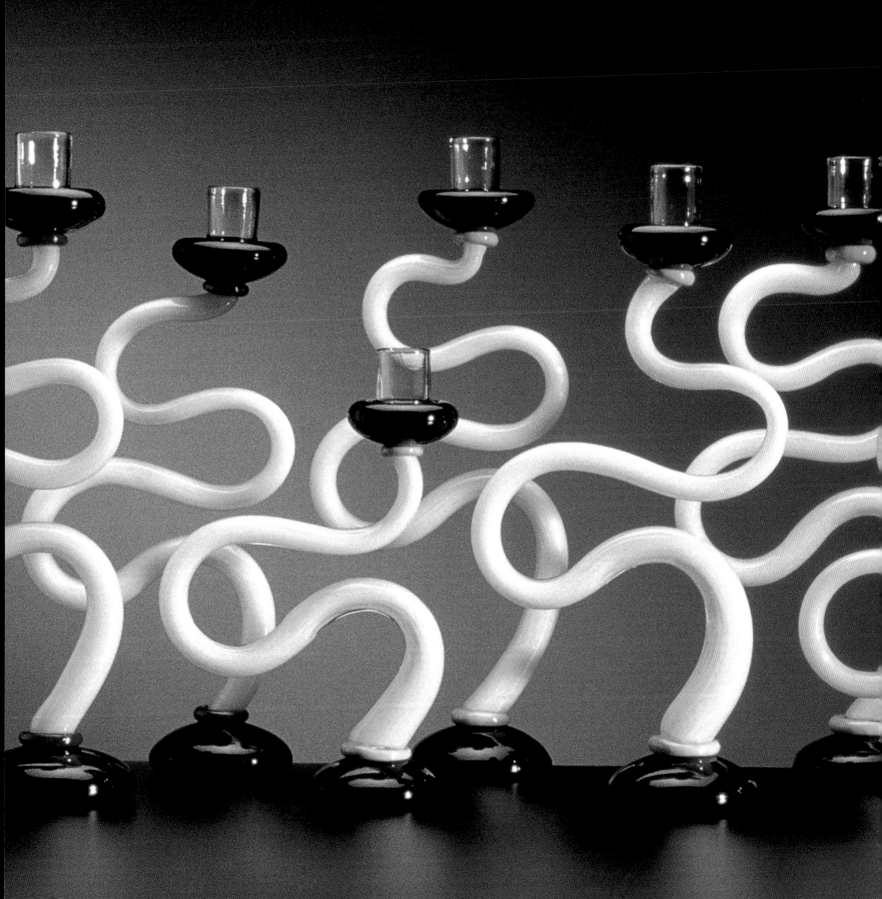

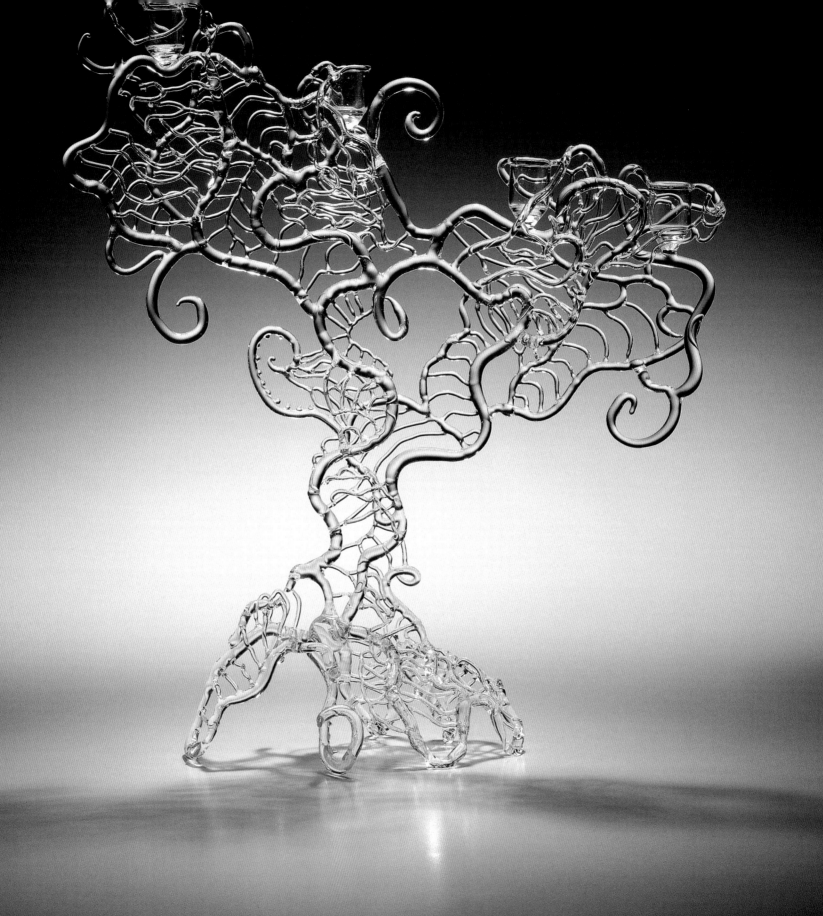

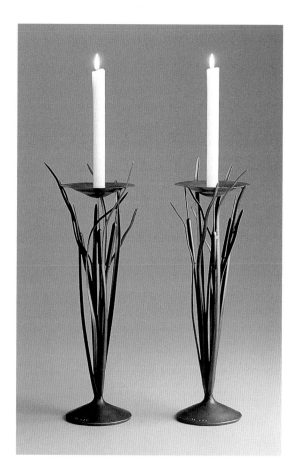 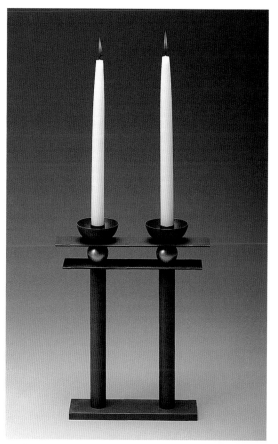

Susan Plum. **"Vine" candelabra**. Pyrex glass. Flameworked. 21 x 5 x 19"
Gary S. Griffin. **"Cattail" candlesticks**. Steel. Forged, spun, hydraulic pressed. 16 ¾ x 5" diam.
Lisa Waters. **Candlestick**. Brass. Fabricated. 13 ½ x 10 ½ x 2 ½"

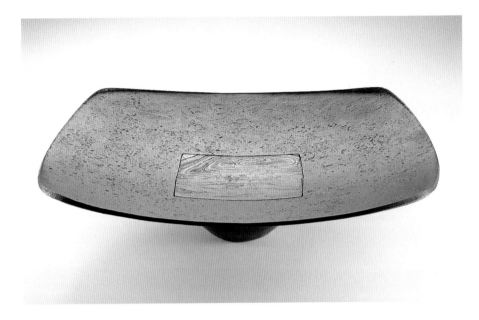

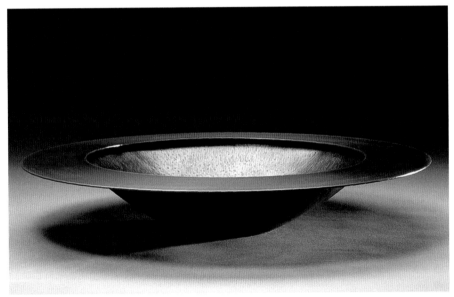

Tom Joyce. **Inlaid square bowl**. Mild steel, iron. Forged, fire welded, raised, planished, burnished. 3 ¾ x 14 ½ x 14 ½".
Collection American Craft Museum, gift of the Horace W. Goldsmith Foundation
Karen L. Pierce. **Rimmed bowl**. Copper, paint. Raised and fabricated, patinated. 4 x 24" diam.
Karen L. Pierce. **Double-walled bowl**. Copper, 24k gold, electroplate, lapis lazuli, garnet. Spun, fabricated, patinated. 6 x 9" diam.

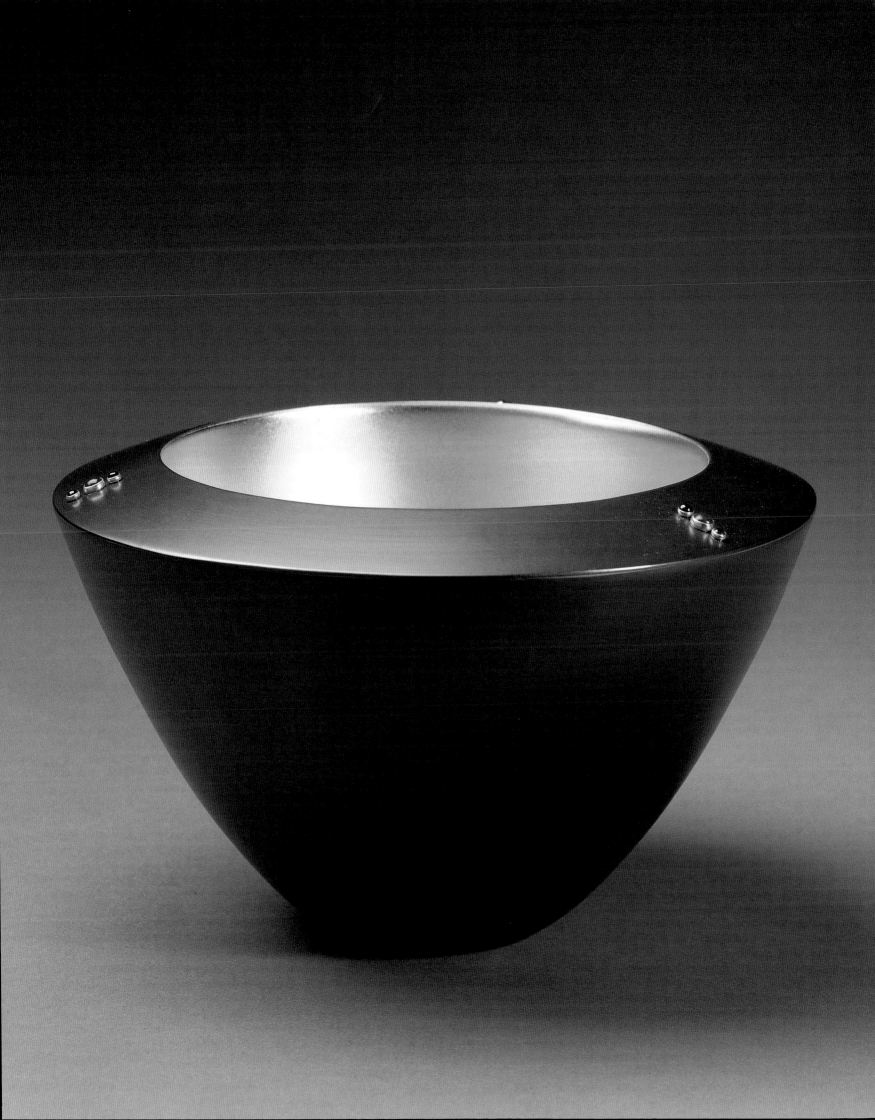

Gary S. Griffin. **Vase**. Steel, copper. Forged, welded. 12 x 6 ¼" diam.
Randy Long. **"La Madonna" lily vase**. Sterling silver. Sheet-metal fabrication, soldered. 12 x 4 ½" diam.

David William Levi, Ibex Glass Studio
"Amphora" vase group. Glass. Blown. 15 x 5" diam.
"Deluxe Cone" bowl. Glass. Blown. 7 x 15" diam.

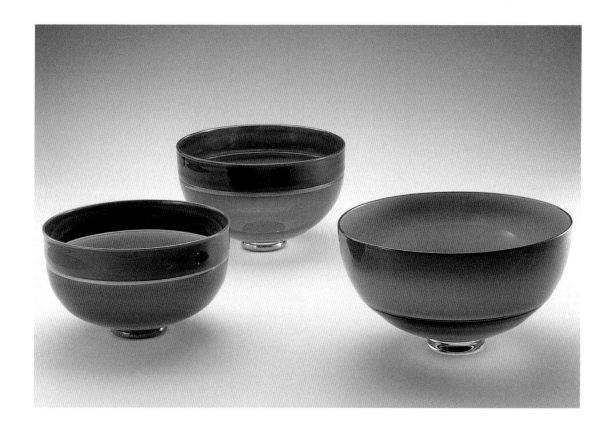

Alex Brand. **"October" bowls**. Glass. Blown, color overlay, incalmo technique. 6 x 9–13" diam.
Åsa Sandlund. **"Stockholm" vase group**. Glass. Blown. 11 x 6 x 2"

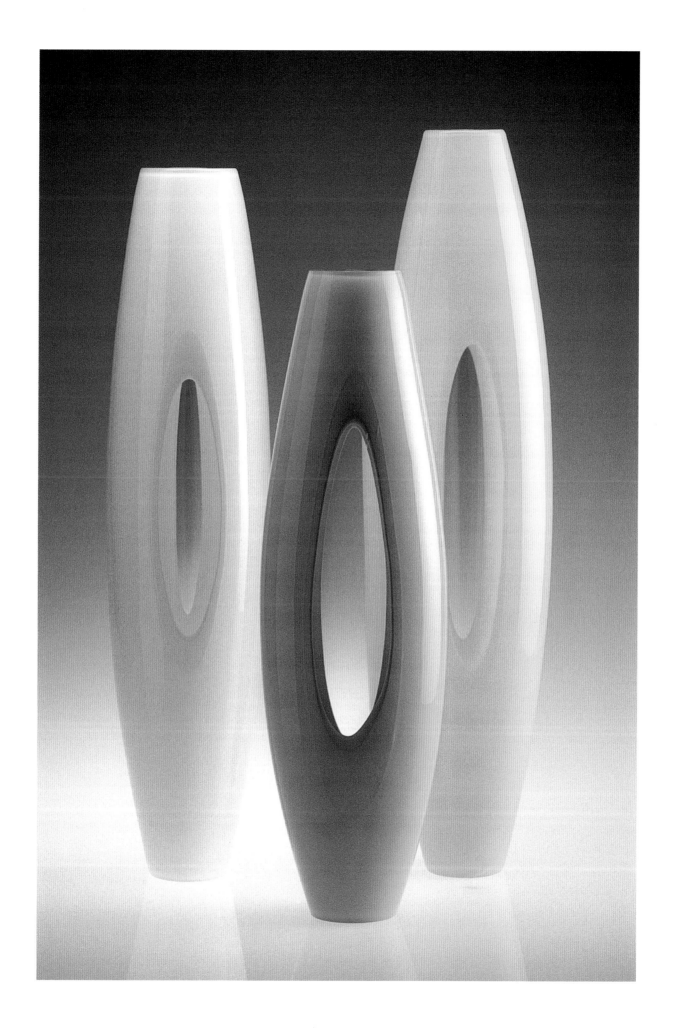

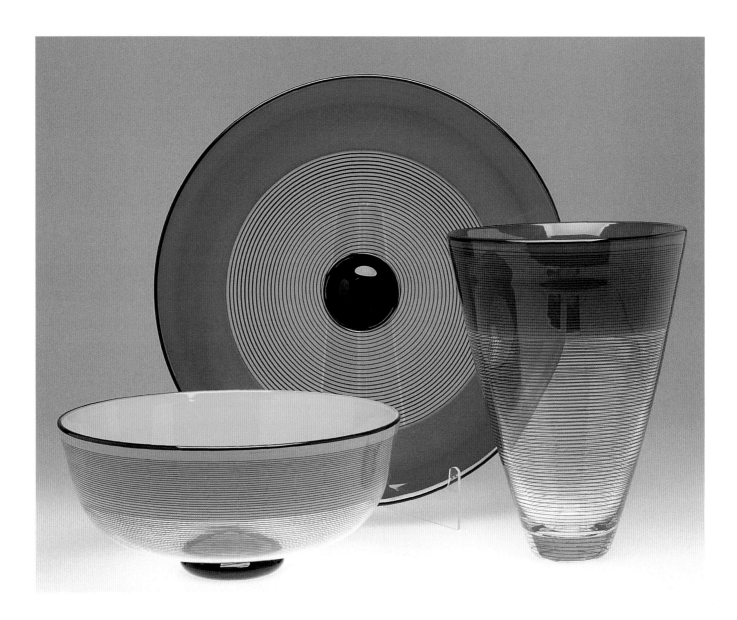

James H. Nadal. **"Z line" platter, bowl, vase**. Glass. Blown, clear with incalmo with black thread. Platter 2 x 16" diam.; bowl 5 x 9" diam.; vase 13 x 6" diam.

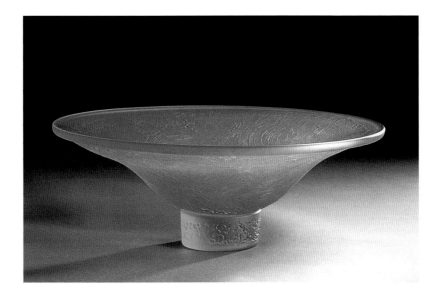

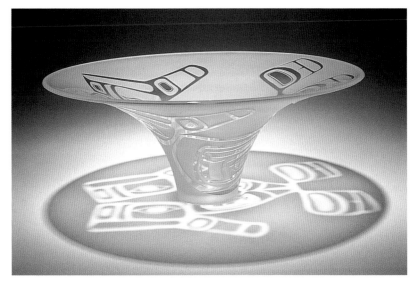

Tommie Pratt Rush. **"Milky Way" bowl**. Glass. Blown, sandblasted, acid etched. 6 ¼ x 17 ¼" diam.
Preston Singletary. **"Whale Hat."** Glass. Blown, sandblasted. 9 x 18" diam.

Mary A. Roehm. **Bowl**. Porcelain, celadon glaze. Thrown, wood fired. 15 x 21" diam.
Klara Borbas. **Vase group**. Stoneware. Thrown, painted underglaze, glazed. Tallest 17 x 4" diam.
Matthew Metz. **Box**. Porcelain. Thrown, altered, carved, wood-oil salt fired. 5 x 8 x 4"

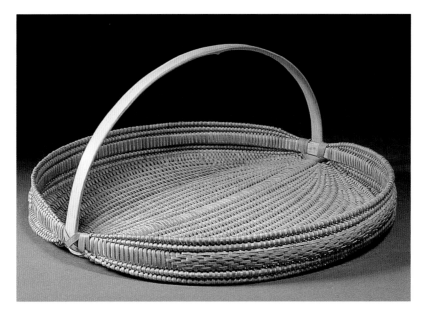

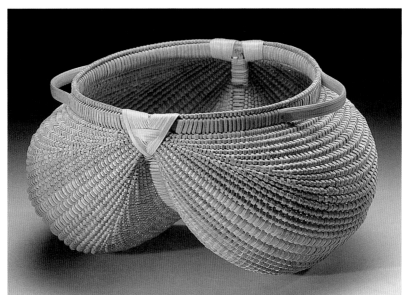

Aaron Yakim. **"Rib" tray**. Hand-split white oak (light sapwood and dark heartwood). Ribbed construction. 8 x 13 x 15"
Cynthia W. Taylor. "**Egg Basket" with side handles**. Hand-split white oak (light sapwood and dark heartwood). Ribbed construction. 7 x 11 x 13"
Billie Ruth Sudduth. **"Calabash Clam" baskets**. Split oak, European-cut reed splints, iron oxide, crushed-walnut-hull dye.
Twined double bottom, stip-up arrow twill, split stakes, carved handle. Smallest 9 x 6" diam.; largest 18 x 14" diam.

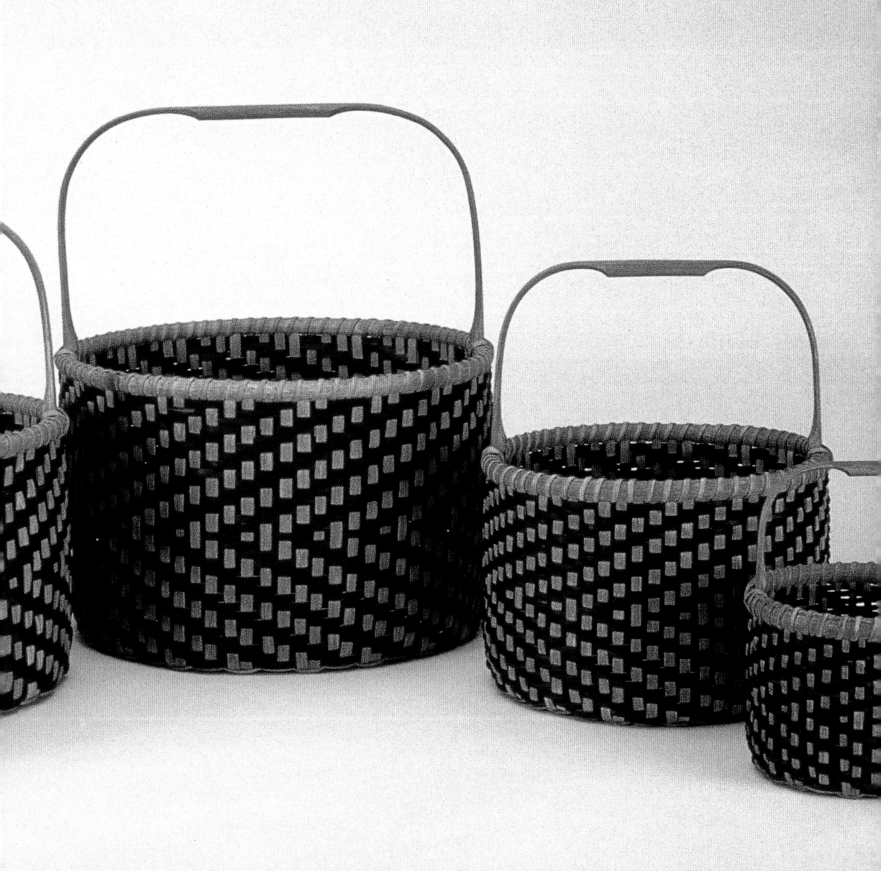

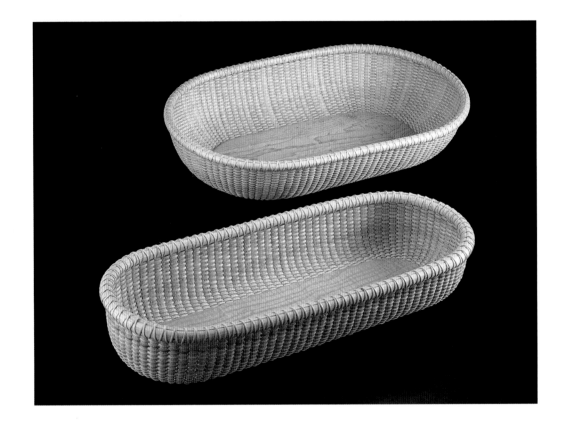

Lawrence Wheeler. **"Nantucket Lightship" baskets**. Rattan, bird's-eye maple base. Traditional plain weaving. Oblong tray 3 ½ x 16 ½ x 10 ½"; French bread basket 3 x 16 ½ x 7"

Lawrence Wheeler. **Oval "Nantucket Lightship" basket**. Rattan, oak handle, cherry base, bone knobs. Traditional plain weaving. 11 x 8 ½" diam.

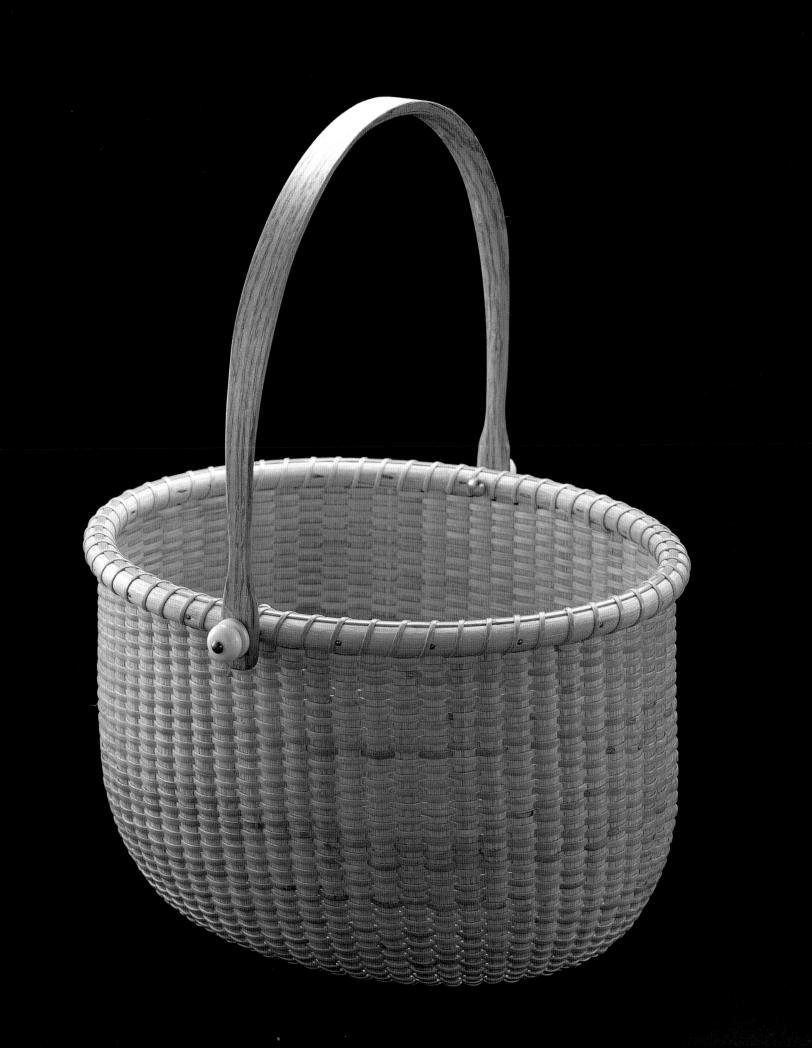

"Bowls and platters serve as my canvas on which to investigate surface manipulation and explore visual images. The nature of wood—with its inherent differences in color, grain, texture, and density—offers the ground for experimentation with pigments and texture." — Merryll Saylan

clockwise from top left:
Ronald DeKok. **"Southwest Red" plate**. Padauk, wenge, zebra, maple line. Laminated, turned. 2 x 19" diam.
Ronald DeKok. **Plate**. Ash, wenge, maple line. Laminated, turned. 2 x 19" diam.
Merryll Saylan. **"Patterns: Series III" platter**. Ash. Lathe turned, carved, charred, dyed, oil-color glazed, waxed. 2 x 26" diam.
Merryll Saylan. **"Purple & Red" platter**. Padauk. Lathe turned, textured, dyed, oil-color glaze. 2 ½ x 20" diam.

Merryll Saylan. **Bowl**. Norway maple. Lathe turned, bleached, lacquered. 5 x 17" diam.

John B. May. **"Vim & Vigor."** Curly maple, lemonwood, black-dyed costello. Lathe turned, bent laminated wood base. 3 ½ x 5 x 20"

John B. May. **Krater**. Bird's-eye maple, ebony, mahogany. Lathe turned. 7 x 22" diam.

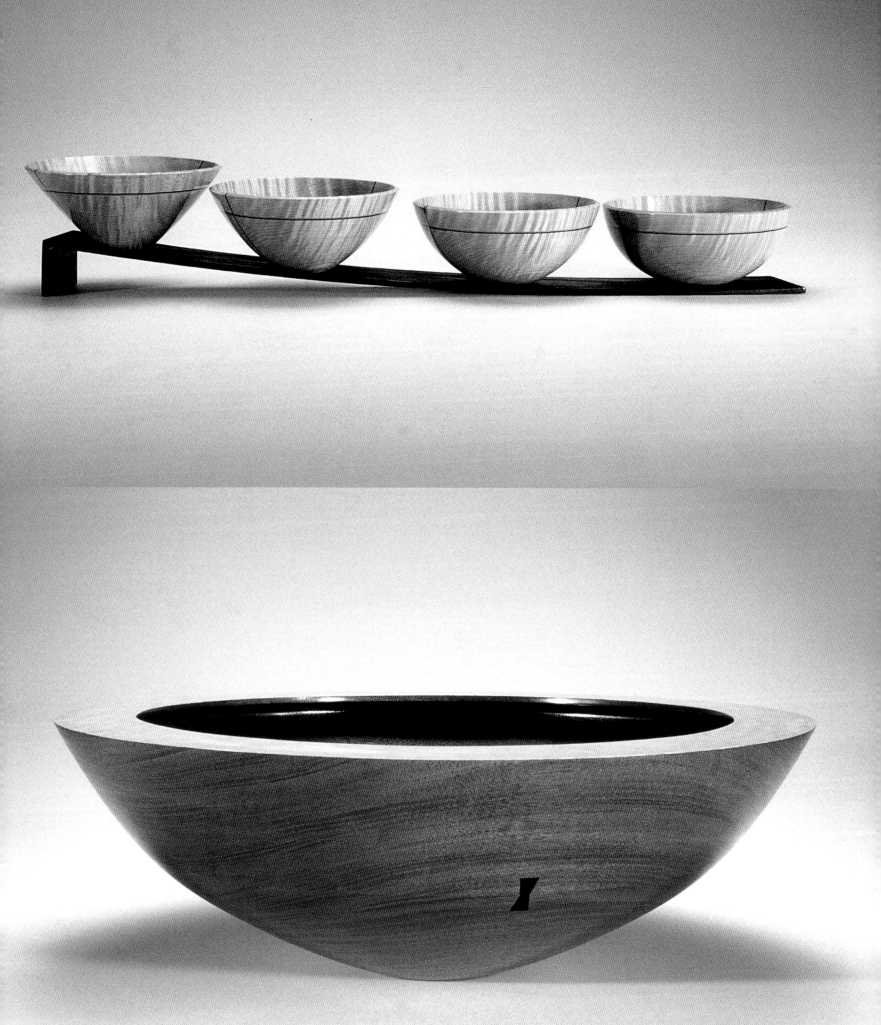

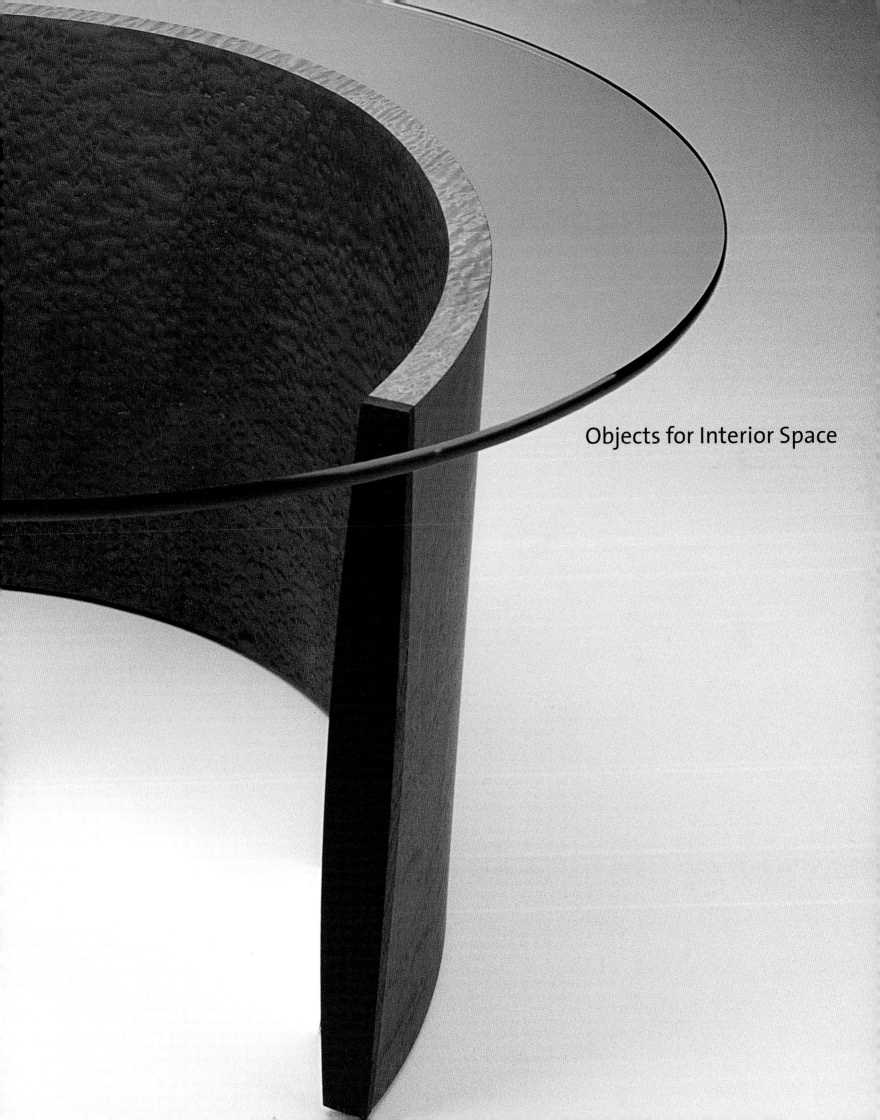

Objects for Interior Space

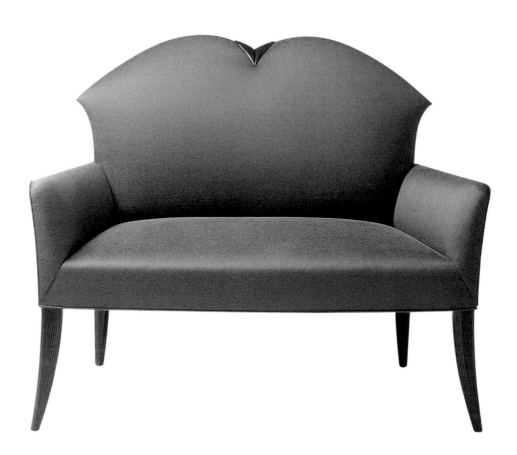

Robert A. Harman. **"Asymmetrical" chair**. Maple, silk, velvet, jacquard fabric. Upholstered. 34 x 41 x 30"
John Dunnigan. **Settee**. Purpleheart, viscose. Constructed, upholstered. 34 x 48 x 24"

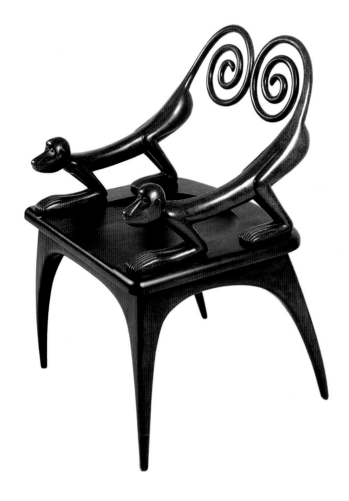

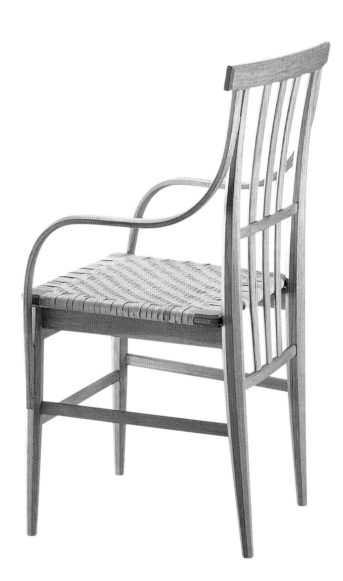

Judy Kensley McKie. **"Monkey" chair**. Bronze, stained walnut. Cast. 36 x 25 x 25". Collection American Craft Museum, promised gift of Nanette Laitman
Bruce Beeken and Jeff Parsons, Beeken/Parsons. **Hickory chair**. Hickory. Steam bent, shaped, joined. 33 x 20 x 18"

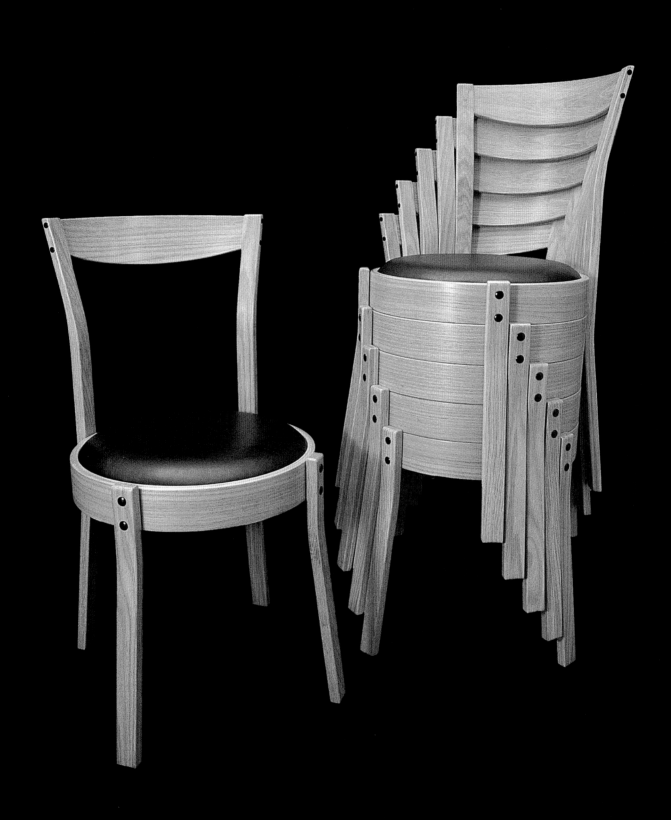

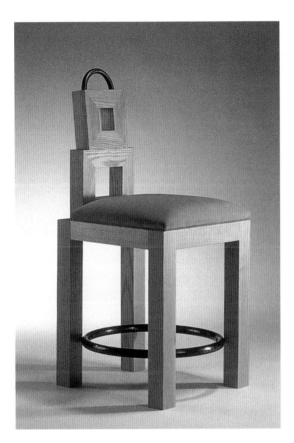 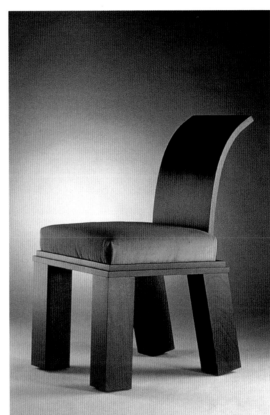

Curtis Erpelding. **"Series 1000" stacking chairs**. Oak, leather. Bent lamination, constructed. 32 x 22 x 22"
Wendell Castle, Wendell Castle Collection. **"Hi Q 2" chair**. Ash, copper, upholstery. Constructed. 42 x 18 x 19 ½"
Wendell Castle, Wendell Castle Collection. **"Boxer" chair**. Mahogany, upholstery. Constructed. 33 ½ x 20 x 24 ½"

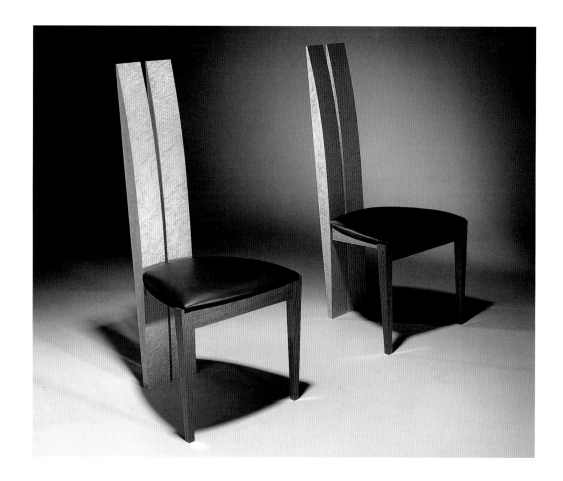

Henry S. Fox. **"Hocus Pocus" chairs**. Cherry, bird's-eye maple, leather. Constructed. 42 x 20 x 21"
Peter Danko. **"Gotham" rocker**. Maple veneer, recycled automotive seat belts. Mortise-and-tenon joinery,
parts formed and bonded in a hot mold. 42 x 28 x 39"

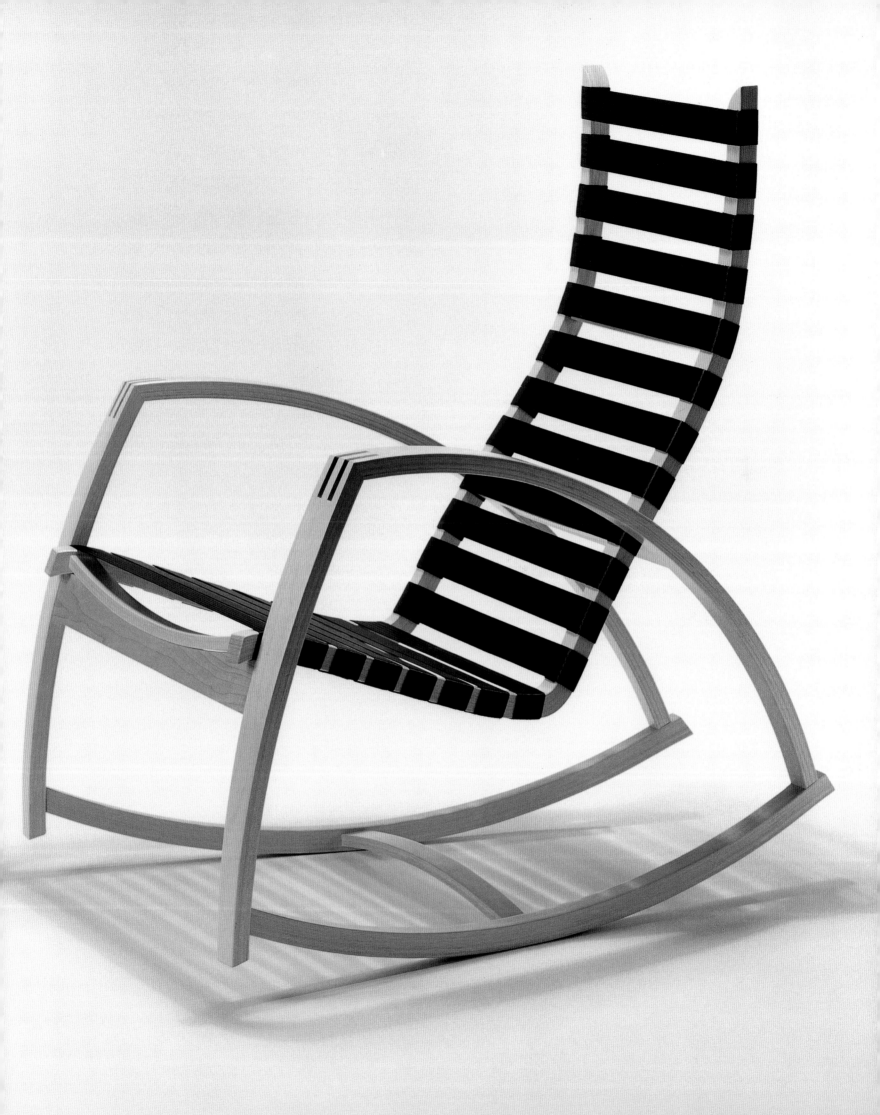

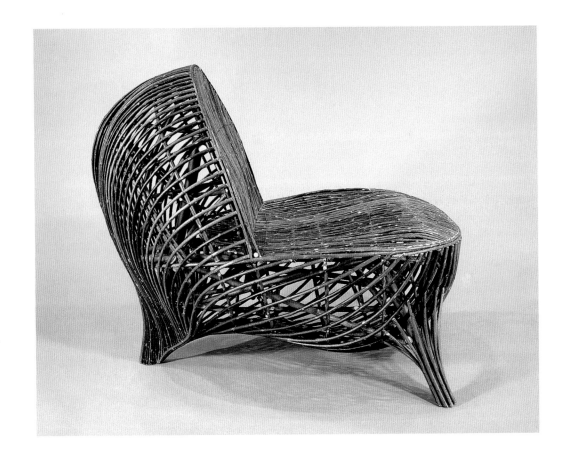

David Chapman. **"Egg" chair**. Willow. Bent, constructed. 30 x 23 x 37"

Clifton Monteith. **"Moon-Viewing Aspen" chair**. Willow aspen. Constructed. 44 x 24 x 43". Collection American Craft Museum, gift of Robert and Gayle Greenhill

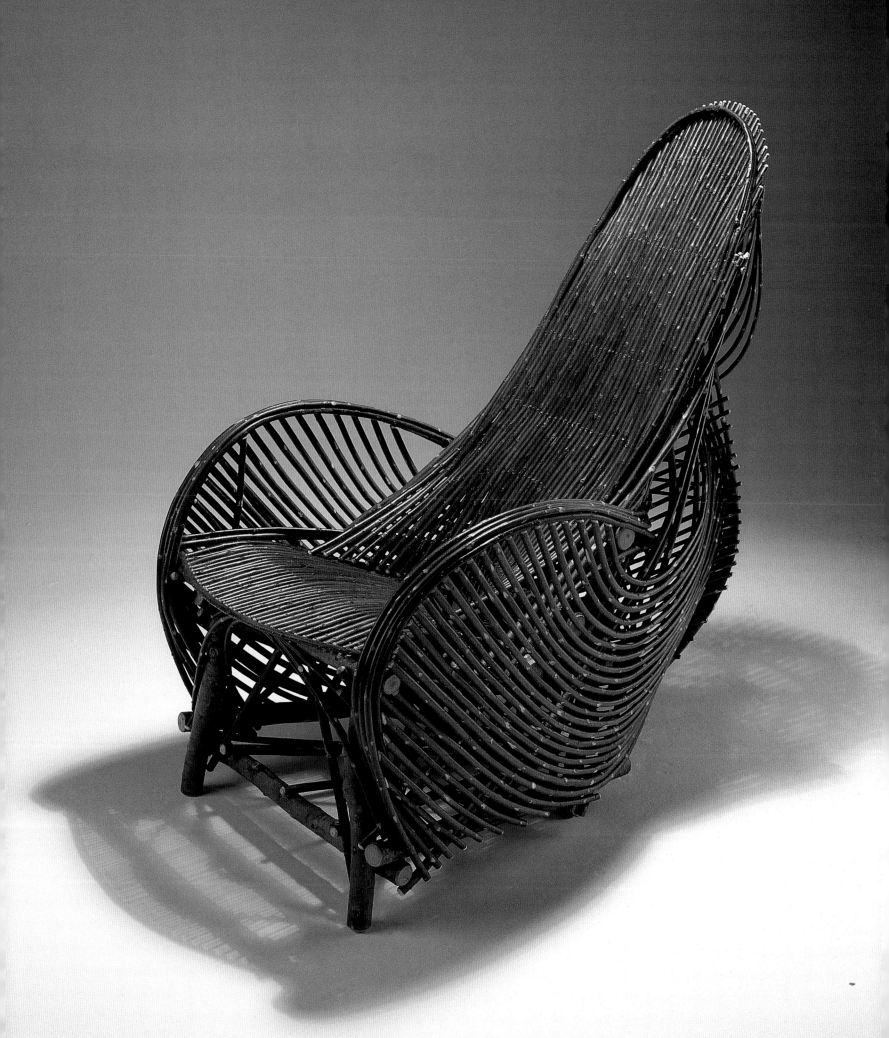

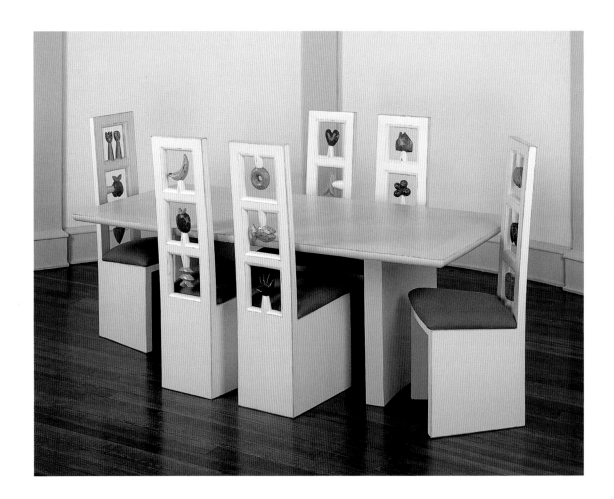

Randy Shull. **"Toast" table and chair set**. Wood laminate, paint. Constructed, carved, painted. Chairs 44 x 18 x 22"; table 29 x 40 x 84"
Dick Wickman. **"Crescendo" table**. Mahogany, textured laminate, sterling silver inlay. Constructed, applied oil enamel. 22 x 24" diam.

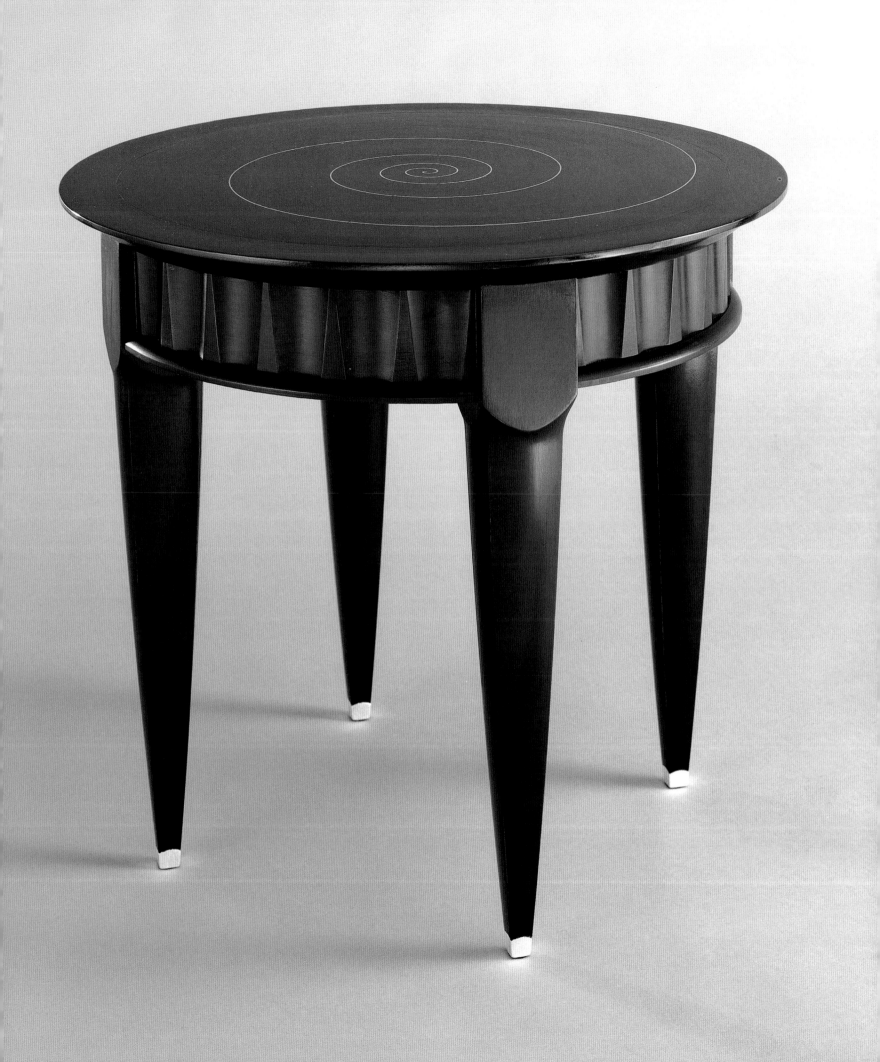

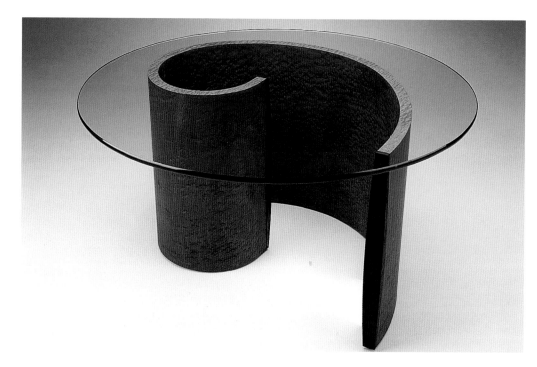

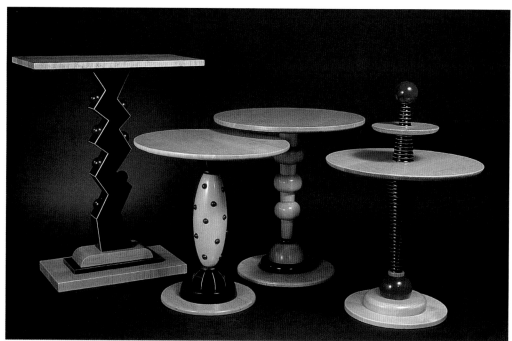

Richard Judd. **"Spiral" table**. Pommele sapele veneer, bent plywood, wenge, glass. Form bent. 18 x 36" diam.
Steve Madsen. **Table group**. Maple, colored and clear lacquer, dye. Turned, constructed. Tallest 32 x 28 x 18"

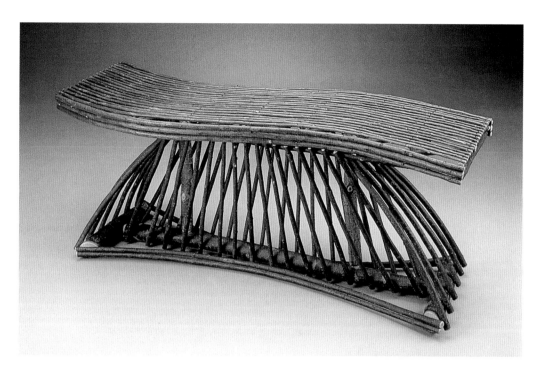

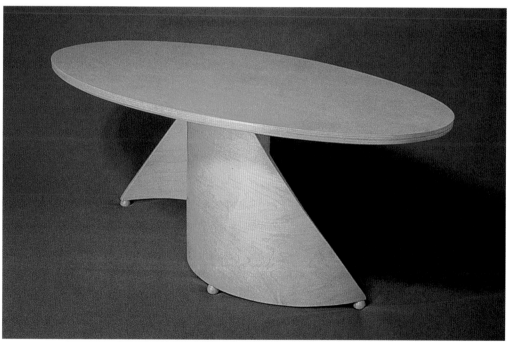

Kimberly Sotelo. **"Wavy Top II" table**. Willow. Bent, nailed. 22 x 48 x 20"
Tim Stewart. **"Hugo" coffee table**. Maple, Baltic birch. Formed, constructed. 17 x 44 x 18"

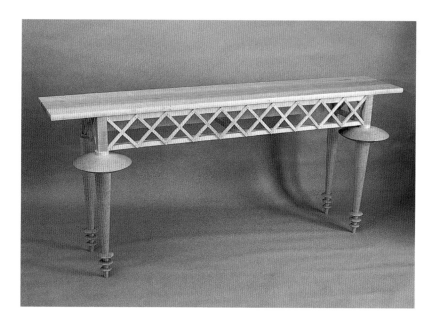

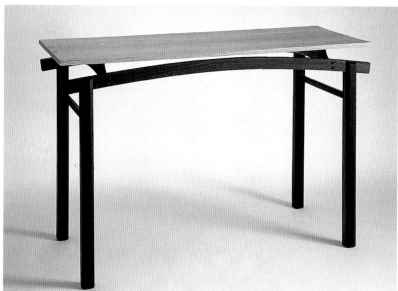

Edward Zucca. **Side table**. Curly maple. Constructed, turned legs. 30 x 71 x 17"
Michael Puryear. **Table**. Ash, wenge. Constructed. 32 x 52 x 18". (detail opposite)

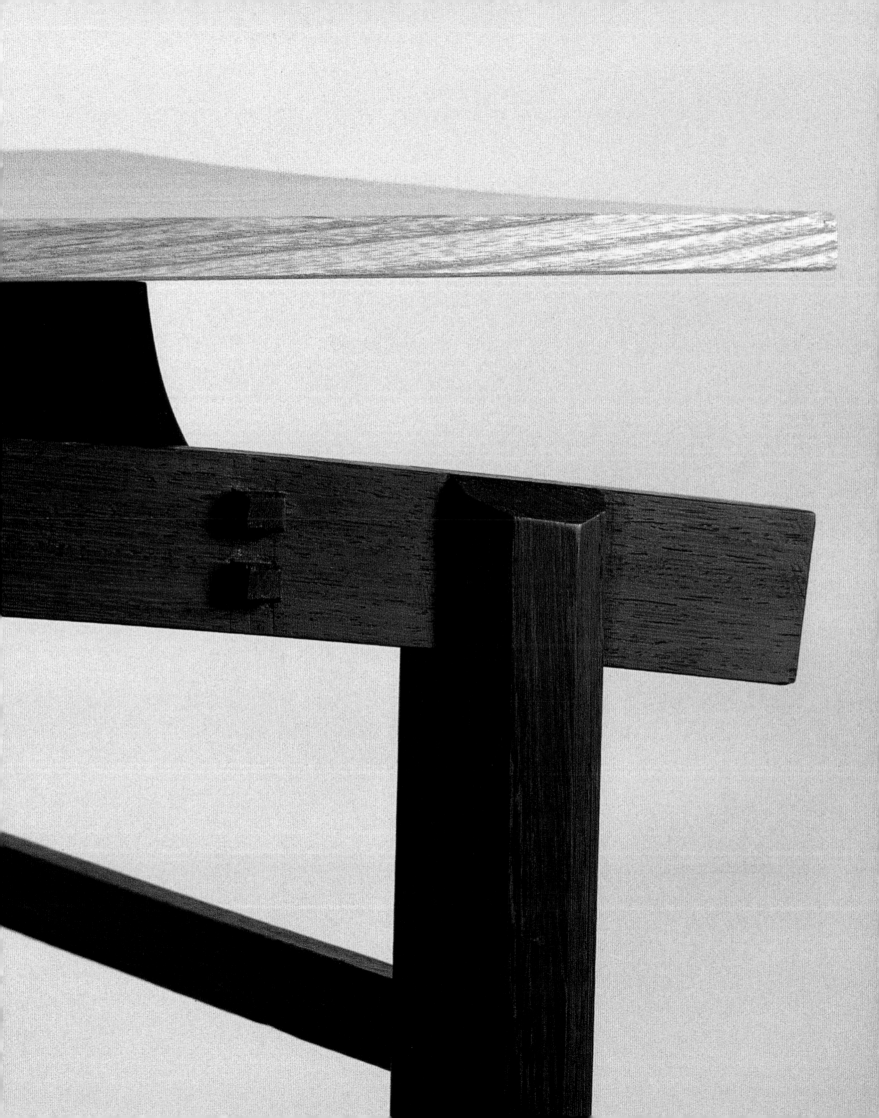

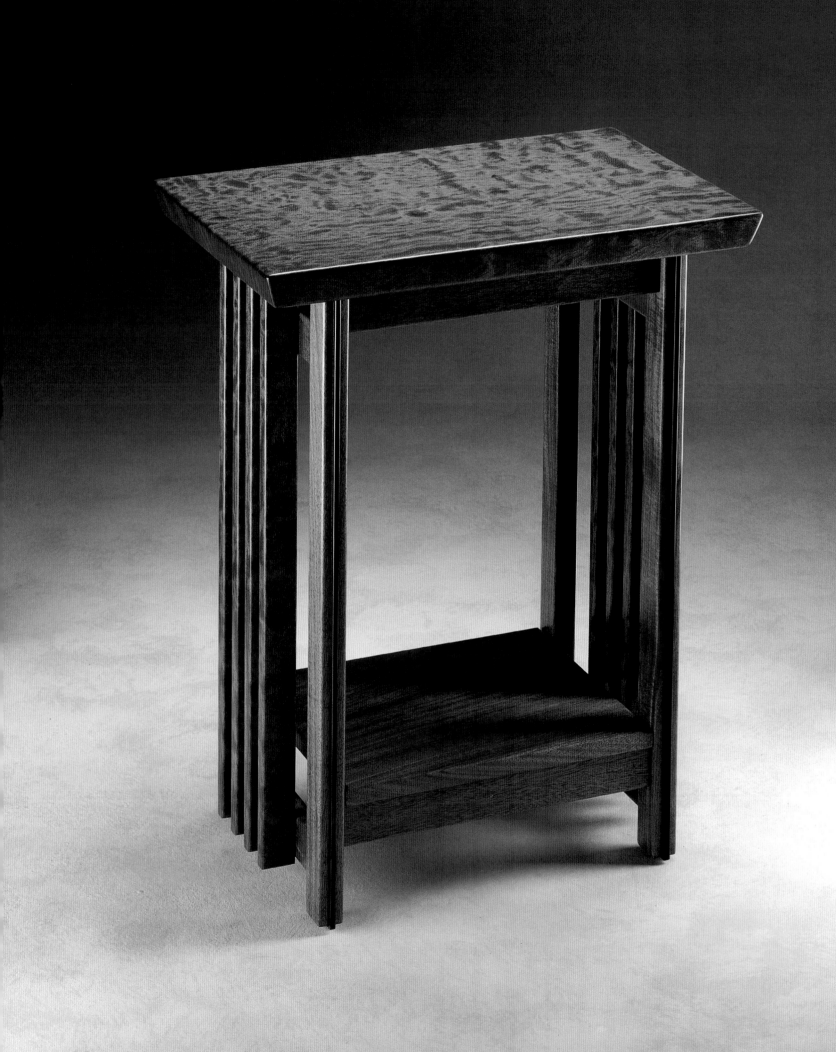

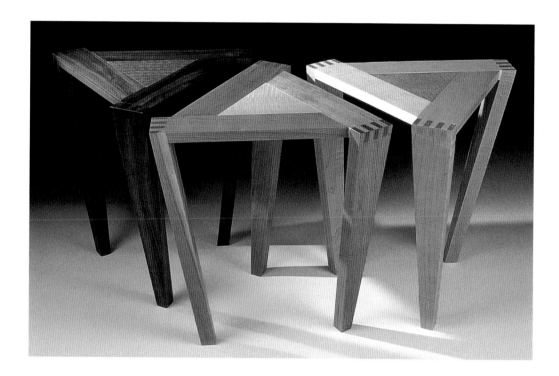

Anthony Beverly. **Pedestal table**. African rosewood, mahogany, ebony. Constructed. 32 x 26 x 16"
Jay Wiggins, spaghetti western furniture. **Side table group**. Assorted hardwoods. Constructed. 22 x 20 x 20"

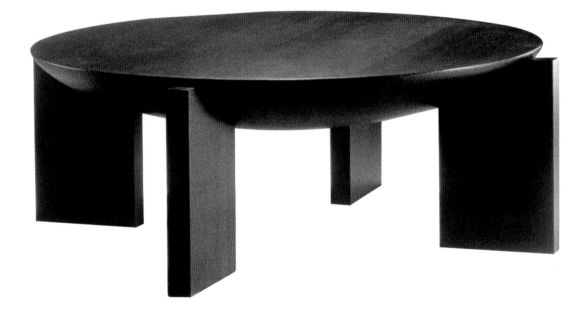

Wendell Castle, Wendell Castle Collection. **"Olympia" table**. Mahogany, fiberglass. Constructed. 15 x 43" diam.
Craig Nutt. **"Onion Blossom" table**. Cherry, paint. Steam bent, constructed, carved, painted. 29 x 16 x 16"

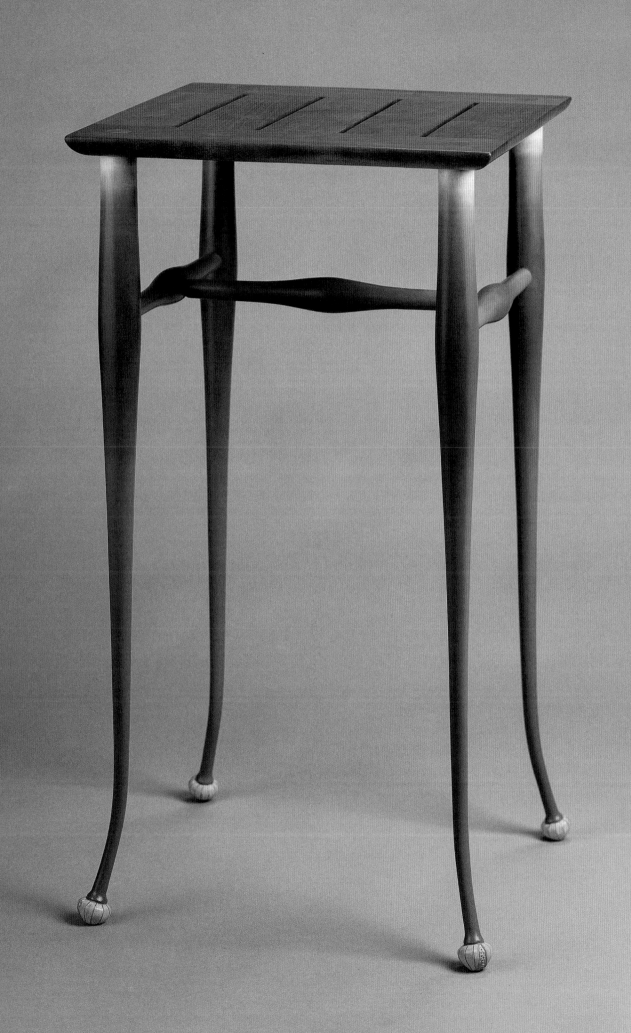

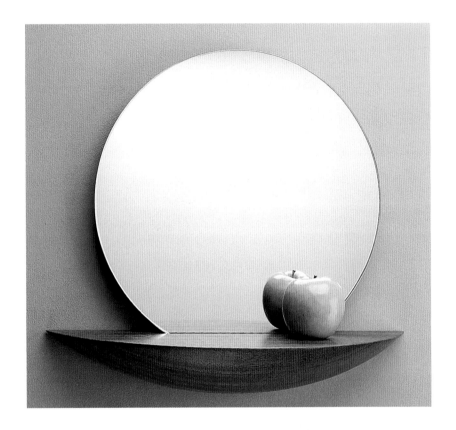

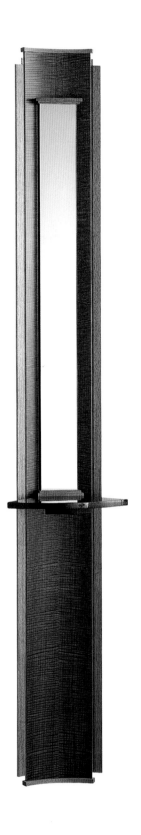

"I design furniture that simply and elegantly performs its function. Fulfillment for me as a furniture designer comes from creating functional objects that enhance the rituals of everyday life, hopefully for a lifetime. The enjoyment of a piece of my furniture by an individual gives me the energy to begin again." — John Dodd

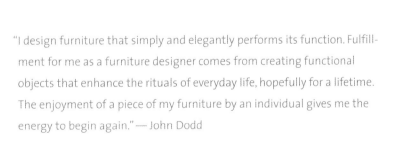

Richard Judd. **"Demilune" mirror**. Mahogany, mirror. Band sawed and shaped, routed mirror slot. 16 x 18 x 6"
John Dodd. **Wall niche**. Fiddleback makore, mahogany, granite, mirror. Vacuum formed, veneered panel. 80 x 12 x 12"
Peter Pierobon. **"Jargon" chest**. Ebonized mahogany. Constructed, carved, lacquer finish. 71 x 31 x 26"

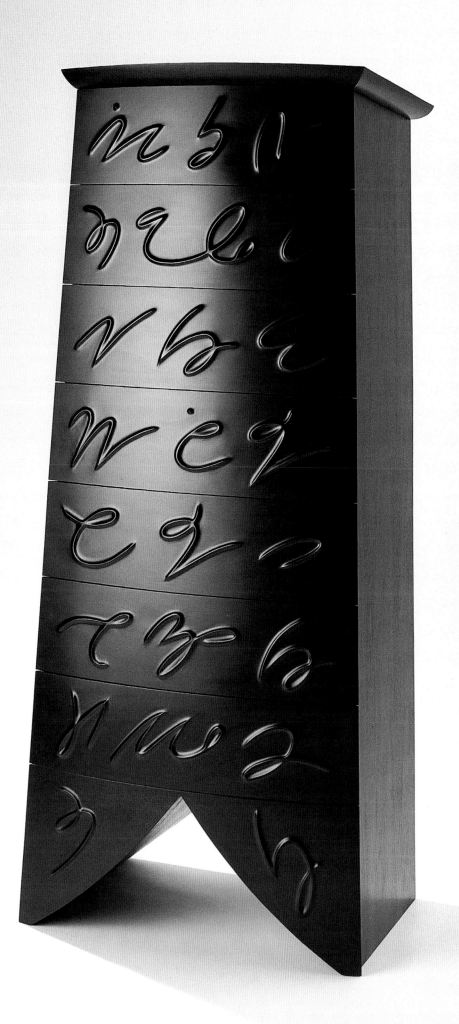

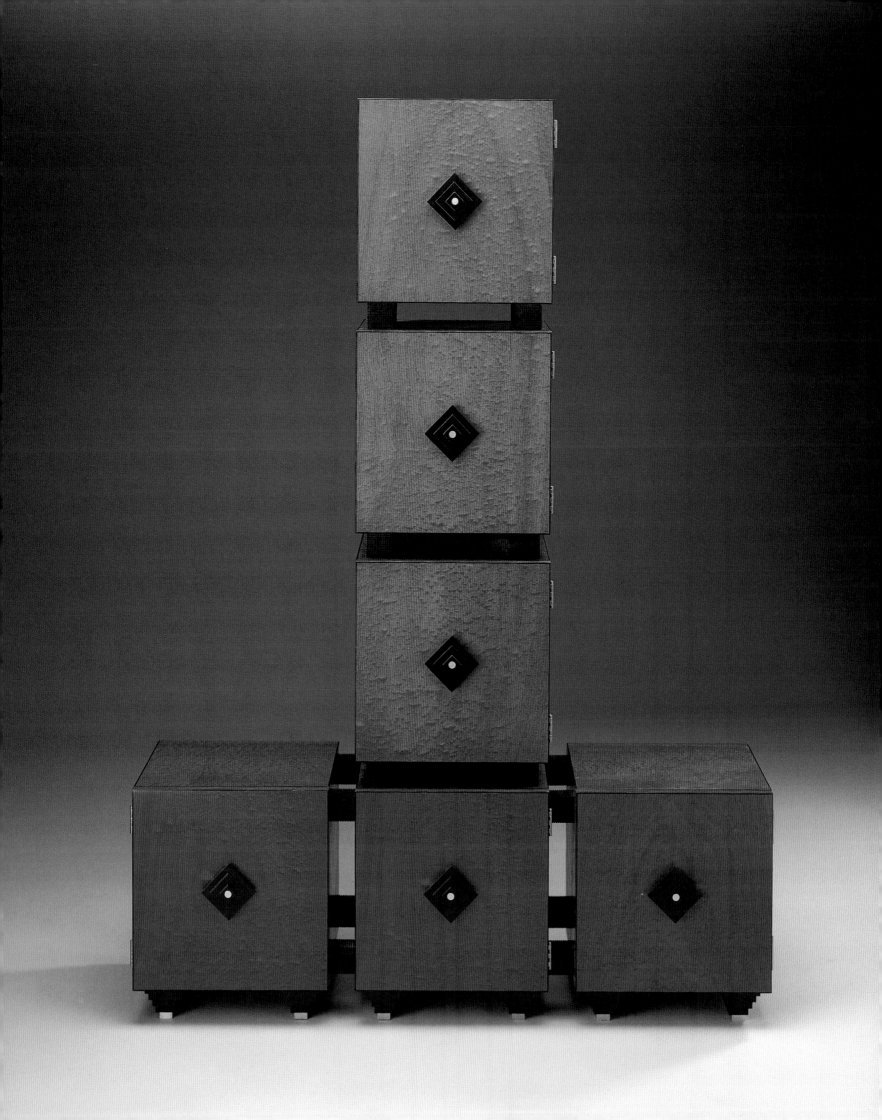

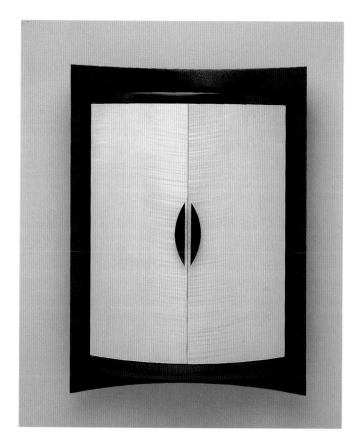
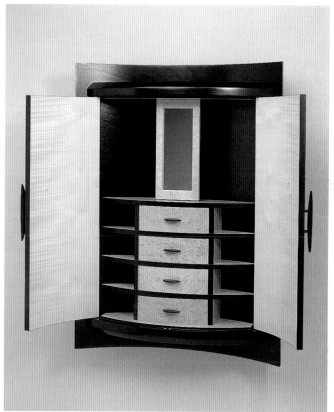

David R. Kiernan
"Squares" modular cabinet. Pommele sapele, black-lacquered mahogany, gold inlay in pulls. Constructed, lacquered. 72 x 48 x 16"
"Jewel" wall cabinet. English sycamore, bird's-eye maple, ebony pulls, mirror. Constructed, lacquered. 32 x 24 x 9"

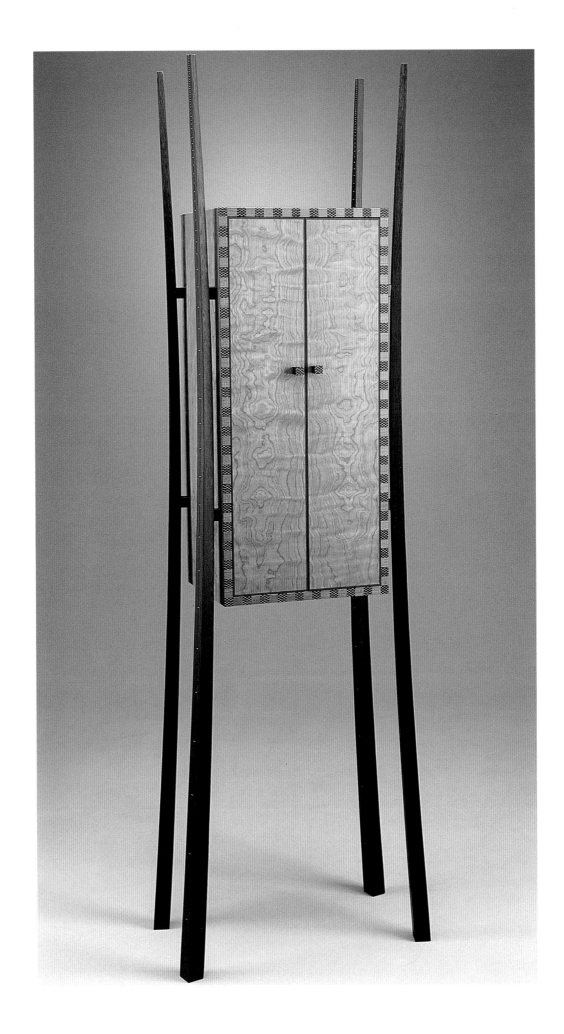

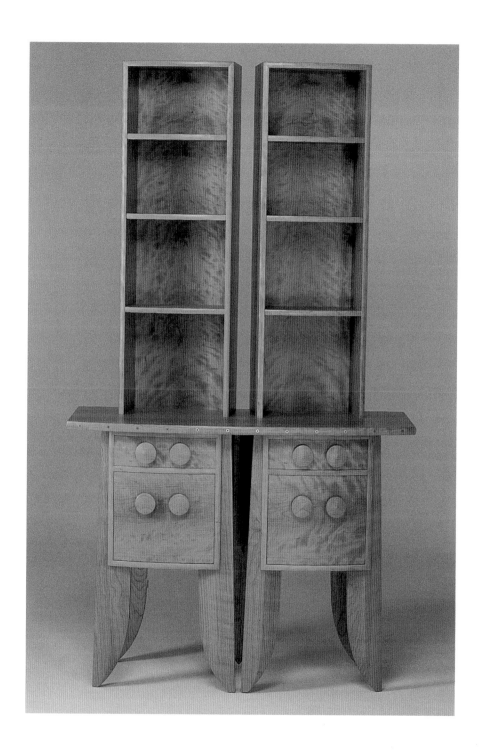

Ronald DeKok. **Standing cabinet**. Cherry, wenge, bloodwood, maple, green-dyed satinwood. Laminated, constructed, bent poles. 75 x 24 x 20"
John Dunnigan. **"9704" cabinet**. Cherry, brass. Constructed. 84 x 48 x 24"

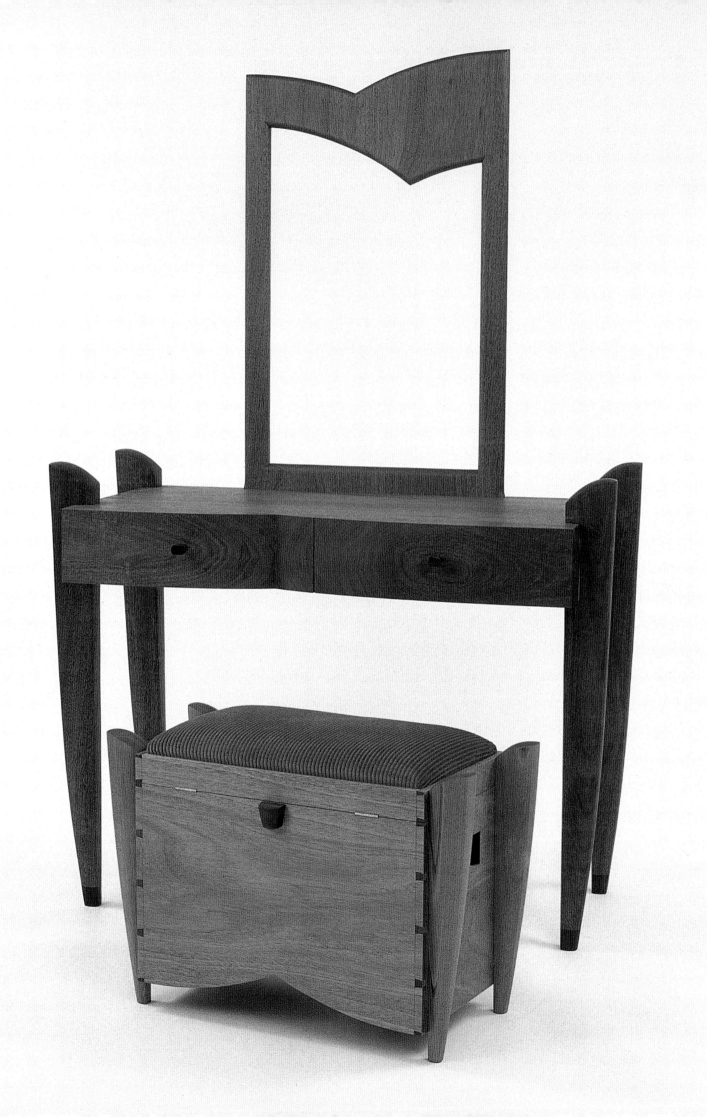

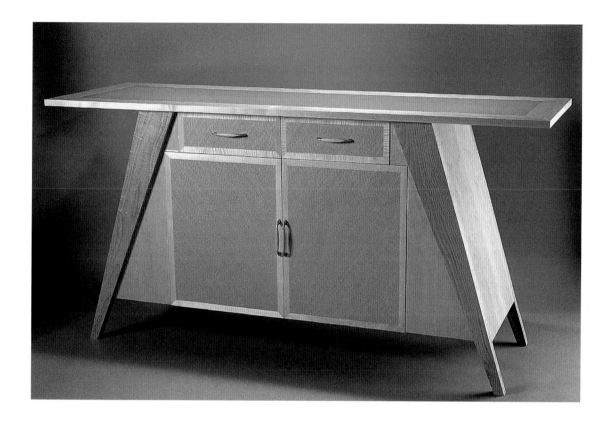

Keizo Tsukada. **Vanity with stool**. Mahogany, padauk, mirror. Constructed. 58 x 36 x 18"
Jay Wiggins, spaghetti western furniture. **Buffet**. Maple, caleidalegno, glass. Constructed. 42 x 72 x 24"

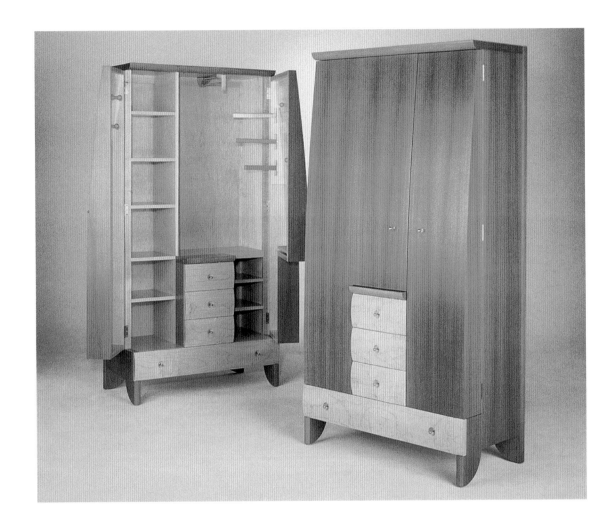

James Schriber
Pair of armoires. Pear, curly maple, stainless steel. Constructed, lacquer finish. 72 x 68 x 19". Private collection
Double chest with stand. Ebony, figured pommele sapele, mahogany, bronze pulls. Constructed, lacquer finish. 75 x 36 x 15"

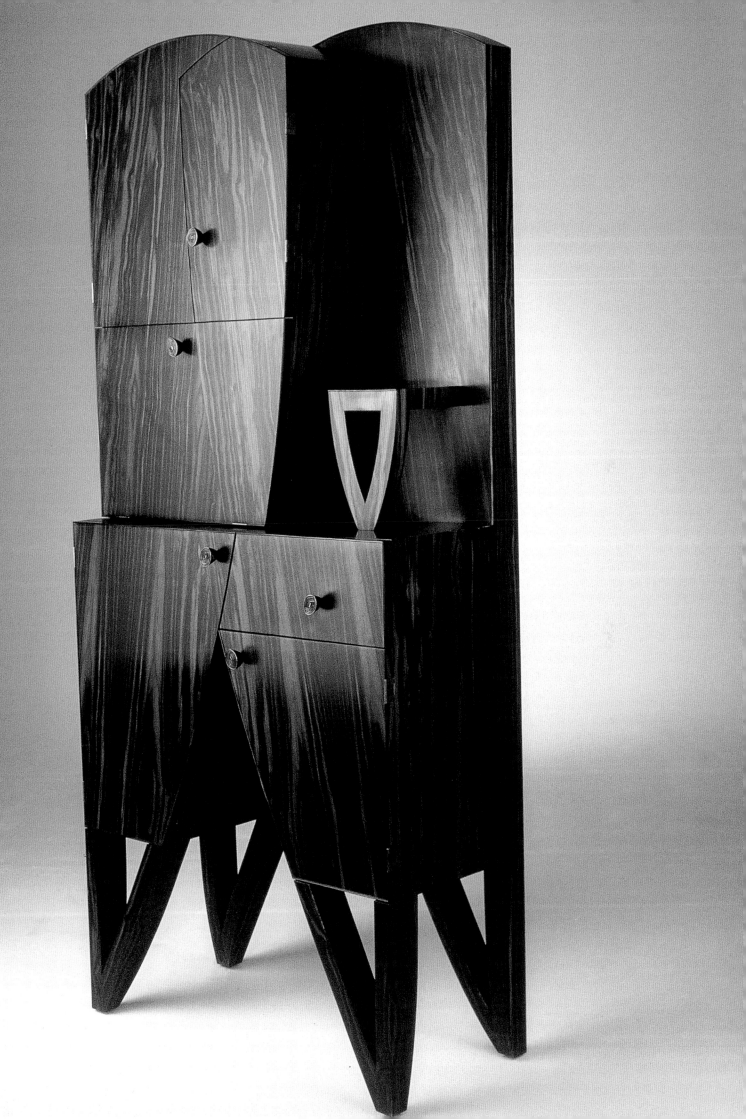

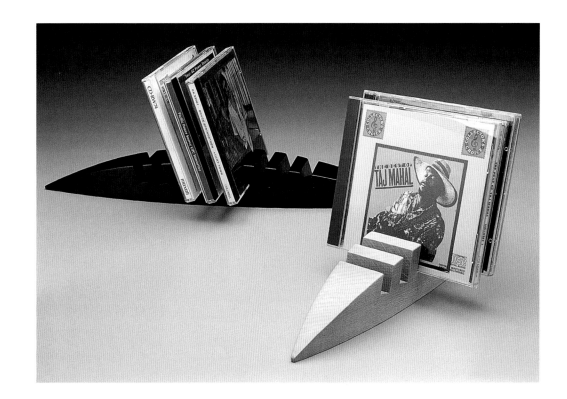

Richard Judd. **Tabletop CD holders**. Maple, poplar, black lacquer. Band sawed, edge sanded. 2 x 2 ½ x 16"
Yuko Shimizu. **"White-Black" CD towers**. Mahogany, maple, milk paint, black dye. Constructed, painted, dyed. 78 x 22 x 14"

Richard Judd. **Folding screen**. Birch plywood, mahogany, sapele, moabi, makore, ebony veneer. Constructed, veneered. 72 x 48 x 1"
David R. Kiernan. **Folding screen**. Curly makore, ebonized details, brushed-aluminum rod. Constructed. 72 x 48 x 1"

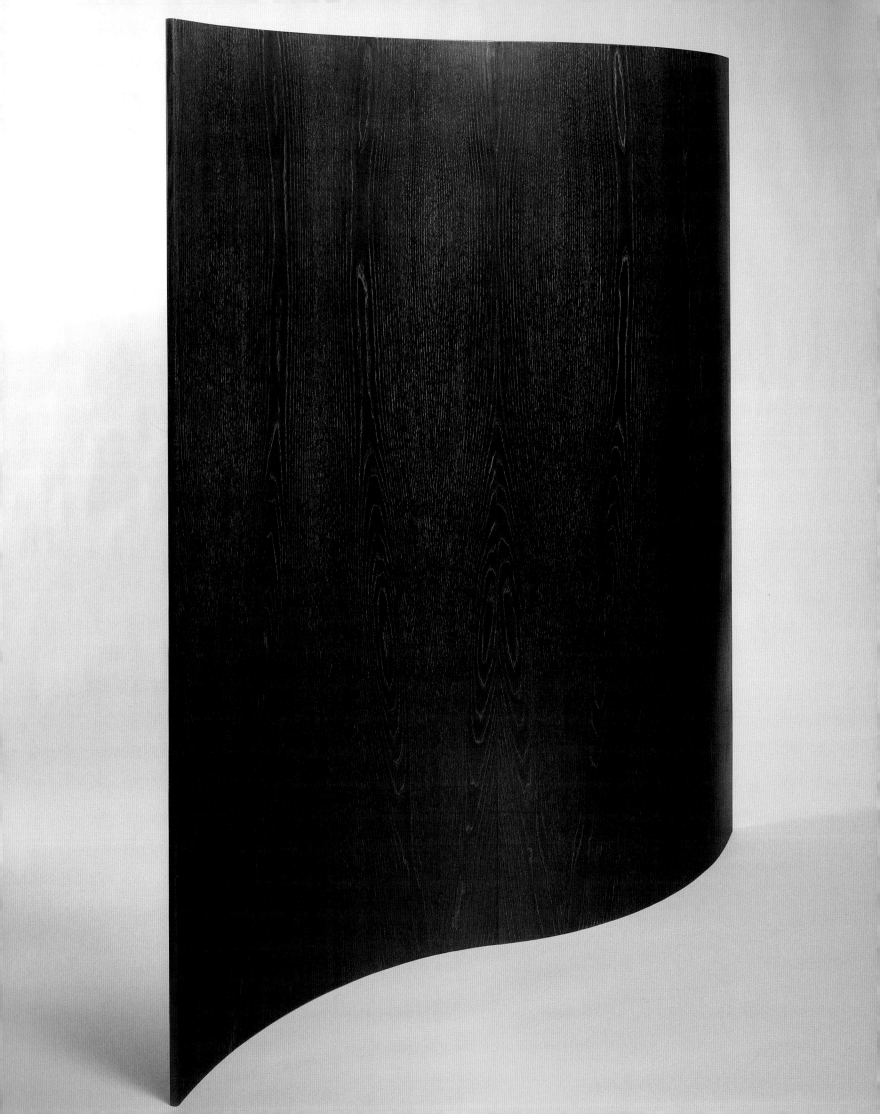

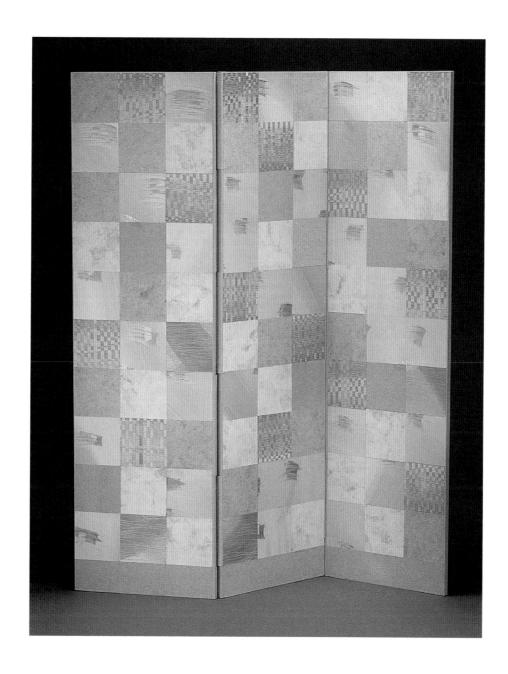

Michael Puryear. **Screen**. Dyed ash. Form laminated, dyed, filled. 69 x 59 x ⅝"
JoAnne Schiavone. **"Six Springs" screen**. Paste paper, fabric, handmade papers, wood, gold leaf. Constructed, layered, hinged. 61 x 53 x ¾"

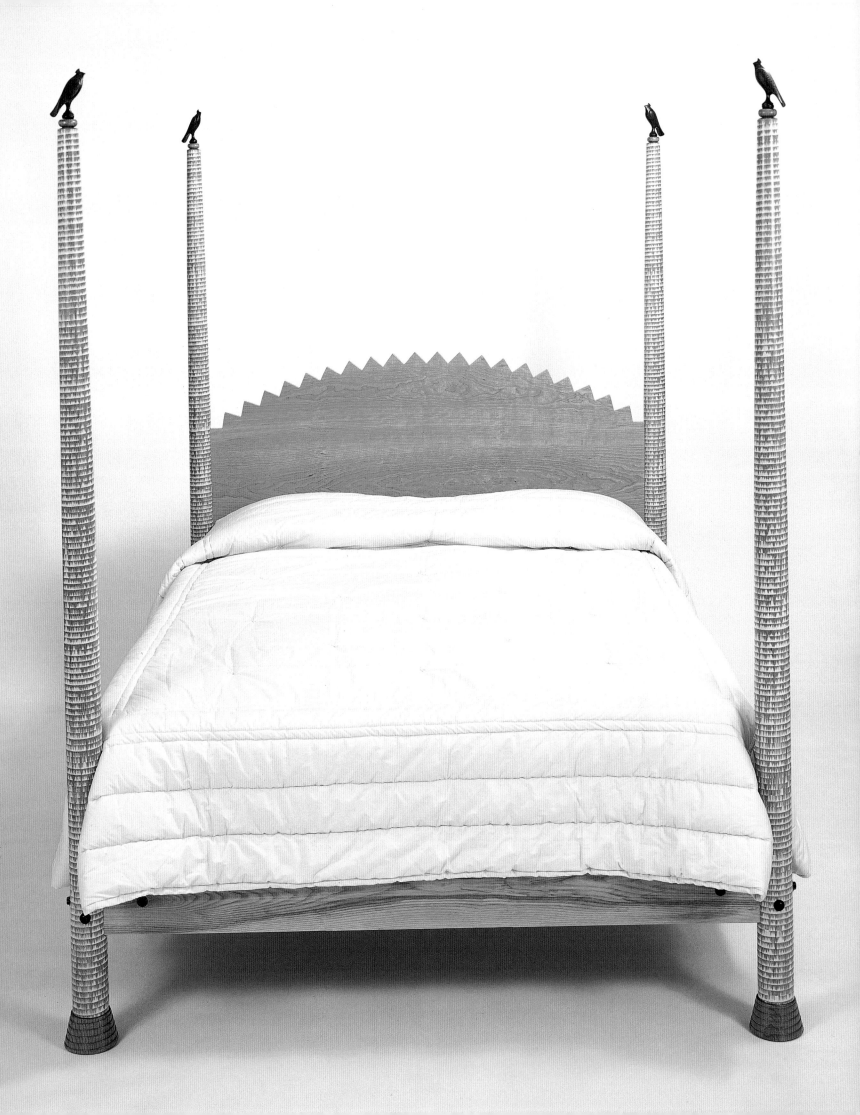

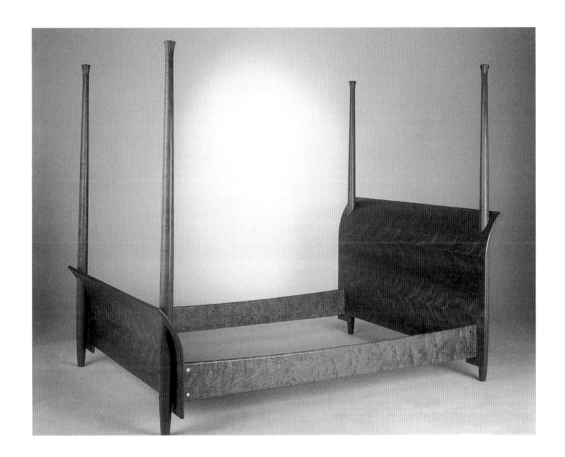

Brad Smith. **Highpost bed**. Cherry, ash, steel. Constructed, turned and textured posts. 88 x 66 x 86"
James Schriber. **Bed**. Cherry, solid and veneer. Constructed. 78 x 68 x 94"

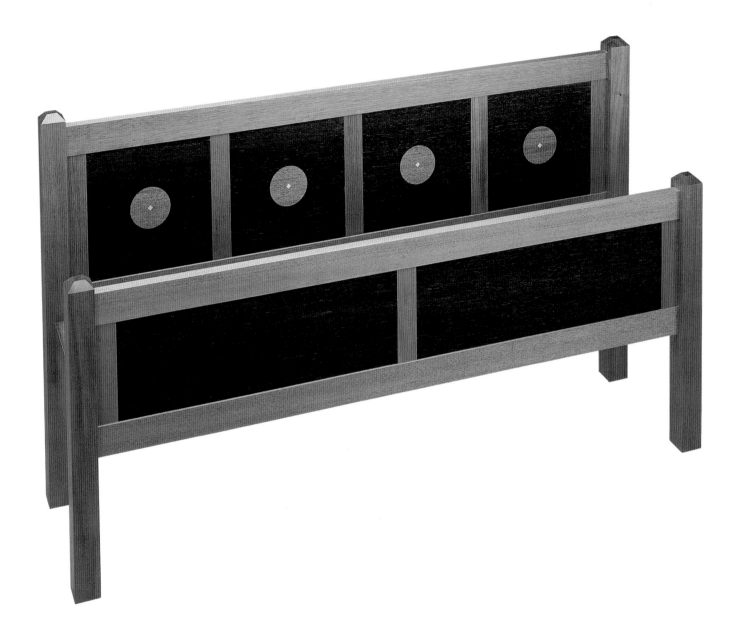

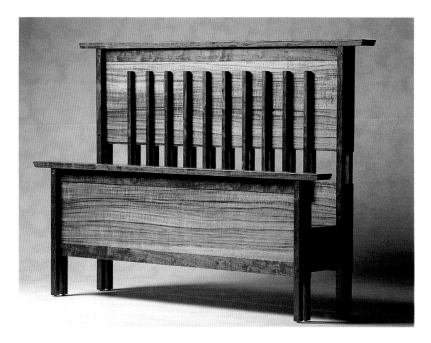

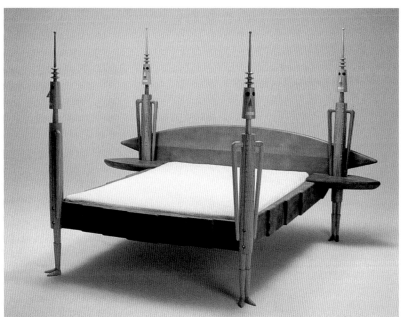

David R. Kiernan. **"Circles & Squares" bed**. Mahogany, wenge, brass inlay. Constructed. 38 x 64 x 84"
Anthony Beverly. **Bed**. Bubinga, koa. Constructed. 50 x 80 x 84"
Edward Zucca. **"Robot" bed**. Curly maple, poplar, ebony, paint. Constructed, carved. 77 x 112 x 89". Private collection

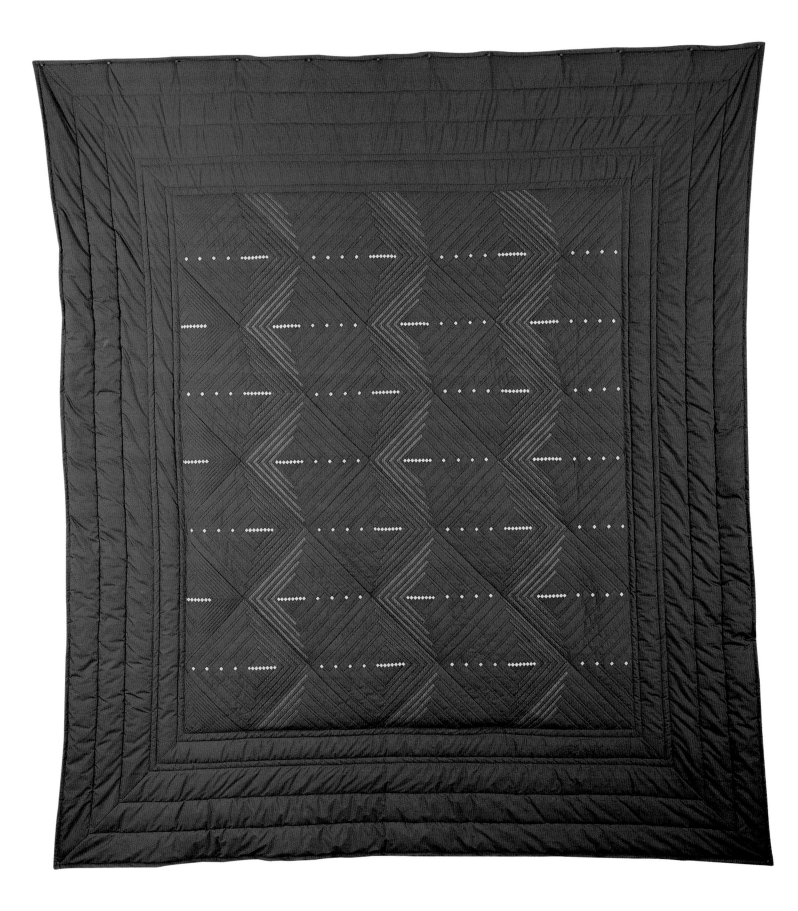

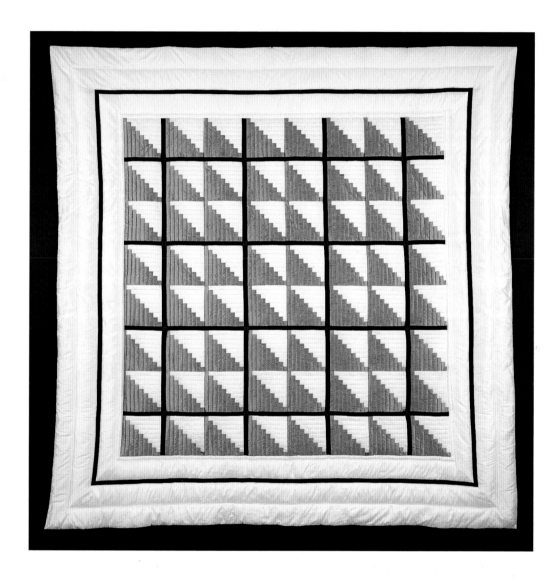

Pamela Hill. **"Goldrush" quilt**. Pima cotton, dupioni silk. Hand cut, pieced, machine quilted. 104 x 112"
Pamela Hill. **"Architectural Squares" quilt**. Dupioni silk. Hand cut, pieced, machine quilted. 106 x 106"

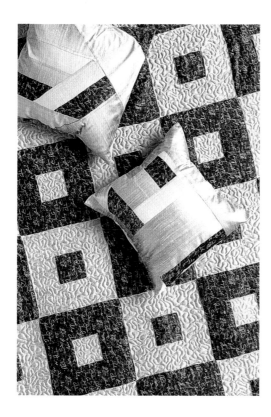

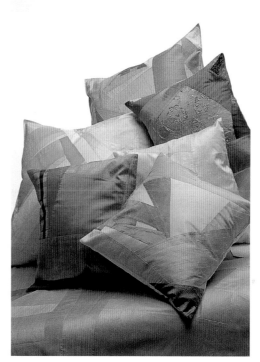

Ellen Kochansky. **"Tiles/Canyon" quilt** (detail). Mixed fabric. Machine pieced, quilted. 86 x 100"

Beth Cassidy. **"SQ/SQ" quilt with pillows** (detail). Silk, cotton blend, polyester fiber. Machine pieced and quilted. 89 x 102"

Beth Cassidy. **Pillows**. Silk, cotton blends, polyester fiberfill. Machine pieced. 16 x 16"–20 x 20"

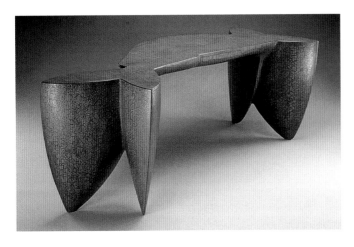

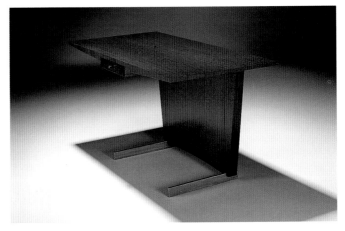

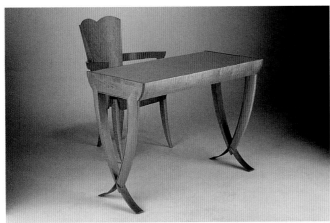

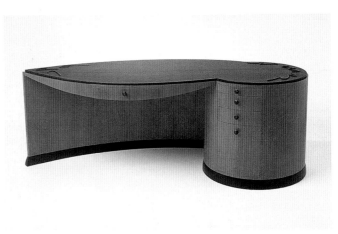

clockwise from top left:
Wendell Castle. **"No Excuses" desk**. Madrone. Constructed, shaped, crackle finish. 30 x 87 x 36". Private collection
Henry S. Fox. **"Early Boy" desk**. Wenge, ebony, steel. Constructed. 29 x 54 x 27"
Peter Pierobon. **"Point of View" desk**. Mahogany, leather, ebony. Constructed, veneered, carved, lacquer finish. 30 x 80 x 36". Private collection
James Schriber. **Writing table and chair**. Curly and bird's-eye maple, stainless steel, fabric. Constructed, upholstered. 36 x 40 x 30". Collection Dayton Art Institute, Dayton, Ohio

right:
Judy Kensley McKie. **"Lynx" desk**. Bronze, glass. Cast. 41 x 79 x 44"

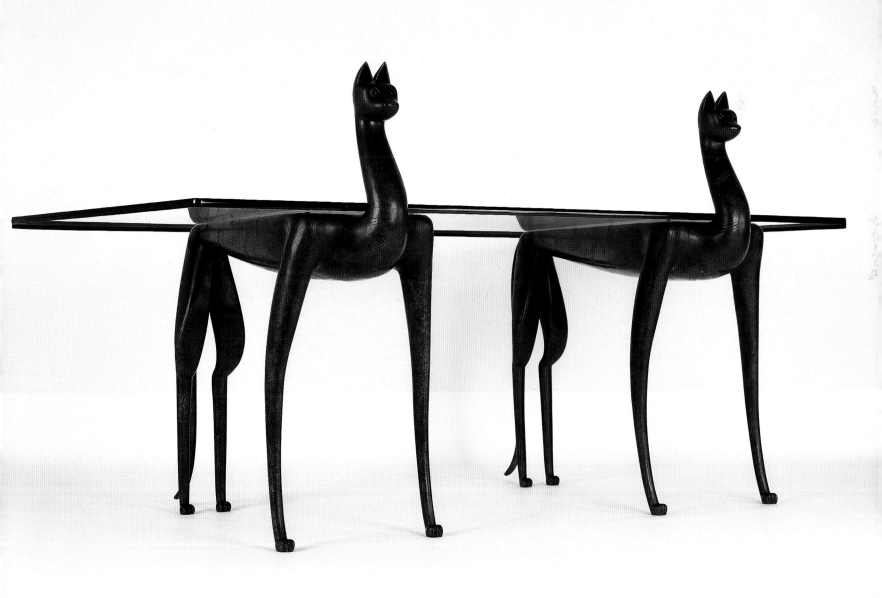

Floriana Petersen. **Desk set**. Leather, cherry, marbled paper. Fabricated, debossed leather. Pad ½ x 20 x 25"; book ½ x 5 x 7"; box 2 ½ x 6 x 6"

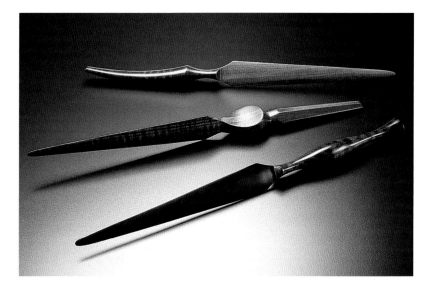

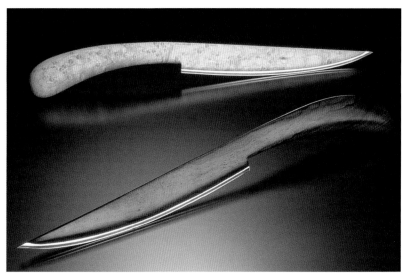

Norm Sartorius. **Letter openers**. Pernambuco, snakewood; bloodwood; ebony, snakewood. Hand shaped and finished. 1 x 1 x 11"

Thomas Davin, Davin & Kesler. **Silver-edge letter openers**. Bird's-eye maple, cocobolo with fine silver. Hand shaped and finished. ¾ x 10 ¼"

David Levy, Hardwood Creations. **Mail holder, card holder**. Exotic and domestic hardwoods. Laminated, shaped. Mail holder 2 x 7 x 10"; card holder 1 x 3 x 4"

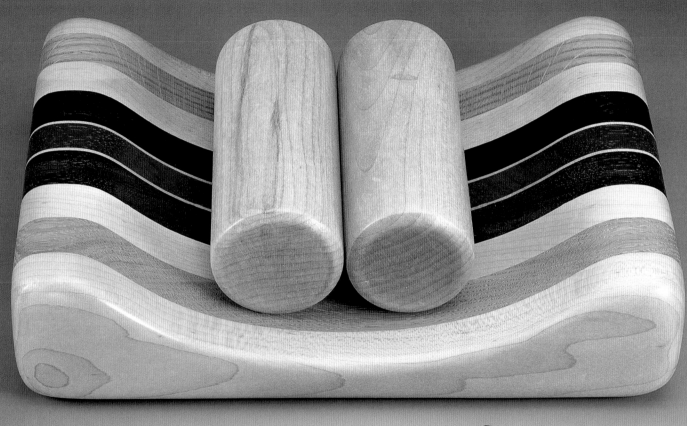
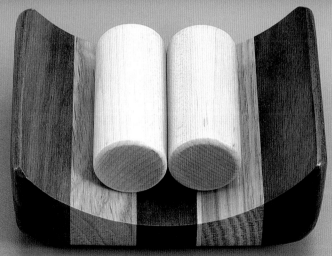

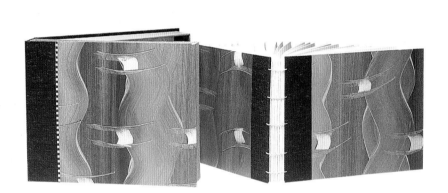

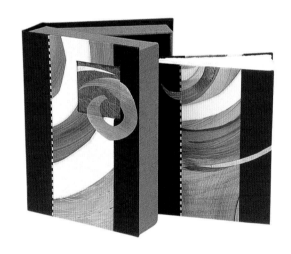

JoAnne Schiavone. **"Bronze River" album and box**. Paste papers, book cloth, handmade paper. Constructed, coptic bound. 9 x 11 ½ x 2"
JoAnne Schiavone. **"Wind" album and box**. Paste papers, book cloth, handmade paper. Constructed, coptic bound. 9 x 6 ½ x 2"
Thomas Davin, Davin & Kesler. **Bookends**. Maple. Shaped, laminated, glued. Each 8 x 4 x 5"

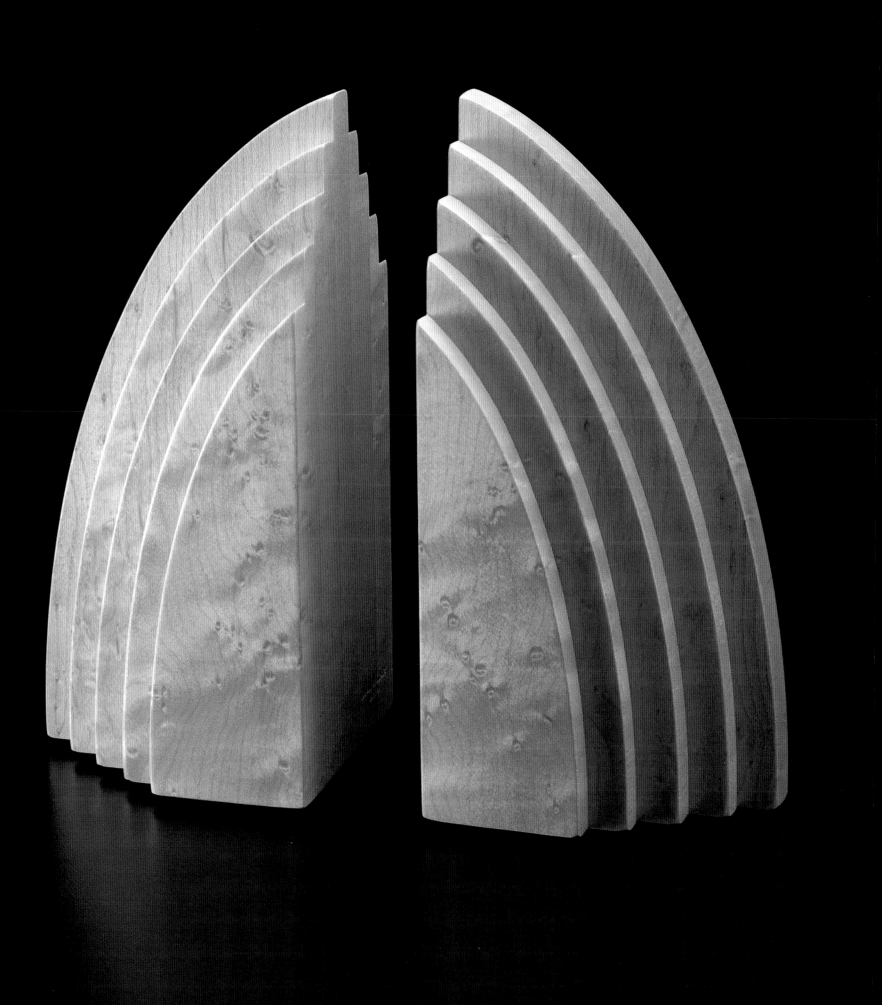

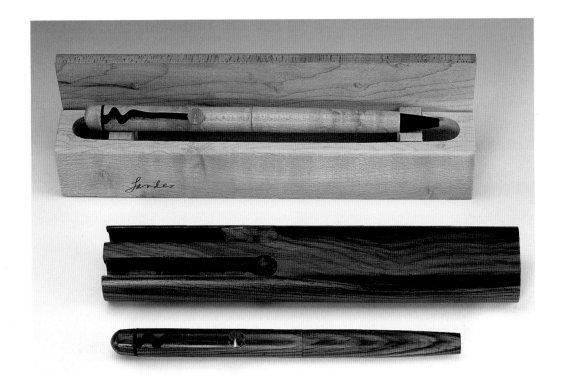

Elliot Landes, Penmakers

Pen with box, pen and pencil in case. Maple, rosewood, metal. Shaped, lathe turned, carnauba wax finish. Box 1 ¼ x 1 ¼ x 6"; case ⅝ x 1 ¼ x 6"

Pen holder, stamp box, card holder. Maple, black laminate. Shaped, carnauba wax finish. Pen holder 2 x 5 x 11"; stamp box 2 x 1 ½ x 1 ½"; card holder 1 x 2 ½ x 4"

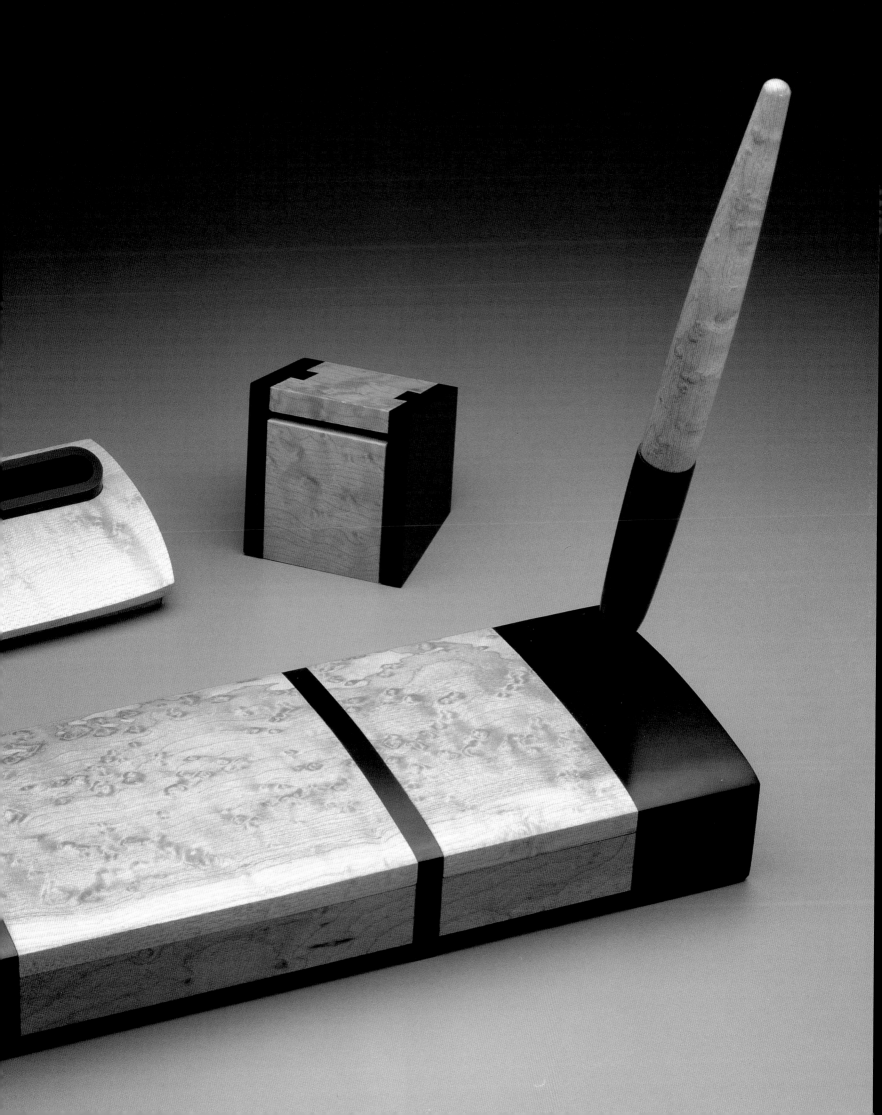

"I am a maker of objects. I have chosen basketry as my vehicle because
it allows me the greatest freedom to work with color and pattern in a
rigid form. Baskets are my way to make a personal difference in a
vast, often impersonal, computerized world." — Kari G. Lønning

John L. Skau, New Image. **"Solar Flares" sculptural basket**. Maple, poplar, paint, varnish. Damask weave combined with bentwood laminations. 7½ x 25 x 25"

Don and Jenifer Green, Greentree. **Wastepaper basket group**. Birch, leather, stainless steel. Constructed, bent, ebonized. 20 x 8 ½ x 13"

Kari G. Lønning. **"Becoming Band" containers**. Rattan, procion dyed. 5-rod wale with tapestry weave. 12 x 12" diam.

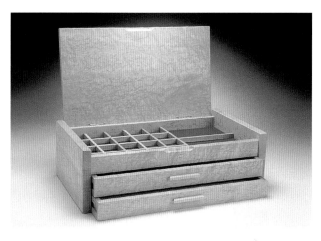

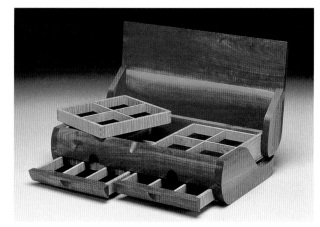

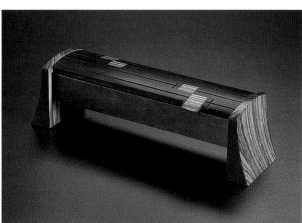

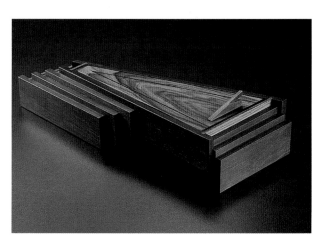

"I believe that a wood box should be just that— wood. So, as much as possible, I use only wood in my boxes, including the fasteners, hinges, and drawer slides. I am fascinated by wooden mechanisms, and the intersections of various geometric shapes." — Ray Jones

clockwise from top left:
Russell Pool. **Panel jewelry chest**. Bird's-eye maple, rayon velvet. Constructed. 6 x 20 x 11"
Ray Jones. **Box**. Pink ivorywood. Constructed, exposed-dowel joinery, wood hinges, oil finish. 4 x 15 x 9"
Philip Weber. **"Baby Grand" box**. Ebony, rosewood. Constructed. 2 ½ x 10 x 5"
Philip Weber. **"Left of Center" box**. Ebony, tulipwood. Constructed. 3 x 9 x 2 ½"

Ray Jones. **Assorted boxes**. Top to bottom: avodire, spalted beech, chakte kok, mesquite, maple burl, myrtle burl, bird's-eye maple, walnut, mahogany. Constructed, exposed-dowel joinery, wood hinges, oil finish. Smallest 1 ¾ x 3 ½ x 3 ½"; largest 5 x 15 x 9"

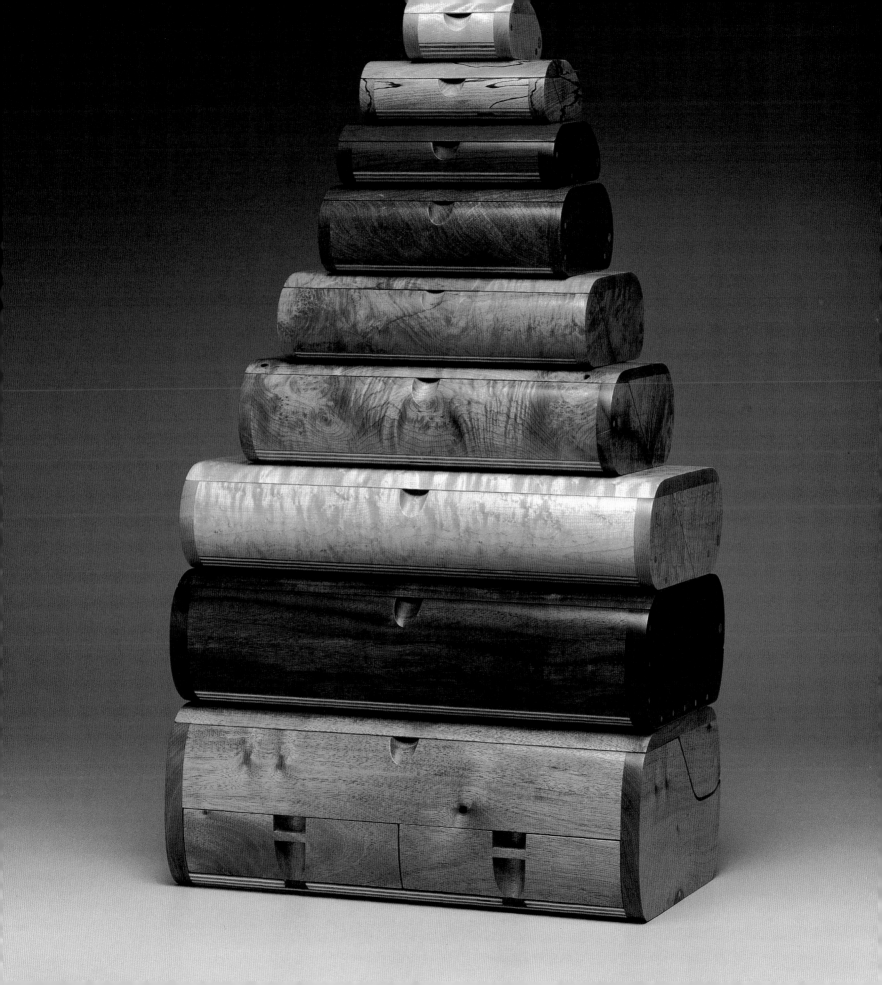

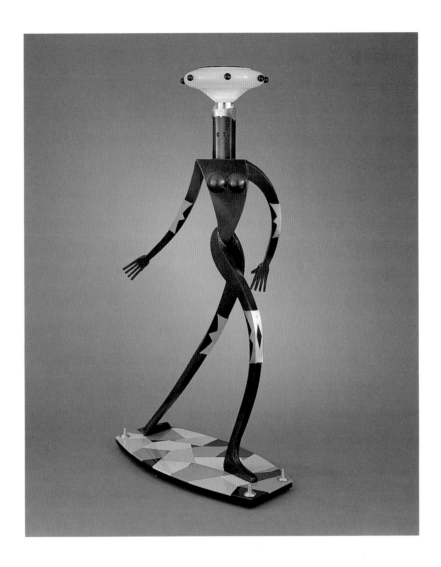

Dan Dailey

"Female Figurative" floor lamp. Glass, bronze, anodized aluminum, Vitrolite. Blown, cast, fabricated. 74 x 28 x 44"

"Bird" sconces. Glass (blown and plate), bronze, gold and zinc plate. Blown, cut, plated, fabricated. 16 x 10 x 10"

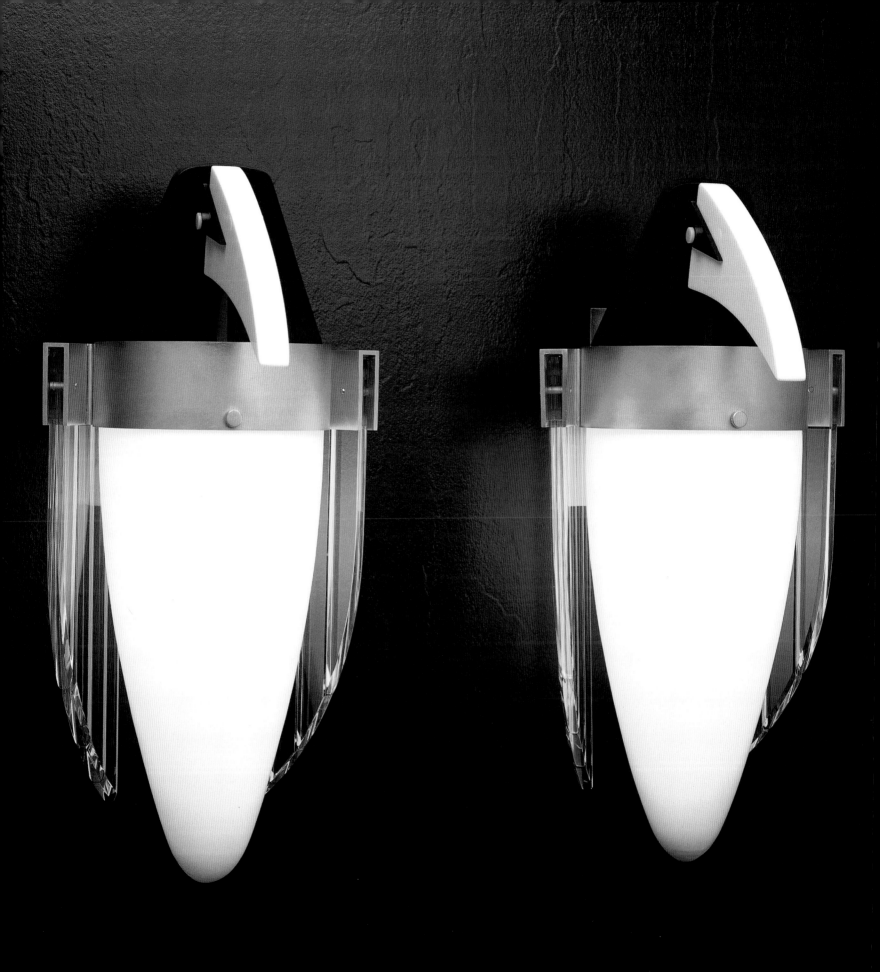

Louis Mueller
"**Magritte in Moscow" sconce**. Bronze, glass, enamel. Fabricated. 22 x 11 x 5"
Wall sconce. Bronze, glass. Constructed, hand-blown glass. 15 x 15 x 4"

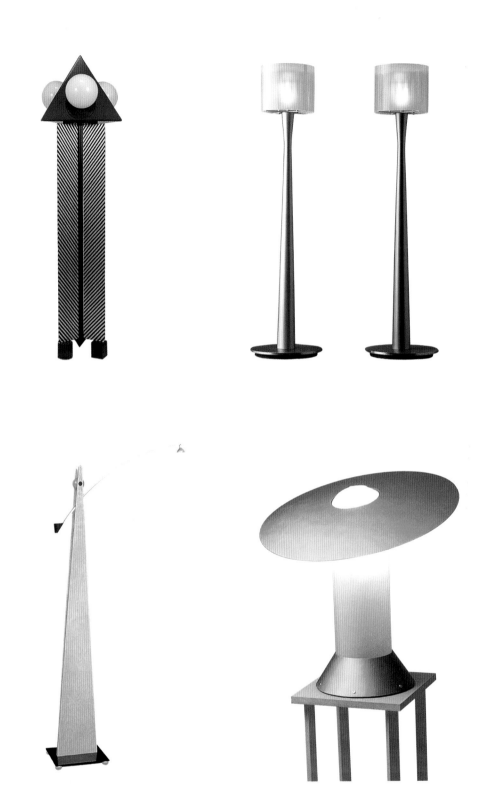

clockwise from top left:

Chunghi Choo. **"Sentry" floor lamp**. Aluminum, enamel paint, glass. Fabricated. 57 x 16 x 16"

David D'Imperio. **"Vortex" table lamps**. Stainless steel, aluminum, wood, glass. Turned and lacquered, machine-tooled, sandblasted, fabricated. 22 x 5 ¾" diam.

Jonathan Bonner. **Table lamp no. 5**. Aluminum, glass. Hand formed, spun. 20 x 19 x 19"

Tim Stewart. **"Alto 4" floor lamp**. Baltic birch, purpleheart, maple, aluminum, steel, 12v halogen lamp. Fabricated. 67 x 34 x 11"

right:

Benjamin Moore. **"Hornet" lamp**. Glass, brass. Blown, assembled. 24 x 15" diam.

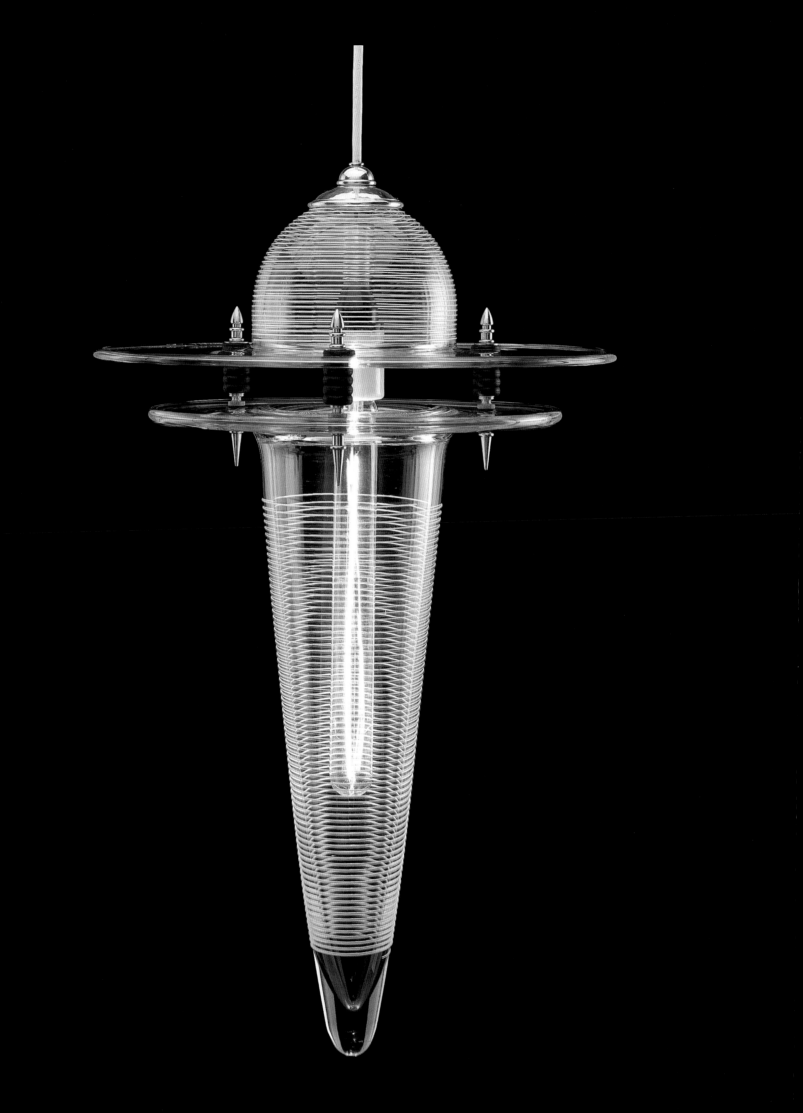

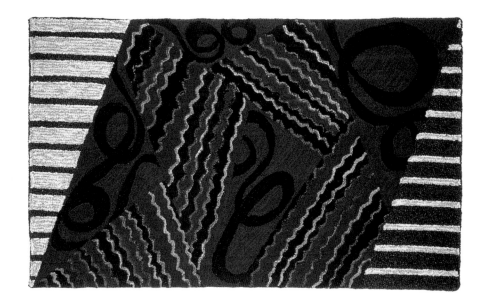

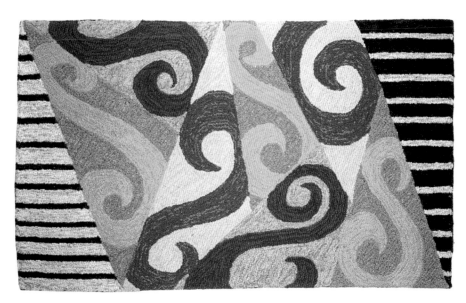

Cloria E. Crouse. **"Fusion" rug**. Wool on linen ground. Hand tufted, sculpted. 108 x 84"
Meg Little. **"Crazy Squiggles" rug**. Wool on polyester, backed with cotton, latex. Hand tufted. 36 x 60"
Meg Little. **"Crazy Scrolls" rug**. Wool on polyester, backed with cotton, latex. Hand tufted. 36 x 60"

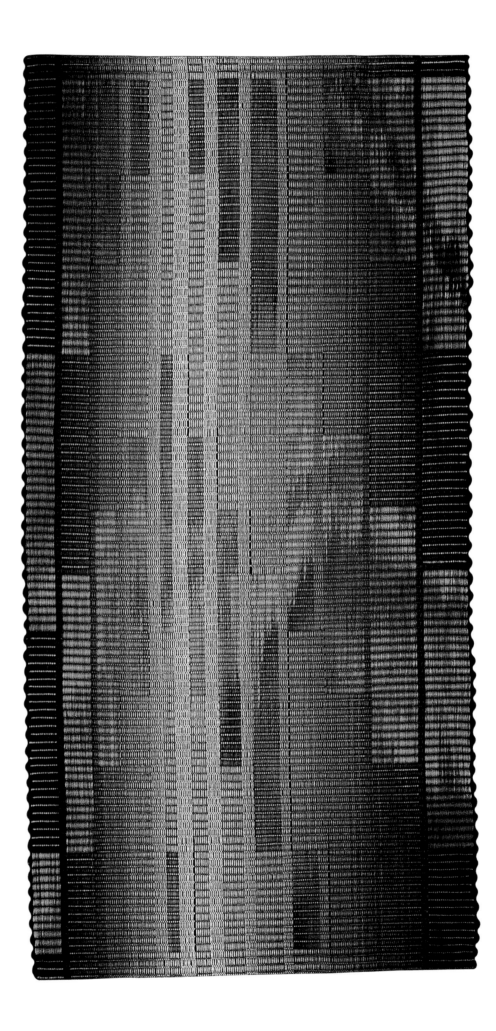

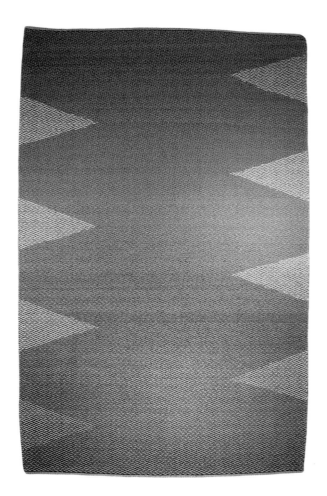

John Gunther. **"Graph" rug**. Hand-dyed wool. Woven, 8-harness ripsmatta weave. 82 x 36"
Michael F. Rohde. **"Celebration by the Sea" rug**. Hand-dyed wool, linen warp. Woven. 67 x 44"
Michael F. Rohde. **"Debbie's Windows" rug**. Hand-dyed wool, linen warp. Woven. 57 x 30"

Sara Hotchkiss. **"Autumn Water" rug**. Cotton fabric, cable cotton warp. Woven. 96 x 32"
Wendy Mueller. **"Piecemeal" rug**. Dyed wool. Felted. 55 x 80"

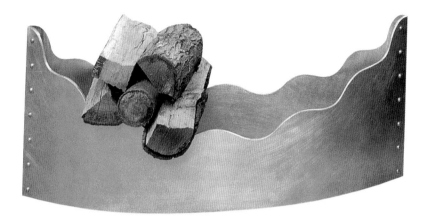

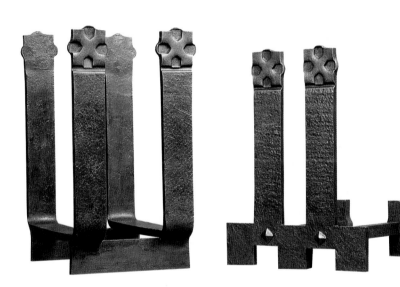

"For me, forging is primarily a performance art during which the violent encounter between fire, metal, and smith is recorded in the finished piece's powerful form and textured surface." — Russell C. Jaqua

Dick Wickman. **"Bulwark" andiron set**. Iron. Cast. Each 24 x 9 ½ x 18"
Jonathan Bonner. **"Rose" firewood holder**. Brass, copper. Fabricated, riveted, hinged. 17 x 40 x 14"
Russell C. Jaqua. **"Postmodern" basket and andiron set**. Mild steel. Forged, hot-stamped, welded. 15 x 12 x 13"

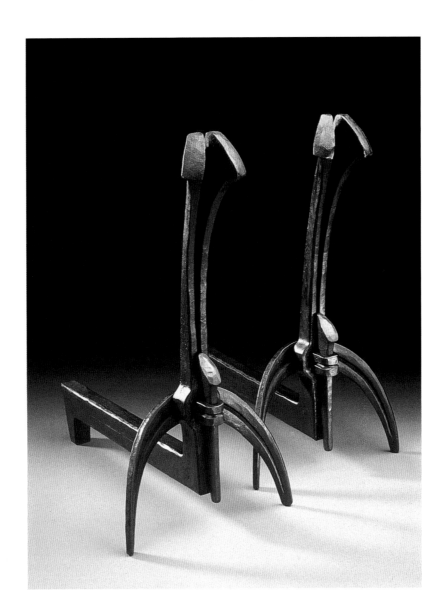

Daniel Miller. **"Agamemnon Undone" andiron set**. Mild steel. Forged. 21 x 23 x 18"
Dan Dailey. **Fireplace figure**. Bronze, stainless steel, nickel- and gold-plated elements. Cast, fabricated, patinated. 25 x 31 x 20"

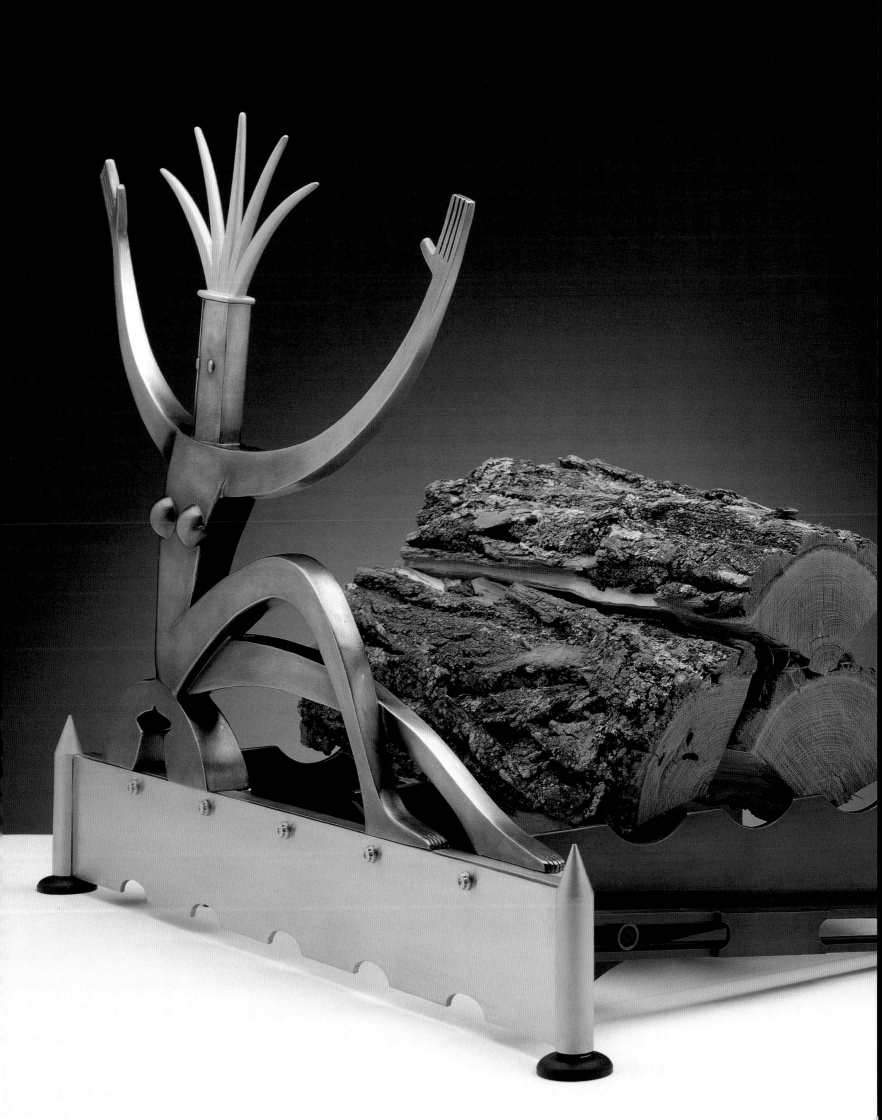

Tom Joyce. **Pieced-plate door handles**. Iron. Forged. 16 x 15 x 2"
Tommy Simpson. **Door handle**. Iron. Forged. 13 ½ x 4 x 2 ½"

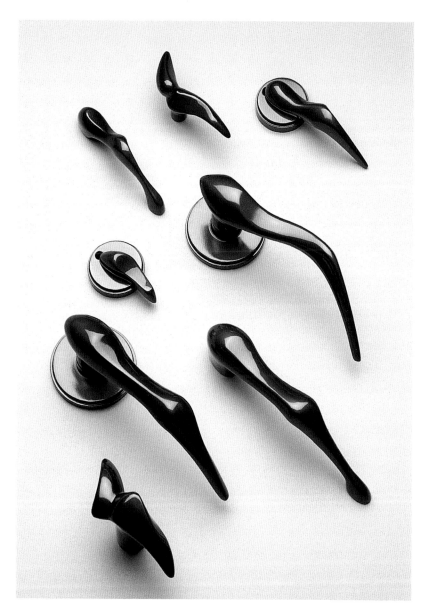

Judy Kensley McKie. **"Gecko" door handles**. Bronze. Cast. 30 x 10 x 4 ½"
Jennifer Coppel, Eden Hardware. **"Legs" right and left door levers**. Nickel. Cast, machined, satin finish. 2 x 10 ½" overall
Jennifer Coppel, Eden Hardware. **"Legs Series" door pulls**. Bronze with dark patina finish. Cast, machined, polished, patinated. Largest 2 x 6 x 1"

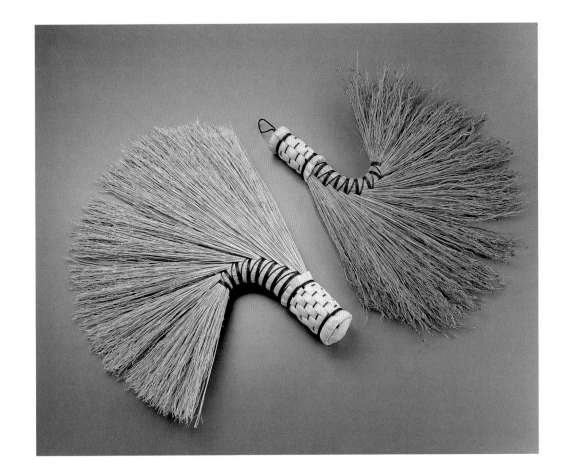

Carlson Tuttle. **"Turkey Wing" brooms**. Mexican broom corn, thread. Constructed, coiled, woven. 13 x 11 x 1 ¼"; 15 x 12 x 1 ½"
Dennis MacDonald, Highpoint Crafts. **Feather dusters**. Ostrich feathers, wood. Assembled. 30 x 12"

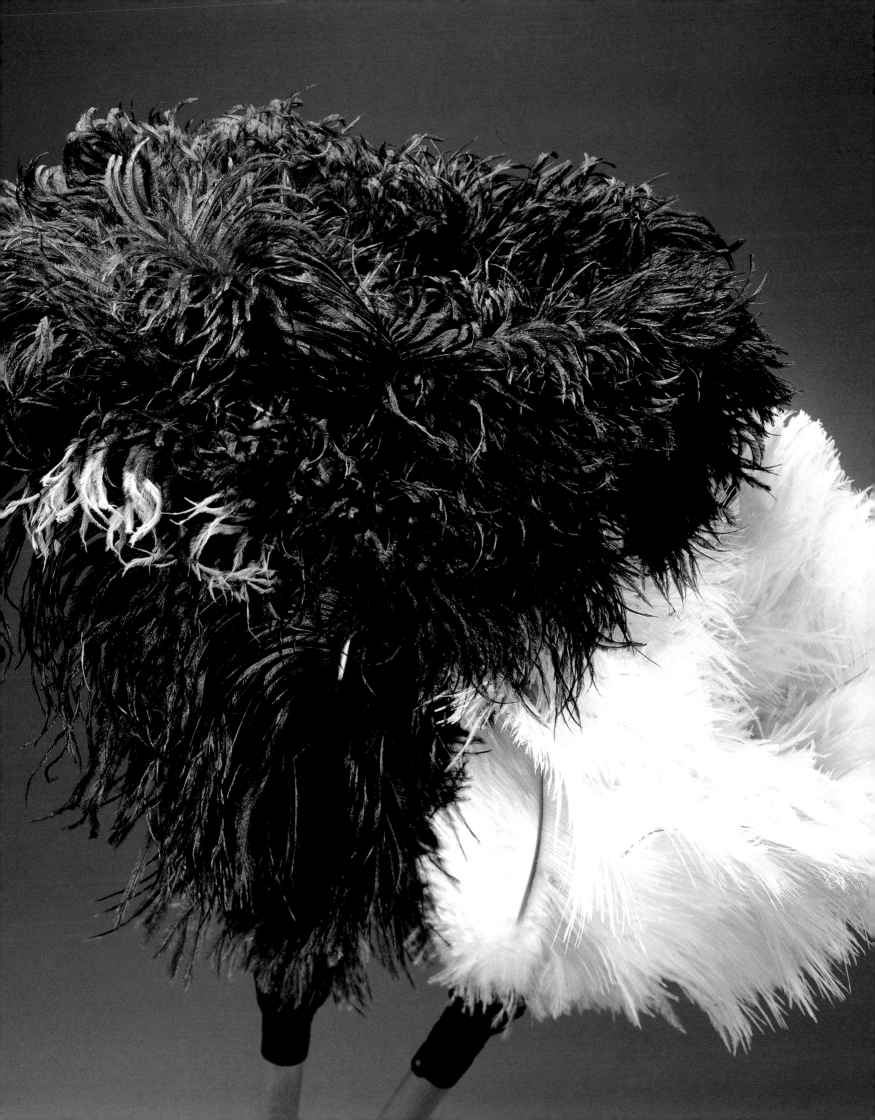

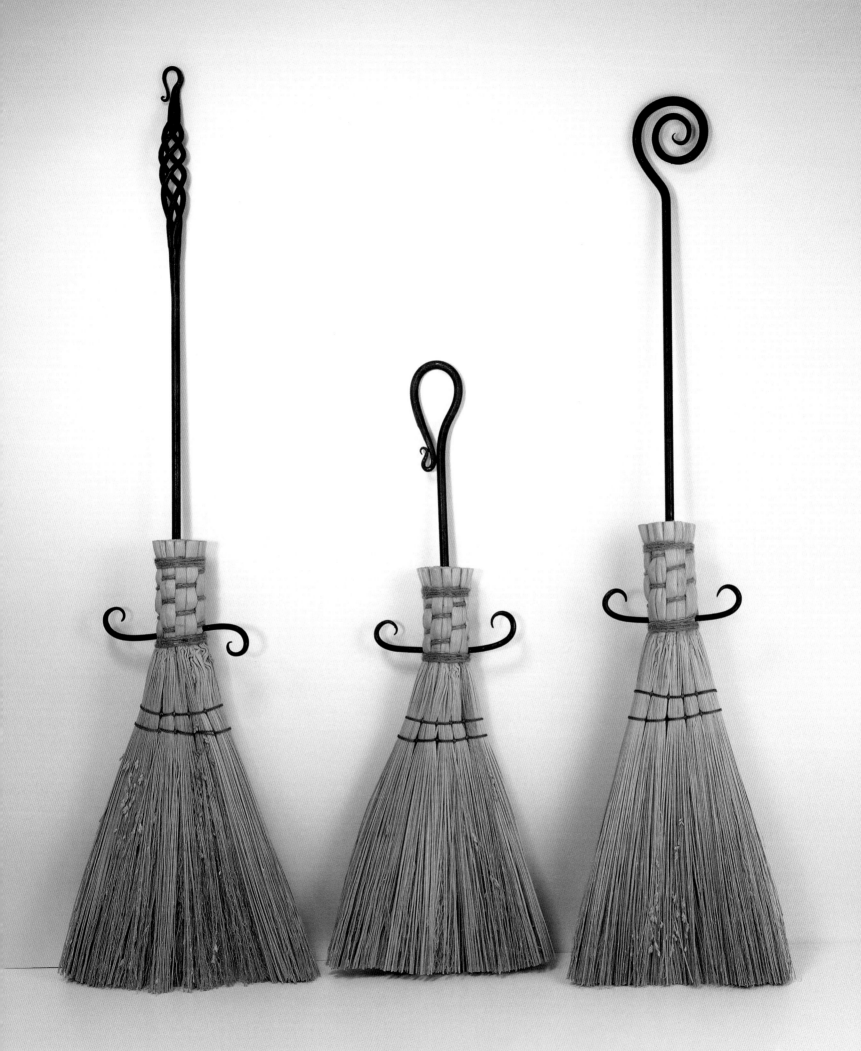

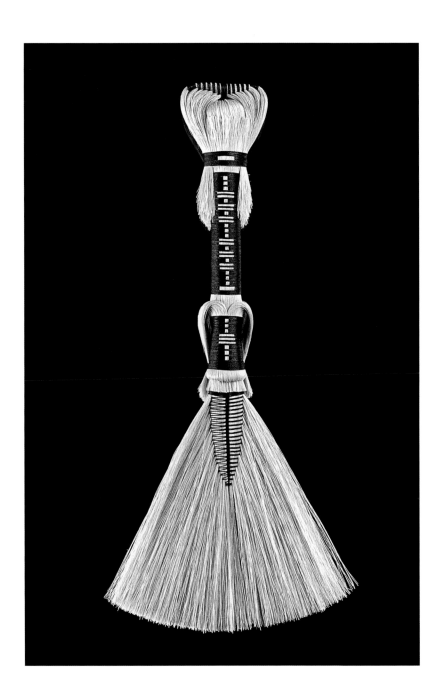

Dennis MacDonald, Highpoint Crafts; forged metal handles by Durand Van Doren. **Brooms**. Broom corn, iron. Constructed, woven. Tallest 36 x 7"
Bobbe McClure. **"Chombu" brush**. Lechuguilla fiber. Woven, plaited. 16 x 8 x 2"

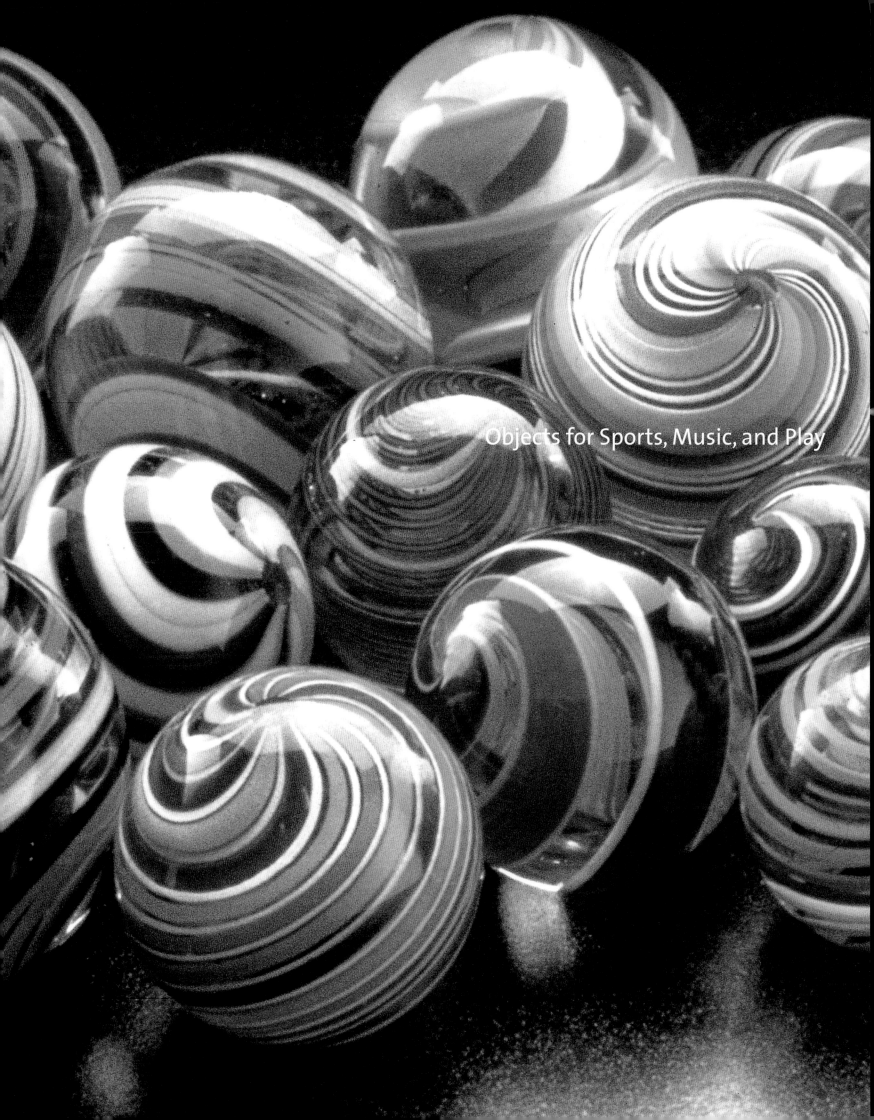

Objects for Sports, Music, and Play

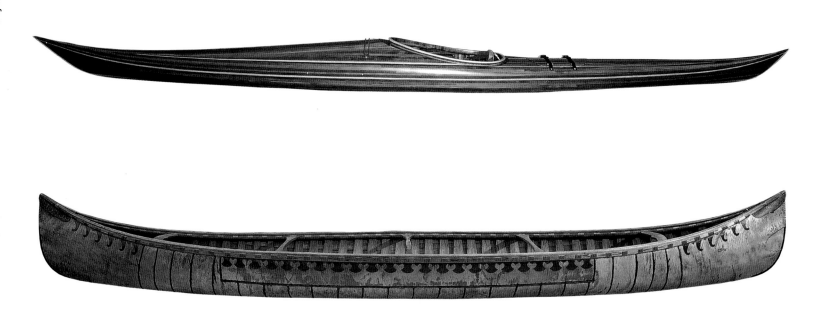

Nick Schade, Guillemot Kayaks. **"Night Heron" sea kayak**. Western red cedar, pine, fiberglass, epoxy. Cold-molded-strip construction, covered with fiberglass. 20 x 14 x 216"
Henri Vaillancourt. **"St. Lawrence River" Malecite birch-bark canoe**. Birch bark, white cedar, spruce root, pine pitch. Traditional construction based on techniques used by Malecite Indians of Quebec, Maine, and New Brunswick. 26 x 34 x 192". (detail opposite)

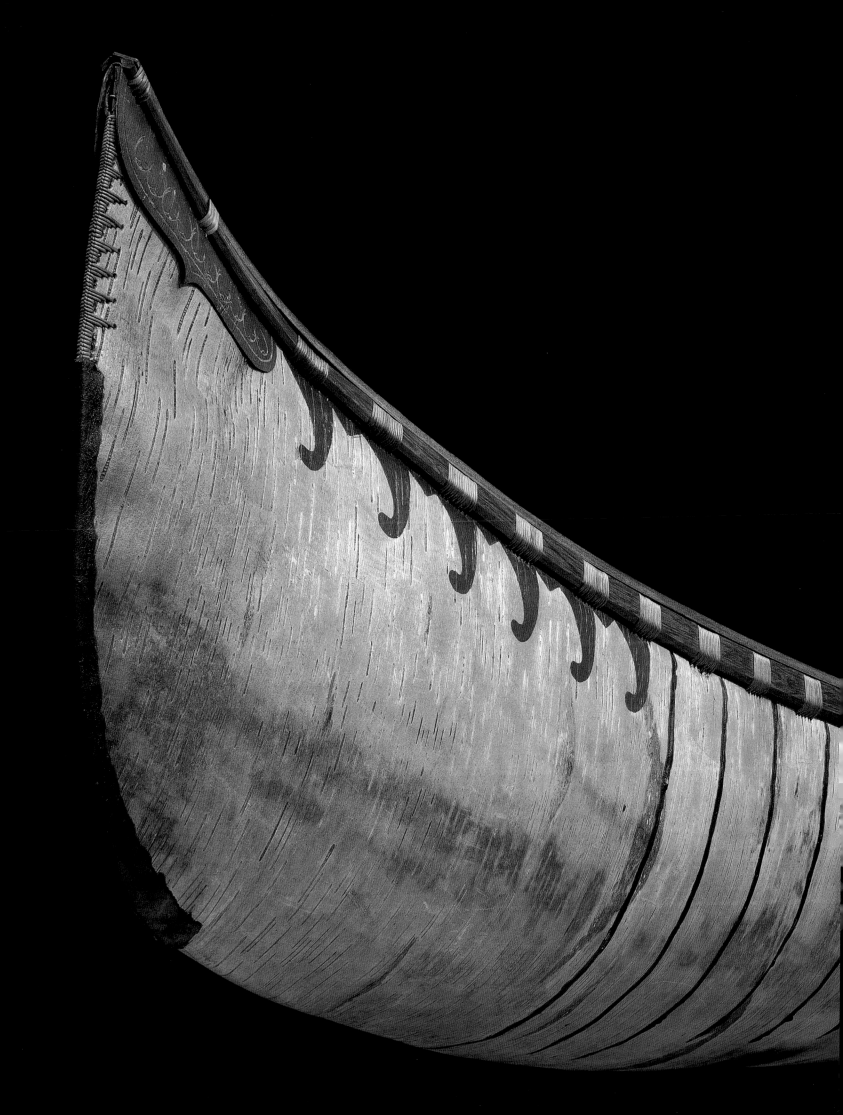

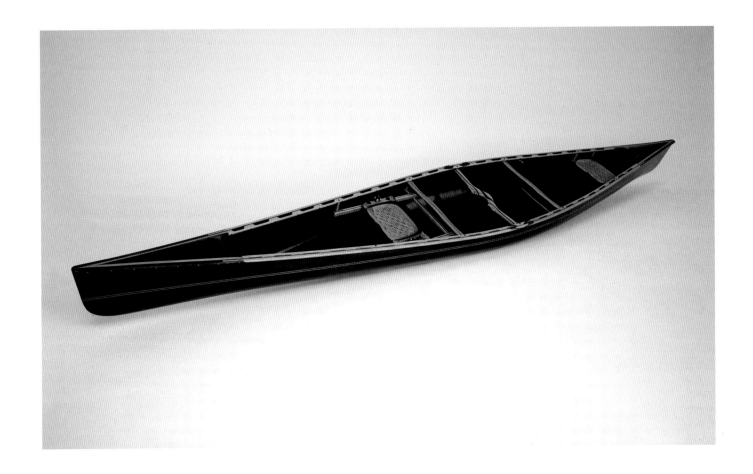

Philip A. Greene, Wood Song Canoes. **"Whistlewood" canoe**. Mahogany, curly maple. Strip construction, carved, polyurethane finish. 20 x 34 x 235". (detail opposite)

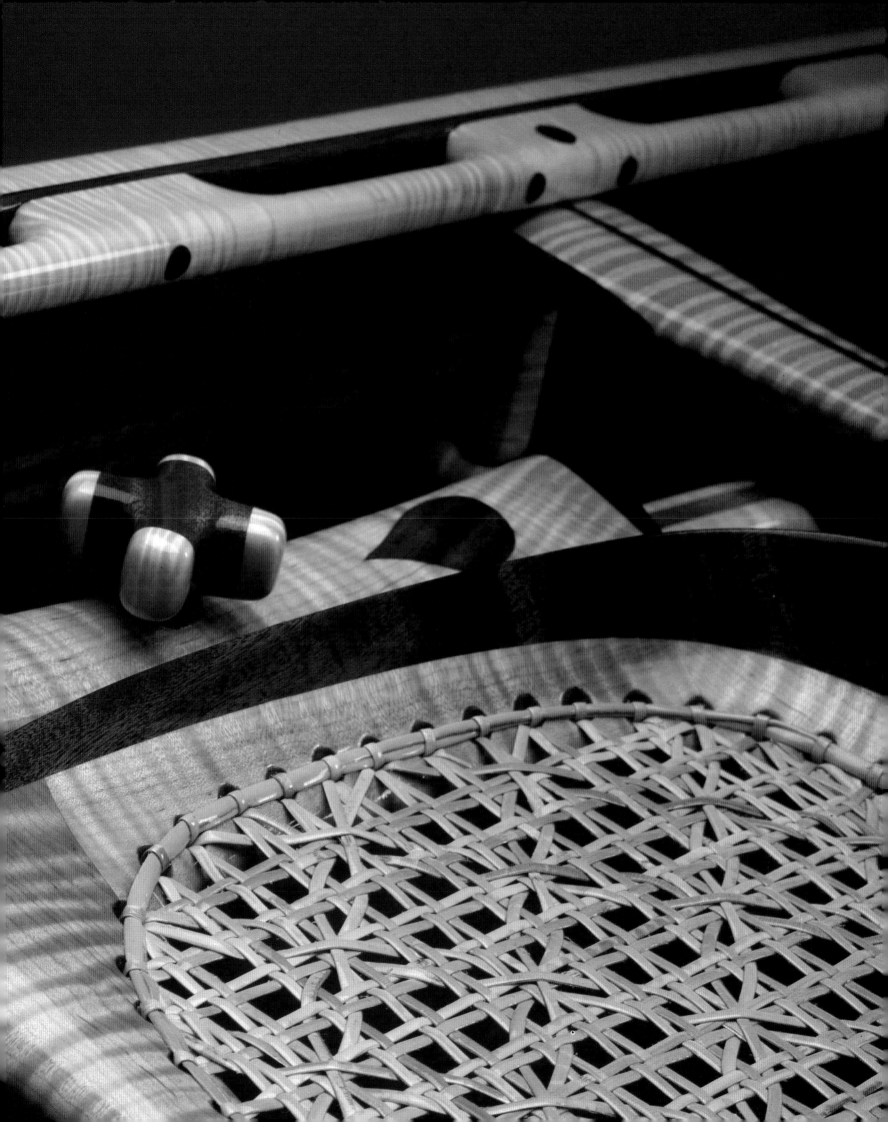

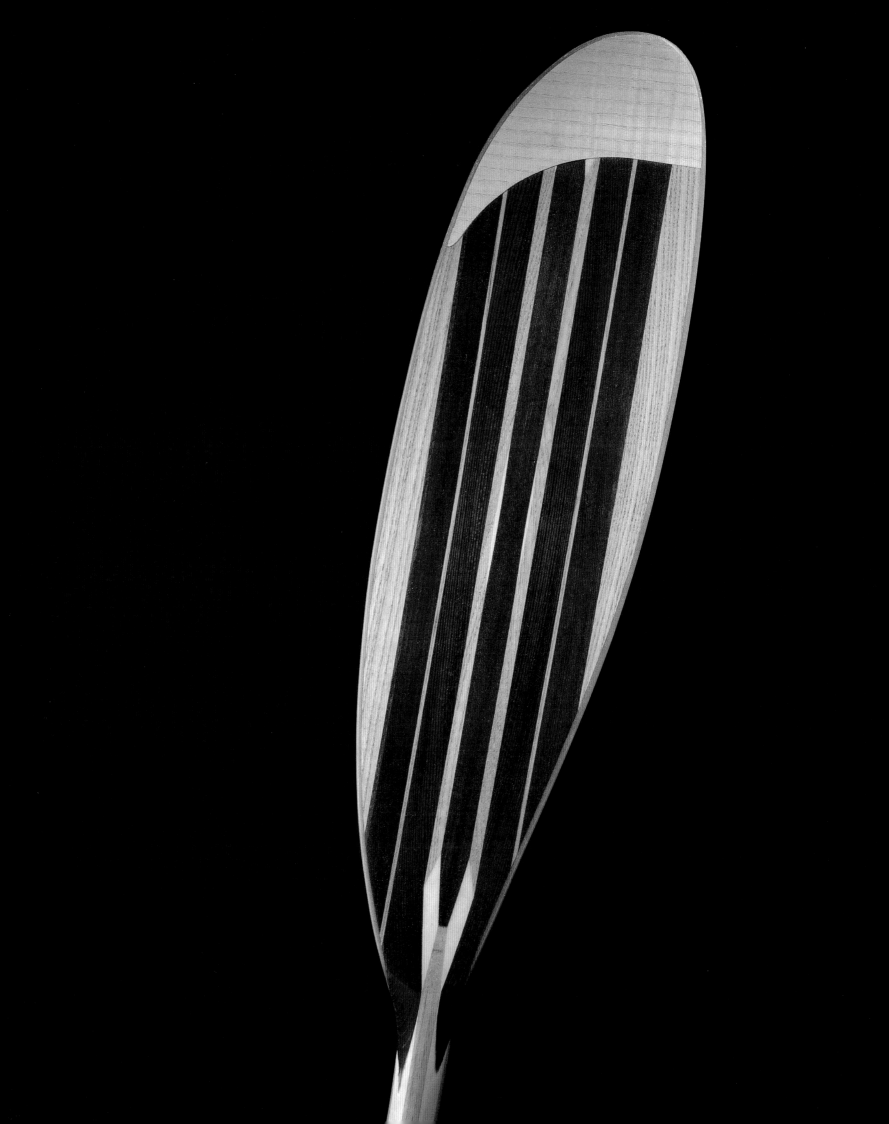

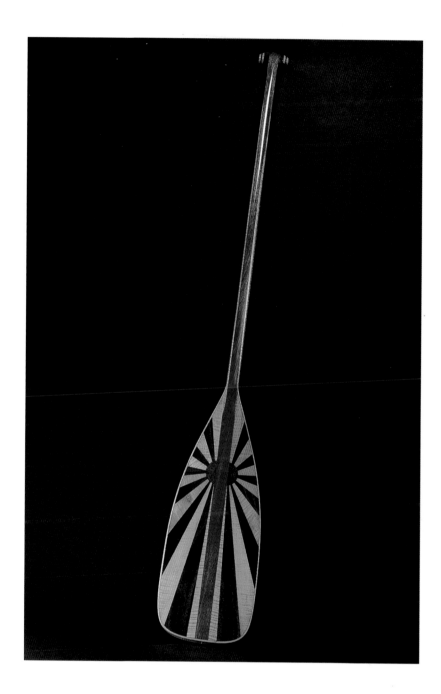

Chris Franznick. **"Islander" sea kayak paddle** (detail). Ash, red cedar, spruce, fiberglass, carbon fiber, epoxy. Laminated, formed. 91 x 6 x 2". Private collection
Philip A. Greene, Wood Song Canoes. **"Sunrise" paddle**. Mahogany, black walnut, curly maple, white oak, polyurethane finish. Laminated, shaped. 52 x 9 x 2 ½"

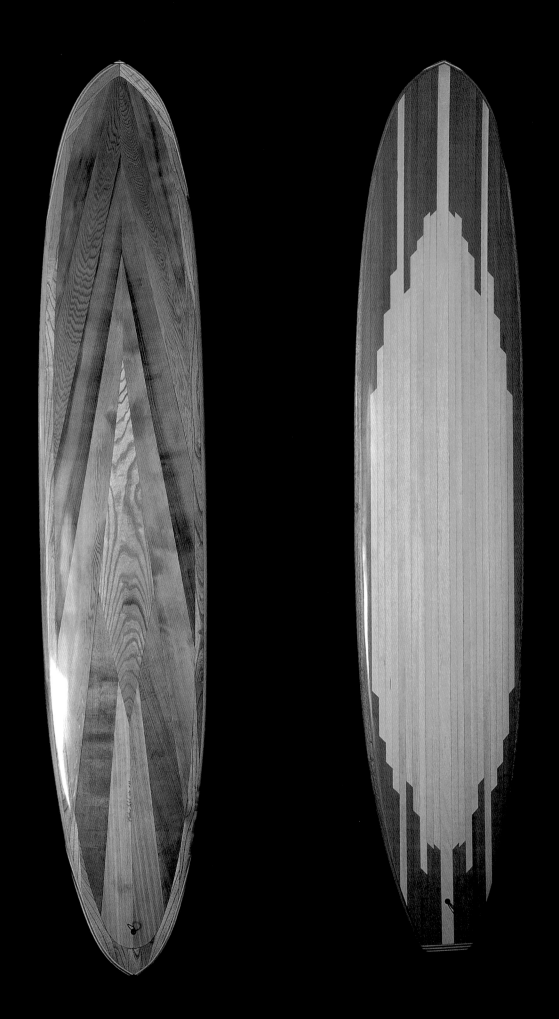

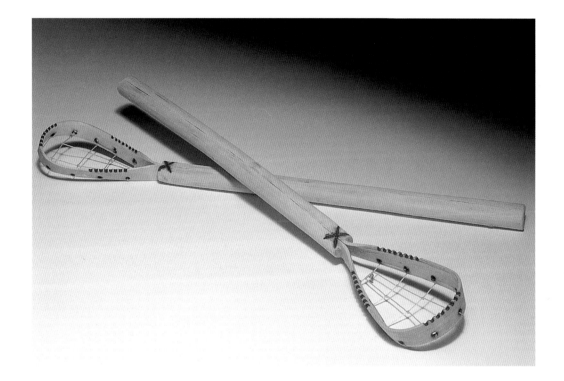

Matthew Lyford. **Surfboard**. White pine, Brazilian mahogany, foam core. Wood laminated over foam core, finished with glass fabric, epoxy resin, varnish. 112 x 22 ½ x 3"
Matthew Lyford. **Surfboard**. Western red cedar, butternut. Wood laminated over foam core, finished with glass fabric, epoxy resin, varnish. 112 x 22 ½ x 3"
Jerry Wolfe. **Ball sticks**. Hickory, sinew. Carved, formed, pegged, laced. 1 ½ x 4 x 26"

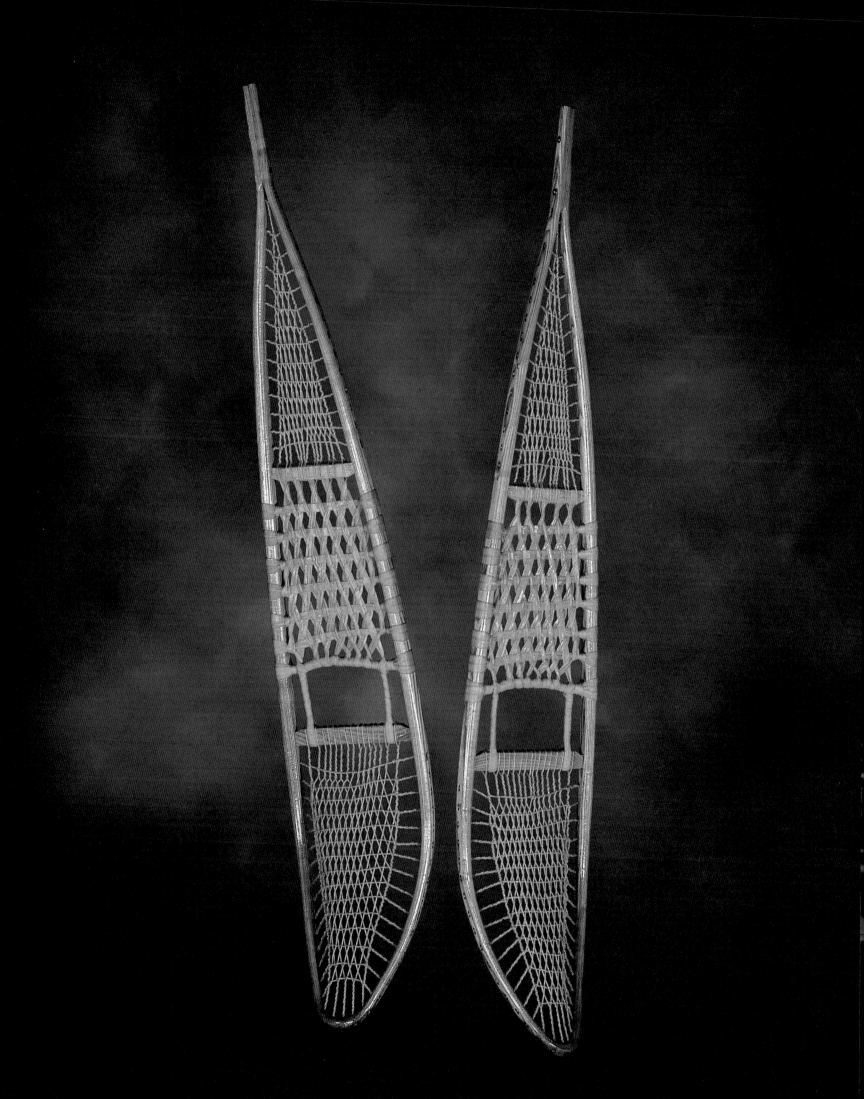

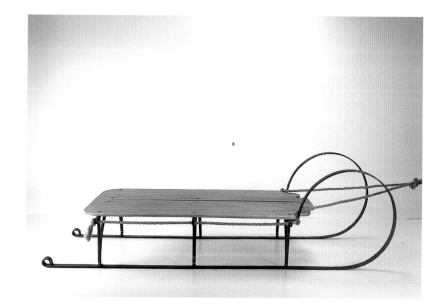

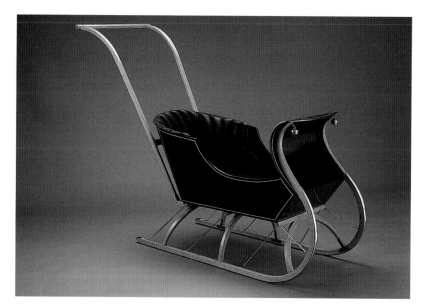

Paul Bergren. **Snowshoes**. Ash, nylon, fiberglass, varnish. Steam curved on form, laced. 7 x 10 x 56"

Jerry Gier. **Snow sled**. Iron, oak. Forged, formed top, tung-oil finish. 17 x 23 x 61"

C. H. Becksvoort. **Snow glider**. Ash, brass, leather, lacquer, gold leaf. Bent lamination, marine epoxy. 38 x 48 x 16"

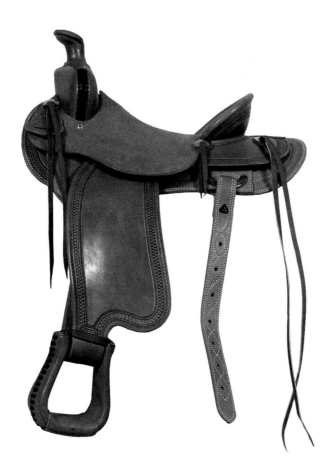

"I enjoy making saddles and equipment for working cowboys that will stand the test of time. Having been a working cowboy since 1972, I know that men and horses require quality equipment, as their safety and sometimes their lives depend on it." — Mike Wilder

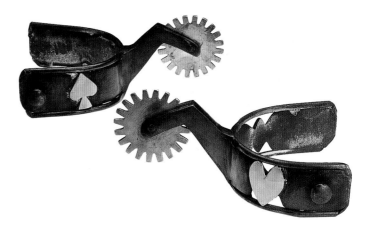

Mike Wilder. **"Working Ranch" saddle**. Leather, oak, sheepskin, metal fittings. Cut and formed, assembled. 36 x 30 x 18"
Billie Davis. **Spur set**. Iron, brass. Forged, cut, welded, assembled. 1 ½ x 4 x 8"
Krist King. **12-foot "Blacksnake" whip**. Black kangaroo hide. 14-strand braid with French whipping overlay. 1 ¼ x 144"
Krist King. **9-foot "Brown Kangaroo" bullwhip**. Brown kangaroo hide. 24-strand braid with 10-strand crocodile-edge braid on wrist loop. 1 ¼ x 108"

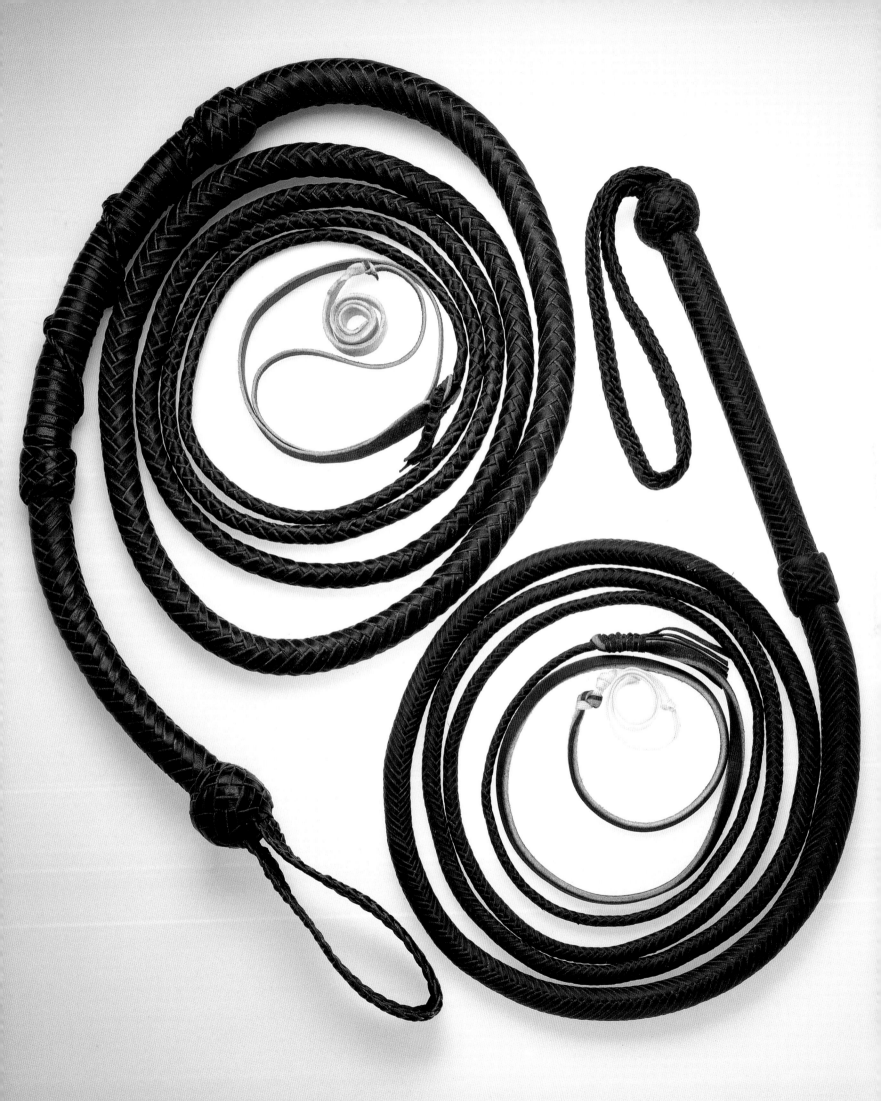

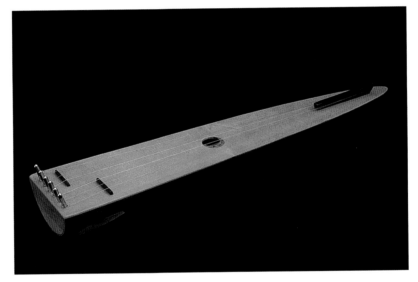

Bob McNally

Cymbal sticks. Ebony, brass, pigmented epoxy resin. Formed, shaped, assembled. 7 x 3 x 1 ½"

"Paraboloid Meditation" instrument. Walnut, spruce, ebony, metal strings, hardware. Laminated, formed, assembled. 26 x 5 x 2 ½"

"Backpacker" guitar (left). Mahogany, spruce, ebony, metal strings, hardware. Constructed and assembled. 32 x 6 x 3"

Strumstick (right). Padauk, spruce, maple, metal strings, hardware. Constructed and assembled. 29 x 4 x 2"

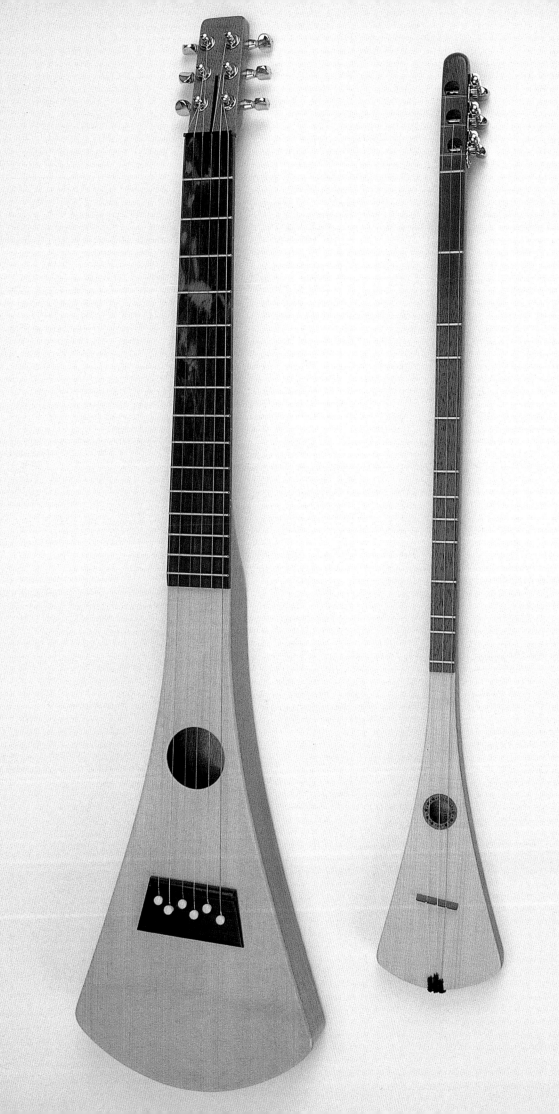

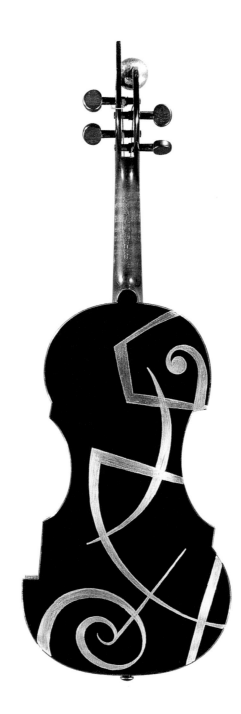

Guy Rabut. **"Modern Form" violin**. Spruce, maple, ebony, metal strings, gold leaf, varnish.
Constructed and assembled, varnished, gilded. 24 x 8 ½ x 4". (front detail opposite)

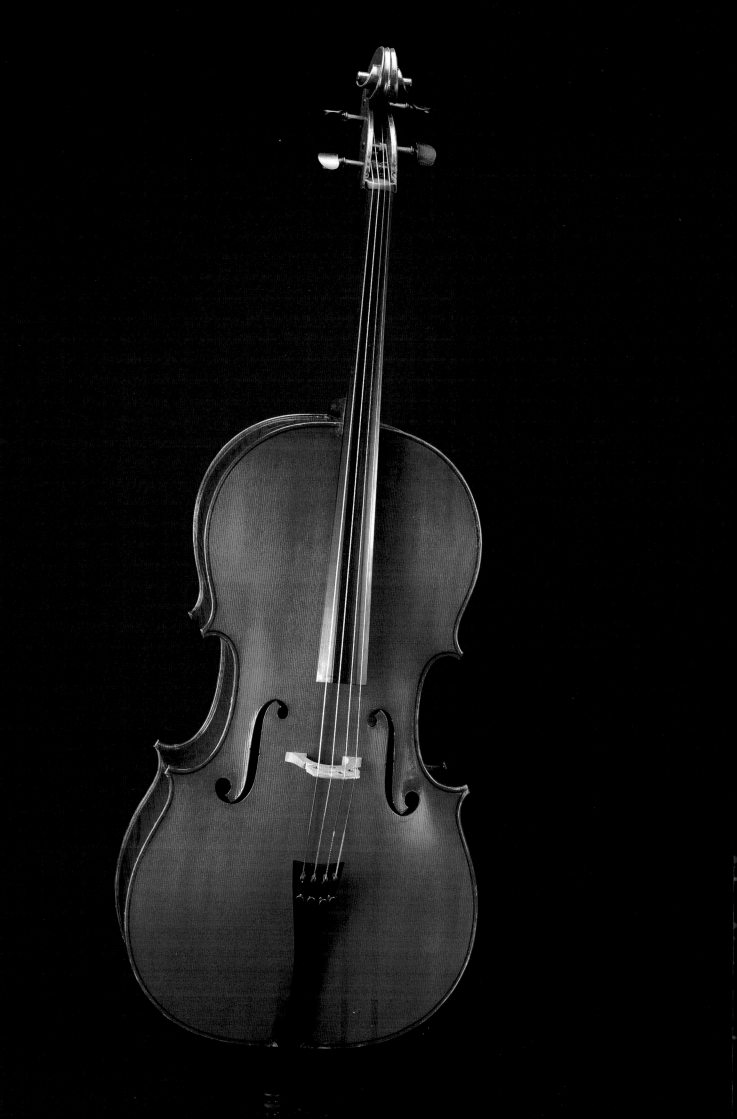

"I feel the best way to re-create the musicality of an era is to try to recapture the spirit rather than the appearance of the instruments used. Therefore, I don't make copies of instruments. Rather, I make instruments that try to capture the inspiration of the original instrument." —James N. McKean

James N. McKean. **Violoncello**. Maple, spruce, assorted detail woods, metal strings, hardware. Constructed and assembled. 50 x 18 x 11"
H. F. Grabenstein. **Bow for Baroque double bass** (detail). Maple, walnut. Turned, hand shaped, assembled. 30 ¼ x 1 ½ x ¾"

C. H. Becksvoort. **Music stand**. Black cherry. Constructed. 50 x 20 x 18"

Brad Smith. **Adjustable music stand**. Cherry, steel. Spiral turned, textured, constructed. Varied height x 21"

Catherine Campbell. **Large Gothic harp, "1550 style."** Quilted and fiddleback big-leaf maple, metal strings, hardware. Constructed and assembled. 46 x 23 x 9"

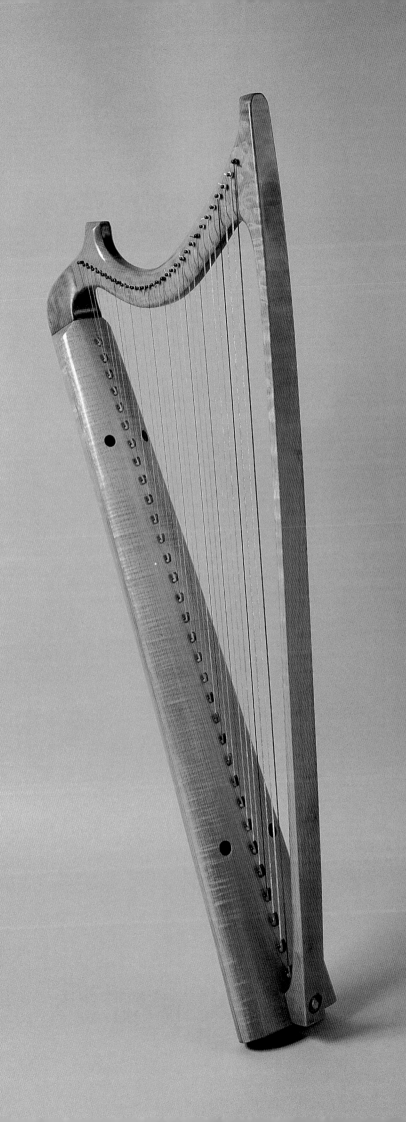

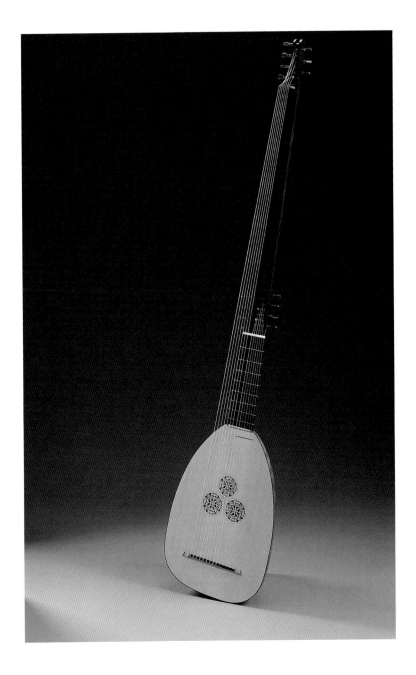

Daniel Larson. **Italian-style theorbo**, based on an instrument made by Michael Harton, Padua, 1599.
Cherry, ebony, rosewood, spruce, gut. Constructed and assembled. 70 x 15 ⅞ x 6 ¾". (detail opposite)

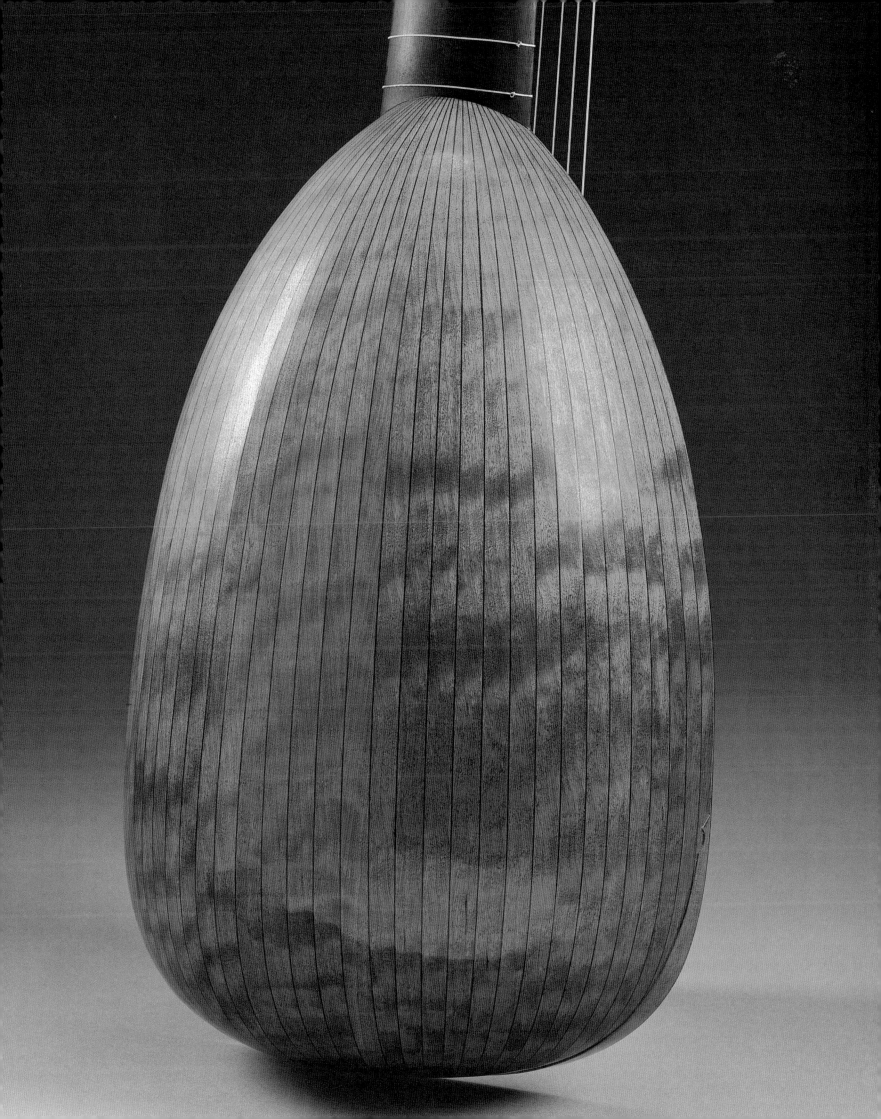

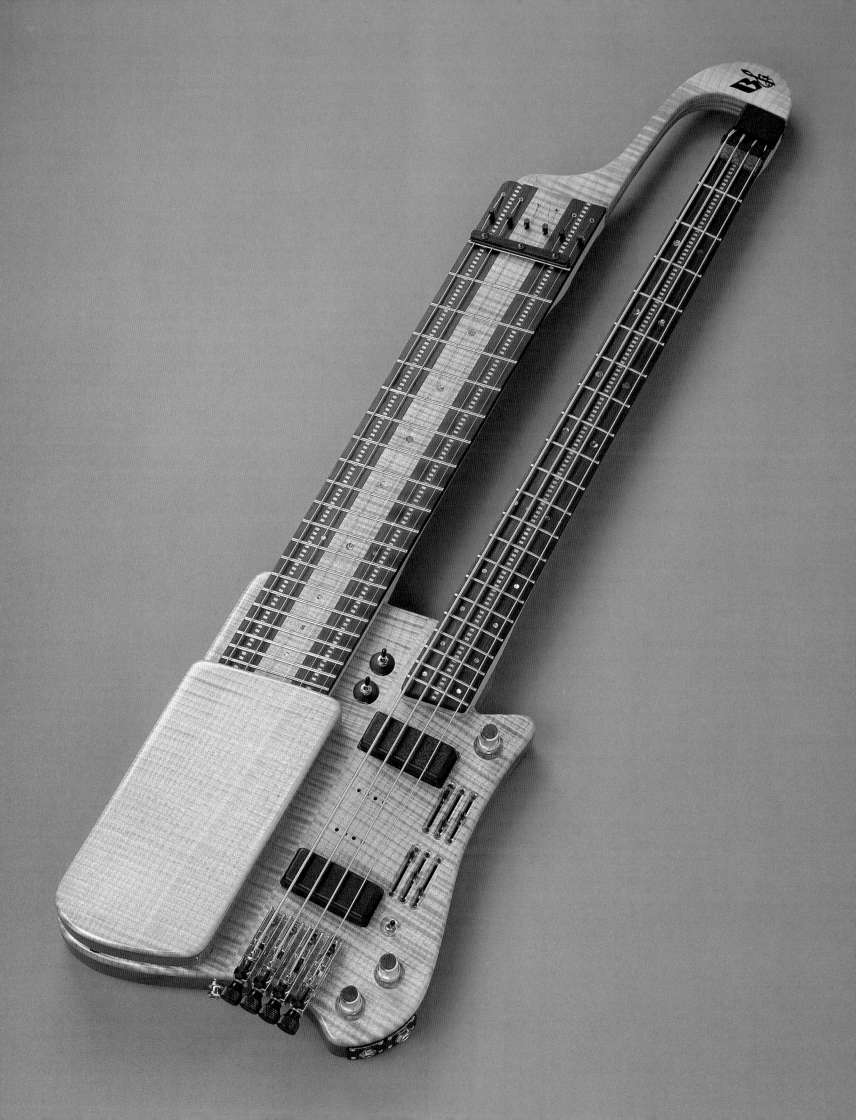

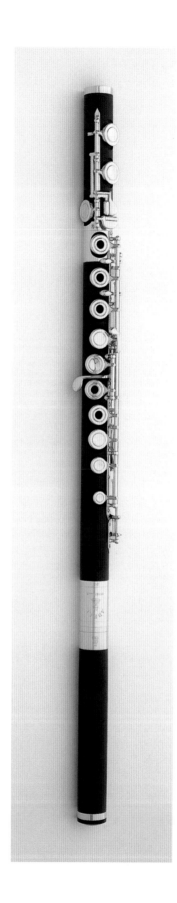

Dave Bunker, Bunker Guitar Technology. **"Touch" guitar**. Western Tiger maple, mahogany, ebony, metal strings, hardware. Constructed and assembled. 38 x 12 x 1 ½"
Chris Abell. **"Boehm System" flute**. African blackwood, 14k rose gold key work. Lathe turned and milled, cast- and machined-metal elements, assembled. 26 x 1 ¼" diam.

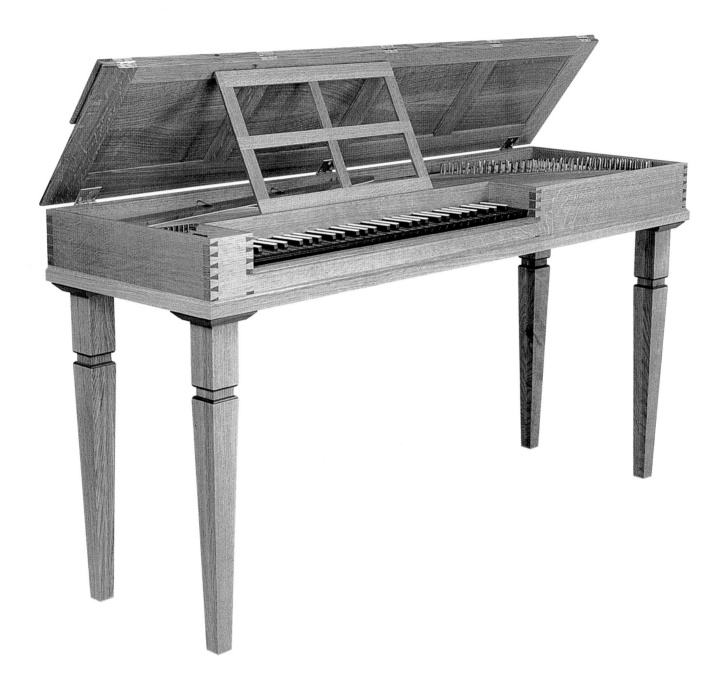

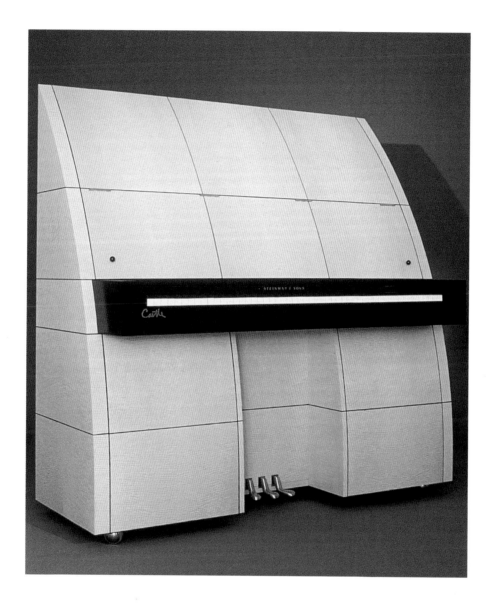

Allan Winkler. **Clavichord**. White oak, Engelmann spruce, French walnut, ebony, handspun music wire. Traditional joinery, constructed. 45 x 62 x 20"
Wendell Castle. **"Bold Venture" piano**. Mahogany, bubinga, maple, poplar, aluminum, ebony, leather, bronze, brass; outer case for Steinway & Sons instrument. 57 x 72 x 40". Private collection

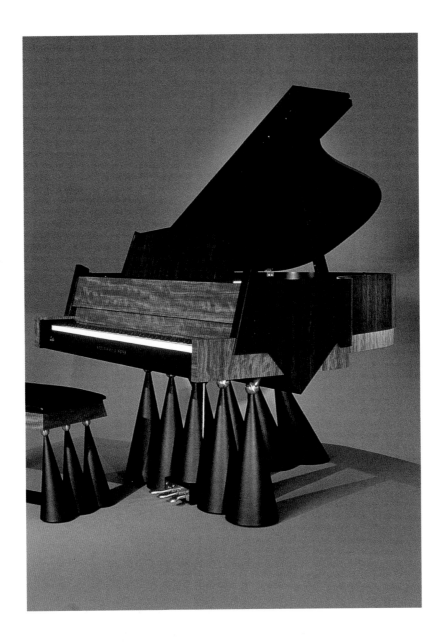

Wendell Castle. **"Ivory Spirit" piano**. Curly sycamore veneer, mahogany veneer, maple, poplar; outer case for Steinway & Sons instrument. 57 ¾ x 28 ¾ x 58 ¾". Private collection
James Schriber. **"Pianissimo" Steinway & Sons piano**. Pearwood (solid and veneer), curly maple, pewter-plated hardware. 36 x 56 x 70"

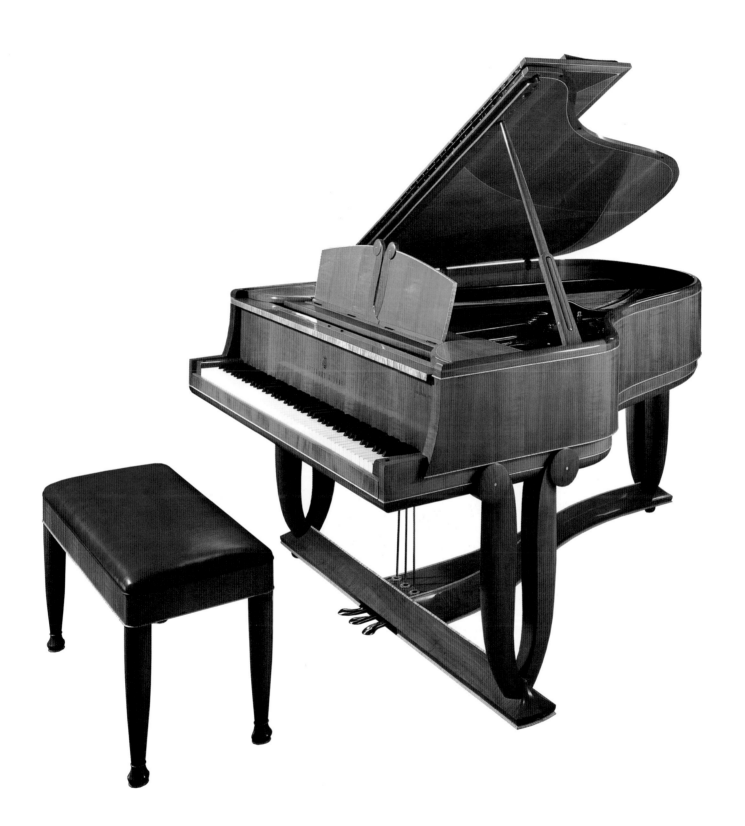

Robin L. Hodgkinson. **"Spirit Vessel" flute**. Clay. Slab construction, raku fired. 12 x 7 x 2 ½"
Larry Halvorsen. **Rattles**. Stoneware. Press molded, slip and sgraffito surface. 2–8"

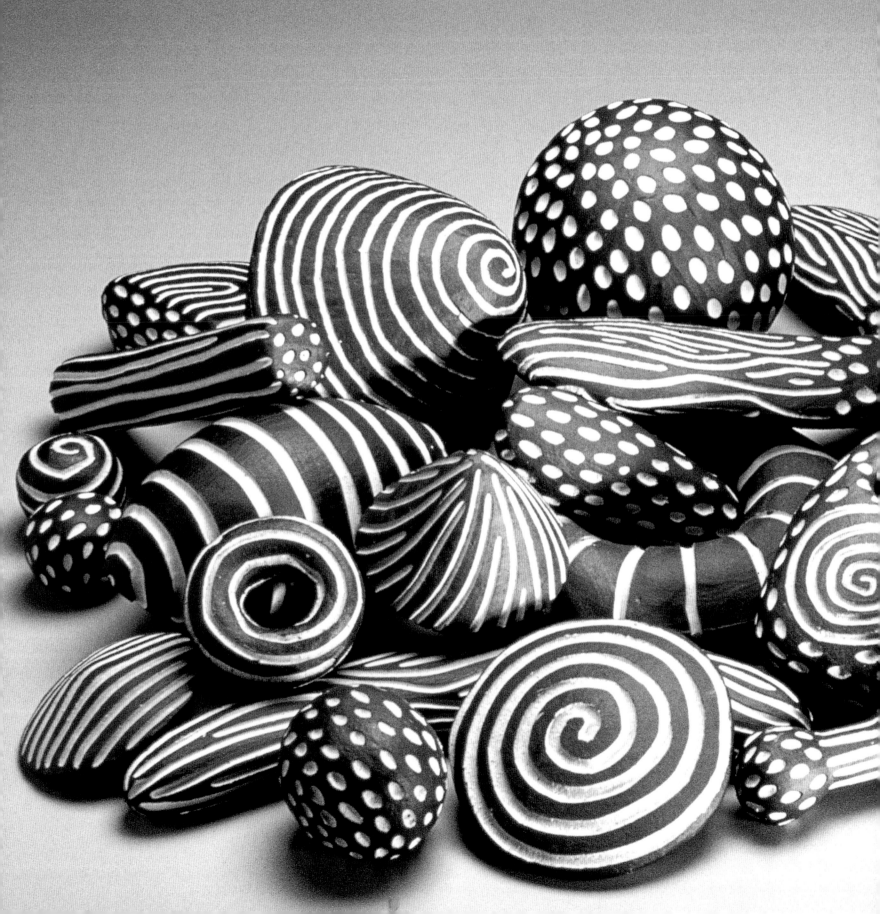

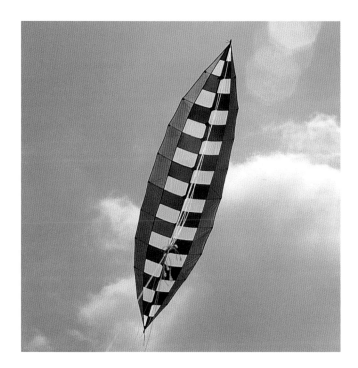
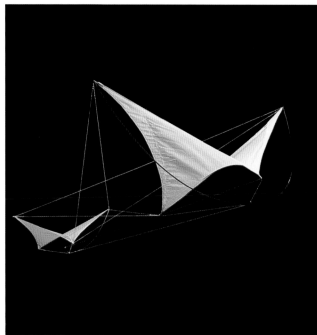

Tal Streeter. **"Small Bee" kite**. Ripstop nylon, fiberglass. Sewn, assembled. 96 x 19 ½"
Tal Streeter. **"Black, Red, White, Blue, Yellow Squares" kite** (one of three). Ripstop nylon, fiberglass. Sewn, assembled. 96 x 19 ½"
Tal Streeter. **"Medium Venus Sign Bee" kite.** Ripstop nylon, fiberglass. Sewn, assembled. 180 x 38"
Marc Ricketts. **"TetraFoil" glider**. Carbon fiber, spectra fiber, ripstop polyester sailcloth, plastic. Cut, sewn, glued, tied, assembled. 23 x 63 x 56"

clockwise from top left:
Russell Greenslade. **"Gecko" puzzle**. Basswood. Hand cut, stained. 5 x 9 x 1". (detail opposite)
Russell Greenslade. **"Hippo Family" puzzle**. Basswood. Hand cut, stained. 3 ½ x 13 x 1"
Gunther Keil. **"Wiggle Worm" toy**. Ash. Constructed. 3 x 3 x 12"
Gunther Keil. **"Dragon" pull toy**. Maple. Constructed. 5 ¾ x 7 x 11 ½"

Peter B. Chapman. **"Snake" puzzles**. Maple, cocobolo, ebony. Band sawed, shaped, finished. Long 1 ½ x 1 ¾ x 26"; medium 1 ⅛ x 1 ⅞ x 20"; short ¾ x ¾ x 18". (detail opposite)

Frank R. Cheatham
"LA Cool Stack & Balance" toy set. Plastic over brass. Fabricated
Sculptural blocks. Maple. Hand formed. Collection the Arkansas Art Center, Little Rock

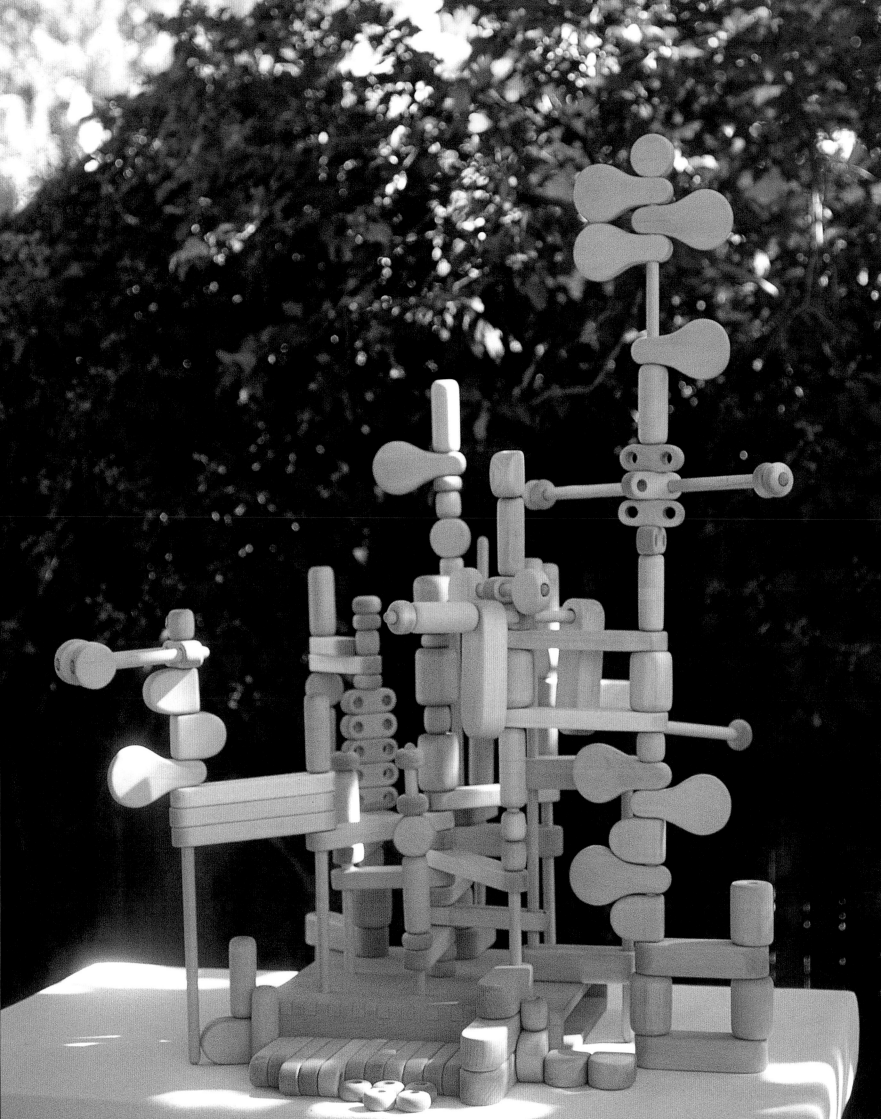

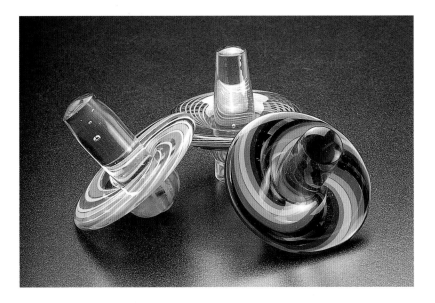

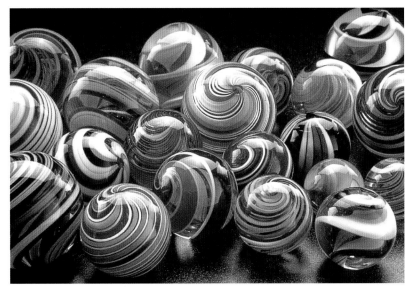

Jody Fine. **Spinning tops**. Glass. Hand formed from latticinio stock. 3 x 3 x 3"
Jody Fine. **Marble group**. Glass. Hand formed and polished from handmade latticinio stock. ⅞ –1 ⅝" diam.
Edith Axer. **Chess set**. Steel, rubber, leather. Turned, constructed. Each piece 2 x 1 ⅛" diam.

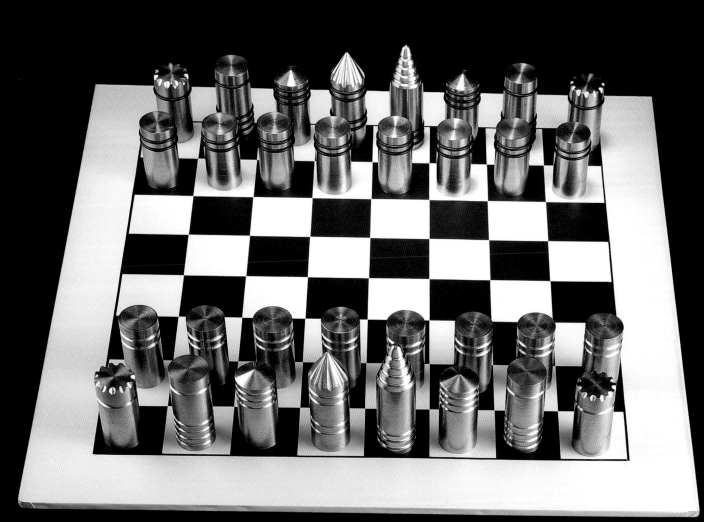

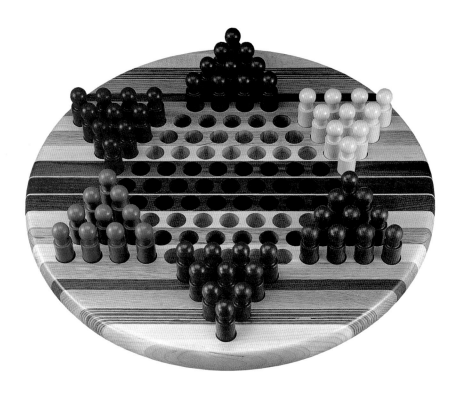

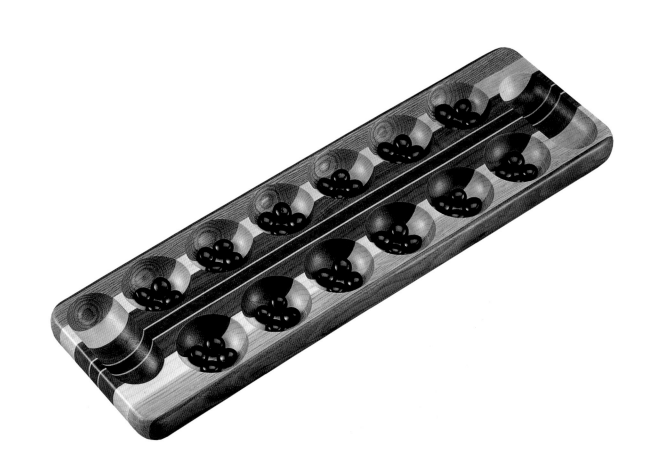

David Levy, Hardwood Creations. **Chinese checker board**. Exotic and domestic hardwood. Laminated, shaped, drilled, hand-painted pegs. 1 x 16" diam.
David Levy, Hardwood Creations. **Mancala**. Exotic and domestic hardwood. Laminated, shaped. 1 x 6 x 20"
Richard Chudy. **Cue handles**. Maple, purpleheart, assorted veneers, ebony, kingwood, cocobolo, amboyna burl, maple burl, holly, field burl, manzanita, Irish linen, sterling silver, leather. Turned, inlaid. 29 x 1 ¼" diam.

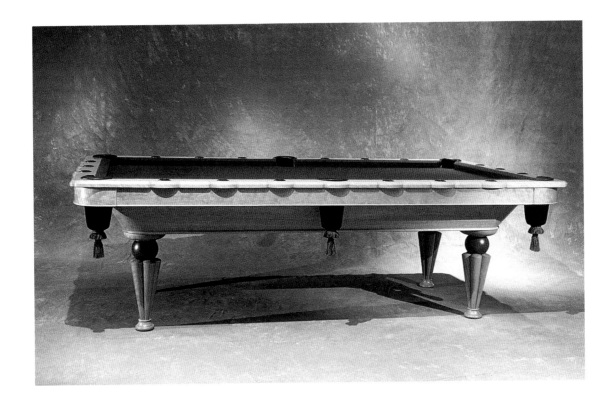

John Dunnigan
Pool table. Cherry, mahogany, slate, leather, rayon, wool. Constructed. 31 x 99 x 55". Private collection
Cue cabinet with cues. Wenge, cherry, rayon, phenolic, brass. Constructed. 70 x 27 x 12". Private collection

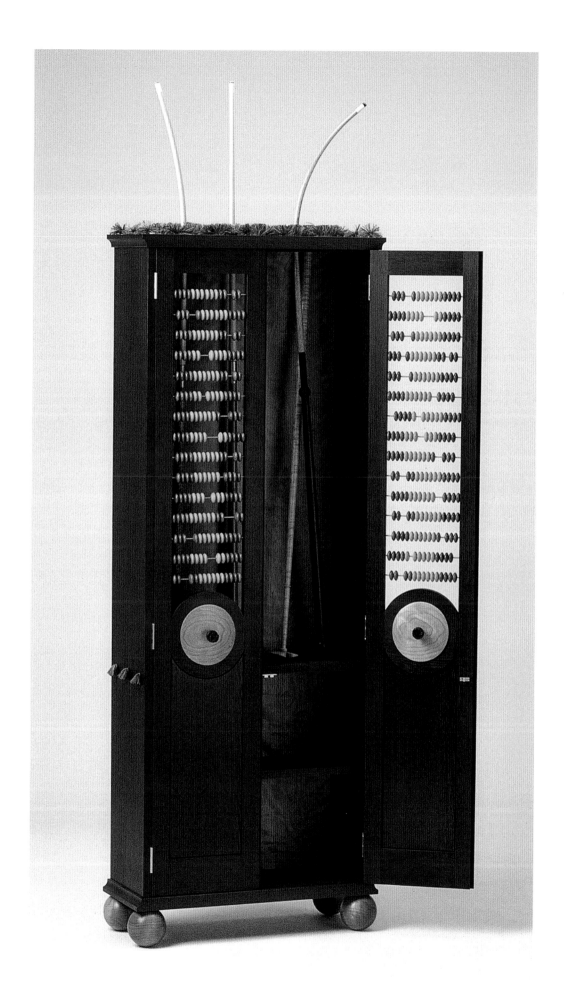

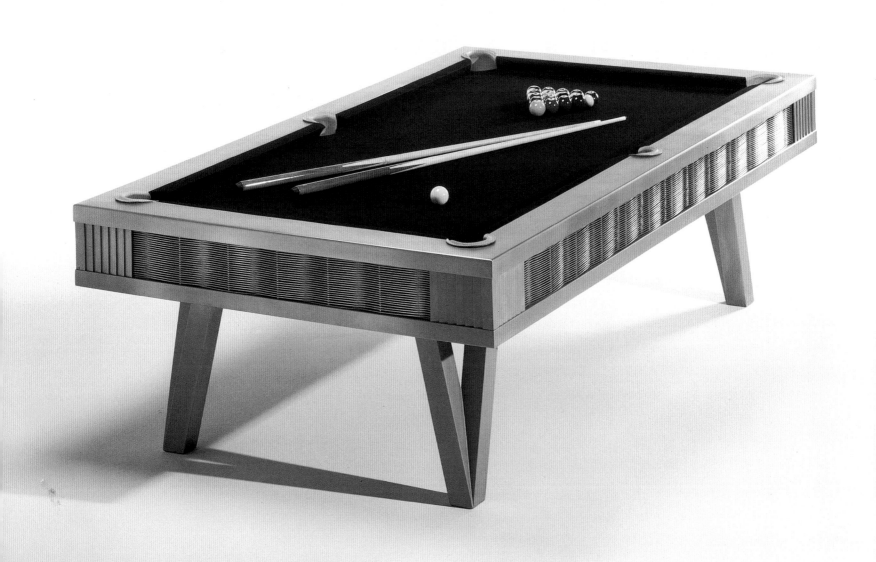

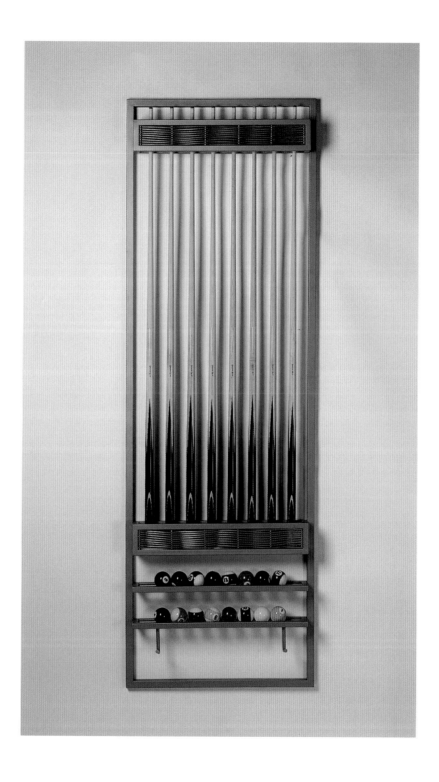

Michael Heltzer
"Woven Metal" pool table. Stainless steel, bronze. Fabricated. 32 x 60 x 106"
"Woven Metal" equipment rack. Stainless steel, bronze. Fabricated. 77 x 25 ½ x 6 ¾"

Artists' Biographies

Julia Gaviria

Chris Abell

Asheville, NC
Born: 1951, New Haven, CT
Education: St. Andrews College, Laurinburg, NC, 1970–72

Chris Abell's interest in flute design began after he bought his first flute at the age of 22. Ten years later, after becoming an accomplished flute and whistle player of Irish traditional music, Abell began assisting an instrument maker building Boehm system flutes of silver-plated brass. With his new skills, he then approached Brannen Brothers Flutemakers of Boston and was hired as a keywork technician. After three years of apprenticeship there, Abell pursued new instrument design in his own shop. In 1985 he started the Abell Flute Company with a focus on reintroducing and producing professional-model wooden flutes. He moved the company in 1995 to North Carolina, where it continues to manufacture up to 15 Boehm system wooden flutes and more than 100 wooden whistles per year. Abell's customers include professional players and serious amateurs from around the world.

Marc Aroner

Conway, MA
Born: 1947, Mare Island, CA
Education: BFA, Art Education, University of Massachusetts, Amherst, 1971
See page 62

Edith Axer

Washington, DC
Born: 1957, Cologne, Germany
Education: IB, Abitur, 1976
BA, Educational Science, University of Cologne, Germany, 1980
Apprentice goldsmith at Jeweler Hoelscher, Cologne, 1980–84
Master Goldsmith degree, 1987

Edith Axer's Impression & Expression Product Design, Inc. specializes in unique handcrafted metal tableware influenced by German Bauhaus design. Simplicity, clarity, and character mark the form, while variability, playfulness, and surprise characterize the function of her work. After studying goldsmithing in her native Germany, Axer was employed by a renowned jeweler in Cologne from 1984 to 1987. She achieved the status of master goldsmith in 1987 and set up her own studio in 1988. Several exhibitions of her work followed. She then worked as a freelance designer for German Table Top Companies and was a guest faculty member at the National Institute for Fashion and Technology in New Delhi. In 1996 she established Eindruck & Ausdruck Produkt Design in Germany, designing and manufacturing tableware. Axer moved to Washington, D.C. in 1997 and founded her current company. She sells at craft and trade fairs across the country.

Phillip Baldwin

Snohomish, WA
Born: 1953, New York, NY
Education: BA, Political Science, Art Foundation, State University of New York at Potsdam, 1976
MFA, Southern Illinois University, Carbondale, 1979

Phillip Baldwin was born in New York City and grew up in Northport, New York. The son of a studio clay artist and a nuclear engineer, he discovered arts and sciences at an early age. Baldwin first encountered hot ironwork in junior high school shop class, and as a teenager built his own forge. After graduating from SUNY Potsdam in 1976, he participated in an ethnographic blade research project with Dan Maragni. He then earned his MFA from Southern Illinois University in Carbondale, where he studied with Brent Kington and Richard Mawdsley. Following two years as a resident artist at the Oregon School of Arts and Crafts in Portland, Baldwin formed Shining Wave Metals in 1983, a firm that manufactures exotic metals for the art-metal field. Baldwin's own designs range from blade forms to architectural metalwork. He teaches at the School of Art of the University of Washington.

Boris Bally

Providence, RI
Born: 1961, Chicago, IL
Education: Goldsmith apprenticeship to Alexander Schaffner Goldschmied, Basel, Switzerland, 1979–89; Tyler School of Art, Temple University, Philadelphia, PA, 1980–82; BFA, Metals, Carnegie Mellon University, Pittsburgh, PA, 1984
See page 42

Michael and Maureen Banner

Monterey, MA
Born: (Michael) 1939, Kalamazoo, MI; (Maureen) 1946, Chicago, IL
Education: (Michael) BS, Western Michigan University, Kalamazoo, 1963; Cleveland Institute of Art, OH, 1964; (Maureen) Northern Illinois University, DeKalb; Evanston Art Center, IL; Berkshire Community College, Pittsfield, MA

Michael Banner began silversmithing at Western Michigan University and continued at the Cleveland Institute of Art. Maureen Banner has a background in fine arts and learned metals and enameling from Michael. The Banners met at an Evanston (Illinois) Art Center Fair in 1968 and three months later were married. Early in their joined careers they became full-time collaborative metalsmiths and worked in Michael's studio gallery in Chicago. In 1975 they moved to Massachusetts, drawn to the area by its many crafts fairs. At their home and studio in the Berkshires the Banners design and produce sterling silver pieces, including fine jewelry, teapots, candleholders, and other hollow-formed items, using techniques that traditional silversmiths have used for hundreds of years. Their work is sold at select craft shows, has been included in numerous exhibitions, and is found in public and private collections around the country.

D. Hayne Bayless

Ivoryton, CT
Born: 1952, Seattle, WA
Education: Student of potter Itaka Sokkuzan and sumi painter Ryoichi Saito,1970; BA, Journalism, University of Minnesota, 1983

After a career as a newspaper arts editor, D. Hayne Bayless decided to pursue his interest in pottery full-time. In a cramped 12-square-foot basement space in his home he established Sideways Studio in 1990, named after the limited working area that required him to walk sideways from his storage racks to his production equipment. In 1999 Bayless relocated to his present, newly enlarged home and studio, where he hand builds each porcelain and stoneware object, often combining wood, metal, or rubber elements for stems and handles. He sells his award-winning work from his studio and through craft fairs, galleries, and museum shops.

C. H. Becksvoort

New Gloucester, ME
Born: 1949, Wolfsburg, Germany
Education: Apprentice to master cabinetmaker Henry Becksvoort, 1962–72; BS, Wildlife Science/Forestry, University of Maine, Orono, 1972
Photography, Montgomery College, Rockville, MD 1971–73
Wood Technology, University of Southern Maine, Gorham, 1979

C. H. Becksvoort works out of a one-man shop in rural Maine, where he makes custom wood furniture. He constructs each piece individually, completing only 30 to 40 pieces a year. Becksvoort works primarily in American black cherry wood (he also plants 20–50 trees a year to do his part in regenerating the forests that supply his wood). He feels the greatest honor in his career thus far is to have done restoration work for the last remaining Shaker community at Sabbathday Lake, Maine. Since 1989, Becksvoort has also been a contributing editor to *Fine Woodworking* magazine. He teaches furniture making and wood technology at the Center for Furniture Craftsmanship in Rockport, Maine, and is the author of two books, *In Harmony with Wood* and *The Shaker Legacy*.

Bruce Beeken and Jeff Parsons

Shelburne, VT
Born: (Beeken) 1953, Hanover, NH (Parsons) 1956, Boston, MA.
Education: (Beeken) Certificate of Mastery, Boston University, Program in Artisanry, 1978 (Parsons) BAA, Boston University, Program in Artisanry, 1979

Bruce Beeken and Jeff Parsons met in the 1970s while attending the Program in Artisanry at Boston University. Prior to that Beeken had apprenticed in Vermont to furniture maker Simon Watts and to canoe maker Carl Bausch. After graduating in 1978, Beeken returned to Vermont to open his own studio. He and Parsons met up again in Burlington, Vermont, where Parsons was working for Depot Woodworking Company, and the two established their partnership in furniture making in 1983, focusing especially on chairs. From their studio at the 19th-century Shelburne Farms barn, Beeken/Parsons have produced furniture for residences, exhibitions, and university libraries. Their most recent interest has been in resource issues pertaining to the furniture industry's relationship with the hardwood supply. Working with loggers, foresters, and ecologists, they have explored the use of less traditional woods for their furniture, and invested in their own kiln to dry such woods.

Paul Bergren

Minot, ND
Born: 1942, Sioux Falls, ND
Education: Golden Leaf Farrier College, Sturgis, SD
See page 70

John Betts

Denver, CO
Born: 1937, East Orange, NJ
Education: BS, Forestry, University of Vermont, Burlington, 1967
See page 64

Anthony Beverly

Stephentown, NY
Born: 1951, Washington, DC
Education: B.Arch., Catholic University, Washington, DC, 1975
Studied in Rome and Paris, Pangborn Fellowship
See page 50

Sandra Bonazoli

Fall River, MA
Born: 1968, Boston, MA
Education: BA, Art History, Boston College, MA, 1990
MFA, Metals and Jewelry, University of Massachusetts, Dartmouth, 1995

Sandra Bonazoli creates kitchenware from her 2,000-square-foot studio in Fall River, MA, in an old textile mill. Bonazoli was first inspired to make beautiful things for the kitchen one morning in 1998 while looking at her favorite old, orange enamel colander. She lamented that today's functional things were usually plain, and thought of all the items she could create with beauty in mind. She now hopes that her playful and ornamental kitchenware enhances the experience of food preparation. Since 1999, her husband, James Dowd, who is also a metalsmith, has been working with Bonazoli full-time, and together they sell their line of kitchenware at craft fairs, galleries, and stores around the U.S.

Jonathan Bonner

Providence, RI
Born: 1947, Princeton, NJ
Education: BFA, Philadelphia College of Art, PA, 1971
MFA, Rhode Island School of Design, Providence, 1973

Jonathan Bonner set up his studio in 1973 for his work in nonferrous metals, based on the silversmithing, coppersmithing, and auto-body and aircraft sheet-metal trades. He feels the process, material, and the concept are all important aspects of his work. His work has been in numerous solo and group exhibitions, and

is represented in several collections around the U.S. Bonner sells his objects from galleries, his studio, and on commission.

Klara Borbas

Union City, NJ

Born: 1955, Budapest, Hungary

Education: Self-taught

In the 1980s Klara Borbas owned and ran a successful ceramics business in Budapest, Hungary, that produced low- and high-fire vases, candle holders, and tea and coffee servers. She simultaneously pursued an interest in sculpture and created works in metal, stone, and other media. Her highly acclaimed sculpture has been exhibited widely in Hungary and in other countries, including Austria, Italy, France, Germany, and Korea. Borbas moved to New York in 1995 and has been working in high-fire ceramics. Inspired by architecture, sculpture, and classical European art, her work is wheel thrown or hand built from fine yet dense porcelain, and each piece is decorated individually. Borbas's functional yet modern forms have been featured in many prestigious publications. She sells her work at major craft shows.

Alex Brand

Corning, NY

Born: 1957, Aberdeen, MD

Education: Penland School of Crafts, Penland, NC, summer 1978 BFA, Tyler School of Art, Temple University, Philadelphia, PA, 1979

Alex Brand's first glass studio was located in Concord, Massachusetts, where he worked from 1981 to 1985. He then moved to Corning, New York, a city renowned for its glassmaking, and operated a studio there from 1985 to 1997. Since 1997, he has rented work space at the Corning Museum's studio to blow glass, while maintaining a separate personal studio. Brand finds he is most alive when creating, and writes songs and poetry in addition to working with glass. He derives great satisfaction in creating works that reflect his observations of the natural world, including flowers, fruits, and foliage. He sells his glass mostly through craft fairs and also through gallery shows.

Cynthia Bringle

Penland, NC

Born: 1939, Memphis, TN

Education: Southwestern College (now Rhodes College), Memphis, TN, 1957–58; BFA, Memphis Academy of Art, TN, 1962; MFA, Alfred University, Alfred, NY, 1964

Cynthia Bringle has had her own clay studio since 1965—first in Eads, Tennessee, until 1970, and then in Penland, North Carolina, where she continues to work today. Bringle finds working in clay constantly challenging yet enjoyable and is pleased that most people buy her pieces for everyday use. The majority of her work is wheel oriented, with some altering, and is fired in a variety of kilns—gas, wood, salt, and raku. She has been exhibiting her clay objects regularly since the 1960s, when she obtained her MFA from Alfred University, and her work is found in numerous public and private collections. Bringle sells her pieces from the studio, at galleries, and at private showings.

Jack Brubaker

Bloomington, IN

Born: 1944, Chicago, IL

Education: BFA, Syracuse University, NY, 1966; MFA, Indiana University, Bloomington, 1968

Jack Brubaker has been a blacksmith since 1970. He works from a studio on ninety acres of wooded hills near Bloomington, Indiana. Although he studied art in college and in graduate school, he feels his most important artistic education came from his family. He began painting and drawing at the age of five with his grandmother, Chicago artist Mary Brubaker. His great aunt Edith Keith was a bowl turner and painter, his aunt Miriam McGrew was a painter and silversmith, and his grandfather and father were wood- and metalworkers. The latter two and their inventive ways of doing things continue to inspire Brubaker in his forge today, where he builds many of his own tools and machines. Brubaker works in hammered iron—as well as bronze, copper, aluminum, and brass—for his production series of candleholders, wine racks, sculpture, furniture, and architectural ironwork. He currently employs three apprentices.

Dave Bunker

Mill Creek, WA

Born: 1935, Bunker Creek, WA

Education: Joe Farmer Music School, Burien, WA, 1955–57

For the past 30 years Dave Bunker has been making guitars and basses for many top performing artists. He began his career designing instruments for his band and other musicians on the side while entertaining with his lounge act in Las Vegas. He and his father, Joseph L. Bunker, built and patented the first Bunker Touch Guitar in 1961, which is characterized by two necks, one for playing lead and the other for playing bass. In 1993 his company PBC Guitar Technology was commissioned to build high-quality American-made guitars for Ibanez, a Japanese company. In addition to creating instruments and running his business, Bunker has also performed for more than two decades alongside such artists as Barbara and Louise Mandrell, the Everly Brothers, and Merle Haggard. He demonstrates the Touch Guitar along with other of his patented products at trade shows throughout the world and occasionally performs on special occasions.

Glenn Burris

Jefferson, OR

Born: 1949, Wichita, KA

Education: BA, Pepperdine University, Malibu, CA, 1971 MFA, Ceramics, University of Iowa, Iowa City, 1973

Glenn Burris began working in clay in 1968 and established his first studio in rural Oregon in 1974. Since the beginning, he has produced dinnerware and ceramics in high-fired porcelain. In his present studio, established in 1979, Burris works by himself creating unique pieces that he considers both sculptural and functional. It is Burris's constant challenge to create not only objects for practical use, but pieces that will continue to interest and please the user. He sells through annual studio sales and through ten galleries in the Northwest.

Catherine Campbell

Port Townsend, WA

Born: 1950, Detroit, MI

Education: Wayne State University, Detroit, MI, 1970

Catherine Campbell is a historical harp maker from a family of folk musicians and cabinetmakers. In 1976 Campbell settled with her husband in Seattle. There she began to research and practice violin making and playing, and studied string-instrument repair. In 1988 Campbell combined her interests in historical music and instrument-making by reproducing her own historical harp. In 1991 she completed her first 17th-century, 32-gut-string Northern European harp, and in 1992, her first copy of the 24-string 16th-century Nuremberg harp. In 1994 she styled a version of the harp found in Hieronymous Bosch's *Garden of Earthly Delights*. By 2000 she had completed forty-two harps made of maple, cherry, and walnut. Campbell is a member of the Historical Harp Society and travels around the country encouraging research on the construction of early harps, as well as on the music of the Middle Ages, Renaissance, and Baroque periods.

Beth Cassidy

Snohomish, WA

Born: 1957, Niagara Falls, NY

Education: Self-taught

Beth Cassidy has been a working artist for more than 20 years. She lived in Alaska for 15 years, showing her fine art and fiber work in juried art shows around the country. She was so encouraged by the positive responses, including several awards, that when she moved to Seattle in 1993 she decided to work full-time on her fiberart. She currently produces a line of bed and table linens that are made from the highest quality silks and other fabrics. Her success has created such a demand that she now uses outside sources for most of her production in order to focus on design and one-of-a-kind pieces. Cassidy markets her lines through fine craft and gift shows, galleries, and department, gift, furniture, and museum stores.

Wendell Castle

Scottsville, NY

Born: 1932, Emporia, KS

Education: BFA, Industrial Design, University of Kansas, Lawrence, 1958; MFA, Sculpture, University of Kansas, Lawrence, 1961

Wendell Castle has been a sculptor, designer, and educator for more than 30 years. Born and educated in Kansas, Castle moved to the Rochester, New York area in the 1960s to teach woodworking at the Rochester Institute of Technology. After a stint instructing at the State University of New York at Brockport in the 1970s, he returned to R.I.T., where he remains an artist-in-residence at the School for American Crafts. Castle has built his reputation making one-of-a-kind pieces in wood, plastic, and bronze, and he has been commissioned to create indoor and outdoor site-specific sculptural works. He has recently launched a line of his own furniture designs for mass production, the Wendell Castle Collection.

Marek Cecula

New York, NY

Born: 1944, Kielce, Poland

Education: Self-taught

See page 34

Teresa W. Chang

Brooklyn, NY

Born: 1965, Fairfax, VA

Education: B.S., Architecture, University of Virginia, Charlottesville, 1987 M.Arch., Columbia University, New York, 1992

In 1993 Teresa Chang set up an informal pottery studio in her loft to give her long-time hobby a more permanent place in her life. In 1995, after working three years in the New York nonprofit housing sector, she decided to pursue her passion for ceramics as a profession. She developed a line of ceramics and began to market her first dinnerware in 1996. Encouraged by the response from local craft fairs and private studio sales, she presented a collection at the 1997 New York International Gift Show, which resulted in orders from prestigious galleries and stores in the U.S. and abroad. At present she continues to personally make her designs, working with three part-time assistants.

David Chapman

San Francisco, CA

Born: 1968, Bay Village, OH

Education: University of Colorado, Boulder, 1987–88 BFA, University of Michigan, Ann Arbor, 1992

David Chapman makes furniture out of willow branches. The willows, with their inherent strength and flexibility, allow him to create organic forms that stretch the boundaries of a traditional furniture style into the realm of contemporary design. The malleability of the willows enables him to shape the seat and back of each chair to fit and support the contours of the human body, while pushing the rest of the chair's form to its limits as sculpture. Chapman started working with willow in 1992 at a workshop taught by Clifton Monteith at the University of Michigan in Ann Arbor. In 1996 he moved his studio to San Francisco, where he continues to make sculptural furniture and is beginning to explore the architectural possibilities of his work. He sells his work through galleries and from his studio.

Peter B. Chapman

Bent Mountain, VA
Born: 1944, Roanoke, VA
Education: School of Architecture, Virginia Polytechnic Institute, Blacksburg, 1961–64

Peter Chapman studied architecture for four years at Virginia Tech in Blacksburg. In 1969 he went to work for furniture maker George Nakashima in New Hope, Pennsylvania, where he gained a greater appreciation for wood and meticulous joinery. Chapman returned to the Blue Ridge Mountains in 1975 to establish his own woodworking studio. At his work space surrounded by apple orchards he creates his unique style of furniture and sculpture, including popular three-dimensional animal puzzles. Chapman has developed a technique of cutting a single piece of wood for his interlocking puzzles, which have been featured widely in the press and have won numerous awards. He sells them through galleries and shops around the country.

Frank R. Cheatham

Lubbock, TX
Born: 1936, Beeville, TX
Education: BPA, Design, Art Center College of Design, Los Angeles, CA, 1959; BFA, MFA, Design, Mixed Media Sculpture, Ceramics, Los Angeles County Art Institute, CA, 1968

Frank Cheatham has been a self-employed artist since 1998. Prior to that he was a professor of art at Texas Tech University from 1973 to 1998. He was also president and creative director of a design firm based in Los Angeles and Chicago from 1960 to 1973. His work, including paintings, sculptures, ceramics, mixed media, and prints, has been exhibited widely in galleries and museums.

John Chiles

Weston, VT
Born: 1962, Groton, CT
Education: Bucks County Community College, Newtown, PA, 1980
Self-taught glassblower

John Chiles began working with glass in 1980 while he was a student at Bucks County Community College in Pennsylvania. He continued his education in blowing glass while working in a production studio and doing freelance jobs. He also took classes in glass and worked as a teaching or studio assistant as often as possible, holding positions at the Appalachian Center for Crafts in 1984, at Pilchuck Glass School in 1987, and at Penland School of Crafts and Haystack Mountain School of Crafts in 1988. After having the opportunity to work with very accomplished glass artists, in 1994 Chiles decided to design and make his own line of glass work as well as glass-shop equipment. He built his studio in 1997 in Weston, Vermont, where he currently designs both functional and decorative glass using traditional glass-blowing techniques, with the help of assistants. He also maintains a glass-equipment business with two partners. Chiles's glass is represented by several U.S. galleries.

Chunghi Choo

Iowa City, IA
Born: 1938, Inchon, Korea
Education: BFA, Ewha Women's University, Seoul, Korea, 1961
MFA, Cranbrook Academy of Art, Bloomfield Hills, MI, 1965

Chunghi Choo is a metalsmith, designer, and educator working and teaching in Iowa City, where she has lived for more than 30 years. After getting her BFA in Seoul, Korea, Choo moved to the U.S. in 1961 to study at the Cranbrook Academy of Art. Her study of Oriental and Western art and philosophy, her love of nature and classical music, and her many years of teaching experience have had an impact on her work. Her functional and nonfunctional metalworks, jewelry, sculptures, mixed media objects, and textile art have been exhibited around the world and are in the collections of many major museums. Choo is currently a professor of art and the head of the Jewelry and Metal Arts program at the University of Iowa.

Richard Chudy

Pleasant Hill, CA
Born: 1948, Detroit, MI
Education: Northern Michigan University, Marquette, 1966–67
Wayne State University, Detroit, MI, 1972–74

Richard Chudy began making cues at Saffron Billiard Supply in Detroit, Michigan, where he worked from 1968 to 1977. He then moved with his wife, Cindy, to northern California, where he continued to make cues. He joined the American Cuemakers Association in the early 1990s and served as its director from 1996 to 1999. Chudy currently works full-time building no more than 100 custom cues per year for an international customer base. His studies in fine arts have influenced his work as a cuemaker, as do his experiences in woodworking, jewelry making, leather craft, and photography. Chudy's cues are made of maple, snakewood, ebony, and buckeye burl, and are often detailed with ivory, 14-karat gold, and sterling silver.

Mardi-jo Cohen

Philadelphia, PA
Born: 1959, Brooklyn, NY
Education: BFA, Tyler School of Art, Temple University, Philadelphia, PA, 1982

Mardi-jo Cohen has been motivated to design and create since she was a young child. She established her studio in Philadelphia in 1986 to make jewelry. In 1988–89 she expanded her work to include tableware inspired by her personal interest in food and cooking. Although she has had great success in selling her objects at craft shows and galleries, Cohen now prefers to work alone in her studio to produce commission work, which she promotes through a catalogue, and one-of-a-kind pieces shown in a few galleries. In her current work that incorporates metal, acrylic, and found objects, Cohen strives to capture the energy, charisma, and attention to detail that is inspired by the performing arts and popular culture.

Michael Cohen

Amherst, MA
Born: 1936, Boston, MA
Education: BFA, Massachusetts College of Art, Boston, 1957
Cranbook Academy of Art, Bloomfield Hills, MI, 1960
Studio assistant, Haystack Mountain School of Crafts, VT, 1957, 1960

As a student at the Massachusetts College of Art, Michael Cohen began experimenting with clay. He soon developed his skill at throwing and casting forms while working with local ceramist Bill Wyman in his studio. Cohen later explored raku pottery with Toshiko Takaezo and Hal Riegger at the Haystack Mountain School of Crafts. After one year of study with Maija Grotell at the Cranbrook Academy of Art, Cohen set up his own studio in his home in Massachusetts, where he designed and manufactured a line of production tableware. He and his wife, Harriet Goodwin, moved to New Hampshire in 1964 and established a production studio for their functional stoneware. Cohen later moved to his present studio in Amherst, where he works with two assistants and his son Josh, currently focusing on slab and extruded work and tilemaking. He sells his work from his studio and through craft fairs and galleries.

Robert Coogan

Silver Point, TN
Born: 1952, Culver City, CA
Education: AA, Fullerton College, Fullerton, CA, 1974; BA, Humboldt State University, Arcata, CA, 1976; MFA, Metalsmithing, Cranbrook Academy of Art, Bloomfield Hills, MI, 1979

Since 1981, Robert Coogan has taught at Tennessee Technological University's Appalachian Center for Crafts, where he is head of metalsmithing, including jewelry and blacksmithing. He began making knives in 1976 and since then has continued to maintain an active exhibition and lecture schedule, giving talks on knife making and Damascus steel across the country as well as in the United Kingdom and Korea. Coogan feels that although the knife is the most common tool, used nearly every day in preparing food, little thought usually goes into making it. He says he produces the best knife he can by combining both beauty and functionality in order to make a tool that is enjoyable to use.

Jennifer Coppel

Detroit, MI
Born: 1974, Washington, D.C.
Education: BS, Art, Skidmore College, Saratoga Springs, NY, 1996; MFA, Cranbrook Academy of Art, Bloomfield Hills, MI, 1998

Jennifer Coppel established Eden Hardware in 1999 in Detroit, where she creates original custom and designer production hardware in a community studio space. Her hand-built architectural hardware— including door levers, pulls, and locks—is inspired by the decorative door hardware found in Tuscany, where Coppel studied during college. Her mentor, Gary Griffin, with whom she studied metalwork at Cranbrook Academy of Art, is a further inspiration for her. She currently works alone but plans to engage part-time employees so that she may concentrate on designing new lines and on custom projects. Coppel exhibits her work primarily at design trade shows and hardware showrooms, as well as on her website.

R. Guy Corrie

Richmond, CA
Born: 1954, Hayward, CA
Education: California College of Arts and Crafts, Oakland, 1976–78
See page 38

Michael Croft

Tucson, AZ
Born: 1941, Minneapolis, MN
Education: BFA, University of New Mexico, Albuquerque, 1963
MFA, Southern Illinois University, Carbondale, 1965

Michael Croft was trained as a metalsmith and jeweler, but for the past several years has focused his work on the blade form. Croft studied art in college and graduate school, concentrating on metalsmithing. Brent Kington, a professional artist and teacher at Southern Illinois University, was his role model. Croft primarily made jewelry when he was invited to participate in the 1981 traveling exhibition "The Cutting Edge." He was excited at working with a new focus and putting disparate materials together in a visually interesting yet functionally comfortable way. He now concentrates on blades and knives, small works that he calls "Bitty Blades," and more playful and whimsical sculptural pieces. Croft works out of his home studio in Tucson and teaches art at the University of Arizona. He sells his work through galleries and exhibitions.

Gloria E. Crouse

Olympia, WA
Born: Great Falls, MT
Education: BA, Textiles/Clothing, Art, University of Washington, 1952
Postgraduate work in metals, welding, architecture, Edison Tech, Seattle and Puget Sound Community College, Seattle, WA

As a child growing up on a remote wheat farm in Montana, Gloria Crouse turned to embroidery to avoid boredom. While in junior high school, she taught herself to sew, and making clothing became her passion. Crouse studied textile/clothing and art in college, where her appreciation of all fabrics and textiles was enriched, and she continued in a career as a fashion designer. After five years as a custom designer, she decided to pursue other areas of textile crafts as a creative outlet. Though she had studied textiles, she taught herself most fiber techniques including knotting, surface design, beading, and rug hooking, which she still finds the most versatile and stimulating

of all the fiber media. She also found it to be the most economical, with few tools and little investment. Crouse passes on her expertise to the one to three interns who come to her studio each week—she teaches not only her craft, but how she markets and shows her work. Crouse sells through exhibitions, her website, and to art consultants and decorators, and she is the author of *Rug Hooking: New Materials/New Techniques.*

Charles Crowley
Gloucester, MA
Born: 1958, Baltimore, MD
Education: BFA, Boston University, Program in Artisanry, Boston, MA, 1984

Charles Crowley creates holloware and furniture in sterling, steel, and aluminum, and jewelry of steel and 18-karat gold from Top Dog Studio, which he established in 1985. Crowley finds inspiration in a range of forms, from human or animal to botanical. His aim is to create a clean, machined appearance without losing the sign of the maker's hand, an important element for Crowley. Top Dog was originally founded as a cooperative studio in the tower of the old Waltham Watch Factory. The studio is now located in the chapel of a former nun's retreat in Gloucester, which he shares with his wife, Claire Sanford, who is also a jeweler and metal artist. Crowley sells his work primarily through commissions, galleries, and architects.

Brian Cummings
Rumney, NH
Born: 1952, Franklin, NH
Education: BA, Dartmouth College, Hanover, NH, 1974
Self-taught blacksmith

Since 1978, Brian Cummings has been designing and handcrafting lifestyle accessories such as cheese knives, skewers, cappuccino spoons, bread knives, and hearth tools, at his studio in Rumney, New Hampshire, in the foothills of the White Mountains. He first began metalworking at Dartmouth College, where he majored in biology. Although Dartmouth did not offer any formal instruction in blacksmithing, he took advantage of the blacksmithing equipment in the student metal shop on campus. According to Cummings, most of the objects he makes are inspired by a need for that particular type of item in his own life. When

designing a piece, Cummings feels it is necessary to think first about how that object would function most effectively and then letting the design flow from there. Cummings individually handcrafts all of his work and is assisted by his wife, Karen.

Edison Cummings
Mesa, AZ
Born: 1962, Keams Canyon, AZ
Education: Associate of Fine Arts in Three-dimensional Art, Institute of American Indian Arts, Santa Fe, NM, 1984; Art Education, Metalsmithing, Arizona State University, Tempe, 1987–90

Edison Cummings creates fine Native American jewelry, sterling silver teapots, and flatware that, as he describes, go beyond the rules of traditional jewelry and silversmithing. Since 1996, Cummings has owned and operated his own jewelry business out of a studio in his home in Mesa, Arizona, creating sterling silver, gold, and platinum Native American contemporary jewelry. Prior to that, Cummings worked for White Hogan in Scottsdale designing and fabricating Indian jewelry. He sells his work at art shows and galleries as well as to a clientele that he has acquired throughout the U.S. Cummings donates some of his jewelry to fund-raising events benefitting arts and Indian health organizations in the Southwest.

William R. Cumpiano
Northampton, MA
Born: 1945, San Juan, Puerto Rico
Education: Tufts University, Medford, MA, 1962–64
BA, Industrial Design, Pratt Institute, Brooklyn, NY, 1968
See page 58

Dan Dailey
Kensington, NH
Born: 1947, Philadelphia, PA
Education: BFA, Philadelphia College of Art, PA, 1969
MFA, Rhode Island School of Design, Providence, 1972

Dan Dailey is an internationally known glass artist who often incorporates metal in his work. He founded the glass program at Massachusetts College of Art in 1974 and remains a professor at the college today. Dailey's focus in his own work is the production of his vases, lamps, sculpture, drawings, wall reliefs, and site-specific architectural installations, and works from his studio in New Hampshire. He has com-

pleted numerous architectural commissions consisting of cast glass murals, windows and doors, chandeliers, sconces, illuminated sculpture, and entire rooms including walls, floors, ceilings, lighting, furniture, stair railings, mirrors, and tables. Dailey has participated in more than 300 juried group and invitational exhibitions since 1972 and his work is in the permanent collections of many museums worldwide.

Peter Danko
York, PA
Born: 1949, Washington, D.C.
Education: BA, Art History, University of Maryland, College Park, 1967
See page 48

Thomas Davin
Exeter, RI
Born: 1956, Exeter, RI
Education: Cabinetmaking, Los Angeles Technical College, CA, 1975–76; Industrial Design, California State University, Northridge, 1976–80

Tom Davin grew up in Massachusetts and spent summers on the coasts of Maine, Cape Cod, and Rhode Island, where he observed sailboats and their combination of beauty and function. Understanding that these qualities could fit together in an object if made properly, Davin creates his fine wood products, such as letter openers, business card cases, pill boxes, and picture frames, in a variety of woods including cocobolo, ebony, maple, cherry, and walnut for his business, Davin and Kesler, Inc. In addition to watercraft, Davin is influenced in his work by modernism, minimalism, Asian art, and Frank Lloyd Wright. He established his first studio in Woodland, California in 1980, and moved back to Rhode Island in 1986. He currently works with Mary Kesler, who manages the business, in a 5,000-square-foot studio in an old granite mill building, where he has four assistants. He sells his work through craft shows and galleries.

Billy Davis
St. Cloud, FL
Born: 1953, St. Augustine, FL
Education: Self-taught

Billy Davis has spent his life working cattle in south central Florida, like most of his family of previous generations. He is currently foreman of the Crescent-J Ranch, near Kenansville, and is also an outstanding spur maker,

working in a shop at his home near the ranch. Davis has always enjoyed making things, including whittling wood and crude welding. He also has a longtime interest in antique spurs as well as old bridles and stirrups, which precipitated his hand-making his first spurs. These were based on 19th-century pieces from his collection and old Sears catalogues. (He refers to the period between 1890 and 1940 as the golden age of ranching.) Davis now adapts older designs for spurs that are more functional and aesthetically pleasing to contemporary ranchers and horse riders. He also customizes spurs for the individual horse rider based on his or her size and practical needs.

Malcolm Davis
Washington, D.C.
Born: 1937, Newport News, Va.
Education: BS, Mathematics, College of William and Mary, Williamsburg, Va., 1959
MA, Divinity, Union Theological Seminary, New York, NY, 1964
Theological Studies, University of Basel, Switzerland, 1962–63
Corcoran School of Art, Washington, D.C., 1974–76
The George Washington University, Washington, D.C., 1977–79

In the fall of 1981 Malcolm Davis resigned from his position as Ecumenical Chaplain at the George Washington University in Washington, D.C., and rented a studio in Penland, North Carolina, to work in ceramics. In 1985 he set up a new studio at a summer retreat in Upshur County in West Virginia, where he produces individual porcelain functional forms that are inspired by rich Asian ceramic traditions, especially Shino ware. As he says, his wish is to bring to life pots that are friendly and intimate and that grow more personal with daily use.

Ronald DeKok
Belleville, WI
Born: 1947, Kenosha, WI
Education: BA, University of Wisconsin-Madison, 1969
MFA, University of Wisconsin-Madison, 1971

Ronald DeKok has been making furniture for 30 years, working out of an old general store in Belleville, Wisconsin, that he bought and converted into a studio after earning his MFA from the University of Wisconsin in 1971. DeKok designs and constructs his furniture forms, often incorporating decorative elements using hardwood

and veneer, which form aesthetically pleasing textures and patterns. DeKok draws inspiration from the ancient art and cultures of Africa, Egypt, and Japan. His reputation as an artist and craftsman allows him the luxury and freedom of working exclusively on private commissions and small inventories for a few select shows.

Barbara Diduk
Carlisle, PA
Born: 1951, Munich, Germany
Education: BA, College of William and Mary, Williamsburg, VA, 1973
Surrey Diploma, West Surrey College of Art and Design, Farnham, England, 1976
MFA, Ceramics, University of Minnesota, Minneapolis, 1978

Barbara Diduk's sculptural yet functional objects draw on a variety of visual traditions including traditional pottery, contemporary design, and object-oriented sculpture. She constructs pieces from clay parts thrown on the potter's wheel and assembled into larger structures, incorporating metallic and polychrome glazes and hammered-looking lusters on the surface. Diduk has worked for the past 20 years in a studio in Pennsylvania; she also teaches ceramics and sculpture at Dickinson College in Carlisle. She has also maintained a studio in New York City since 1989, and in 1997 she spent a year working and living in Holland, where she was influenced by the modernist de Stijl movement. She sells her work through galleries.

Joseph DiGangi
Santa Cruz, NM
Born: 1946, Brooklyn, NY
Education: Self-taught
See page 24

David D'Imperio
Stony Run, PA
Born: 1960, Allentown, PA
Education: BFA, Graphic Design, Kutztown University, PA, 1982

David D'Imperio has been making distinctive sculptural lighting since 1987. His innovative lighting objects are characterized by curvilinear elements, echoing the organic forms and fluidity of flowers, birds, and fish. D'Imperio utilizes various highly technical skills for his sophisticated lighting. While simple and delicate, these forms are assembled of dozens of minute parts. He uses materials such as stainless steel, cast acrylic, or turned lacquered maple for the bases, and cuts most of the shades

from a translucent, heat-resistant plastic called polycarbonate. He lives and works in Pennsylvania.

John Dodd
Canandaigua, NY
Born: 1954, Rochester, NY
Education: BFA, Woodworking and Furniture Design, School for American Craftsmen (now School for American Crafts), Rochester Institute of Technology, NY, 1978

A year after earning his BFA from the School for American Craftsmen at R.I.T., John Dodd established a studio in downtown Rochester. In 1993 he set up his woodworking studio in the Bristol Hills of the Finger Lake region of western New York. There he designs and constructs furniture using natural materials and is influenced by the simple belief that form follows function. Dodd always had a passion for architecture, walking in the woods, and building with his hands—so furniture design seemed a natural combination of these interests. He sells his work at craft shows, galleries, on his website, and out of his studio. Dodd also teaches furniture design and construction part-time at his alma mater, the School for American Crafts of R.I.T.

Mike and Roz Duflo
St. Joe, AR
Born: (Mike) 1954, Kearny, NJ; (Roz) 1945, Dunkirk, NY
Education: (Mike) Morristown Community College, NJ, 1974 (Roz) State University of New York at Buffalo, 1965–66 Foothill Junior College, Mountain View, CA, 1969–70

Mike and Roz Duflo moved to the Ozarks of Arkansas in 1981. As a builder trained in framing and finish carpentry, the mixed hardwood forests of the Ozarks were part of Mike's attraction to the region. He soon began working at a cutting-board shop that needed expansion, and Roz became an apprentice woodworker. Together they participated in their first juried craft show in 1984. Shortly after, they built their home studio and established Duflo Woodcrafts. Today the business is called Wood Duflo, and as partners, they concentrate on creating unique kitchen accessories using available local hardwoods and other North American figured hardwoods. While Mike's woodworking skills allow him to explore the realm of functional handmade objects, Roz's finishing skills give each piece a smooth feel and a durable finish.

John Dunnigan
West Kingston, RI
Born: 1950, Providence, RI
Education: MFA, Furniture Design, Rhode Island School of Design, Providence, 1980; BA, English, University of Rhode Island, Kingston, 1972

John Dunnigan is a furniture maker with more than 25 years of experience. While he is best known for his contemporary furniture in exotic woods and sumptuous fabrics, he also works in cast bronze, glass, and plastic. His work ranges from petite cabinets and chairs to interior architecture and has even included pool tables and cues. Dunnigan works from his studio in West Kingston, Rhode Island. He is also a professor at the Rhode Island School of Design, where he teaches theory, technique, and design history. His work has been exhibited nationally and internationally and is represented by several major private and museum collections. Dunnigan has lectured and served as a panelist at schools and institutions across the country.

Curtis Erpelding
Port Orchard, WA
Born: 1950, Fort Dodge, IA
Education: BA, English, University of Colorado, Boulder, 1972

Curtis Erpelding lived and worked in construction trades in Denver after receiving his undergraduate degree from the University of Colorado in 1972. He traveled throughout Europe before moving to Seattle in 1975. There he began designing and making furniture and started his own company in 1977. He worked in several shop locations in Seattle before establishing himself in Port Orchard in 1990, where he currently designs and makes custom as well as limited production furniture. Since 1980, Erpelding also has been a member of Northwest Fine Woodworking, a cooperative gallery in Seattle, which shows finely made furniture and other crafts. His work has been included in several exhibitions and publications. Erpelding has led numerous workshops and written articles on woodworking.

Kathy Erteman
New York, NY
Born: 1952, Santa Monica, CA
Education: University of California Los Angeles, 1970–71 BFA, California State University, Long Beach, 1977

Kathy Erteman set up her first ceramics studio in 1978 in industrial Signal Hill, California, to develop sculptural work incorporating clay and neon. She then began making porcelain lustreware vessels influenced by china painting traditions and twentieth-century European studio ceramics. In 1981 Erteman moved her studio to a waterfront warehouse in Benicia, California. By 1984 she was concentrating on functional forms employing color porcelain, and in the early 1990s she began working with earthenware, exploring freely carved black and white patterns, which characterize her current work. Erteman moved to New York City in 1994, where she now maintains her studio. Her work has been exhibited widely and is sold through galleries, museum shops, and home design stores. She also teaches part-time.

Robert Joseph Farrell
Fort Atkinson, WI
Born: 1960, Fort Atkinson, WI
Education: BA, English and Studio Art, University of Wisconsin-Whitewater, 1987 MFA, Metal and Jewelry, Tyler School of Art, Temple University, Philadelphia, PA, 1989

After earning an MFA from Temple University's Tyler School of Art in 1989, Robert Farrell moved back to his hometown, Fort Atkinson, Wisconsin, and set up a studio in the basement of his family home, where he continues to work today. Farrell creates silver tableware, including serving sets, candlesticks, place settings, and vases, and works alone in his studio using traditional tools and equipment. He fabricates pieces from flat sheet metal, and inlays various metals for surface patterns. Farrell constructs his pieces by hammering, using steel stakes, or forcing metal into carved wood, and uses silver solder and an acetylene torch. He then files and sands the surfaces, and adds patina to heighten contrast between metals. Farrell sells directly from his studio and at retail events, such as juried craft shows. His work has been shown in numerous exhibitions and is found in collections around the country.

Fred Fenster
Sun Prairie, WI
Born: 1934, New York, NY
Education: BS, Education, City College of New York, NY, 1956 MFA, Cranbrook Academy of Art, Bloomfield Hills, MI, 1960

Fred Fenster established his studio in 1962 in Wisconsin, where he produces gold and silver jewelry and holloware in sterling silver, bronze, copper, and pewter. His pieces include sterling silver flatware and presentation pieces, Jewish ceremonial work, and functional pewter pieces, as well as wedding and engagement rings, pins, chokers, and pendants. In his work, Fenster explores the interplay of process and idea. Many of his forms grow from natural work processes, such as twisting or collapsing in prepared areas. Fenster believes there is a constant dialogue between the craftsperson and the response of the material, and feels he is both an observer and a worker as he creates a piece. He uses such observations of process to develop new ideas and forms. Fenster sells his work out of his studio, through exhibitions, and on commission.

Jody Fine
Berkeley, CA
Born: 1952, Santa Monica, CA
Education: Bard College, Annandale, NY, 1970–71; University of California, San Diego, 1971 Apprentice to master glassblower William Bernstein, 1974–76

Using classical Italian techniques of latticino, murrini, millifiori, and other ancient methods, Jody Fine creates contemporary off-hand blown glass work. His one-of-a-kind pieces include sculptural forms and vessels distinguished by bright multicolored patterns and organic shapes. He also produces studio lines of bowls, jars, spinning tops, and, most notably, marbles. Fine established his own studio, J. Fine Glass, in 1980, after two years in partnership with Dick Marquis and Jack Wax in Berkeley, California. Fine conducts workshops and seminars at schools throughout the country, and his work has been shown widely in galleries and museums.

Henry S. Fox
Newburyport, MA
Born: 1958, New York, NY
Education: BA, History, Trinity College, Hartford, CT, 1981

Henry Fox has been making furniture in colonial Newburyport, Massachusetts, since 1985. Fox Brothers Furniture Studio is named after his two young sons, William DeLana and Orren Carrere, who inspire him in his work. Fox is also influenced by the landscape and the Federalist and contemporary architecture of Newburyport,

and by his experiences rowing on a crew team. After graduating from college in 1981, Fox coached crews and built and repaired boats. He then decided to refocus his attention on architecture, a long-held interest (his grandfather was New York Public Library architect John M. Carrere), eventually finding furniture making as his career. Fox's studio is located in a renovated car dealership, where he works with wood, nontraditional design elements, and unusual materials. As he says, his furniture is an alignment of light, tension, weight, and the unexpected. Fox designs and makes all his own pieces with two assistants and works mostly on commission.

Chris Franznick
Flagstaff, AZ
Born: 1958, Oyster Bay, NY
Education: AA, Liberal Arts, Tusculum College, Greenville, TN, 1979; Arts Program, University of Arizona, Tucson, 1980; studied with architect Paolo Soleri at Arcosanti, AZ, 1980–84; Arcosanti/Haystack Exchange Program, Haystack Mountain School of Crafts, Deer Isle, ME, 1981

Chris Franznick became interested in working with wood in college. After graduating in 1979 he developed his skills as a craftsman in wood working, furniture-, and cabinetmaking at Arcosanti, the experimental city in Arizona created by architect Paolo Soleri. After four years he moved to New York to work on major furniture projects and in 1990 he founded Franznick Studio in California, creating custom furniture installations. He later moved his shop to Flagstaff, Arizona, hoping to combine his outdoor interests and professional skills. As an avid boater and a fine craftsman, Franznick had always admired the beauty and responsiveness of handcrafted wood paddles, which motivated him to turn his attention to the development of the ultimate wood kayak paddle, focusing on issues of weight, durability, and performance. After a year of researching, designing, and testing, he founded the ZuZu Paddle Company in 1997.

Jerry Gier
Upper Sandusky, OH
Born: 1942, Upper Sandusky, OH
Education: Self-taught blacksmith

Jerry Gier began smithing in 1980 as a hobby and decided to do it full-time in 1990, establishing Mouse Hole Anvil Blacksmith

Shop. Gier is a self-taught blacksmith, frequently attending blacksmithing events and reading books about various smithing techniques. In his studio in Ohio he produces a variety of wares, including door hardware, furniture, chandeliers, fireplace accessories, and lawn and garden items, using traditional techniques and antique tools. Having taught his son Jamie and his daughter-in-law Jennifer how to forge iron, they now assist him in the studio. He sells his work through craft fairs and also accepts custom orders.

John Parker Glick
Farmington Hills, MI
Born: 1938, Detroit, MI
Education: BFA, Wayne State University, Detroit, MI, 1960
MFA, Cranbrook Academy of Art, Blooomfield Hills, MI, 1962

John Glick established Plum Tree Pottery studio in 1964, where he continues to explore different forms of functional pottery. Since the 1990s, he has also devoted a portion of his work time to nonfunctional ceramic objects, creating wall pieces that incorporate drawing and painting, with forms and colors derived from nature, landscapes, and architecture. He is an enthusiastic educator, leading ceramics workshops here and abroad, writing, giving lectures, and offering apprenticeship training to young potters. His work is included in numerous art and university collections around the country, and has been widely exhibited.

Alan Goldfarb
Burlington, VT
Born: 1959, New York, NY
Education: Keene State College, NH, 1977; AS, School for American Craftsmen, Rochester Institute of Technology, NY, 1982

Alan Goldfarb opened his Burlington, Vermont, studio in 1983 in a small 2,000-square-foot former truck garage and warehouse. Prior to that he studied with master glassworkers across the country, including Bertil Vallien, Lino Tagliapietra, and Dale Chihuly. His work ranges from studies of glass tableware from ancient Rome, the Middle Ages, and the Renaissance, which he calls Historical Deviations, to more unique pieces that cleverly contemporize ancient glass, which he calls Historical Revisions. Goldfarb continues to study glassblowing through workshops at Pilchuck Glass School, Haystack Mountain

School of Crafts, and the Studio of the Corning Museum of Glass. He usually works with the aid of one or two assistants.

H. F. Grabenstein
Williston, VT
Born: 1947, Philadelphia, PA
Education: BA, Temple University, Philadelphia, PA, 1969

H. F. Grabenstein is a bowmaker who builds a full range of historical as well as modern bows for the viola and violin families of stringed instruments. He studied bowmaking with William Salchow at the University of New Hampshire and was bowmaker at the Tourin Musica from 1983 to 1990. Using snakewood, pernambuco, ebony, and other hardwoods, he creates detailed bows that will play expressively and that are secure on the string. His clients include many well-known chamber and orchestral groups, including The King's Noyse, The Baltimore Consort, The Boston Symphony, and The Cleveland Orchestra. He sells his work directly from his studio and through music festivals and exhibitions.

Katherine Gray
Seattle, WA
Born: 1965, Toronto, Canada
Education: AOCA, Glass, Ontario College of Art, Toronto, Canada, 1989; MFA, Glass, Rhode Island School of Design, Providence, 1991

Katherine Gray is a glassblower who works in various studios in Seattle. Since 1996 she has been an assistant glassblower to Sonja Blomdahl, Janusz Pozniak, Dante Marioni, Dick Marquis, and Dimitri Michaelides. Her elegant glass tableware attempts to preserve a dining ritual that, although distant to many of us today, Gray continues to idealize. Her work has been included in exhibitions across North America. In the past few years Gray has held several positions as an instructor. She is currently a visiting assistant professor at the University of Illinois at Urbana-Champaign.

Don and Jenifer Green
Delhi, NY
Born: (Don) 1965, Wilmington, DE
(Jenifer) 1965, New Haven, CT
Education: (Don) Cleveland Institute of Art, Program in Stone Carving, LaCoste, France, 1985
BFA, Philadelphia College of Art, PA, 1987; Apprentice to studio furniture maker Michael Hurwitz, Philadelphia, PA, 1988
(Jenifer) BFA, University of the

Arts, Philadelphia, PA, 1987

GreenTree was founded by Don and Jenifer Green in 1993 in upstate New York. The Greens produce a line of studio furniture and accessories using domestic and imported hardwoods and veneers, milk paint, and metals such as steel and brass, and employing traditional joinery. Since 1987, after obtaining his BFA at the Philadelphia College of Art, Don has designed and built studio furniture for solo exhibitions and individual commissions. He is the principal designer for GreenTree and continues to explore the boundaries of design, materials, and techniques, while Jenifer manages sales and marketing.

Philip A. Greene
Round O, SC
Born: 1964, Milford, CT
Education: Self-taught
Philip Greene is a canoe and paddle maker who works from a 2,800-square-foot studio in rural Round O, South Carolina. Greene has always loved water and admired the pioneer lifestyle. As a child growing up in Connecticut and in New York's Adirondack Mountains, Greene would shape boats from wood and bark and float them in nearby brooks. Greene joined the Navy in 1983, and in 1984 he and his wife, Paula, moved to South Carolina where he was stationed. In 1988 he and Paula established a studio and built their first wood canoe. Over the years Greene has improved his canoes by creating and experimenting with new designs. Although he has no formal training in boat making, he considers trial and error his education. He also credits his father's high expectations for driving his quest for perfection. Today, he and two assistants at Wood Song Canoes produce six to eight canoes annually and up to 80 paddles.

Russell Greenslade
Girard, OH
Born: 1941, Penzance, Cornwall, England
Education: Penzance School of Art, Cornwall, England, 1959–62
National Diploma in Design-Textiles, Central School of Arts and Crafts, London, 1965

In the 1970s Russell Greenslade worked as a designer and art educator in England, where he was born and studied art and design. He established his first studio in 1966, producing woven wall hangings that were exhibited

in galleries throughout Britain. In 1978 he moved to America and established a studio in northeast Ohio. Since 1979 he has been the owner and creative director of Russell Greenslade Designs, which produces original textile designs and hand-cut wood art puzzles. Puzzle-making came as a result of Greenslade's interest in both toy-making and natural forms. After making a series of drawings, often of tropical birds, fish, reptiles, and fantastical creatures, Greenslade cuts the puzzle with a scroll saw. Each of his puzzles is individually handcut, sanded, handcolored, and finished in natural oil.

Gary S. Griffin
Bloomfield Hills, MI
Born: 1945, Wichita Falls, TX
Education: BA, California State University, Long Beach, 1968
MFA, Tyler School of Art, Temple University, Philadelphia, PA, 1974

Gary S. Griffin has been the artist-in-residence and head of metalsmithing at Cranbrook Academy of Art in Bloomfield Hills, Michigan, since 1984. Prior to that he taught at the School for American Craftsmen, Rochester Institute of Technology, where he worked after obtaining his MFA from the Tyler School of Art in 1974. He established his studio in Bloomfield Hills in 1984, where his metalsmithing practices focus primarily upon applied and decorative arts, including lighting fixtures, hardware, tables, fireplace screens, and gates and fences. His commissioned works are placed throughout the U.S. Most recently he completed the pedestrian and vehicular entrance gates to the Cranbrook Academy of Art. Griffin has written extensively on metalwork for exhibition catalogues, critical reviews, and articles.

William Gudenrath
Corning, NY
Born: 1950, Houston, TX
Education: BA, Music, Organ Performance, North Texas State University, Denton, 1974
MA, Music, Harpsichord Performance, The Juilliard School, New York, NY, 1978

William Gudenrath began glassblowing at age 11 and pursued it until he was 18. After developing a passion for music, he took a 10-year hiatus from glass into the world of classical music, studying and performing organ and harpsichord. Still intrigued by glass, Gudenrath came across the New York Experimental Glass

Workshop (now Urban Glass) in Brooklyn in 1979, and his glass-blowing career took off. A self-taught artist who has mastered the methods of the 16th- and 17th-century glassblowers, Gudenrath is now considered one of the foremost American authorities on glassmaking techniques of the ancient world and the Renaissance. In addition to creating objects in the style of a particular historical period, he also produces his own designs, which are sold at fine stores and in galleries nationwide.

John Gunther
Abingdon, VA
Born: 1949, Flint, MI
Education: BA, Michigan State University, East Lansing, 1972

John Gunther has been a textile designer and weaver since 1973. He established his first studio attached to his home in the mountains of the southern Appalachians in 1975. He later moved to Abingdon, Virginia, where he worked out of a studio in his home, and in 1994 he built his current 3,600-square-foot work space, which has views of the surrounding mountains and woods. He feels these vistas are a constant source of inspiration. Gunther's current focus is on creating rugs and wall hangings using Ripsmatta, a traditional symmetrical weave originating in Sweden, in an altered asymmetrical fashion for a contemporary appearance. Gunther loves working with color and enjoys shifting gradations of color in his work, often influenced by landscapes and natural phenomena. He sells his work through craft fairs, galleries, shops, and the Internet.

Larry Halvorsen
Seattle, WA
Born: 1948, Ellensburg, WA
Education: BS, Fisheries Biology, University of Washington, 1973
Self-taught potter

As a child, Larry Halvorsen traveled extensively throughout the U.S. with his parents and was deeply affected by southwestern Native American art and architecture. In 1972, while at the University of Washington, Halvorsen became interested in making pottery. He began producing and selling his own pottery and took a job at the Kirkland Art Center firing kilns and teaching throwing. He later traveled with the Peace Corps to Central America, where he examined various collections of Pre-Columbian pottery and

visited local potters. He returned to the U.S. in 1981 and began experimenting with surface carving, which has evolved to his current black-and-white sgraffiti ware, inspired by art from various cultures. For the past nine years he has worked out of a Seattle studio with one or two part-time assistants. Halvorsen also teaches part-time at Seattle Pacific University.

Robert A. Harman

Bloomington, IN
Born: 1946, Aberdeen, Scotland
Education: BA, History, Aberdeen University, Scotland, 1975
MA, Sociology, Aberdeen University, Scotland, 1977
MS, Telecommunications, Indiana University, Bloomington, 1982

Robert Harman has always worked with his hands. From a family of artisans and craftsmen, Harman has been a leather worker, shoe maker, clothes designer, and for the last 15 years, an upholsterer and furniture maker. In the mid-1980s Harman gave up the academic life (he was a Ph.D. candidate in Telecommunications and Instructional Systems Design) to make one-of-a-kind upholstered chairs, couches, and ottomans using silks, velvets, and jacquards. He uses maple for durability and makes cushions with down or cotton and springs. His studio is in Bloomington, Indiana, where he has lived with his wife and daughter for 20 years. Harman sells to designers, through galleries and major craft shows, and to private individuals, and has had several solo exhibitions.

Cheyenne Harris

Tempe, AZ
Born: 1963, Phoenix, AZ
Education: BFA, Jewelry/Metalsmithing, Northern Arizona University, Flagstaff, 1988; MFA, Artisanry, University of Massachusetts, North Dartmouth, 2001

Of Navajo and Northern Cheyenne heritage, Cheyenne Harris is a fourth-generation metalsmith. At an early age she began learning the techniques of traditional Navajo silversmithing from her mother, Roberta Multine Tso, who was trained by Kenneth Begay at Navajo Community College. Harris started making her own jewelry and metal objects in 1979 while in high school and ever since has sought to learn about numerous aspects of art and design history and how they come together in a work of metal.

In college and in graduate school she studied European, Korean, and Japanese metalsmithing. The range of her work includes flatware, holloware, jewelry, and mixed media sculpture. Her pieces have been included in many exhibitions and are held in several collections in the U.S.

Michael Heltzer

Chicago, IL
Born: 1960, Chicago, IL
Education: BA, Philosophy, University of Colorado, Boulder, 1982
JD, Northwestern University School of Law, Chicago, IL, 1987
School of the Art Institute of Chicago, IL, 1986–88

It took a while for Michael Heltzer to find his calling. After college and during the first two years of law school Heltzer was not sure how to pursue his creative interests. During his last year at Northwestern Law School, however, he enrolled at the School of the Art Institute of Chicago and decided to make furniture. In 1986 he set up a studio at a former camera factory and began making models of his designs to show potential clients. With the help of friends, Heltzer started his line of sleek, contemporary, and comfortable furniture. A few years later he added two pool table designs to the collection. Heltzer emphasizes clean lines in his pieces through the use of high-quality, lightweight materials. His current studio is in an old candy factory in Chicago, which also houses the manufacturing facilities and administrative offices for 25 employees.

Doug Hendrickson

Lesterville, MO
Born: 1938, Minneapolis, MN
Education: BFA, Minneapolis College of Art and Design, MN, 1963; MFA, University of Minnesota, Minneapolis, 1968

After earning an MFA from the University of Minnesota in 1968, Doug Hendrickson was continuously employed in academia for 14 years as a professor of art. Then, in 1983, Hendrickson established his studio, Peola Valley Forge, in the Ozark Mountains of southeast Missouri, where he forges iron utilitarian objects that, he hopes, enrich and add meaning to the rituals of life. He also creates gallery pieces and does liturgical commissions. His work is influenced by nature and how elements move, affect, and shape each other. Hendrickson works alone in creating his metalworks.

Pamela Hill

Mokelumne Hill, CA
Born: 1948, Carbondale, IL
Education: BA, English Literature, University of Illinois, Urbana, 1973; University of California, Los Angeles, 1974–75
Self-taught quilter

Pamela Hill grew up in an Amish area of central Illinois and remembers the strong tradition of quiltmaking as an early influence on her work. She is inspired by and makes frequent use of handwoven and dyed fabric of other cultures, especially Japanese, African, and Guatemalan fabrics, which she finds especially appropriate to her own broadly drawn designs and intricate piecing method. She primarily makes one-of-a-kind pieces but continues to produce a few quilts as limited editions, reserving the right to reproduce a piece up to 50 times. Hill established a studio in northern California in 1976 and since 1988 has lived and worked in the Italianate Victorian Werle Soda Works Building (c. 1887) in a historic gold rush village of 500 people. With the help of two full-time assistants in her studio, Hill designs and quilts each piece, which she signs, dates, and numbers. Her work is sold at craft fairs, stores, and galleries.

Robin L. Hodgkinson

Haydenville, MA
Born: 1948, Los Angeles, CA
Education: BA, Anthropology/Education, Friends World College, Long Island University, Southampton, NY, 1971

The study of ethnomusicology introduced Robin Hodgkinson to the wide variety and complexity of sounds created by simple flutes from around the world. He began making flutes full-time in 1976, experimenting with materials such as bamboo, acrylic tubing, brass pipe, and lathe-turned exotic hardwoods. Inspired by the creativity of design and sonic motifs expressed in pre-Columbian clay flutes and whistles, Hodgkinson began producing accurately tuned ("musically relevant") clay flutes in 1980. His current series of multichambered, earthenware vessel flutes entitled "Spirit Vessels" expresses his interest in the study of comparative religion and mythology, and the role of ceremonial music in ritual. Hodgkinson shows his sound instruments at craft fairs and sells his work nationally and internationally in galleries, museum gift stores, and mail order catalogues.

Jim Holmes

Chatham, MA
Born: 1952, Frostburg, MD
Education: MFA, Tyler School of Art, Temple University, Philadelphia, PA, 1985; BA, Art, Goddard College, Plainfield, VT, 1978

Glassmaker Jim Holmes has designed a series of functional objects that include glass bud vases, candlesticks, and bowls. His work is characterized by organic forms and a playful use of color—bold, vibrant, and often unusual hues add to the unique quality of his glass. At his studio, Chatham Glass Company, which was established in 1987 in Massachusetts, Holmes uses traditional glass-blowing methods, creating and signing each piece individually.

Sara Hotchkiss

Portland, ME
Born: 1951, New Haven, CT
Education: BS, Studio Art, Skidmore College, Saratoga Springs, NY, 1974
See page 52

Mary A. Jackson

Charleston, SC
Born: 1945, Mount Pleasant, SC
Education: Secretarial Training Certificate, Trident Technical College, Charleston, SC, 1963
Self-taught basketmaker
See page 28

Peter Jagoda

Spokane, WA.
Born: 1946, Boston, MA
Education: BS, Ashland College, Ashland, OH, 1970; MFA, Arizona State University, Tempe, 1972; Certificate from Turley Forge, Santa Fe, NM, 1987

When Peter Jagoda was a child, his parents took him to the George Walter Vincent Smith Museum in Springfield, Massachusetts. Its exquisite collection of Japanese armor and metalwork made an impression on the future artist and metalsmith. Jagoda later studied sculpture with Ben Goo at Arizona State University and established his own metalworking studio in Yuma in 1972. Jagoda produces knives of high carbon Sheffield or 440C steel, which holds a keen edge and can be resharpened easily. For handles he uses both synthetic and natural materials, including micarta (a laminate of paper or cloth bonded with resins), cocobolo, ebony, and tulipwood. He maintains a studio in an old barn in Washington State and sells his work through craft shows, galleries, and from

his studio. He also teaches jewelry and metalwork at Spokane Falls Community College.

Russell C. Jaqua

Port Townsend, WA
Born: 1947, Detroit, MI
Education: Alma College, Alma, MI, 1965–67; Penland School of Crafts, Penland, NC, 1973

In the late 1960s Russell Jaqua left college to serve in the U.S. military in Vietnam. He later traveled to West Africa, where he was a bead trader in Liberia and Ghana in 1971–72. He returned to the U.S. to attend Penland School of Crafts in 1973–74. While at Penland, Jaqua experimented using a forge and switched his focus from jewelry making to blacksmithing. In 1976, following an apprenticeship at Storm Temper Forge in Maryland, Jaqua established Nimba Forge in Port Townsend, Washington, which was named after a Liberian mountain of 90 percent pure iron ore. Jaqua's large-scale memorials, garden sculpture, architectural elements, furniture, and accessories are known for bold textures and the resulting play of light and shadow. Jaqua enjoys manipulating form, material thickness, and surfaces in the single process of blacksmithing. His forms record the dramatic encounter between fire, metal, and smith. Jaqua sells his work from his studio, through galleries, and on commission.

Michael Jerry

Santa Fe, NM
Born: 1937, Grand Rapids, MI
Education: BFA, School for American Craftsmen, Rochester Institute of Technology, NY, 1958
Cranbrook Academy of Art, Bloomfield Hills, MI, 1960–61
MFA, School for American Craftsmen, Rochester Institute of Technology, NY, 1962

Michael Jerry was raised in a family of artists—his father was a painter and museum director and his mother a craftsperson and art educator. An exhibition of Danish silver that Jerry attended as a teenager decided his future. He studied silversmithing with Hans Christenson at the School for American Craftsmen at R.I.T. and he served as a production assistant in the studios of Ronald Pearson and Toza Radakovich. He also studied for nearly two years with Richard Thomas at Cranbrook Academy of Art. Jerry likes to experiment with metal and its limits, creating fluid and dramatic jewelry and functional

holareware in silver, gold, and pewter. He taught metalsmithing at Syracuse University until May 2000, and recently relocated to Santa Fe, New Mexico, where he lives and works. He sells his work from his studio and through galleries.

Olle Johanson
Pawtucket, RI
Born: 1956, Stockholm, Sweden
Education: Apprentice to master silversmith Olle Ohlsson, 1977–79 Apprentice to Nils Nisbel and Ralf Ohlsson at The Konstfackskolan, Stockholm, 1979–80 MFA, Rhode Island School of Design, Providence, 1984

Olle Johanson began metalworking as a youngster in his native Sweden. After apprenticing to silversmiths Olle Ohlsson, Nils Nisbel, and Ralf Ohlsson, Johanson set up his own studio in Stockholm in 1980 with Rolf Knophammar. In 1982 he moved to the U.S. to attend the Rhode Island School of Design, where he got his MFA in 1984. He continued at RISD as a technical assistant and teacher until 1985, when he was hired as a silversmith for Wallace International in Wallingford, Connecticut. From 1986–90 Johanson worked as a designer and silversmith for Richard Fishman in Providence, and, along with Fishman, also taught metal at Rhode Island College. In 1990 Johanson set up his own studio and business in Providence, which moved to Pawtucket, Rhode Island in 1993. In addition to creating his own metal flatware and jewelry, Johanson has also designed for the Ralph Lauren Jewelry Collection and the Collections of the Vatican Museums (CVM) in Rome.

Ray Jones
Asheville, NC
Born: 1955, Ukiah, CA
Education: BS, Aeronautical Engineering, California Polytechnic State University, San Luis Obispo, 1976

While in college, Ray Jones worked summer jobs as a carpenter's assistant. After obtaining his degree in aeronautical engineering, he moved to Southern California for a job at an aerospace propulsion firm. Instead of buying furniture for his new home, he bought the tools to make his own. After the furniture was complete, he continued working with wood by making gifts, including a jewelry box for his future wife. In 1982 , when Jones left his engi-

neering job, boxes then became the foundation of his woodworking career. Jones uses only wood fasteners, hinges, and drawer slides for his boxes, and is interested in many different types of wood from around the world. He currently lives in western North Carolina with his family and sells his work through galleries and craft fairs.

Tom Joyce
Santa Fe, NM
Born: 1956, Tulsa, OK
Education: Self-taught
See page 44

Richard Judd
Paoli, WI
Born: 1953, Marshfield, WI
Education: University of Wisconsin-Madison, 1971–73 BS, Architecture, University of Wisconsin-Milwaukee, 1975

Richard Judd's work in architecture and the building trades led to his own business as a furniture designer and craftsman in 1984. He purchased an old industrial building (a former blacksmith's shop) near Madison, Wisconsin, in 1987, which is still his full-time studio. Judd's background in architecture continues to influence his work today. He feels that form follows function, and that a well-designed object should be comfortable to use and should perform its tasks well. If it can also be sculpture at the same time, then it is a successful piece. He sells mostly through craft fairs, directly to repeat customers, and through his gallery, Zazen (Japanese for "meditation"), which he established in 1997 with Karen Judd. Housed in the front of the studio building, Zazen Gallery features not only his work but that of other American craftspeople as well.

Karen Karnes
Morgan, VT
Born: 1925, New York, NY
Education: Brooklyn College, NY, 1946; New York State College of Ceramics at Alfred University, 1951–52

In 1954 Karen Karnes established a studio in Stony Point, New York, a community that included artists John Cage, MC Richards, and David Weinrib (her husband), where she worked for 25 years making stoneware forms for use. She also gave wheel-forming workshops in the 1970s and into the 1980s. In 1980 she moved to Morgan, Vermont, where she works today. As a pioneer produc-

tion potter she has received many awards and honors for her unique work. Karnes remains committed to creating clay objects that reflect her personal philosophy and lifestyle.

Gunther Keil
Trumansburg, NY
Born: 1939, Berlin, Germany
Education: MA, German Literature, University of Waterloo, Ontario, Canada, 1978

Gunther Keil moved to the U.S. after attending graduate school in Canada in the 1960s. He then taught German literature at the University of Georgia in Athens and at Alfred University in New York State. During his years of teaching, Keil became interested in woodworking and taught himself the craft. He started making toys for his children in 1970 and was soon selling toys at craft fairs. Keil focuses on animal themes and prefers to work with natural wood colors, although he occasionally uses dyes for enrichment. He has recently developed miniature habitats, which portray animals in their regional environments. His work, especially the habitats, expresses the fragility and exquisiteness of life, which is often neglected in our technical world. Keil lives with his family on Cayuga Lake in central New York. He sells his work in craft stores and galleries throughout North America, Europe, and Japan.

David R. Kiernan
Harmony, RI
Born: 1958, Springfield, MA
Education: University of Lowell, MA, 1981, 1985; Worcester Center for Crafts/School for Professional Crafts, MA, 1991–93

David Kiernan became a furniture maker because he felt the need to express his creativity, which he had not been able to do during his previous 10-year career as an engineer. He established his furniture-making studio in Rhode Island in 1993 immediately after completing a two-year program at the Worcester Center for Crafts in Massachusetts. With one part-time assistant he makes limited production and commission furniture using both solid wood and veneers, and often accents them with other materials such as metal. Making furniture gives him satisfaction in creating objects that are both useful and beautiful. Kiernan sells his work mostly through craft fairs and galleries.

Krist King
Pettisville, OH
Born: 1956, Pettisville, OH
Education: Self-taught whipmaker

Krist King learned his trade, making whips for horseback riding, while working as a cowboy on ranches in Nevada, Idaho, Oregon, Washington, Arizona, and Florida. He found that making whips filled the creative urge in him and satisfied the need to work with his hands. King has been braiding whips for twenty years and gets satisfaction from making quality gear that is used by working cowboys as well as by performers and hobbyists. He says he is always challenged to perfect his skills. While living in Idaho, King became intrigued with the idea of making the world's longest whip and cracking it for the *Guinness Book of World Records*. His leaded nylon stockwhip, measuring 184 ft. 6 in., broke the previous record of 140 ft. set in 1991 and remains the record. Today King works out of his home in Ohio and sells his whips wholesale, retail, and by word of mouth.

Ellen Kochansky
Pickens, SC
Born: 1947, Brooklyn, NY
Education: BFA, Syracuse University, NY, 1969
See page 54

Elliot Landes
Winters, CA
Born: 1951, Oakland, CA
Education: BA, Design, California College of Arts and Crafts, Oakland, 1975; Hebrew University, Jerusalem, Israel, 1969–71

Elliot Landes began wood turning in college, and in his last year came up with the idea of making turned-wood writing instruments. In 1977 he started his business in Winters, California, and over the course of the next decade, Penmakers, Inc. grew, acquiring several employees. Landes currently produces more than two dozen types of writing instruments and accessories—including a wood pen box that lifts the pen up when opened, a double box for pen and pencil, and an uplifting calligraphy set. The Penmakers studio is now located in an old apricot-packing warehouse in Winters.

Daniel Larson
Duluth, MN
Born: 1954, Corpus Christi, TX
Education: Certificate in Musical Instrument Technology, London College of Furniture, England, 1975

Daniel Larson is devoted to the research and production of historical musical instruments, including violins, Renaissance lutes, and Baroque mandolins. Larson's artistic mission is to capture the inspiration of the original instruments based on extensive research of period music, principles of construction, and the tools and materials that were used. The internationally known violin band The King's Noyse plays a matched set of Larson Renaissance violins modeled after the instruments Andrea Amati made for the court of King Charles IX in the 16th century. Authenticity in Larson's instruments extends even to the strings, which are made in his workshop under the trade name Gamut Strings and are sold worldwide. In his studio in the basement of an old school building on Lake Superior, he is assisted in instrument production by his son Jakob, and with string order preparation by his wife, Bobbye.

Thomas Latané
Pepin, WI
Born: 1955, Baltimore, MD
Education: Towson State University, MD, 1978–79

Thomas Latané grew up watching the blacksmiths at Catoctin Mountain State Park in Maryland and at Colonial Williamsburg, Virginia. In 1972, while still in high school, Latané constructed his first blacksmith forge and began making traditional-looking objects of iron and wood, combining his interest in history with a self-reliant craftsmanship. In 1974 he studied woodworking with Slimen Maloof at Penland School of Crafts and in 1978–79 attended jewelry and metalsmithing classes with John Fix at Towson State. Latané still uses the skills acquired there for jewelry-like detailed ornamentation, which he feels has been missing in mass-produced objects. In 1983 he and his wife, Catherine Hillman, set up their current studio in an old bank in Pepin, Wisconsin, where he repairs antiques and produces unique hardware, tools, and furnishings. Latané also teaches advanced blacksmithing at various schools and instructs students in his own shop.

R. Bruce Lemon
Lake Placid, NY
Born: 1949, Lansing, MI
Education: University of Buffalo, NY, 1967–70
See page 68

David William Levi
Clinton, WA
Born: 1959, St. Louis, MO
Education: BFA, Washington University School of Fine Arts, St. Louis, MO, 1983; trained with Ann Warff, Jan-Erik Ritzman, and Sven-Ake Carlson at Kulturarbetare I Glas, Transjo/Kosta, Sweden, 1985

IBEX Glass Studio was founded as a three-person partnership in St. Louis in 1985 and relocated to Washington State in 1993 under the direction of David Levi. Levi had extensive training in glass-working in Europe and the U.S., including an apprenticeship in Sweden, and attended many workshops with Italian master Lino Tagliapietra. At his 4,000-square-foot shop in a renovated chicken barn, Levi makes all of his pieces by hand using off-hand blowing methods, with the help of two assistants, and dates and signs each with the IBEX name. Levi also produces unique sculptural pieces that he exhibits internationally under his own name.

Daniel Levy
New York, NY
Born: 1952, Bronx, NY
Education: BA Anthropology, Archaeology, State University of New York, Stony Brook, 1974 BFA, Ceramics/Sculpture, Alfred University, State College of Ceramics, NY, 1978

After completing his studies in sculpture and ceramics at Alfred University, Daniel Levy moved to New York City. In 1978 he set up his first sculpture studio in the Green-point neighborhood of Brooklyn, where he worked in welded steel, cement, and wood. He closed the studio in 1981 to set up and supervise a porcelain doll factory in Long Island City, Queens. There he learned the ceramic process of slip casting. In 1982 Levy once again established his own studio, in a garage on East 13th Street, Manhattan, and began developing utilitarian forms specifically designed to be slip cast in porcelain. In 1995 he moved his studio to an 1,800-square-foot loft on West 29th Street, where he continues to explore aspects of design, function, and surface decoration through slip-cast porcelain forms. Levy has held a number of teaching positions, including most recently at the New School/ Parsons (1984–99).

David Levy
Davis, CA
Born: 1957, Dallas, TX

Education: BS, Design, University of California, Davis, 1980

David Levy grew up in the pine forests of southern New Mexico and worked summers in a logging camp, which influenced his decision to work with wood. He studied design at the University of California in Davis, where he used domestic and exotic hardwoods in creating functional pieces with geometric patterns. Levy currently uses laminations of hardwood of contrasting colors and grains to produce patterns in a variety of products, including kitchenware, desk accessories, game boards, and tables. Levy says he makes each piece as if it were going to be his own, selecting the finest materials and combining traditional and modern woodworking techniques, including tongue-and-groove and dovetail joinery, followed by sculpting, shaping, sanding, and finishing. Levy is especially concerned with maintaining an environmentally sound and safe shop, where he works with three assistants. He sells his work through craft fairs, his studio, and retail galleries.

Meg Little
Newport, RI
Born: 1953, Boston, MA
Education: Pitzer College, Claremont, CA, 1971–73 BFA, Tyler School of Art, Temple University, Philadelphia, PA, 1977 MAE, Rhode Island School of Design, Providence, 1984

Meg Little established her studio, On the Spot, in Newport, Rhode Island, in 1990, where she employs four people to make one-of-a-kind pieces and very limited edition rugs. Her hand-tufted rugs give her the freedom to explore interactions between color and pattern, while allowing her to work in textiles, her first love. Her work is influenced by many painters as well as by ancient patterns and archetypal motifs found in various cultures. She describes her work as painterly, with its multiple patterns and colors defining space and evoking movement, but her main objective is to make rugs that will be used. Much of Little's work is done on commission, though she also sells through craft fairs.

Randy Long
Bloomington, IN
Born: 1951, Natrona Heights, PA
Education: BA, Art, San Diego State University, CA, 1974; MA, San Diego State University, CA, 1977;

MFA, California State University at Long Beach, 1983

Randy Long has maintained her own studios since she graduated with an MA from San Diego State University in 1977. She taught metalsmithing, design, and ceramics at Drake University in Des Moines, Iowa, for five years before enrolling for her MFA at California State University at Long Beach. She earned her degree in 1983 and moved to Bloomington where she accepted a position as Head of the Metalsmithing and Jewelry Design Program at Indiana University. Working from her home studio, Long makes one-of-a-kind functional holloware, art jewelry, and small-scale sculptures that are inspired by her studies of ancient Roman, Greek, and Gothic jewelry, art, and architecture. Her mentors have included instructors at San Diego State University, Arline Fisch, Hiroko and Gene Pijanowsky, Ruth Laug, and Helen Shirk, as well as Alma Eikerman of Indiana University. She sells her work through galleries and occasionally through exhibitions.

Kari G. Lønning
Ridgefield, CT
Born: 1950, Torrington, CT
Education: Summer apprentice at Brookfield Craft Center, Brookfield, CT, 1968; University of Oslo, Norway, 1970; BFA, Ceramics and Textiles, Syracuse University, NY, 1972; Handarbetets Vanner, weaving school, Stockholm, Sweden, 1972; apprentice to tapestry artist Marie Triller, Dannemora, Sweden, 1972

In the early 1970s following her graduation from Syracuse University, where she studied ceramics, textiles, and metal, Kari Lønning made and sold "beasts," handwoven animal forms, sewn together and stuffed. Although successful, these creations were highly labor-intensive and expensive to make. Lønning then turned to basketry as a way to explore color and pattern in a rigid form, utilizing her training in various media. She is inspired by architecture, Japanese and English gardens, as well as birds' nests. In keeping with her Norwegian heritage, she works in a subdued palette of warm reds, purples, blues, and neutral shades of gray and taupe. When she's not in her garden or greenhouse, Lønning works out of her home studio and sells her work through gallery exhibitions and craft fairs. She also teaches workshops in basketry.

Matthew Lyford
Exeter, NH
Born: 1954, Brooklyn, NY
Education: Self-taught

As a child Matt Lyford began building boats with his father. As a teenager he made kayaks and a speedboat in his spare time. As Lyford says, he has always been interested in being on or in the water. He started building boats professionally at the age of 20, but did not take up surfing until nearly 20 years later. In 1995 Lyford began making surf boards, drawn to the simplicity of the form. Always impressed by wood and the way wooden boats move through water, Lyford now produces wooden boards of white pine, mahogany, spruce, cedar, butternut, or redwood—locally gathered or recycled from lumberyards. He then covers the boards in a thin fiberglass cloth and epoxy resin, and says they are meant to last a lifetime. In addition to his surfboard business, Lyford Long-boards, Lyford also builds and repairs boats and runs a martial arts institute.

Dennis MacDonald
Fabius, NY
Born: 1955, Walton, NY
Education: Self-taught

High Point Crafts was established in 1970 in Fabius, near Syracuse, New York, in what remains its current studio on Main Street. After an apprenticeship there, Dennis MacDonald purchased the company in 1995 and is now the sole proprietor. With the assistance of his two sons, MacDonald makes one-of-a-kind brooms using traditional broom-squire techniques, as well as introducing fancy weaves and vine-wrapped handles. MacDonald also produces an extensive line of feather fans and dusters using ostrich or peacock feathers gathered when the bird molts, and hand makes bellows from fine hardwood, quality leather, and brass. Durand Van Doren fabricates the ironwork on MacDonald's products, which are sold in shops and at craft and art fairs around the country.

Steve Madsen
Albuquerque, NM
Born: 1947, Oxnard, CA
Education: Engineering, Utah State University, Logan, 1965–67 Art/Art History, University of New Mexico, Albuquerque, 1971–73

Steve Madsen was always interested in art, but concentrated

in math and science in school. He started cabinetmaking for a shop that was doing work at his parents' house. He considers that job his only formal training. Madsen began thinking more about furniture and design after discovering *Woodenworks*, a catalogue that included the work of Sam Maloof. Other influences include living in New Mexico with its many artists and craftspeople, and an art appreciation class he took at UNM. Madsen established his own studio in 1972 after he quit his job and was accepted to the New Mexico Arts and Crafts Fair. He has been at his present location, an old casket manufacturing company, for the past 22 years. Madsen works primarily alone but has close working relationships with tenants of other studios in the building. Madsen attends local and national craft shows and exhibits his work in Albuquerque galleries. He also sells directly through his studio.

James Makins
New York, NY
Born: Johnstown, PA
Education: BFA, Philadelphia College of Art, PA, 1968 MFA, Cranbrook Academy of Art, Bloomfield Hills, MI, 1973

James Makins's interest in Japanese and British pottery began early in his career, when he was an apprentice to Byron Temple, an American potter who had worked with British potter Bernard Leach. Makins explored other cultural influences at Cranbrook, where he studied with artist Richard DeVore. He established his own studio in 1973 in New York's SoHo neighborhood, where he continues to live and work today, producing limited edition porcelain. He travels extensively and has organized and conducted several pottery trips to China. In 1993 he received a Professional Fulbright Fellowship to Japan, where he established a second studio that he returns to each summer. His work has received many awards and is represented in museum collections in the U.S. and in Europe. He also teaches full-time at the University of the Arts, Philadelphia.

John B. May
Kittery, ME
Born: 1966, Fall River, MA
Education: BA, Art History, Bates College, Lewiston, ME, 1988

After graduating from Bates College in 1988, where he studied

324

art history, John May worked with his father, John May, Jr., as the resident cabinetmaker at Strawberry Banke Museum in Portsmouth, New Hampshire. There he designed and built furniture and produced wood turnings. The following year he established his own studio, Three60, where he continues to design and produce turned bowls and accessories. May also creates fine and custom furniture at Fox Brothers Furniture Studio in Newburyport, Massachusetts, where he works with master woodworkers to build one-of-a-kind pieces, using both modern and traditional tools. May exhibits his work at national and international trade and craft shows.

Bobbe McClure
Van Horn, TX
Born: 1953, Welch, WV
Education: BS, University of Kentucky, Lexington, 1972
See page 56

Linda McFarling
Burnsville, NC
Born: 1953, Macon, GA
Education: Mercer University, Macon, GA, 1972–75; BFA, Painting, Wesleyan College, Macon, GA, 1978

After graduating from Wesleyan College and attending concentrated sessions in pottery at the Penland School of Crafts, Linda McFarling established her studio in 1994 in Burnsville, North Carolina, where she works by herself producing salt-fired stoneware. Her work has been influenced by a range of artists, styles, and forms, from the figure and nature to African and Japanese folk art traditions. She markets her work from a gallery attached to her studio and at a few juried craft fairs, galleries, and invitationals. McFarling also teaches workshops nationally.

James N. McKean
New York, NY
Born: 1953, Bethesda, MD
Education: Violinmaking School of America, Salt Lake City, UT, 1977

Since 1981, James McKean has run his own atelier specializing in making violins, violas, and cellos. He works from his own models as well as those of other great masters of the craft, integrating contemporary making with long-standing tradition. After graduating from the Violinmaking School of America in 1977, the first institution in this country to offer training in the craft of making violins,

McKean learned restoration and the principles of violin sound from Vahakn Nigogosian in New York. McKean is a frequent contributor and corresponding editor to *Strings* magazine as well as a past president and a longtime board member of the American Federation of Violin and Bow Makers.

Judy Kensley McKie
Cambridge, MA
Born: 1944, Boston, MA
Education: BFA, Rhode Island School of Design, Providence, 1966
See page 46

Bob McNally
Rockaway, NJ
Born: 1948, Albany, NY
Education: Lowell Technological Institute, MA, 1970
Self-taught musician and instrument maker

After obtaining a degree in plastics engineering in 1970, Bob McNally worked for one year as an engineer. He then turned to teaching, repairing, and eventually making guitars, banjos, and dulcimers, and found his passion. Around 1981 he developed and patented the Backpacker's Guitar and started a career inventing his own instruments (including the Strumstick, Doorchime, and Swingchime). In 1983 he established Handcrafted Recordings and began recording music using his own inventions. As a self-taught woodworker and instrument maker, McNally has evolved nontypical techniques. He feels that as a self-trained artist his work develops slowly; however, he often discovers novel solutions. He lives in northern New Jersey with his family, recording and making instruments in his creative and unorthodox fashion.

Matthew Metz
Houston, MN
Born: 1961, Kendallville, IN
Education: BFA, Ceramics, Ball State University, IN, 1983; MFA, Ceramics, Edinboro University of Pennsylvania, 1985

Matthew Metz has been living and making pots on a small farm in southeast Minnesota for 10 years. He uses a wood- and oil-fired kiln, typically working in six-week cycles, creating pieces with decorative carved and drawn surfaces. Metz cites as influences on his work early American ceramics, quilts, and folk art, as well as Asian and European ceramic traditions. Metz worked as a ceramics techni-

cian at the University of Michigan and was a resident at the Archie Bray Foundation in Helena, Montana, before setting up his own work space with his wife, Linda Sikora, who is also a potter.

Robert A. Mickelsen
Melbourne, FL
Born: 1951, Fort Belvoir, VA
Education: Humbolt State University, Arcata, CA, 1970–71; apprentice to Steven L. Sebaugh, Glass Impressions, Greeley, CO, 1975–76

In the 1970s, Robert Mickelsen apprenticed to Steven Sebaugh, a professional lampworker, and then for 10 years sold his own lampwork designs at street craft fairs. After attending a class with Paul Stankard in 1987, his eyes were opened to new possibilities of working in glass. In 1989 Mickelsen established Mickelsen Studios, Inc. in Melbourne Beach, Florida, which moved to its present 1,200-square-foot space in 1997. Once he started his own studio, Mickelsen began marketing his work exclusively through galleries. He participates in several exhibitions a year, and his work is found in collections around the country, including the Renwick Gallery at the Smithsonian Institution and the Corning Museum of Glass. Mickelsen also teaches at prestigious glass and craft schools, holds annual workshops in his studio, and writes technical and historical articles on lampworking.

Daniel Miller
Waynesville, NC
Born: 1954, Ithaca, NY
Education: BA, Principia College, Elsah, IL, 1980

Daniel Miller studied three-dimensional design and metalsmithing with Judith Felch at Principia College. He works in hot forging, or classic blacksmithing, as well as with modern equipment and techniques out of his studio in a two-story stone and frame building near his home on the side of a mountain in North Carolina. Miller began working in metal in 1976 doing production craft work, but for the last ten years has focused on one-of-a-kind pieces, usually working alone. He also has created sculpture in iron, forged bronze, and marble but most recently is drawn to functional pieces. He participates in numerous local, national, and international blacksmithing conferences, and has held several

teaching positions. Miller lives with his mate and three children.

David Monette
Portland, OR
Born: 1955, Vicksburg, VA
Education: Self-taught instrument maker
See page 60

James Mongrain
Seattle, WA
Born: 1968, International Falls, MN
Education: Moorhead State University, MN, 1988; Massachusetts College of Art, Boston, 1989–91; Appalachian Center for Crafts, Smithville, TN, 1991–93

Since 1997, James Mongrain has owned and operated Mongrain Glass Studio, Inc. in Seattle. From the beginning of his career, Mongrain has been interested in the Venetian tradition of glass goblet making. As his proficiency in this area has grown, he has become more focused on the simplicity and functionality of his work. In addition to his own output, Mongrain has also been active over the past decade in numerous large-scale projects, including those of glass master Dale Chihuly. Mongrain sells his glass from his studio and through galleries.

Clifton Monteith
Lake Ann, MI
Born: 1944, Detroit, MI
Education: BFA, Painting and Education, Michigan State University, East Lansing, 1968 MFA, Painting, Michigan State University, East Lansing, 1974

Since 1985, Clifton Monteith has worked full-time at Twig Furniture and Sculpture Design and Construction in Lake Ann, Michigan. Monteith feels strongly that the medium of his work should be in harmony with the object and its function. The form of his furniture is determined by the natural characteristics—the shape and properties—of the wood used. He hunts for just the right materials for his work and hopes that being alert and sensitive to his environment will be passed on through the pieces themselves. In 2000 Monteith spent six months in Kyoto on a Japan Foundation Grant studying and working in Urushi lacquer, which is another natural material and process that he feels is in keeping with his method of working. Monteith has held numerous teaching positions and has exhibited widely.

Benjamin Moore
Seattle, WA
Born: 1952, Olympia, WA
Education: Central Washington University, Ellensburg, 1970–72 Instituto de Artes Plasticas, Guadalajara, Mexico, 1972 BFA, Ceramics, California College of Arts and Crafts, Oakland, 1974 MFA, Glass, Sculpture, Rhode Island School of Design, Providence, 1977

Since 1985, Benjamin Moore has operated his own glass studio and business, Benjamin Moore, Inc., in Seattle. He collaborates with architects and designers for specialty lighting in contemporary architectural settings, such as pendant lamps, wall sconces, and floor lamps, as well as decorative objects. Moore focuses on simplicity, balance, and clarity of form in his blown glass. Opacity, translucency, and transparency are elements he varies to create different decorative impressions. He uses certain ancient Roman techniques of manipulating glass to vary saturation according to form and to provide simple decorative elements. Moore's one-of-a-kind pieces are exhibited in galleries around the world and his lighting projects are done on commission. Since 1991, he has been on the board of trustees at Pilchuck Glass School, and in 2000 he served as its Interim Executive Director. Moore has also been on the faculty of several other prestigious art schools.

Louis Mueller
Providence, RI
Born: 1943, Paterson, NJ
Education: BFA, Rochester Institute of Technology, NY, 1969 MFA, Rhode Island School of Design, Providence, 1971

Louis Mueller began his work in metal in 1966 in a studio that was the ground floor of Shop One in Rochester, New York, where he was studying for his BFA at the Rochester Institute of Technology. He has had studios in Berkeley, California and in New York, but since 1992 he has been working in a 3,000-square-foot former machine shop in a one-story building in Providence. Mueller specializes in creating lighting, furniture, sculpture, and jewelry, as well as drawing and printmaking. He sells his work through galleries around the U.S., and since 1977 he has been on the faculty of the Rhode Island School of Design.

Wendy Mueller
Providence, RI
Born: 1954, New York, NY
Education: Boston University, MA, 1972; BFA, Kansas City Art Institute, MO, 1977;. New York State College of Ceramics at Alfred University, Alfred, NY, 1984; Summer Textile Institute, Rhode Island School of Design, Providence, 1997

Wendy Mueller studied ceramics and printmaking in art school and eventually used those skills to learn more textile-oriented applications. Working with fiber led to a deeper investigation of fabric itself and ultimately to felting. Mueller's work is influenced by ancient art and civilizations, and she finds Scythian, Etruscan, Coptic, and early Byzantine worlds especially rich and inspirational. Mueller established her two-story studio in Providence in 1986. Upstairs she draws or paints designs and stores dyed wool fleece. Downstairs she uses an old cook stove in her dye laboratory to make felt. Mueller's friends who raise sheep provide her the wool fleece for her work. The wool of each breed of sheep has unique characteristics and Mueller utilizes them for certain desired results. She sells her work from her studio and through galleries and shows.

James H. Nadal
Canandaigua, NY
Born: 1946, New York, NY
Education: University of the Americas, Mexico City, Mexico, 1965; Pratt Institute, Brooklyn, NY, 1966; BA, MacMurray College, Jacksonville, IL, 1967; MA, Painting, University of Iowa, Iowa City, 1969; Illinois State University, Normal, 1971–72

James Nadal received most of his academic training in the fine arts. After earning his masters degree in painting from the University of Iowa, he worked in New York City for two years and in 1971 studied with Joel Phillip Myers at the University of Illinois. In 1972 Nadal moved to the Finger Lakes region of New York State, where he built his first studio. That same year he fabricated the equipment for the first glass studio at the Rochester Institute of Technology and taught there for a summer session. Nadal's functional glass and unique work are known for their bold primary colors and clean, straightforward forms. He sells his glass in shops and galleries around the U.S. His one-of-a-kind pieces are in many

public and private collections. Nadal Glass is currently located in an old 1878 firehouse that was renovated by Nadal and his son, Blas, also a glassblower. Nadal employs one full-time employee and many glassblowers on a part-time basis.

Katheleen Nez
Santa Fe, NM
Born: 1954, Tuba City, Navajo Nation (AZ)
Education: Associates Degree, Ceramics, Photography, Institute of American Indian Arts, Santa Fe, NM, 1983

Katheleen Nez moved to Santa Fe, New Mexico, from California 20 years ago to attend the Institute of American Indian Arts. Although initially a student of printmaking, she quickly was drawn to clay and throwing pots. Since 1992, Nez, a full-blood Navajo, has worked out of her home studio space, where she produces wheel-thrown, functional stoneware, which is glazed and gas-kiln fired. She hand paints the exterior surfaces of her pieces with mineral paint and uses motifs taken from Anasazi and Mimbres pottery. She sells her work through her gallery in Santa Fe and through regional craft fairs.

Gary Lee Noffke
Farmington, GA
Born: 1943, Decatur, IL
Education: BS, Education, Eastern Illinois University, Charleston, 1965; MFA, Metal, Southern Illinois University, Carbondale, 1969

Gary Lee Noffke began metalworking professionally in 1969, making metal cooking utensils and tableware. He says his love of good food and his ability to cook has contributed greatly to his interest in making implements for preparing and serving food and drink. In his more recent work, Noffke is concentrating on liturgical and selected commissions, utilizing new gold alloys and direct hand forming processes. He works at his Farmington, Georgia, studio, as well as at his studio at the University of Georgia, Athens, where he is a professor of art and has taught since 1971.

Greg Noll
Crescent City, CA
Born: 1937, San Diego, CA
Education: Self-taught
See page 66

Craig Nutt
Kingston Springs, TN
Born: 1950, Belmond, IA

Education: BA, University of Alabama, Montgomery, 1972

Craig Nutt is a furniture maker who enjoys contrasts and juxtapositions of the familiar and the unexpected, and of the real and the fantastic. Since 1999, he has been working in a 3,000-square-foot studio near his home in Kingston Springs, Tennessee. Before that he worked in studios in Tuscaloosa, Alabama (1977–79), and the adjacent community of Northport, in the Kentucky Arts Center (1979–98). Much of Nutt's work is inspired by vegetable forms. Vegetables have provided him with a visual and metaphorical vocabulary, visible in a two-foot-long cayenne pepper as a table leg, or a bent asparagus stalk as a Queen Anne cabriole leg. Recently Nutt has been developing a technique for producing cast polychrome concrete slabs for use as table tops. His work has appeared in numerous exhibitions and publications.

Jeff Oestreich
Taylors Falls, MN
Born: 1947, St. Paul, MN
Education: BA, Bemidji State University, MN, 1969; University of Minnesota, Minneapolis, 1967–68; apprentice at Bernard Leach Pottery, St. Ives, England, 1969–71

Jeff Oestreich set up his first pottery studio in 1971 in rural Wisconsin, following his two-year apprenticeship with renowned British potter Bernard Leach. After a fire destroyed his studio, he relocated to his current 45-acre home and studio in rural Taylors Falls, Minnesota. There Oestreich creates his utilitarian vessels that incorporate traditional methods and styles with more contemporary forms. He likes to experiment with glazes and slips, often leaving portions of his pottery unglazed with throwing lines still visible on the surface. Oestreich creates objects that are meant to be held, with designs that take into account the natural manner in which the piece will be used. For 12 years Oestreich worked with a partner, but he now works primarily alone. He sells his work through his studio and from exhibitions and shows around the country and abroad.

Floriana Petersen
San Francisco, CA
Born: 1960, Idrija, Slovenia
Education: MA, Art History, University of Ljubljana, Slovenia, 1985

While a student of art history in her native Slovenia, Floriana Petersen worked in the restoration department of the Slovenian Conservatory and in the library of Ljubljana's Museum of Modern Art. She moved to San Francisco in 1986 and found a job with a leather wholesaler. Though not formally trained in bookbinding or leather working, she gradually learned the craft. Her first bookbinding project was a gift for her husband and was so well received that she eventually developed a small leatherworking business of her own. In 1993 she established On Your Marque and began to work full-time designing not only books, but also boxes, photo albums, and artist display portfolios for many successful commercial artists and photographers. She developed a unique debossing technique that now characterizes her work. Petersen enjoys designing products that not only protect and preserve, but that grow more beautiful with age.

Karen L. Pierce
Evergreen, CO
Born: 1956, Aurora, IL
Education: BFA, Colorado State University, Fort Collins, 1978 MFA, Metalsmithing, Arizona State University, Tempe, 1993

Karen Pierce's interest in metalsmithing began in 1978 as a student of interior design at Colorado State University. After graduating, Pierce traveled to various tropical countries, and exposure to exotic cultures and habitats, especially in Bali, had a profound impact on her designs. After taking another metals class in 1989 she decided to abandon her career in interior architecture in 1991 to get her MFA at Arizona State University, where she studied with metalsmith Dave Pimentel. Pierce's vessels are strongly influenced by her natural environment and her interest in the custom of ritual offerings. Her current work reflects elements inspired by the Arts and Crafts movement, as well as her architecturally influenced appreciation of clean lines. Since 1993 Pierce has worked from her studio in Colorado. She is also on the Board of Governors for Arrowmont School of Arts and Crafts and is a part-time archaeologist in Belize.

Peter Pierobon
Berkeley, CA
Born: 1957, Vancouver, British Columbia, Canada

Education: Ceramics, Capilano College, Vancouver, Canada, 1976–79; AOS, Furniture Design, Wendell Castle School, Rochester, NY, 1981–83

Peter Pierobon began studying ceramics in 1976, but after discovering the contemporary furniture movement, he decided to pursue furniture design at the newly established Wendell Castle School in Rochester, New York. After graduating, Pierobon was hired by Castle and worked in his studio from 1983 to 1985, during which time he created his own furniture in his off hours. In 1985 he left Rochester to establish his first studio in Toronto, Canada, but in 1987 moved to Philadelphia for a teaching position at the University of the Arts, where he remained for ten years. In 1997 he moved to his current studio in Berkeley, California. Over the years Pierobon's residential furniture has become more organic and sculptural. He is influenced by indigenous art from around the world as well as by contemporary sculpture and painting. He accepts commissions and shows his work in galleries around the country.

Susan Plum
Berkeley, CA
Born: 1944, Houston, TX
Education: University of Arizona, Tucson, 1962–63; University of the Americas, Mexico City, Mexico, 1963–65; Pilchuck Glass School, Stanwood, WA., 1986, 1987, 1994

Susan Plum started working in glass in 1987, intrigued by flame working as a technique for making candelabras. Raised in Mexico City, she was taken by the mythic, poetic, and magical realism that is deeply rooted in the arts and literature as well as the folk tradition there. The Tree of Life candelabra, which is usually made in clay and which has both ceremonial and traditional aspects, has been an inspiration for Plum's own candelabras. Since 1992, in addition to her functional work, Plum has created installations and has also exhibited sculpture and painting. She has taught at Pilchuck Glass School, Penland School of Crafts, Corning Studio, and Urban Glass. Her work has been in several exhibitions and is found in many public and private collections.

Russell Pool
Durango, CO
Born: 1958, Lansdale, PA
Education: BA, History, University of Pennsylvania, Philadelphia, 1981

Temple University School of Law, Philadelphia, 1982–83

Russell Pool decided to enter a monastery in 1983 after a year of law school. He started woodworking as a hobby at the monastery in 1986 and became the community's furniture maker in 1991. While he had some training there, he is primarily self-taught in woodworking. Pool currently focuses on wood jewelry boxes and chests at his studio in Durango, Colorado, which he established in 1995. Pool concentrates on one piece at a time, working a design until he feels the craftsmanship and the beauty are perfected, and that they satisfy his aesthetic sense of simplicity. Pool works with two apprentices and sells his work mainly through galleries and his website.

Janusz Pozniak
Seattle, WA
Born: 1965, Swindon, England
Education: D.A.T.E.C. Diploma, Southport College of Art, Merseyside, England, 1982
BA, West Surrey College of Art and Design, Farnham, England, 1986
apprentice to Ronald Wilkinson, Glasshouse, London, England, 1987–89

Janusz Pozniak is a professional glassblower, who, since 1992, has worked in association with various artists in Seattle, including Dante Marioni, Benjamin Moore, Lino Tagliapietra, Sonja Blomdahl, and Dick Marquis. After an apprenticeship with master glassblower Ronald Wilkinson in London, Pozniak worked as a technician and glassblower for Dale Chihuly from 1990 to 1992. Pozniak has attended numerous workshops with other glassmasters and has taught and exhibited his work throughout this country.

Michael Puryear
New York, NY
Born: 1944, Washington, DC
Education: BA, Anthropology, Howard University, Washington, DC, 1973
Self-taught furniture maker

Michael Puryear came to furniture making after working as a carpenter, contractor, and cabinetmaker. He was always interested in furniture, however, and throughout his other vocations, he made pieces for himself and occasionally for clients. He opened his shop in the early 1980s with a friend, producing mostly cabinets and built-in furniture. He has mastered a wide variety

of skills over the years and now works alone creating unique pieces. Puryear is interested in the expressive potential of furniture, while maintaining its functional integrity, and uses curves and contrasting color as expressive elements. He sells his work from his studio and through craft fairs and galleries.

Guy Rabut
New York, NY
Born: 1953, Westport, CT
Education: Violin Making School of America, Salt Lake City, UT, 1978
Apprentice to master restorer René Morel at Jacques Français Rare Violins

Guy Rabut, the son of an artist and an illustrator, was captivated from an early age by the cello and by drawing and sculpture. He discovered that a career in violin making offered a blend of music and art, and enrolled at the Violin Making School of America. After graduating in 1978, Rabut apprenticed to master restorer René Morel at the prestigious Jacques Français Rare Violins in New York, where he was exposed to many of the finest instruments in the world. In 1984 Rabut established his own studio to build new violins, violas, and cellos that are inspired by classical models as well as crafted from his own innovative designs. After several years in the historic Carnegie Hall building, Rabut recently moved to a larger space in Manhattan. Musicians generally visit his studio to commission or select their new instruments. Rabut also gives workshops and guest lectures at professional conventions.

Claudia Reese
Austin, TX
Born: 1949, Des Moines, IA
Education: BA, Connecticut College, New London, 1971
MFA, Ceramics, Indiana University, Bloomington, 1974

Claudia Reese started Cera-Mix Studios in 1981 on the front porch of her Austin, Texas, house, after she decided to focus on her craft rather than on her career as a teacher of ceramics at the university level. In 1985 Reese built a new studio for her growing business, and in 1993 her husband, Phil Martin, constructed another, larger studio, where she continues to work today. Since 1979, Reese has developed a line of platters that are decorative and functional. She uses ceramic and printmaking techniques for her earthenware,

which she then coats with a clear glaze. She has successfully marketed her pieces around the world. At Cera-Mix, Reese constantly creates new dinnerware and tile designs, then reviews these designs with assistants in her studio before introducing the lines each year.

Jacquelyn Rice
Providence, RI
Born: 1941, Orange, CA
Education: MFA, University of Washington, Seattle, 1970
See page 36

Marc Ricketts
Braddock Heights, MD
Born: 1970, Silver Spring, MD
Education: B.Arch., Pratt Institute, School of Architecture, Brooklyn, NY, 1993
See page 72

Mary A. Roehm
New Paltz, NY
Born: Endwell, NY
Education: BFA, Ceramics/Sculpture, Daeman College, Buffalo, NY, 1973
MFA, Ceramics, School for American Craftsmen, Rochester Institute of Technology, NY, 1979

Mary Roehm is a studio potter and professor of art at the State University of New York at New Paltz, where she has taught since 1991. She began her career in the early 1970s as a studio potter making tableware at the Carborundum Museum of Ceramics and at the Clayworks pottery studio and gallery in Buffalo, New York. In 1977 Roehm began working with porcelain and wood firing, and studied with Hobart Cowles at the School for American Craftsmen. She worked as a consultant and crafts coordinator at Artpark in Lewiston, New York, and served as artistic director and executive director for Pewabic Pottery in Detroit. Roehm's vessels are usually thrown, altered, or constructed, and she works with several different porcelains, including a black porcelain she discovered as a guest artist at the Shigaraki Ceramic Cultural Park in Japan. She sells her work through galleries and from her studio.

Jean and Kevin Rogers
Uniontown, OH
Born: (Jean) 1944, Cincinnati, OH
(Kevin) 1958, Akron, Ohio
Education: (Jean) Pilchuck Glass School, Stanwood, WA, 1977; BFA, Crafts and Design, Kent State University, Ohio, 1985

(Kevin) apprentice to glassblower David Moorehead

Kevin and Jean Rogers met in 1977, when Kevin took a stained-glass class Jean was teaching at Akron University. Kevin was an apprentice glassblower at Hale Farm and Village in Bath, Ohio, from 1979 to 1985, and Jean owned and operated Labour Panes Stained Glass in Akron from 1975 until 1985, when she earned her BFA from Kent State University. The two were married in 1985 and moved to Santa Barbara, California, where Kevin took a job in Grant Randolph's studio and later worked for Carl Radke of Phoenix Design. In 1987 Kevin began working for Elaine Hyde at her studio, doing his own glass work there as well, developing his expertise. Jean worked at a plant nursery and also attended art classes at Santa Barbara City College and at the University of California. In 1995 they established Rogers GlassWorks, Inc. At their current studio in Uniontown, Ohio, Kevin is the full-time glassblower, while Jean runs the business and consults on product design, especially color. The Rogers sell their hand-blown vases, bowls, and sculpture through their studio and at craft fairs.

Michael F. Rohde
Westlake Village, CA
Born: 1943, Fort Worth, TX
Education: Ph.D., Biochemistry, Ohio State University, Columbus, 1974; Alfred Glassel School of the Houston Museum of Fine Arts, TX, 1977–79

Michael Rohde has been a fervent weaver since 1973. He is primarily self-taught, having experimented with a lap loom and using a *Sunset Magazine* book as his guide. He later received instruction in weaving from Sharon Keech, Libby Platus, Morgan Clifford, and others, and studied drawing, color, and design at the Alfred Glassel School of the Houston Museum of Fine Arts. Rohde finds working in fiber, primarily woven pieces, exciting because of the relationship between textures and the interaction of light and color. All of his pieces are hand-dyed wool, and more than 100 colors may be used in a rug. Over the years Rohde has held positions as a teacher and lecturer, workshop leader, juror, exhibition organizer and exhibitor, and in art and guild organizations. He sells his work through galleries in California, New Mexico, and New York City.

Jon Michael Route
Frederic, WI
Born: 1954, Frederic, WI
Education: BS, Art, University of Wisconsin-Stout, Menomonie, 1977; MFA, University of Wisconsin-Madison, 1979

Jon Route started his business in 1983 in Kansas City and in 1988 moved his studio to the north woods of Wisconsin, not far from where he grew up. Route designs and fabricates holloware from sheets of pewter. He executes a series of sketches on paper before he begins working directly and spontaneously with the metal. He prefers not to burden his work with a narrative, striving to make forms that are engaging to the eye and a delight to hold and use. Route's favorite pieces are his pitchers and teapots. His wife, Deborah, assists in completing the finishing aspects of the work. The Routes sell most of their work through craft fairs and galleries.

Tommie Pratt Rush
Knoxville, TN
Born: 1954, Mobile, AL
Education: BFA, University of Tennessee, Knoxville, 1976
Arrowmont School of Crafts, Gatlinburg, TN, 1975–76

From 1976 to 1981 Tommie Rush worked at her one-person clay studio, Northshore Pottery, in Knoxville, Tennessee. Since 1983, Rush has shared a glass studio, also in Knoxville, with her husband, where she makes her own glass and colors using raw materials, oxides, and rare earth elements. As society moves toward an interest in the virtual, Rush views her glass objects as a link to the real world of the hand-made and the individual. She sells her vessels and objects through galleries and at an annual craft fair. Her work has been exhibited around the country since 1984.

Peter and Peg Saenger
Newark, DE
Born: (Peter) 1948, Orange, NJ
(Peg) 1948, Dayton, OH
Education: (Peter) BFA, Ceramics, Wittenberg University, Springfield, OH, 1971; (Peg) BA, Psychology, Wittenberg University, Springfield, OH, 1970; BA, Special Education, Wittenberg University, Springfield, OH, 1971

In 1972, after earning their degrees from Wittenberg University, Peter and Peg Saenger began producing reduction fired stoneware, including kitchenware and planters, in West Grove,

Pennsylvania. Their work, which they sold through craft fairs, shops, and galleries, was mostly kickwheel-thrown and decorated with brushed oxides. In 1980 the Saengers designed and built their current studio and home in Newark, Delaware. Their current work is about designing composite elements that fit together. Their production includes cast tabletop designs of tea and coffee sets, sugar bowls, and creamers in black and white satin-matte glazes. Their fit-together design concept has also been expanded to stemware, dinnerware, and vases. Saenger Porcelain is sold from the studio and at art fairs, craft shows, museum shops, and galleries.

Åsa Sandlund

Seattle, WA
Works with husband Preston Singletary
Born: 1969, Stockholm, Sweden
Education: L'Université de Sorbonne, Paris, France, 1988–89 Beckmans School of Design, Stockholm, Sweden, 1991–94 Pilchuck Glass School, Stanwood, WA, 1994–95

Åsa Sandlund was first inspired to work with glass after taking photographs of glass still lifes. While attending the Beckmans School of Design in Sweden, she worked at the Kosta Boda factory as an assistant to Gunnel Sahlin. There Sandlund met glass artist Preston Singletary on his 1993 visit to Sweden, which led to her attending a summer session at Pilchuck Glass School in Seattle, where Singletary lived. In 1995 Sandlund and Singletary were engaged and she moved to this country. Sandlund's current work reveals her perspective as a designer and her special consideration to form and details with opaque and transparent colors in combination to highlight various dimensions of the design as well as the function. Her pieces are blown by Singletary and she does the cold working. Sandlund has worked for Nordstrom in Seattle in a number of positions, most recently as Brand Design Manager.

Norm Sartorius

Parkersburg, WV
Born: 1947, Salisbury, MD
Education: BA, Psychology, Western Maryland College, Westminster, 1969; apprentice at Jurus Studio, 1973–74; work study at Bob Falwell Studio, Murray, KY, 1980–81

After obtaining a degree in psychology and working as a social worker, Norm Sartorius decided to pursue woodworking in 1974, when he moved to the rural mountains of West Virginia. In 1980 he was invited to the Bob Falwell Studio in Murray, Kentucky, for an 18-month intensive work study. He then returned to West Virginia in 1982 to establish his current studio and home. Sartorius has created functional pieces in various forms, including spoons and letter openers. He is drawn to the sculptural as well as functional value of an object, and allows the qualities of the wood to determine in part the final form of each work. Sartorius's pieces are in the collections of the Renwick Gallery of the Smithsonian Institution and the Detroit Institute of Art. He sells his work primarily through retail craft fairs and galleries.

Merryll Saylan

San Rafael, CA
Born: 1936, Bronx, NY
Education: BA, Art, Design, University of California, Los Angeles, 1973 MA, Art, Wood, California State University, Northridge, 1979

Merryll Saylan lives and maintains a studio in San Rafael, California, near the bay, on the end of a tidal marsh. She says her environment—the beauty of the natural surroundings and the movement and pattern of the tidal waters—as well as her urban background and love of Japanese design have influenced her woodturned plates and platters. Saylan is drawn to the nature of wood and its inherent differences in color, grain, texture, and density for her work. She is an active member of the Woodturning Center and a former president of the American Association of Woodturners, and has taught and written on the subject of art and wood turning.

Nick Schade

Glastonbury, CT
Born: 1963, Newton, MA
Education: BS, Electrical Engineering, Clarkson University, Potsdam, NY, 1986

As a child, Nick Schade spent his summer vacations canoeing and kayaking in the waters of New England. He says he knew how to canoe before he could ride a bike. After graduating from college with a degree in engineering, he decided to buy his own kayak only to find he couldn't afford one. He

then built his own, using the strip-built method he had seen used for canoes, and was pleased with the results. Although working as an engineer for the Navy, over the next few years he designed and built enough kayaks to open his own business, Guillemot Kayaks, in 1993. He also wrote *The Strip-Built Sea Kayak*, a guide to building your own kayak. In 1995 he finally quit his engineering job and now concentrates on his kayaks. His current studio is located in Connecticut, where he produces a few prototypes and custom-made kayaks a year.

JoAnne Schiavone

Dallastown, PA
Born: 1953, Long Branch, NJ
Education: BS, Art Education, University of Delaware, Newark, 1975; Penland School of Crafts, Penland, NC, 1979–80; Philadelphia College of Art (now The University of the Arts), PA, 1980–82

JoAnne Schiavone established her studio in 1982, currently located in an 1850s barn in southeastern Pennsylvania, where she works with one part-time assistant. She began her career by making a production line of journals, albums, and letter boxes, and her business has grown to include tabletop folding screens and larger-scale folding screens and wall panels. She also makes paste papers, handmade papers, and prints to produce one-of-a-kind pieces. Schiavone frequently uses water imagery in her work, which she feels weaves together stories of family, environment, and faith. Her work has been widely exhibited and is sold in galleries, craft shows, to interior designers, design consultants, and by word of mouth.

James Schriber

New Milford, CT
Born: 1952, Dayton, OH
Education: Goddard College, Plainfield, VT, 1970–72; Philadelphia College of Art, PA, 1974–75 Certificate of Mastery, Boston University, MA, 1979

James Schriber studied architecture with Dave Sellers and furniture making with Randy Taplin at Goddard College in the early 1970s. Later, at the Philadelphia College of Art and at Boston University, he continued his training with Daniel Jackson, Jere Osgood, and Alphonse Mattia. For more than 20 years Schriber has maintained a studio in New Milford, Connecticut. With two assistants, he produces a wide variety of fur-

niture pieces for both private and corporate clients. In addition to commissioned projects, Schriber designs work that has appeared in numerous gallery and museum shows. Since 1980, he has been an instructor at the Brookfield Craft Center as well as visiting artist at Rhode Island School of Design, California College of Arts and Crafts, and Penland School of Crafts.

Lisa Schwartz and Kurt Swanson

Carmel, NY
Born: (Schwartz) 1959, New York, NY; (Swanson) 1957, Denver, CO
Education: (Schwartz) BFA, Philadelphia College of Art, PA, 1981 MFA, Massachusetts College of Art, Boston, 1983; (Swanson) BA, College of Idaho, Caldwell, 1981; MFA, Massachusetts College of Fine Art, Boston, 1983
See page 40

Mark Shapiro

Worthington, MA
Born: 1955, New York, NY
Education: BA, Amherst College, MA, 1978; studio assistant to Mary Roehm, Penland School of Crafts, NC, 1987; scholarship to Michael Simon workshop, Penland School of Crafts, NC, 1989

Mark Shapiro began his career as a sculptor, making installation pieces in New York City. He decided to make the transition from sculptor to production potter in 1986, and moved from the city to rural western Massachusetts to build a kiln. Shapiro was drawn to the more functional aspect of pottery and wanted more control over all aspects of production—from the concept, to the making and finishing, to the selling of his work. He has been especially influenced by early American pottery, after digging up in his yard a shard of a 19th-century vessel with a local maker's stamp on it. At his Stonepool Pottery studio Shapiro has worked with Michael Kline and Sam Taylor. He now works alone most of the time, employing apprentices and several guest stokers when needed. His work is sold from the studio and through craft fairs and gallery shows.

Yuko Shimizu

Alameda, CA
Born: 1963, Takoname, Aichi, Japan
Education: BFA, Aichi Prefecture University of Fine Arts, Japan, 1986 BFA, Wood Construction/Furniture Design, California College of Arts and Crafts, Oakland, 1990

Yuko Shimizu moved to California from Japan in 1987, after she had earned her BFA at the Aichi Prefecture University of Fine Arts. She then studied wood construction and furniture design at the California College of Arts and Crafts and worked for Wendy Maruyama. She apprenticed to Garry Knox Bennett in 1991–92 and started participating in group exhibitions. In 1999 Shimizu moved her work space from Oakland to Alameda, where she now shares a 4,000-square-foot shop with seven other artists. Shimizu's furniture has been exhibited widely and is included in numerous publications.

Bud Shriner

Burlington, VT
Born: 1951, Montclair, NJ
Education: BA, Comparative Religion, University of Vermont, Burlington; MD, University of Vermont, Burlington, 1980

At an early age, Bud Shriner was encouraged by his parents to participate in craft projects. His father taught him the proper use of tools for such creations. Shriner, though skilled in his artistic endeavors, decided to study comparative religion and then to attend medical school at the University of Vermont. He was first exposed to off-hand glass blowing in 1978, and throughout the 15 years that he practiced emergency medicine, during his spare time, he explored glass, copper sculpture, and furniture design. He studied with glass artists Fritz Dreisbach, Jan Erik-Ritzman, David Levi, and Josiah McIlhenny. In 1995, after two years renting a studio space, Shriner built his own studio and in 1996 left his medical practice to focus solely on glass. At his Church and Maple Glass Studio in Burlington, Shriner now produces art glass, tableware, and sculpture with the aid of three assistants.

Randy Shull

Asheville, NC
Born: 1962, Sandwich, IL
Education: BFA, Rochester Institute of Technology, NY, 1986

Randy Shull learned about making things in his father's garage in the farm country of central Illinois, where he started making furniture in high school. After earning his degree from the Rochester Institute of Technology, where he explored furniture's more expressive and sculptural side, Shull was awarded an artist in residency at the Penland School

of Crafts, North Carolina. He then established a studio in Asheville in 1991. In 1995 he moved his studio to an old weaving shop in Grovewood, North Carolina. Shull's carved and painted furniture is rooted in a love of Southern country furniture and an interest in abstract painting. He has traveled extensively and his exposure to various cultures, including those of the Dominican Republic, Czech Republic, Turkey, and Vietnam, has also broadened his repertoire of colors, themes, and designs for his furniture.

Linda Sikora
Alfred, NY, and Houston, MN
Born: 1960, Saskatoon, Saskatchewan, Canada
Education: BFA, Nova Scotia College of Art and Design, Halifax, Nova Scotia, Canada, 1989
MFA, University of Minnesota, Minneapolis, 1992

While a student at the University of Minnesota, Linda Sikora studied with Mark Pharis, who, in 1991, rented to Sikora (and potter Matthew Metz) his former residence and studio in rural southeastern Minnesota. Metz and Sikora later purchased the property, which included a dairy barn converted to a pottery with a wood- and oil-fueled salt kiln. The atmospheric firing of the kiln came to be a significant factor in the aesthetic of Sikora's work. She is also influenced by highly decorative European and Eastern ceramic traditions. Sikora currently teaches at Alfred University in western New York State and each summer returns to work at the Minnesota studio. Her work is exhibited nationally and internationally.

Jonathan S. Simons
Kempton, PA
Born: 1955, Philadelphia, PA
Education: BA, Art Design, University of Illinois, 1977
Apprentice to designer Jeffrey Green, New Hope, PA, 1978

Jonathan Simons found his niche making spoons in 1977 while apprenticing to woodworker Jeffrey Green. One day while sitting down to his lunch at Green's studio, Simons realized he had forgotten a spoon for his soup. He simply cut one out of scrap wood on the bandsaw and he was inspired. He then began creating spoons in various woods and selling them at craft stores. In the spring of 1978 he moved to Maine and took a job at a canoe-

seat factory, continuing to make spoons on the side. He established his business, Jonathan's Spoons, in January 1979, combining his experiences in custom woodworking and in production. Today his specialty is designing more than 100 uniquely carved and completely functional wooden utensils. He has 12 employees at his studio in Kempton, Pennsylvania, where he makes primarily cherry-wood spoons.

Tommy Simpson
Washington, CT
Born: Elgin, IL, 1939
Education: BS, Northern Illinois University, DeKalb, IL, 1962
MFA, Cranbrook Academy of Art, Bloomfield Hills, MI, 1964

Tommy Simpson is an artist who works in many media—sculpture, painting, ceramics, jewelry, and printmaking. His imaginative art, including sculptural furniture, employs fantasy images constructed with wood and usually painted. He also works with metal to make specialized objects, such as hardware and cookie cutters. Simpson has written three books and has held many teaching positions, but he considers himself a working artist who likes to share his ideas in the workshop rather than as an educator. Over the years, he has had one or two one-person shows a year, and his work has been widely exhibited and is found in numerous public and private collections.

Preston Singletary
Seattle, WA
Works with wife Åsa Sandlund
Born: 1963, San Francisco, CA
Education: Studied with Pino Signoretto, Lino Tagliapietra, Cecco Ongaro, Benjamin Moore, Dorit Brand, Judy Hill, and Dan Daily at Pilchuck Glass School, Stanwood, WA.

Preston Singletary, who is one-quarter Tlingit, an Alaskan Indian tribe, was more interested in music than art when he graduated from high school in 1981. At the suggestion of his friend Dante Marioni, Singletary took a job as a nightwatchman at the Glass Eye in Seattle, and his interest in glass developed. He was soon put on a blowing team. His teachers have been among the best glass blowers in the world, including Lino Tagliapietra. He met his wife, designer Åsa Sandlund, on a 1993 trip to the Kosta Boda glass factory in Sweden, where he was influenced by Swedish design. His

more recent work, objects often in the shape of a Tlingit hat, have earned him much recognition. He applies traditional Tlingit designs to the outer surface of his vases, using stenciling and sandblasting techniques. When illuminated, these designs cast beautiful shadows. Singletary works out of Benjamin Moore Glass Art Studio in Seattle.

John L. Skau
Archdale, NC
Born: 1953, Waukegan, IL
Education: Associate of Arts, College of Lake County, Grayslake, IL, 1978; BFA, Northern Illinois University, DeKalb, 1981; Florida State University, Tallahassee, 1982–83; MFA, Cranbrook Academy of Art, Bloomfield Hills, MI, 1985

John Skau makes sculptural contemporary basket forms. His limited production works comprise series of related forms, such as the stre-e-e-e-etch basket, the swollen plane, the swollen disk, the bicorner, the tricorner, and the cone. Skau also creates series of larger-scale woven forms that are usually inspired by recent life experiences or ethnographic studies. Through his baskets Skau explores geometric patterns and rich color relationships, which he finds especially intriguing. He hand-cuts thin hardwood strips to precise widths, lengths, and tapers, often painting them before seamlessly weaving his forms. Twill, satin, and doubleweave structures with contrasting woods provide endless patterns. Bentwood laminations at the rims and turned elements at the bases are finished with a light application of varnish. Skau's work has been in numerous exhibitions and is found in collections around the country. He sells his work at fine craft shows and in galleries.

Brad Smith
Worcester, PA
Born: 1954, Worcester, PA
Education: BFA, Woodworking and Furniture Design, School for American Craftsmen, Rochester Institute of Technology, NY, 1980

Growing up on a farm in Pennsylvania, Brad Smith was always fixing and building things. This led to an interest in woodworking in high school, and after graduating he worked in several different local wood shops. He earned his degree in woodworking and furniture design from the School for American Craftsmen at R.I.T. in 1980. That same year he and his

wife, Sandy, began their business, Bradford Woodworking, with a line of kitchen tools and accessories that they had designed, made, and marketed themselves. They expanded the business in 1986 by developing a line of distinctive furniture. Working in a farm studio, Smith often incorporates in his furniture various objects or parts found on or inspired by the farm. His work is sold in stores and galleries around the country. He also builds 10 to 15 one-of-a-kind pieces a year on commission.

Kimberly Sotelo
Madison, WI
Born: 1968, Troy, NY
Education: BA, Art, University of Wisconsin-Madison, 1996

Kimberly Sotelo creates unique hybrid furniture forms that combine historical and contemporary styles, sculptural and functional forms, and craft and conceptual concerns. Juxtaposing materials and techniques from the tradition of rustic furniture with the sculptural shapes and whimsy of contemporary industrial design, Sotelo is able to create a variety of innovative, yet warm and inviting furniture pieces, including chairs, tables, and shelves. The design and building process is labor-intensive. Sotelo harvests materials herself from local farmland and ditches. She carefully selects and prepares each stick before nailing it over an aspen armature. Although she begins with a general concept of the desired form, Sotelo engages in a dialogue with her materials—which may redirect and inspire her process—as she methodically applies each stick to the developing form. Sotelo has shown in numerous national exhibitions and has won many awards. She works out of her studio in Madison.

Lin Stanionis
Lawrence, KS
Born: 1954, Rockville Centre, NY
Education: BA, Iowa State University, Ames, 1976; MFA, Indiana University, Bloomington, 1981

Lin Stanionis designs and fabricates holloware and fine metal jewelry. Since 1994, Stanionis has also been associate professor of art at Kansas University in Lawrence. She received her MFA from Indiana University, where she studied with Alma Eikerman, who stressed formalism and traditional silversmithing techniques, as well as Leslie Leupp and Bridgid O'Hanrahan, who encouraged more experimentation. In 1985

Stanionis established her studio, which she runs herself, doing all the research, design, and fabrication. Occasionally she uses commercial casting companies for larger projects. She says she is influenced by the ideals and attitudes of the Bauhaus as well as by sculptor David Smith. She markets her work primarily through exhibitions and also through a gallery and her studio.

Tim Stewart
Charlottesville, VA
Born: 1958, Stockton, CA
Education: BA, Art, California State University, Long Beach, 1989

Tim Stewart was born in Stockton and raised in San Francisco, California. He studied art and furniture design at California State University, Long Beach, and after earning his bachelor's degree, he worked for eight years in the lumber and building material industry. In 1997 he returned to his passion of making fine functional art: residential and commercial furniture, lamps, and sculpture. Stewart often uses aluminum and steel juxtaposed with select hardwoods. His contemporary furniture is characterized by classic lines that he hopes will have timeless appeal. Each piece is handcrafted, signed, and dated.

Tal Streeter
Verbank, NY
Born: 1934, Oklahoma City, OK
Education: BFA, Design, University of Kansas, Lawrence, 1956
MFA, Sculpture, University of Kansas, Lawrence, 1961

Tal Streeter is drawn to sky-oriented themes, whether in his sculpture, his kites, or his writing. Streeter is credited with being the first artist of the Western world to focus on the art of kite making by producing and exhibiting his kite objects as "sky art." Streeter designs his own kites, which are then fabricated with the assistance of Roberto Guidori. Streeter initiated the Sculpture/III-D Media Department in the School of Art+Design at the State University of New York at Purchase, where he taught until 2000 and is now professor emeritus. He has also held teaching positions at Queens College, University of North Carolina/Greensboro, Dartmouth College, and Massachusetts Institute of Technology, where he was a fellow and research professor at the Center for Advanced Visual Studies. Streeter has authored books

on the ancient, traditional, and contemporary forms of both Western and Eastern kites.

Billie Ruth Sudduth
Bakersville, NC
Born: 1945, Sewanee, TN
Education: BA, Psychology/Sociology, Huntingdon College, Montgomery, AL, 1967; MSW, University of Alabama, Tuscaloosa, 1969
Self-taught basketmaker

Billie Ruth Sudduth was pursuing a career as a psychiatric social worker and school psychologist when she became interested in basket weaving. In 1980, while working in North Carolina's Craven County school district, a supervisor observed that Sudduth had been working too hard and suggested she take up a hobby. She enrolled in a basket weaving class at Craven Community College and was hooked. She started her studio JABOBS (Just a Bunch of Baskets) in 1983, and in 1989 she left psychology to weave baskets full-time. Sudduth creates baskets with patterns based on the 13th-century mathematician Fibonacci's sequence of ratios, known as the Nature Sequence. Sudduth feels Fibonacci's numbers give her work a sense of order, yet offer unlimited design possibilities. Sudduth sells her work through craft fairs, galleries, her website, and studio. Her baskets have been exhibited widely and are in numerous public and private collections.

Boyd Ryo Sugiki
Seattle, WA
Born: 1968, Newport News, VA
Education: Pilchuck Glass School, Stanwood, WA., 1987–2000
BFA, California College of Arts and Crafts, Oakland, 1991
MFA, Rhode Island School of Design, Providence, 1996

Boyd Ryo Sugiki learned to blow glass at Punahou High School in Honolulu, Hawaii. It was after he first attended Pilchuck Glass School, where he met Flora Mace, Joey Kirkpatrick, William Morris, Dante Marioni, and Bryan Rubino, that he knew he wanted to be a professional glass blower. In 1989 Marioni advised Sugiki that to blow glass he must study the goblet, which Sugiki continues to learn from today. Since 1996, he has had his own studio, but uses other spaces to blow his work, with the help of one or two assistants. He sells his glass through galleries around the country.

Will Swanson
Harris, MN
Born: 1947, Rochester, MN
Education: BA, Social Welfare, University of Minnesota, 1973
MA, Three-dimensional Design, University of Minnesota, 1983

Will Swanson creates pieces of pottery that are simple in form but which, he hopes, will be cherished over many years of use. His stoneware and porcelain pots are wheel thrown, often altered or assembled from wheel-thrown parts. He formulates his own clay bodies and glazes. Swanson joined his wife, Janel Jacobson, at her pottery studio in 1985 in Sunrise, Minnesota, where she had been working since 1975. The old farm house was both their working space and their living area. They completed their current studio, separate from their house, in 1995. Swanson sells most of his work at the studio and through a few craft fairs each year.

Cynthia W. Taylor and Aaron Yakim
Parkersburg, WV
Born: (Taylor) 1950, Charlottesville, VA; (Yakim) 1949, Charleroi, PA
Education: (Taylor) BS, Biology, College of William and Mary, Williamsburg, VA, 1972
(Yakim) Fairmont State College, Fairmont, WV, 1969

Cynthia Taylor and Aaron Yakim are among the few who continue to make white oak baskets the traditional way—not only designing and weaving baskets, but also finding the suitable timber and creating basket materials from white oak (*Quercus alba*), known for its ease of splitting, strength, and flexibility. They select trees and use hand tools to fell, split, carve, and weave the wood. Yakim learned white oak basketmaking in the late 1970s with basketmaker Oral Nicholson. Having made over 2,500 baskets, Yakim is considered one of the finest masters of the art. Taylor, who was introduced to white oak basketmaking in 1982 by Rachel Nash Law, has extensively documented traditional white oak baskets and basketmakers of central Appalachia. She shared this knowledge in a book and in several exhibitions about the craft. Yakim and Taylor formed their partnership in 1994 and show their work at numerous shows and festivals.

Ikuzi Teraki and Jeanne Bisson
Washington, VT
Born: (Teraki) 1952, Kyoto, Japan

(Bisson) 1952, Montpelier, VT
Education: (Teraki) Kyoto Ceramic School, Japan, 1971; Kyoto Design School, Japan, 1973; (Bisson) University of Vermont, Burlington, 1971–73; Associates Degree, Visual Arts, Berkshire Community College, Pittsfield, MA, 1975; BA, Art Education, Goddard College, Plainfield, VT, 1977
See page 32

Billie Jean Theide
Champaign, IL
Born: 1956, Des Moines, IA
Education: BFA, Drake University, Des Moines, IA, 1978
MFA, Metalsmithing and Jewelry Design, Indiana University, Bloomington, 1982

Bille Jean Theide began working in metal in 1982 after receiving her MFA. She established her first studio upon taking a teaching position at San Diego State University. In 1983 she relocated to Des Moines, Iowa, to join the faculty at Drake University. Since 1985, she has been Professor and Chair of the Metal Program at the School of Art and Design at the University of Illinois, Urbana-Champaign. Theide's early work was characterized by the use of sterling silver and colored acrylic sheet. She later introduced brightly colored anodized aluminum elements and experimented with more subtle color finishes. She applies color through patination and enamel paint, and attempts to evoke a feeling of monumentalism. Her recent hybrid teapot forms combine historical silver plate and fabricated copper. For Theide, in a perfect piece concept, function, and beauty are equal.

Ann Thompson
Biddeford Pool, ME
Born: 1949, Arlington, MA
Education: Philadelphia College of Art, PA,1968; Studied stone setting with Donald Cook, 1972; North Bennett Street Industrial School of Jewelry-making, Boston, MA, 1973; Boston University, Program in Artistry, MA, 1975

Ann Thompson is a self-employed metalworker and designer. She acquired her skills over the years through workshops, jobs, and exchanges with other metalsmiths. She began making baby spoons several years ago as presents for friends, intrigued by the idea of the spoon as a human being's first tool. Her current series of serving pieces is inspired by naturally shaped stones that she

collects near her home on the coast of Maine and that she incorporates in her work. The stones are used as found, without additional carving. Thompson fabricates her metalwork using a variety of tools and techniques, with no cast elements. Her spoons combine the memory of prehistoric stone tools with the evolved contemporary utensil. The challenge for her is to make the natural and the manufactured parts interact harmoniously. The series has expanded to include other types of tableware and sometimes incorporates transparent stone or glass.

Holly Tornheim
Nevada City, CA
Born: 1948, Ann Arbor, MI
Education: BA, Antioch College, Ohio, 1971

Holly Tornheim began doing carpentry as a college student working on a house-building project in the foothills of the Sierra Nevada Mountains in California. The structure was modeled after a Mandan earth lodge and a Japanese farm house and was built with local materials using no electricity. It was her first exposure to wood. In 1977, while helping to remodel a 16th-century convent in Provence, France, she carved her first piece of wood—a hollyhock design on an old beam using a straight edge chisel. After several more years as a carpenter, she began to build and carve doors. She later worked for furniture maker Robert Erickson, who taught her how to use noncarpentry woodworking tools and helped train her eye. Tornheim set up her woodworking and carving studio in 1992 on the San Juan Ridge near Nevada City, where she now works alone creating primarily sculptural platters, bowls, and servers.

Keizo Tsukada
Philadelphia, PA
Born: 1973, Tokyo, Japan
Education: BFA, Crafts, University of the Arts, Philadelphia, PA, 1997

Keizo Tsukada is a wood furniture artist currently working in Philadelphia. He worked as an assistant to Peter Pierobon while he studied for his degree in fine arts at the University of the Arts. When Pierobon left Philadelphia, Tsukada took over his studio and started a career as an independent artist. Tsukada likes to create functional furniture with delicate organic curves that invite human interaction and that have a strong physical presence. He works with

mahogany, figured maple, padauk, and other hardwoods, and finishes his pieces with natural color. Since 1995, his work has appeared in many exhibitions and at craft and furniture trade shows, as well as in gallery exhibitions.

Carlson Tuttle
Burnsville, NC
Born: 1944, New York, NY
Education: University of Windsor, Ontario, Canada, 1967; Graduate work at University of Michigan, Ann Arbor, and University of Western Ontario, London, Canada

Carlson Tuttle makes brooms and has been teaching broom making at the John C. Campbell Folk School in North Carolina since 1988. Tuttle moved to North Carolina in 1971 after doing graduate work in history and geography at the University of Western Ontario. He then learned to make brooms from Lela Howell of Bakersville, North Carolina, in 1972. Since then Tuttle has studied brooms in Jamaica, Belize, Wales, Guatemala, Hungary, and Honduras. He is also interested in broom-making techniques established in this country, such as the Turkey wing style used by Native Americans in the Southeast, and the Broom Corn adaptation of the Turkey wing, which was used by African Americans in the South. Tuttle gives demonstrations on broom making and also works in other fiber arts, such as weaving on a floor loom, card weaving, and making bobbin lace. Tuttle sells his work through craft fairs and shops.

Henri Vaillancourt
Greenville, NH
Born: 1950, Greenville, NH
Education: University of New Hampshire, Durham, 1968–69

Henri Vaillancourt started building canoes as a hobby at the age of 15. He began his own business as a canoe builder in Greenville, New Hampshire, in 1970, after studying forestry at the University of New Hampshire. He has been steadily employed since then, building up to eight birchbark canoes a year. Although he specializes in the type of canoe used by the Malecite Indians, he also builds in other tribal styles, particularly the graceful Algonquin canoe and the various high-ended fur-trade boats. Vaillancourt finds the process of making canoes challenging and enjoyable, requiring a high level of skill to produce a craft that is sophisticated in construction and elegant in line.

In addition to constructing boats, he also has been actively involved in the study of other aspects of Native American material culture, and in 1977 co- founded the Trust for Native American Cultures and Crafts.

Dawn Walden
Omak, WA
Born: 1948, Upper Peninsula, MI
Education: Ferris State College, Big Rapids, MI, 1967; Columbus College of Art & Design, OH, 1972; Lake Superior State College, Sault Ste. Marie, MI, 1979; Wenatchee Valley College, Omak, WA, 1992–94
See page 30

Lisa Waters
Kingston, NY
Born: 1958, Kingston, NY
Education: BFA, Ceramics, State University of New York at New Paltz, 1981; MFA, Metalsmithing, Rhode Island School of Design, Providence, RI, 1988

Lisa Waters's earliest influence as a craftsperson was a high-school field trip to a pottery collective. Seeing people making functional objects in contemporary design, and enjoying the process, had an impact on the aspiring artist. Waters earned her BFA from the State University of New York in New Paltz, where she majored in ceramics, and later studied metalsmithing for her MFA at the Rhode Island School of Design. Another important influence on her work has been her interest in the history of modern design. The art critic and historian Mary Ann Staniszewski, with whom Waters studied, introduced her to the historicity of modern art. Waters established her studio in 1982, a year after graduating from college. She primarily works alone, occasionally using larger commercial companies for mass-production processes. She markets her metalwork through public craft shows and galleries, and sells retail and wholesale.

Philip Weber
Freeport, ME
Born: 1952, New York, NY
Education: State College of New York at Cortland, 1970–72

Philip Weber began working with wood in 1976. He was inspired after reading James Krenov's *A Cabinetmaker's Notebook* and *The Impractical Cabinetmaker*, and the early issues of *Fine Woodworking* magazine. From 1982 to 1986 Weber had a studio in Benson, North Carolina, and since 1986, he has been working at his studio in Freeport, Maine. He makes limited production boxes, refining design and method as he goes. He sells his work through craft shows.

Londa Weisman
North Bennington, VT
Born: 1947, Ann Arbor, MI
Education: BA, Ceramics and Sculpture, Bennington College, VT, 1967; MA, Ceramics and Sculpture, Bennington College, VT, 1974

Londa Weisman has worked out of the same studio overlooking a meadow in North Bennington, Vermont for more than 25 years. While her mugs, bowls, jars, and dinnerware sets are intended for use, Weisman feels that each of her pieces should be read closely, with focus on its unique shape and contrasting textures. Such a sculptural approach to her work is rooted in her training in the 1960s at Bennington College, where she was involved in the major concerns of American art at the time. She studied welded sculpture with David Smith and Isaac Witkin, ceramics with Stanley Rosen, and drawing with Pat Adams. Weisman works alone at her Mechanic Street Pottery & Iron Works studio, where, in addition to pottery, she creates welded steel fabrications, steel-and-glass tables, and cut-clay wall platters. She sells her work through retail fairs and by special order.

Lawrence Wheeler
Westford, MA
Born: 1946, Boston, MA
Education: M.Ed., Antioch University, Cambridge, MA, 1980 Ph.D. candidate, Heller School, Brandeis University, Boston, MA, 1984–86

Lawrence Wheeler first learned Lightship basket making while living on the island of Nantucket in Massachusetts in 1970–74, but making baskets wasn't his full-time occupation until 1994. Wheeler left a long career in public health, and in 1992–94 built two houses, including his current home in Westford, and made baskets part-time. His current studio is a 1,000-square-foot space in his basement, where he works alone designing and making approximately 300 baskets a year. Wheeler creates his own molds based on traditional designs, hand picks the woods to be used, and does his own cutting and shaping. He also designs, cuts, and carves the handles. Wheeler no longer has time to make basket parts or molds for other makers, as he once did, but now focuses on his own designs. He sells most of his work at craft shows and galleries.

Dick Wickman
Verona, WI
Born: 1947, Ashland, WI
Education: BFA, Layton School of Art, Milwaukee, WI, 1969

For the past 26 years, Dick Wickman has worked exclusively as a designer and builder of furniture, lighting, and related furnishings for residential and commercial applications. Though he works alone in his studio, he collaborates closely with a select group of interior designers around the country to produce commissions. Wickman's studio is in a 19th-century barn on the property in Wisconsin where he lives with his wife, Virginia. He has two grown children.

Jay Wiggins
Atlanta, GA
Born: 1959, Shelby, NC
Education: Architecture, Southern College of Technology, Marietta, Ga., 1990–91; Apprentice to Atlanta furniture maker Jack Harich, 1991–93

Jay Wiggins established his furniture-making studio, spaghetti western furniture, at his home in Atlanta in 1993 after a two-and-a-half-year apprenticeship to furniture maker Jack Harich. Wiggins's inspirations have been mainly 20th-century modernists, including Charles and Ray Eames and Gerrit Rietveld. Form and proportion stimulate him, and as we enter the 21st century, he is eager to see what lies beyond modernism. Wiggins's SW-1 table reflects his commitment to efficiency in design, material use, and production. Wiggins takes pride in its strength and trusts it will last well into the next century. He sells his work from his studio and at an Atlanta gallery.

Mike Wilder
Kenansville, FL
Born: 1954, Tampa, FL
Education: Ranch Management Degree, Texas Christian University, Fort Worth, 1974; J. M. Saddlery School, SD, 1977

Mike Wilder makes custom saddles and equipment at a shop adjoining his horse barn in Kenansville, Florida, which he built after working full-time as a cowboy from 1972 to 1992, an experience that makes him uniquely qualified to understand the needs of his customers. For each of his saddles Wilder selects the rawhide-covered tree (the saddle's foundation) and designs and fits the leather pieces, which are either machine- or hand-stitched together. He uses bronze rigging hardware and oak stirrups and usually adds a simple stamped design to his saddles, though more decorative details may be added to suit the rider's tastes. Wilder believes his work will stand the test of time. As he says, horses and the people who ride them require quality equipment—their safety and sometimes their lives depend on it. He sells his work, including reproduction saddles based on 19th-century models and military saddles, out of his studio.

Allan Winkler
Charlestown, MA
Born: Minneapolis, MN, 1948
Education: Boston University, MA, 1966–68; Suffolk University, Boston, MA, 1968–70

Music and craftsmanship have always been in Allan Winkler's family—his father was a flutist and his grandfather was a master cabinetmaker who worked for an organ builder. Winkler, naturally drawn to the world of music, was trained in building harpsichords from 1971 to 1977 in the shop of Eric Herz in Cambridge, Massachusetts. He then set up his own shop in Boston, where he currently makes harpsichords and clavichords, focusing on the methods and materials of the masters of the 17th and 18th centuries. (Winkler studied collections in the U.S., France, England, and Belgium as part of his research.) His use of hand tools is central to the way in which he produces two or three instruments a year. Part of his time is also spent maintaining his existing instruments and restoring those in the collection of the Museum of Fine Arts, Boston.

Edward S. Wohl
Ridgeway, WI
Born: 1942, Cleveland, OH
Education: Ohio State University, Columbus, 1960–63; BS, Architecture, Washington University, St. Louis, MO, 1967
See page 26

Jerry Wolfe
Cherokee, NC
Born: 1924, Cherokee, NC
Education: Cherokee Boarding School

Jerry Wolfe grew up in Cherokee, North Carolina, learning about Cherokee history, culture, and language. As a young man he played stick ball, a popular, traditional Cherokee game, and learned to carve the sticks from wood. After six years in the U.S. Navy during World War II (he was part of the invasion of Normandy), Wolfe returned to America and learned and taught the building trade for 20 years with Job Corps. He has continued to make stick ball sticks, using hickory for its knot-free and straight qualities, and also because the wood is considered sacred by the Cherokee people. Wolfe no longer plays, but is often in demand as a "caller" or announcer for stick ball games. Since his retirement at 86, Wolfe has participated in Methodist building missions in Jamaica, Haiti, South Africa, and Barbados, and works in the outreach program of the Museum of the Cherokee Indian.

Edward Zucca
Woodstock, CT
Born: 1946, Philadelphia, PA
Education: BFA, Philadelphia College of Art, PA, 1968

Since 1974, Edward Zucca has been a self-employed furniture designer and maker. He established his first studio in Putnam, Connecticut, in a small rebuilt barn. In 1983 he designed and built his new home in Woodstock with a wood shop in the basement, where he continues to work today. Zucca tries to do new things following his varied interests rather than maintain the same look over the years. Each of his pieces of functional wooden furniture, he says, is meant to be a new adventure. He sells his work through galleries, exhibitions, and on commission.

Resource List

For information on current and future listings of exhibitions, craft fairs, conferences, and special events, the following organizations, publications, and museums can be contacted through their website or mailing address.

Organizations

American Bladesmith Society
PO Box 1481
Cypress, TX 77410
www.americanbladesmith.com

American Cuemaker's Association
2221 Larbrook Drive
Florissant, MO 63031
www.cuemakers.org

American Craft Council (ACC)
72 Spring Street
New York, NY 10012
www.craftcouncil.org

American Kitefliers Association (AKA)
300 N. Stonestreet Avenue
Rockville, MD 20850-4117
www.aka.kite.org

American Quilter's Society
PO Box 3290
Paducah, KY 42002-3290
www.aqsquilt.com

Artist-Blacksmith's Association
of North America (ABANA)
PO Box 816
Farmington, GA 30638
www.abana.org

Glass Art Society (GAS)
1305 Fourth Avenue, Suite 711
Seattle, WA 98101
www.glassart.org

Guild of American Luthiers
8222 South Park Avenue
Tacoma, WA 98408
www.luth.org

Guild of Book Workers
521 Fifth Avenue
New York, NY 10175
http://palimpsest.stanford.edu/
byorg/gbw

Handweavers Guild of America (HGA)
Two Executive Concourse, Suite 201
3327 Duluth Highway
Duluth, GA 30096-3301
www.weavespindye.org

National Council on Education
in the Ceramic Arts (NCECA)
PO Box 1677
Bandon, OR 97411
www.nceca.net

Society of North American
Goldsmiths (SNAG)
710 East Ogden Avenue, Suite 600
Napierville, IL 60563-8603
www.snagmetalsmith.org

Studio Art Quilt Associates
PO Box 287
Dexter, OR 97431
www.saqa.com

Surface Design Association
PO Box 360
Sebastopol, CA 95473
www.surfacedesign.org

The American Association
of Woodturners
3499 Lexington Avenue N., Suite 103
Shoreview, MN 55126
www.woodturner.org

The Furniture Society
Box 18
Free Union, VA 22940
www.furnituresociety.org

The Violin Society of America
48 Academy Street
Poughkeepsie, NY 12601
www.vsa.to

Wood Turning Center
501 Vine Street
Philadelphia, PA 19106
www.woodturningcenter.org

Periodicals

American Ceramics
9 East 45th Street
New York, NY 10017
www.ceramicsworldwide.com

American Craft
American Craft Council
72 Spring Street
New York, NY 10012
www.craftcouncil.org

American Style
The Rosen Group
3000 Chestnut Avenue, Suite 304
Baltimore, MD 21211
www.americanstyle.com

American Woodturner
The American Association of
Woodturners
3499 Lexington Avenue North,
Suite 103
Shoreview, MN 55126
www.woodturner.org

Ceramics Monthly
735 Ceramic Place
PO Box 6102
Westerville, OH 43086
www.ceramicsmonthly.org

Fiberarts
50 College Street
Asheville, NC 28801
www.larkbooks.com/fiberarts

Fine Woodworking
The Taunton Press
63 South Main Street
Newtown, CT 06470
www.finewoodworking.com

Glass
SFS 230 James Bohanan Drive
Vandalia, OH 45377
www.urbanglass.com

Hand Papermaking
PO Box 77027
Washington, DC 20013-7027
www.handpapermaking.org

Kitelife Magazine
www.kitelife.com

Metalsmith
Society of North American
Goldsmiths
710 East Ogden Avenue, Suite 600
Napierville, IL 60563
www.snagmetalsmith.org

Surface Design
Surface Design Association
PO Box 360
Sebastopol, CA 95473
www.surfacedesign.org

The Anvil's Ring
Artist-Blacksmith's Association
of North America
PO Box 816
Farmington, GA 30638
www.abana.org/anvil_s_ring.html

The Studio Potter
PO Box 70
Goffstown, NH 03045
www.studiopotter.org

WoodenBoat
Subscription Department
PO Box 78
Brooklin, ME 04616
www.woodenboat.com

Museums

The following museums feature shows of historical and contemporary craft. Numerous other museums in the United States have permanent collections that include contemporary works in the craft media and present exhibitions on crafts. Most are listed in the current and future events calendar of craft magazines.

American Craft Museum
40 West 53rd Street
New York, NY 10019
www.americancraftmuseum.org

American Museum of Fly Fishing
Seminary Avenue
PO Box 42
Manchester, VT 05254
www.amff.com

Corning Museum of Glass
One Museum Way
Corning, NY 14830
www.cmog.org

Craft and Folk Art Museum
5814 Wilshire Boulevard
Los Angeles, CA 90036
www.lacma.org/library/wyle.htm

Mint Museum of Craft + Design
220 North Tryon Street
Charlotte, NC 28202
www.mintmuseum.org

National Ornamental Metal
Museum
374 Metal Museum Drive
Memphis, TN 38106
www.metalmuseum.org

Renwick Gallery of the Smithsonian American Art Museum
Pennsylvania Avenue at 17th
Street, NW
Washington, DC 20006
http://nmaa-ryder.sil.edu/
collections/renwick.main.html

The Museum of Craft and Folk Art
Landmark Building A
Fort Mason Center
San Francisco, CA 94123-1382
www.sfcraftandfolk.org

The Schein-Joseph International
Museum of Ceramic Art
New York State College of
Ceramics at Alfred University
Alfred, NY 14802
www.ceramicsmuseum.alfred.edu

Charles A. Wustum Museum
of Fine Arts
2519 Northwestern Avenue
Racine, WI 53404
www.wustum.org

Acknowledgments

The rich spectrum of objects featured in this book reflects the talent and skill of two hundred craftsmen residing in the United States. As a former Director of the American Craft Museum (1963–87), I welcomed the invitation in September 1998 from chief curator David McFadden to organize a major exhibition and publication that features some of America's finest makers of unique functional work. I felt it timely to present this focus, as it represents a vast community of craftspeople and an aspect of the studio movement that often does not get the public recognition it deserves.

To assemble the collection, I conducted an extensive, two-year national search for the best work, as well as for emerging talent and crafts people with whom I was not familiar. My research entailed traveling to many geographical areas of the country and attending numerous craft shows and events where current work was presented. This gave me an opportunity to meet craftsmen and see firsthand the work of several thousand makers. Because of space constraints, many talented and professional craftsmen could not be represented.

Producing this publication and exhibition entailed the resources of many individuals and organizations who supplied important leads of suggested people to contact. I first wish to thank the contributing craftsmen for their cooperation and help in collecting data and photographs. Researching the sports, recreation, and play section was the most challenging, as it required intense effort to enter into fields that are not generally part of the contemporary craft scene.

I wish to thank David McFadden for his help and support throughout the project, and director Holly Hotchner and the staff at the American Craft Museum for their involvement with various aspects of the exhibition. To have Harry N. Abrams, Inc. publish this high-quality book was very important in documenting the project. I wish to extend my special appreciation to senior editor Elisa Urbanelli, with whom it was wonderful to work. I also appreciate the enthusiasm of those involved with the excellent book design. Under the supervision of art director Michael Walsh, Joseph Cho and Stefanie Lew of Binocular created an impressive format. For the excellent book text I am grateful for the perceptive essay "Perspectives of Craft and Design" written by Akiko Busch and to Margaret Mackenzie for her pertinent quote reflecting an anthropological point of view. Julia Gaviria made an important contribution by writing the short artist biographies that give insight to each maker's career. I also wish to thank Joyce Lovelace who did preliminary editing of the studio profiles and my essay. Several state arts councils, folklorist groups, magazine editors, museum curators, craft media organizations, and individuals offered valuable advice and people to consider. Listed here are those who served as a resource or contributed in some form to make this ambitious survey possible.

Paul J. Smith

Organizations

American Craft Council, New York, NY (Emilie Anderson, JoAnn Brown, Lois Moran); Florida Folklife Program, Florida Department of State (Tina Bucuvalas); Indian Arts and Crafts Board / Dept. of Interior (Ken Vanwey, Rosemary Ellison); Milwaukee County Historical Society, Milwaukee, WI (Bob Teske); National Endowment for the Arts, Heritage and Preservation Division, Washington, DC (Barry Bergey); National Council for the Traditional Arts, Silver Springs, MD (Joe Wilson); North Dakota Council on the Arts (Troyd Geist); New Hampshire State Council on Arts, Concord, NH (Lynn Martin); Society of North American Goldsmiths (Donald Friedlich, Peggy Eng); Southern Highland Craft Guild, Asheville, NC (Ruth Summers); Utah Arts Council, Salt Lake City, UT (Carol Edison, Folk Arts Coordinator); Western Folk Life Center, Eiko, UT (Meg Glazer)

Museum Directors, Curators

American Museum of Fly Fishing, Manchester, VT (Sara Wilcox); Arkansas Arts Center – Decorative Arts Museum, Little Rock, AR (Alan DuBois); Heard Museum, Phoenix, AZ (Diana Pardue, LaRee Bates, James Barajas); Historical Museum of South Florida, Miami, FL (Stephen Stuempfle); Institute of American Indian Arts, Santa Fe, NM (Tatiana Slock); National Ornamental Metal Museum, Memphis, TN (James Wallace); Smithsonian Institution, Center for Folklife and Cultural Heritage, Washington, DC (Tod Vennum); Smithsonian Institution, Division of Cultural History, Washington, DC (Gary Sturm); The Wharton Esherick Museum, Paoli, PA (Robert Leonard)

Magazines

The Surfer's Journal, Steve Pezman, editor; *WoodenBoat* magazine, Matthew Murphy, editor

Craft Shows and Expositions

American Craft Council Shows – Baltimore, MD, Charlotte, NC; Boston Early Music Festival and Exposition, Boston, MA; Buyers Market of American Craft, Philadelphia, PA; Crafts at the Castle, Boston, MA; Heard Museum Guild Indian Fair & Market, Phoenix, AZ; International Gift Show, New York, NY; Philadelphia Furniture & Furnishings Show, Philadelphia, PA; Philadelphia Museum of Art Craft Show, Philadelphia, PA; Sculpture Objects & Functional Art (SOFA), Chicago, IL; Smithsonian Craft Show, Washington, DC; Washington Craft Show, Washington, DC; WoodenBoat Show, St. Michaels, MD, Mystic Seaport, Mystic, CT

Galleries

Ferrin Gallery, Croton-on-Hudson, NY (Leslie Ferrin); Northwest Fine Woodworking, Seattle, WA (Christopher Brookes); Perimeter Gallery, Chicago, IL (Frank Paluch); Pritam & Eames, East Hampton, NY (Warren and Bebe Johnson); Robert F. Nichols Gallery, Santa Fe, NM (Robert Nichols); Snyderman-Works Galleries, Philadelphia, PA (Bruce Hoffman); The Fountainhead, Seattle, WA (Sue Peterson); William Traver Gallery – Vetri International Glass, Seattle, WA (William Traver, Julie Rosten, Heather Eslien); Yaw Gallery, Birmingham, MI (Nancy Yaw)

Individuals who were a resource or assisted with making contacts

Stuart Allen; John Cederquist; Nick Conroy; Fran Reed; Olga Garay; Dolph Gotelli; Carolyn Hecker; Lisa Hunter; Lloyd Herman; Ken Loeber; Dona Look; Tom Markusen; Richard Polsky; Michael Schuster; Stuart Smith; Nancy Sweezy; Roy Superior

This project is made possible with public funds from the New York State Council on the Arts, a state agency

Photograph Credits

Dan Abbott: 120 bottom
Noel Allum: 244
Jack Alterman: 272, 273
Sally Andersen-Bruce: 261
Jerry Anthony: 126 top and bottom, 236 right, 282 top and bottom, 283
Jonathan Barber ©2001: 89 bottom left and right
Tim Barnwell: 228, 242 top right, 243
Bob Barrett: 79 bottom, 127, 165 right
D. Hayne Bayless: 106, 107 top and bottom
Beltramis Studio: 32
Elizabeth Betts: 64
John Betts: 65
Roger Birn: 246, 247
Tony Boase: 184
Jonathan Bonner: 248 bottom right
Frank J. Borkowski: 172
Charles Brooks: 175 top
Kip Brundage: 279 bottom
Glenn Burris: 101 all
Cody Bush: 147
Melva Calder: 179
David L. Caras: 46
Michael Cavanagh – Kevin Montague: 169
Rick Chapman: 194
Frank R. Cheatham: 306, 307
Joe Chielli: 207, 230 bottom right
Michael Cohen: 95 top
Tom Collicott: 229 right
Michael Croft: 87 top and bottom right
Gadi Dagon: 34
D. James Dee: 79 top, 108, 119 top, 277
Joseph Deiss ©1997: 61
Didier Delmas: 153
Robert Diamante: 96 top, 150 top and bottom, 234 bottom
Caren Dissinger: 248 top right
David Egan: 302 top left and right, 303
George Ermil: 13
Curtis Erpelding: 190
Robert Joseph Farrell: 131, 148 top left and right
M. Lee Fatherree: 164
Fred Fenster: 134
John A. Ferrari: 20
Florida Folklife Program – Florida Department of State, Robert L. Stone, photographer: 280 left
Martin Fox: 196
Jeff Frey: 290, 291
Charles Frizzell: 269, 308 top and bottom
Kim Fuller: 251 top and bottom
Ralph Gabriner: 93 bottom
Michael Galatis: 295, 296, 312, 313
Lisa Gamble: 50
Ira Garber: 137
Margot Geist: 198 bottom
Robert Gibeau: 257 bottom
John Parker Glick: 102
G/Q Studios Ltd: 162
Dennis Griggs: 52, 53, 254, 288 left
Steve Grubman: 314, 315
Jan Hart: 24
Drew Harty: 241 top
Koichiro Hayashi: 217
Heard Museum, Phoenix, AZ: 143 right, 144
R.H. Hensleigh: 86, 87 top left, 155 bottom, 165 left, 168, 263
Eva Heyd: 8, 9, 10, 11, 12, 14, 15, 16, 18, 19, 29, 33, 41, 55, 59, 75, 76, 77, 78, 80, 81, 82, 83 all, 85, 97, 98, 104 top and bottom, 105, 116, 117, 118, 125 left, 140 top and bottom, 141, 142, 143 left, 158, 159, 166 top, 180, 181, 189 top, 195, 232 top and bottom, 233, 235, 237, 238, 239, 264, 265, 266, 274, 275, 279 top, 280 bottom, 281, 286, 300, 304, 305, 309, 310 top and bottom
Robin L. Hodgkinson: 298
Fred Hoyle: 129, 174
Joey Ivaneco: 139
Kenro Izu: 63
Derk M. Jager: 292
Paul Jeremias ©2000: 178 bottom
Michael Jerry: 136 left, 148 bottom left
Jeff Johnson: 43
Jim Johnson: 71, 278
Russell Johnson: 122, 163, 175 bottom
Russell Johnson / Jeff Curtis: 123, 124
Mark Johnston: 88 top and bottom, 89 top right
Tom Joyce: 260
Martine Julien: 95 bottom, 176 bottom
Uosis Juodvalkis: 36, 37, 99
John E. Kane: 214, 215, 223, 230 bottom left
Ron Kaplan: 276
Bart Kasten: 213
Gunther Keil: 302 bottom left and right
Steven LaBuzetta: 191 left and right, 204
Al Lada: 26, 27
Catherine H. Latané: 84, 91
Joey Lee: 54
Peter Lee: 109 right, 110, 112, 113 top and bottom, 177
William Lemke: 182 top left and right, 183, 187, 198 top, 199 top, 206 left, 210, 216, 218
R. Bruce Lemon: 69
Bob Lenz: 236 left
Kari G. Lønning: 241 bottom
Robert Lowery: 151 top
John Lucas: 205
May Mantell: 121
John B. May: 185
Jerry McCollum: 31
Mason McCuddin: 87 bottom left, 146 bottom
Scott McCue: 231, 262
Nick Merrick – Hedrick Blessing: 45
Neil Michel / Axiom: 96 bottom
Sanders H. Milens: 189 bottom, 287
Buck Miller ©: 72
Gretchen Miller: 301 right
Tom Mills: 89 top left, 94, 109 left, 221
David Mohney: 230 top left
Kevin Montague: 188 top
Dan Morse: 167
Bill Murphy: 51, 202, 225 top
Ric Murray: 188 bottom, 200 top, 211, 225 bottom, 257 top
James Nedresky: 151 bottom, 154, 155 top
Geoffrey Nilsen: 39, 125 right
North Dakota Council on the Arts, Chris Martin, Photographer ©: 70
Jeff Oestreich: 111
Michael O'Neill: 222, 228 right
Hal Orginer ©: 60
Jim Osborn: 234 top, 242 bottom left and right
Woody Packard: 206 right
Rick Patrick: 103 top and bottom
Bill Pogue: 57, 267
Elton Pope-Lance: 62
Dean Powell: 47, 135 top, 138, 145, 208, 209 left and right, 219, 224
Guy Rabut: 284, 285
Michael F. Rhode: 253 left and right
Tim Rice: 48, 193
Paul Rocheleau: 133, 270 bottom, 271
Frank Ross: 289
Deborah Route: 135 bottom, 157
Hap Sakwa: 182 bottom right
Jorge Salas ©: 67
Ron Sawyer: 229 left
Ed Saylan: 182 bottom left
Edith R. Schade: 270 top
Roger Schreiber: 146 top, 152, 170, 171, 173, 250
Michael T. Seidl: 128
William Seitz: 90
Mark Shapiro: 93 top, 114, 115
David Sharpe ©: 49
John L. Skau: 240
Ken Smith: 30
Paul J. Smith: 38, 40, 42, 44, 56, 58, 68, 73
Kenneth Snyder: 119 bottom
Steinway & Sons: 297
Chris Stewart: 252
Tim Stewart: 199 bottom, 248 bottom left
Storm Photo: 113 top, 176 top
Tal Streeter: 301 left
William Struhs: 28
Richard Stum: 166 bottom
Linda Svendsen: 311
Eric Swanson: 25, 92
Will Swanson: 100 top and bottom
Lynn Swigart: 132 top and bottom
Steven Tatum: 248 top left
Cynthia W. Taylor: 178 top
Billie Jean Theide: 130, 136 right
Lynn Thompson: 299
Patrick Trefz: 66
Bill Truslow ©: 160, 192, 230 top right, 245, 259
Keizo Tsukada: 212
Robert Vinnedge: 249
Jonathan Wallen: 242 top left
Bill Waltzer: 35
John Warner: 293
Webstar Photographic: 161, 258
Skot Weidemann: 197, 256
Sarah Wells: 200 bottom, 201, 220
Jay Wiggins: 203
Alex Williams: 120 top
Allan Winkler: 294
John Woodin: 148 bottom right, 149
James Woodson: 226, 227
Chee-Heng Yeong: 255
Kee-Ho Yuen: 156

334

Index

Page numbers in italics refer to illustrations